MAJESTIC SPLENDOR

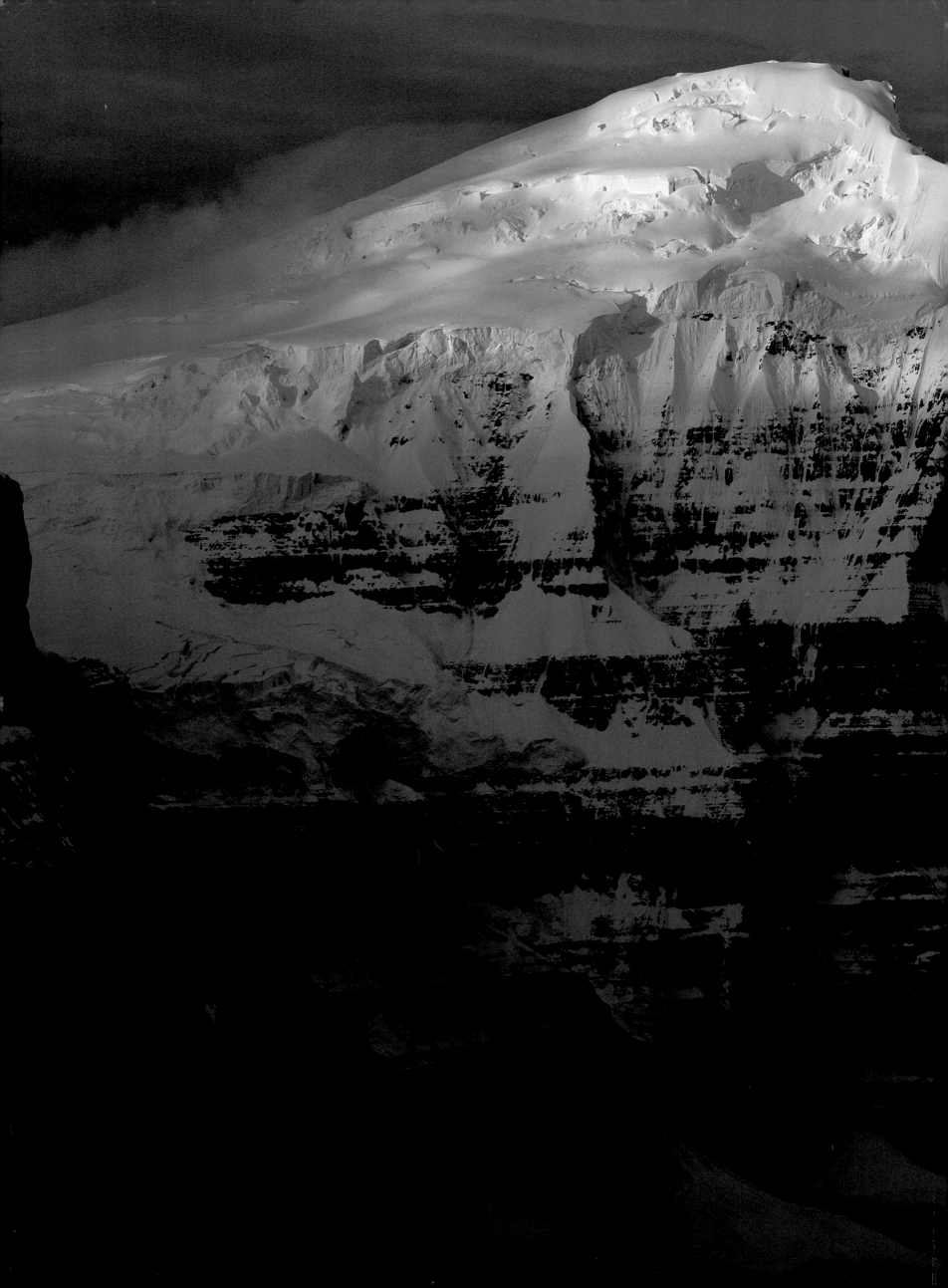

MAJESTIC SPLENDOR

A PORTRAIT OF THE ROCKIES

SHIRO SHIRAHATA

Afterword by Patrick Morrow

CHRONICLE BOOKS

SAN FRANCISCO

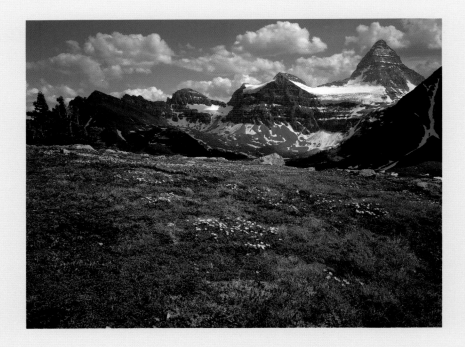

First published in the United States in 1997 by Chronicle Books

Copyright © 1997 by Shiro Shirahata
Afterword Copyright © 1997 by Patrick Morrow
Originated as a co-production of Yama-Kei Publishers Co. Ltd.,
Japan, and Raincoast Books, Canada.

Printed in Hong Kong.

Library of Congress Cataloging-in-Publication Data:

Shirahata, Shirō, 1933-
 [Rocky Mountains]
 Majestic Splendor : a portrait of the Rockies / Shiro Shirahata ;
 afterword by Patrick Morrow.
 p. cm.
 Earlier title: The Rocky Mountains.
 ISBN: 0-8118-1867-5 (hc)
 1. Canadian Rockies (B.C. and Alta.)—Pictorial works. I. Title.
 F1090.S48 1997
 917.8'0022'2—dc21 97-12184
 CIP

Jacket design: Pamela Geismar
Book design: Raincoast Books

10 9 8 7 6 5 4 3 2 1

Chronicle Books
85 Second Street
San Francisco, California 94105

Web Site: www.chronbooks.com

CONTENTS

Text

Plates

Mount Robson, Resplendent Mountain, Whitehorn Mountain, Mount Geikie, The Ramparts, Mount Edith Cavell, Mount Kerkeslin, Mount Brazeau Group, Mount Hooker, Mount Fryatt, Mount Christie, Dragon Peak, Mount Clemenceau, Mount Shackleton, Mount Alberta, Mount Columbia, Snow Dome, The Twins, Stutfield Glacier, Dome Glacier, Mount Athabasca, Mount Andromeda, Mount Lyell Group, Mount Forbes, Mount Bryce, Mount King Edward

Mount Murchison, Epaulette Mountain, Howse Peak, Mount Chephren, White Pyramid, Mount Patterson, Crowfoot Mountain, Mount Burgess, The President, Cathedral Crags, Mount Stephen, Hungabee Mountain, Mount Huber, Mount Biddle, Ringrose Peak, Chancellor Peak, Mount Goodsir, Ten Peaks, Bident Mountain, Quadra Mountain, Mount Fay, Grand Sentinel, Mount Temple, Mount Victoria, Pilot Mountain, Castle Mountain, Mount Louis, Mount Edith, Mount Rundle, Cascade Mountain, Sunburst Peak, Mount Assiniboine, Mount Lougheed, Mount Lyautey, Mount Joffre, The Royal Group, Mount King George

Mount Sir Wilfrid Laurier, Mount Mackenzie King, Mount Sir Mackenzie Bowell, Mount Sir John Thompson, David Peak, Chilkist Peak, Chamberlain Peak, Torii Peak, Mount Lempriere, Mount Albreda, Mount Begbie, Big Blackfriar, Adamant Range, Mount Sir Sandford, Mount Bonney, Mount Tupper, Mount Macdonald, Hermit Range, Mount Sir Donald, Dawson Group, Bugaboo Group, Pigeon Spire, Howser Spire, Snowpatch Spire, Bugaboo Spire, The Lieutenants, Commander Mountain, Karnak Mountain

PREFACE

In 1984 I visited Canada for the first time and had my initial encounter with the Canadian Rockies. Thirteen years have passed since then, but to me it only seems like an instant. It is said that time flies like an arrow; now I really understand what that means.

The weather was bad almost the whole time I photographed the Rockies, which caused a heavy burden for me both mentally and financially. Nevertheless, to my surprise, the results of my efforts were good. I got almost nothing in the first two trips, which means that most of the photographs were taken in the following five trips. All told I shot 320 mountains, but I never planned to photograph that many. It just happened. I have always faced a mountain with the thought that this might be my only chance to photograph it. Today, even when I point my camera at a mountain I have photographed before, I look at it with a fresh mind, as if this were the first time. It has been 47 years since I started climbing mountains and photographing them, and I still have a sense of awe and admiration for them. I want to be in constant contact with mountains. I am at my happiest when I photograph them.

Over the years I have photographed many mountains in Japan and have published a number of photographic collections concerning my native country. As for foreign countries, I have covered the European Alps, the Nepal Himalayas, the Karakoram, the Hindu Kush, the Hindu Raj, the Indo-Himalayas, the Pamirs, the Andes, and Korea. In 1996 I photographed the Himalayas on the Chinese Tibetan side. My photographs of the European Alps, Nepal Himalayas, and Karakoram were published in eight countries.

I have visited many parts of the world and have come to know numerous mountains, but there are still a lot of things I don't know. In my last visit to Canada, although I had consulted the maps a great deal and had read many reference books, I encountered a lot of mountains whose names I had never heard of.

Certainly there is no shortage of maps of Canada's Rockies and Columbia Mountains. However, what is often not marked are the names of the mountains, to say nothing of their elevations. Consequently great effort was required to identify some mountains. The elevation of one mountain can differ from map to map or from book to book. Unfortunately the Canadian federal and provincial tourism offices weren't very receptive to my project. I had the impression that my presence in the Rockies wasn't welcome. I suspect that they felt my work might affect the preservation of nature in Canada. It is true that, once people are allowed into wilderness areas, nature often suffers.

The destruction of nature is now a worldwide calamity. Sensible people call for the preservation of nature, but it often seems as if the majority of the world is indifferent to this very important issue. Ultimately the campaign to protect nature makes little progress, while nature itself is rapidly destroyed.

Canada is said to be a largely forested country that is dedicated to preserving its wilderness. But this is only true of its national parks. In the provincial parks and in the areas that aren't designated as parks, a lot of logging takes place, creating naked valleys and hillsides. When I flew from Vancouver to Calgary, I looked down and saw logging roads snaking through valleys and mountains. There were bare summits, showing a neat circle where trees were chopped down. Looking up from the base of a mountain, you usually can't see this. You might think the whole mountain is fully wooded. Unfortunately this is often not the case. The region in British Columbia just west of the national parks is especially disastrous. It is said that there is no development without the destruction of nature. Somehow, though, a way must be found to preserve the wilderness that is left before it is too late.

Due to the cooperation and assistance of many people, I achieved my goal in this Canadian Rockies project and the results were better than I expected. I would especially like to thank the following: Fuji Photo Film Ltd.; Shigeru Chatani, photographer; Masaaki Ichikawa of Canon Sales Inc.; Shashin Ko-Sha Ltd. and Masayoshi Motohashi; Satoshi Kurokawa and Kazuo Noguchi of Alpine Tour Service; ICI Ishii Sports Ltd. and President Masatoshi Yokota, as well as Hideo Koshigaya and Kazumasa Suzuki; Canadian Mountain Holidays; and, finally, members of my mountain photography club, White Peak, particularly those who participated in the Canadian tour.

I would also like to express my special thanks to Sachiro Masuda and his wife, Haruko, who reside in Canmore and who always accompanied me as guides and interpreters, and Ken Okamoto, who worked as my photography assistant and even as a porter.

For spearheading this huge project of international co-publishing with nine countries, I am grateful to Yama-Kei and its key personnel, including President Yoshimitsu Kawasaki, Executive Directors Naotake Murakami and Akira Egawa, General Manager Shigeo Endo, Mountaineering Books Director Justsu Setsuda, Editor Akira Yamaguchi, Hiroto Kumagaya, who did the jacket design and text layout, and the printer, Dai Nippon Printing Co. Ltd.

THE CANADIAN ROCKIES
MOUNTAINS OF MAJESTY

Canada's impressive Cordillera contains a number of magnificent mountain ranges, including the Mackenzie, Ogilvie, and St. Elias in Yukon Territory; the Coast and Columbia (comprised of the Cariboos, Monashees, Selkirks, and Purcells) in British Columbia; and the most famous of all, the Canadian Rockies, which are shared by British Columbia and Alberta. About 800 kilometers wide and 2,000 kilometers long, the Canadian Cordillera includes Mounts Logan (5,959 meters) and St. Elias (5,489 meters), respectively Canada's highest and second-highest peaks, both of which are found in the St. Elias Mountains in the Yukon. Although only a part of this extensive network of mountains, the 200-kilometer-wide Canadian Rockies still march 1,200 kilometers from the American borders of British Columbia and Alberta to the Liard River Basin near the B.C.-Yukon border. Stretching southward another 2,000 kilometers through the United States, the Rockies essentially form the backbone of North America.

Compared to the American Rockies, the Canadian Rockies yield to their U.S. counterpart in height, but exceed them by far in grandeur. Without doubt one is often left speechless before magnificent, glacier-eroded mountain faces, massive, still-active glaciers and icefields, and wild forests that even today have impregnable reaches.

The result of the collision of a plate in the Pacific Ocean with the North American continental shelf, the Rockies were largely formed during the Cretaceous period (144 to 65 million years ago). The mountains were sculpted into what we see today by the scouring action of glacial periods that visited the Earth from about two million to 10,000 years ago. Roughly speaking, there were four major glacial periods: Günz, Mindel, Riss, and Würm. The North American equivalents were Nebraskan, Kansan, Illinoian, and Wisconsin. In the Wisconsin glacial period (70,000 to 10,000 years ago), the Rockies were covered with 4,000- to 5,000-meter-thick ice. At the time, glaciers even flowed down to the plains and formed a number of glacial lakes across Canada, a good example being the Great Lakes. At present in the Canadian Rockies glaciers can be observed only around 2,200 meters above sea level on the south side of the range and 2,000 meters on the north side. However, the sheer scale of present-day glaciers in the Rockies is much greater than that of those found in the Himalayas and American Rockies, easily indicating what they must have looked like in their prime.

Due to the awesome presence of its glaciers and mountain faces and big-base-to-summit relief, the peaks of the Canadian Rockies appear to be quite high. Actually, though, the highest one is Mount Robson, at 3,954 meters, followed by Mount Columbia (3,747 meters) and the north peak of The Twins (3,730 meters). Hundreds of other mountains in the Canadian Rockies also exceed 3,000 meters.

Five national parks – Banff, Jasper, Yoho, Kootenay, and Waterton Lakes – are located in the Canadian Rockies. There are also a number of provincial parks, including Mount Assiniboine, Peter Lougheed, Hamber, and Mount Robson. In the Columbia Mountains there are two national parks, Glacier and Revelstoke, and several provincial parks and recreational areas, including Wells Gray, Bugaboo Alpine, and Monashee. The most breathtaking and spacious national parks are Banff and Jasper, followed by Yoho. However, provincial parks and recreational areas such as Mount Assiniboine, Mount Robson, Bugaboo Alpine, and Kananaskis Country are just as impressive.

Banff National Park occupies one-third of the southern part of the Canadian Rockies. Mount Assiniboine Provincial Park in British Columbia flanks Banff on the southwest, while Alberta's Kananaskis Country provincial recreation area, which includes Peter Lougheed Provincial Park and two other provincial parks, is found south and east. Banff Park includes the Lake Louise area, a famous tourist spot north of the town of Banff, and the Bow Range, which contains Mounts Temple and Victoria. Along the Bow River, between Banff and Lake Louise, one finds the Sundance and Massive Ranges on the west bank, and the Sawback Range, Castle Mountain, and Slate Range on the east. The Ball Range, which borders Kootenay National Park, also borders Yoho National Park between Ten Peaks in the Bow Range and Mount Rhonda in the Waputik Range.

Farther northwest, on the west side of the Bow River, there are the Conway and Mummery Groups and Mounts Forbes, Lyell, Alexandra, and Bryce. All through this area the main ridge serves as the provincial border between Alberta and British Columbia. The Bow River ends at the Bow Pass, from where the Mistaya River flows north and, at Saskatchewan River Crossing, meets the North Saskatchewan River, which emerges from the Sunwapta Pass in the southern part of the Columbia Icefield. Mount Hector looms on the east bank of the Bow River, while Mount Murchison towers to the east of the Mistaya River.

Snow Dome, the crest of the Columbia Icefield, straddles the border between Banff and Jasper National Parks. It is said that the meltwaters of Snow Dome eventually end up in three oceans. To the east of the icefield one finds

Mounts Andromeda and Athabasca, while to the west Mount Columbia rises. Mount Kitchener stands north of, and is detached from, Snow Dome. The ridge of Snow Dome continues north via The Twins, Mount Alberta, and several other mountains, where it becomes the Winston Churchill Range and ends in Sunwapta Falls.

The main ridge continues westward from Mount Columbia until it reaches the Clemenceau Icefield, where it skirts Hamber Provincial Park and joins The Ramparts. Between Mount Columbia and The Ramparts there are Mounts King Edward, Clemenceau, and Hooker. To the north of The Ramparts stands Mount Geikie. The Sunwapta River flows north between the main ridge and the Winston Churchill Range, then continues northwest. On the east bank of the Sunwapta there is Le Grand Brazeau, the Queen Elizabeth Range, the Endless Chain Ridge, and the Maligne Range. On the west bank there is a cluster of mountains, including Dragon Peak, Mounts Christie, Fryatt, and Edith Cavell, and the Trident Range. The northwest side of Jasper National Park borders Mount Robson Provincial Park. North of the town of Jasper there is the Victoria Cross, De Smet, Bosche, and Boule Ranges on the west side of the Athabasca River and the Colin, Jacques, and Miette Ranges on the east side.

Kootenay National Park doesn't have as many significant mountains as Banff and Jasper Parks. Consequently not many people visit this park, except for the area that adjoins Banff. Yoho National Park, on the other hand, is very popular. Graced with numerous mountains and lakes, it covers the entire area west of Mount Victoria. Mountains such as Lefroy, Hungabee, Biddle, Cathedral, and Stephen, and ranges such as President and Ottertail, which contains Mount Goodsir, are beautifully reflected in lakes such as O'Hara, Oesa, McArthur, and Emerald. The scenery in Yoho has a distinct character all its own and reminds one of the kind of landscaping found in Japanese miniature gardens.

In order to avoid covering too many areas in this book, I didn't include two national parks – Waterton Lakes on the U.S. border and Mount Revelstoke in British Columbia. Nor did I cover provincial parks such as Wells Gray and Monashee. However, I did include shots of the Cariboo, Monashee, and Selkirk Ranges; Bugaboo Alpine and Kananaskis provincial recreation areas; and the Royal Group.

Over a period of three years and seven trips, I spent 270 days in Canada altogether. There are several mountains that I visited two or three times in different seasons to make up for the often unsatisfactory results of my first visit. During all this time, I came to realize that, compared to many other places on the planet, the Canadian Rockies and surrounding ranges remain little changed. Although it is true that various development projects have threatened and continue to jeopardize the environment in the Rockies, much has still been done to preserve nature in the national and provincial parks and conservancies. Wilderness areas are world treasures and ought to be handed down intact for future generations.

For this book I selected 107 out of 35,000 photographs of 320 peaks. Certain sacrifices had to be made, which means many worthwhile mountains couldn't be featured. Still, it is my sincere wish that the photographs found here will impress the reader with the beauty of the Canadian Rockies and act as a reminder of what could be lost if we are not vigilant.

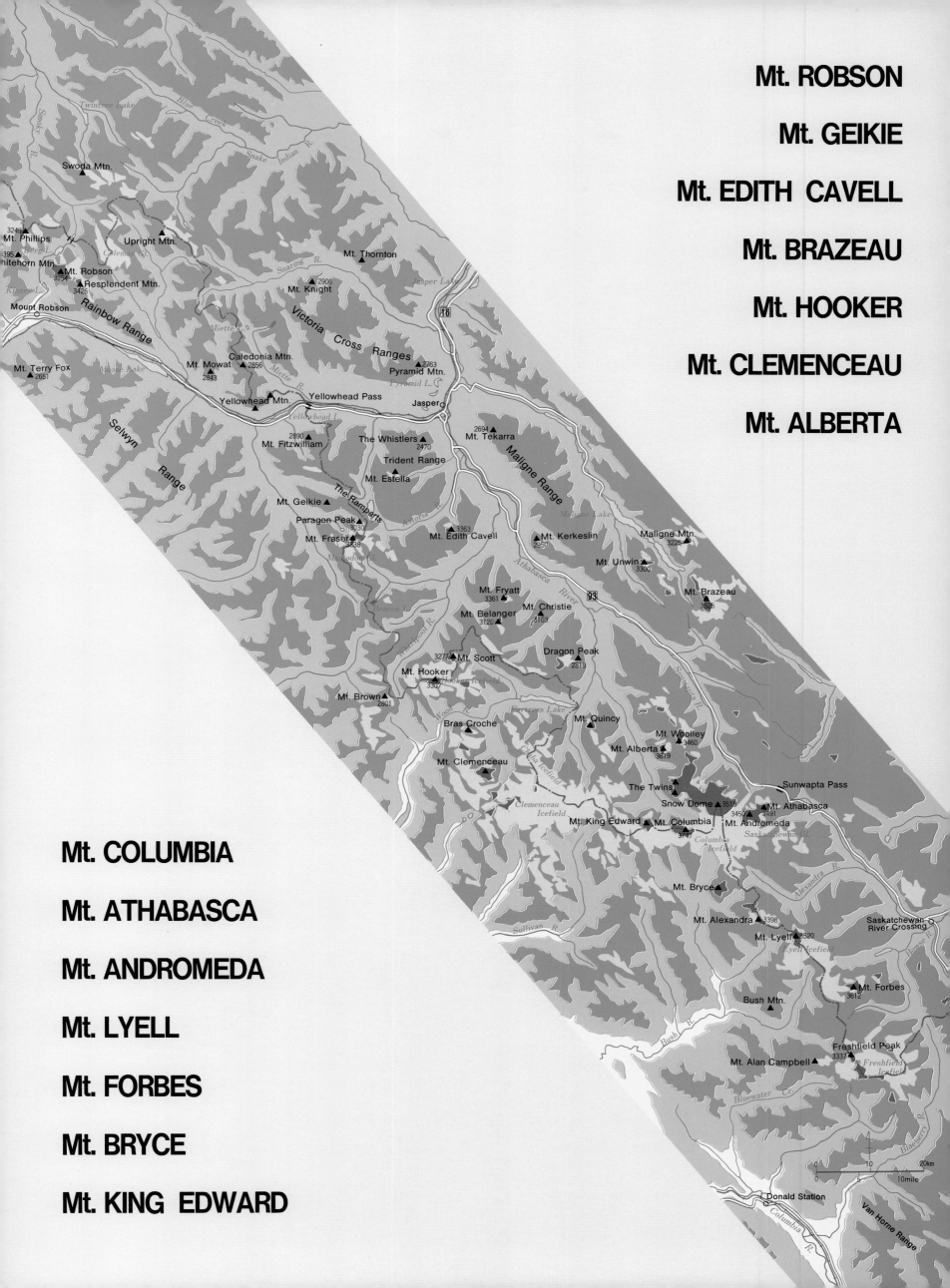

Mt. ROBSON

Mt. GEIKIE

Mt. EDITH CAVELL

Mt. BRAZEAU

Mt. HOOKER

Mt. CLEMENCEAU

Mt. ALBERTA

Mt. COLUMBIA

Mt. ATHABASCA

Mt. ANDROMEDA

Mt. LYELL

Mt. FORBES

Mt. BRYCE

Mt. KING EDWARD

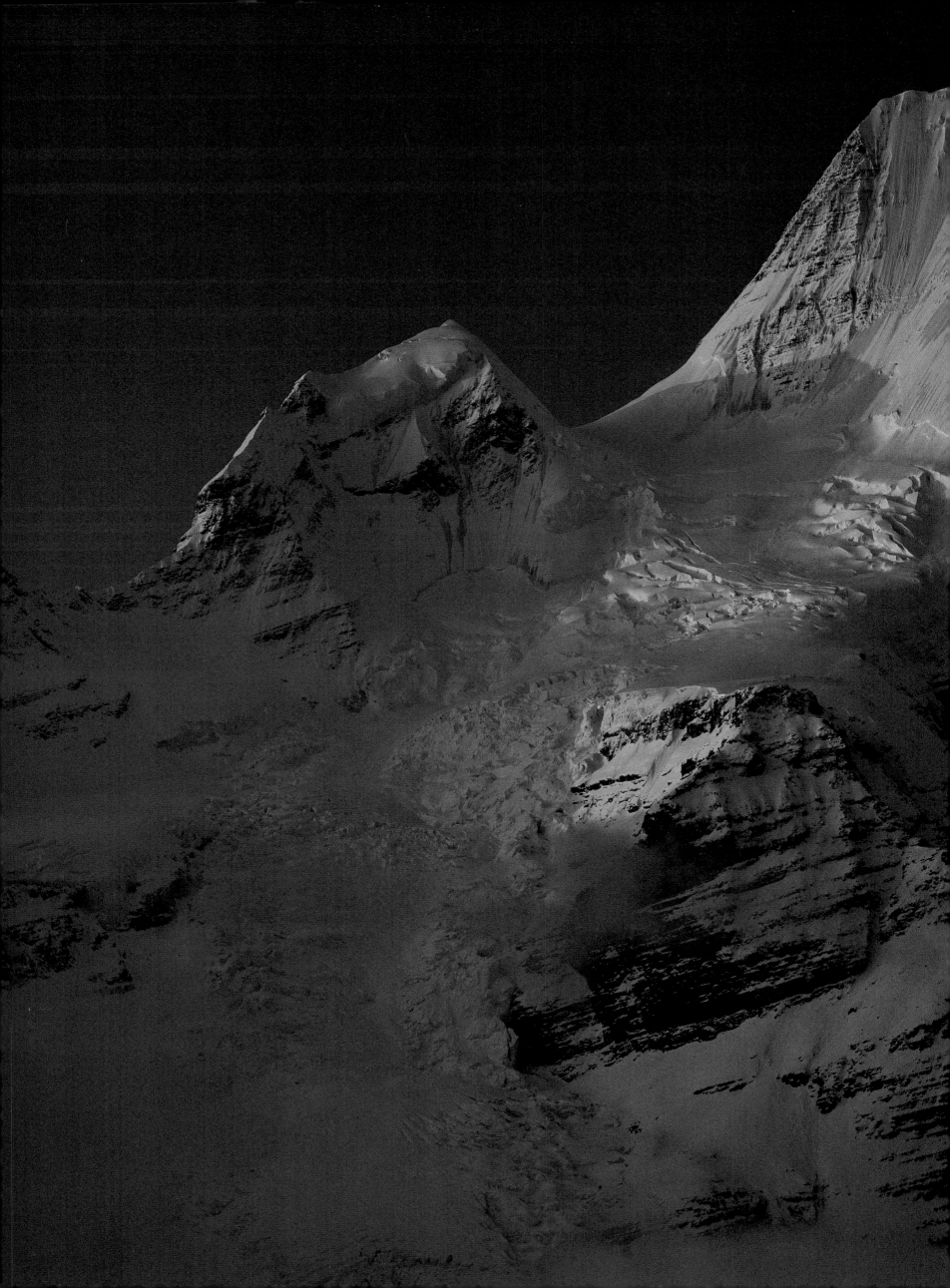

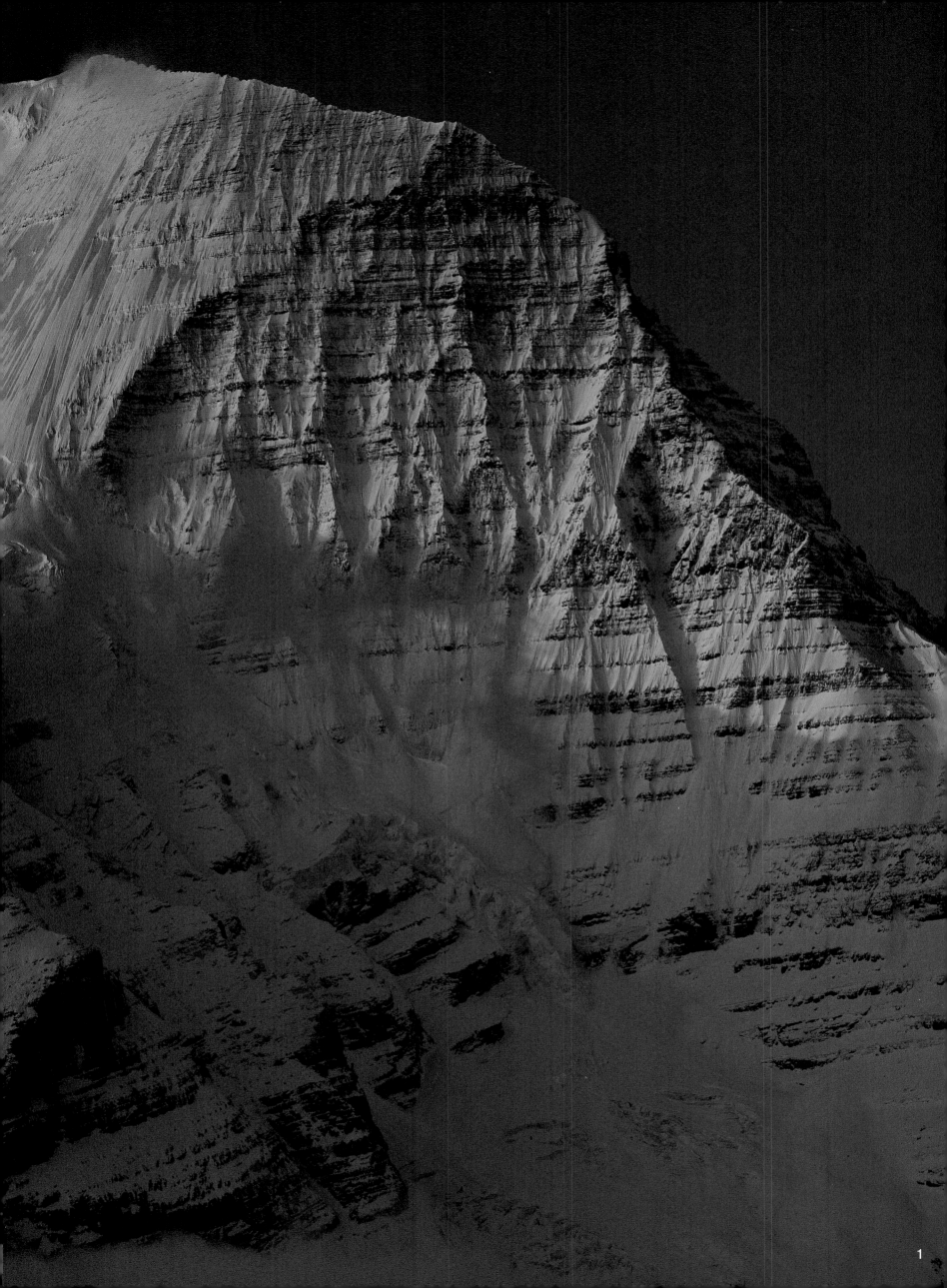

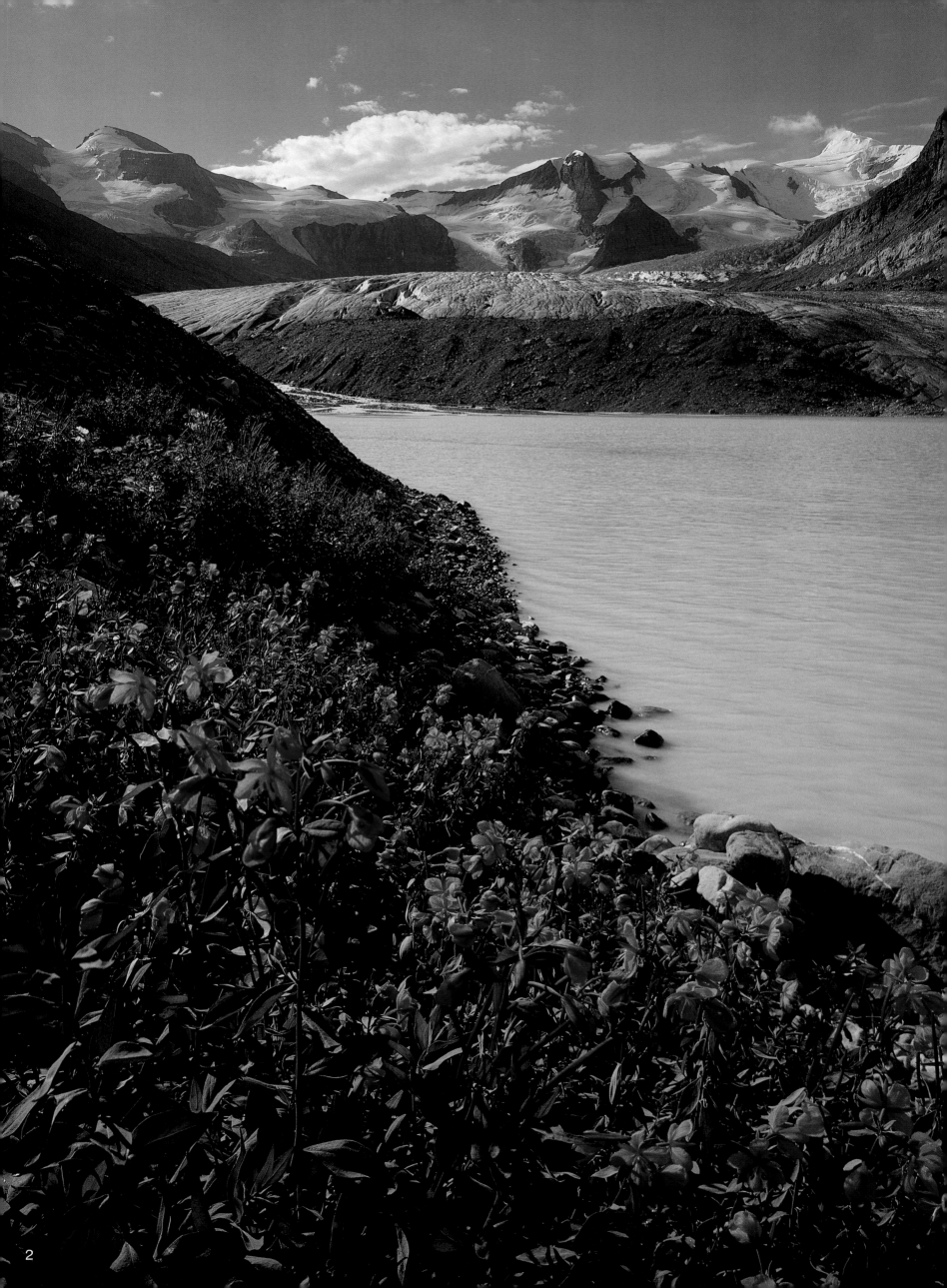

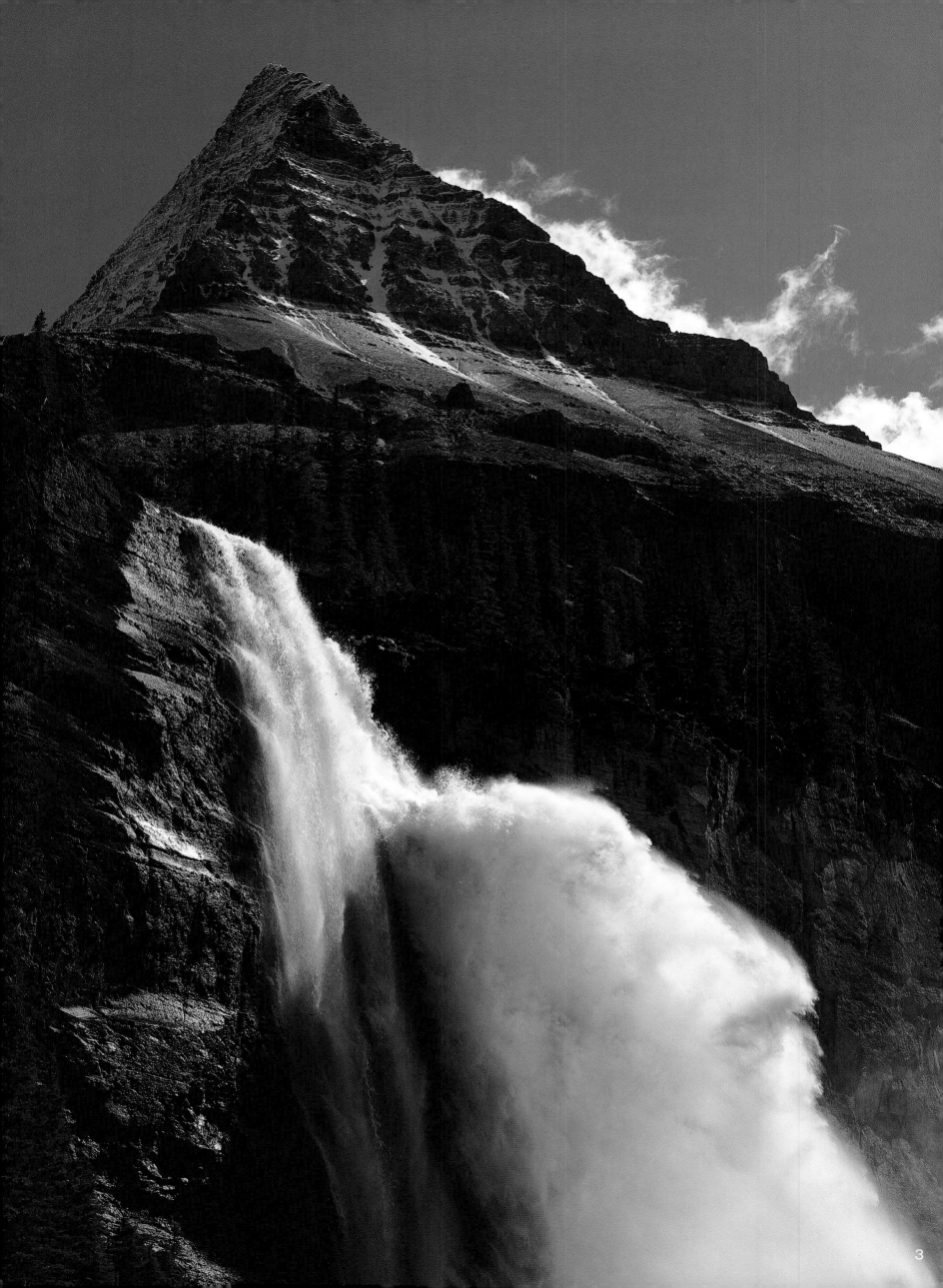

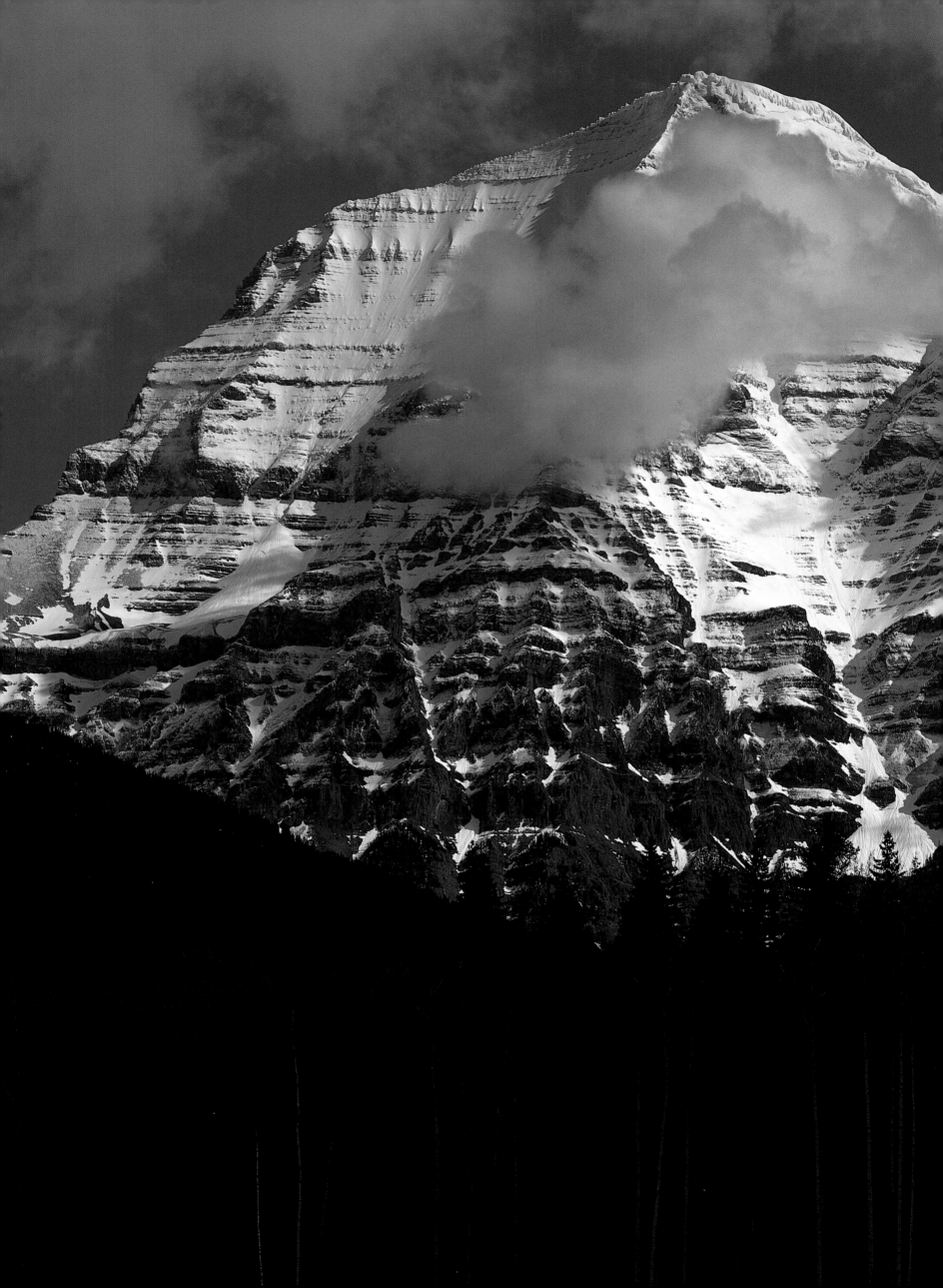

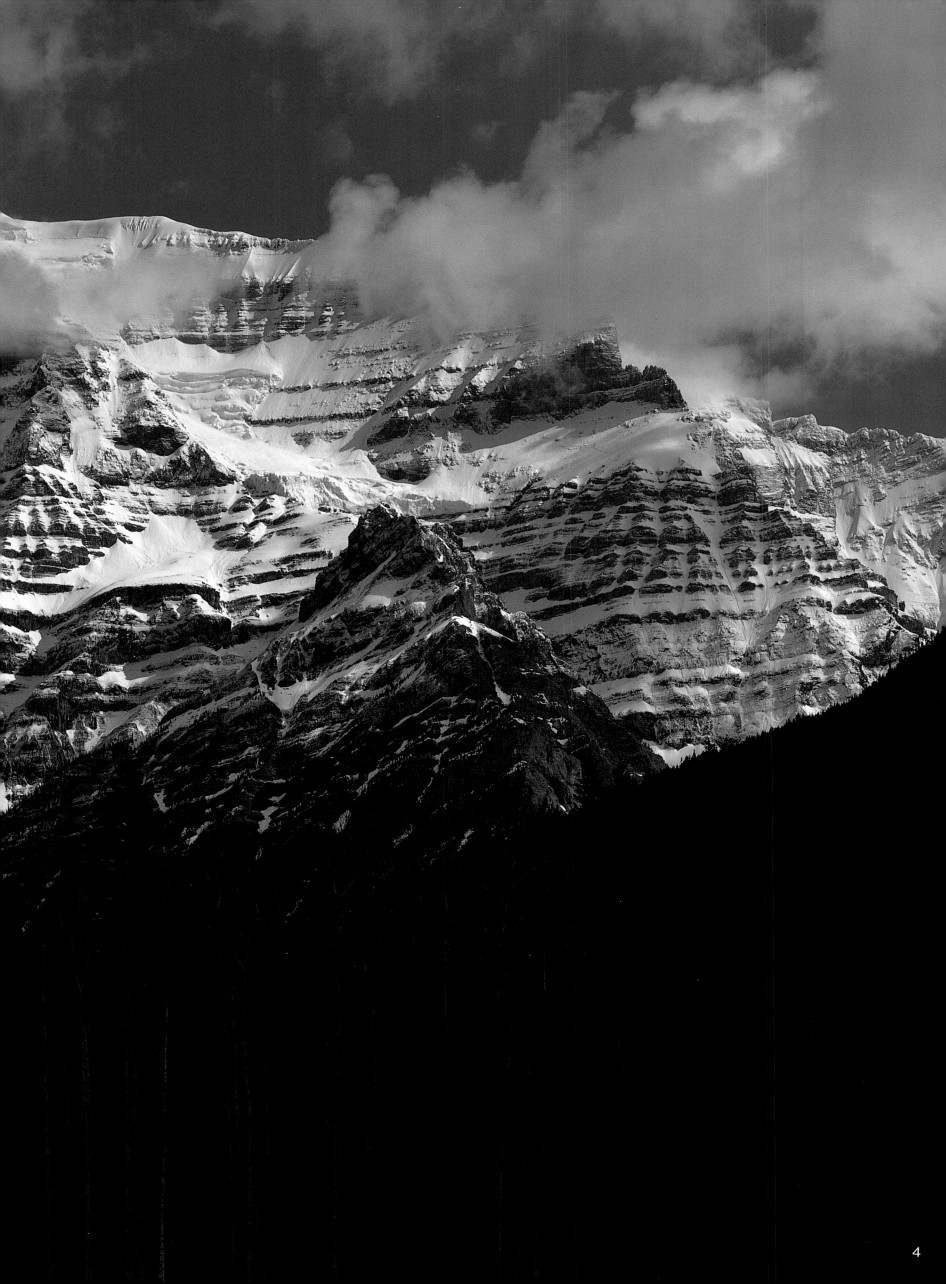

4

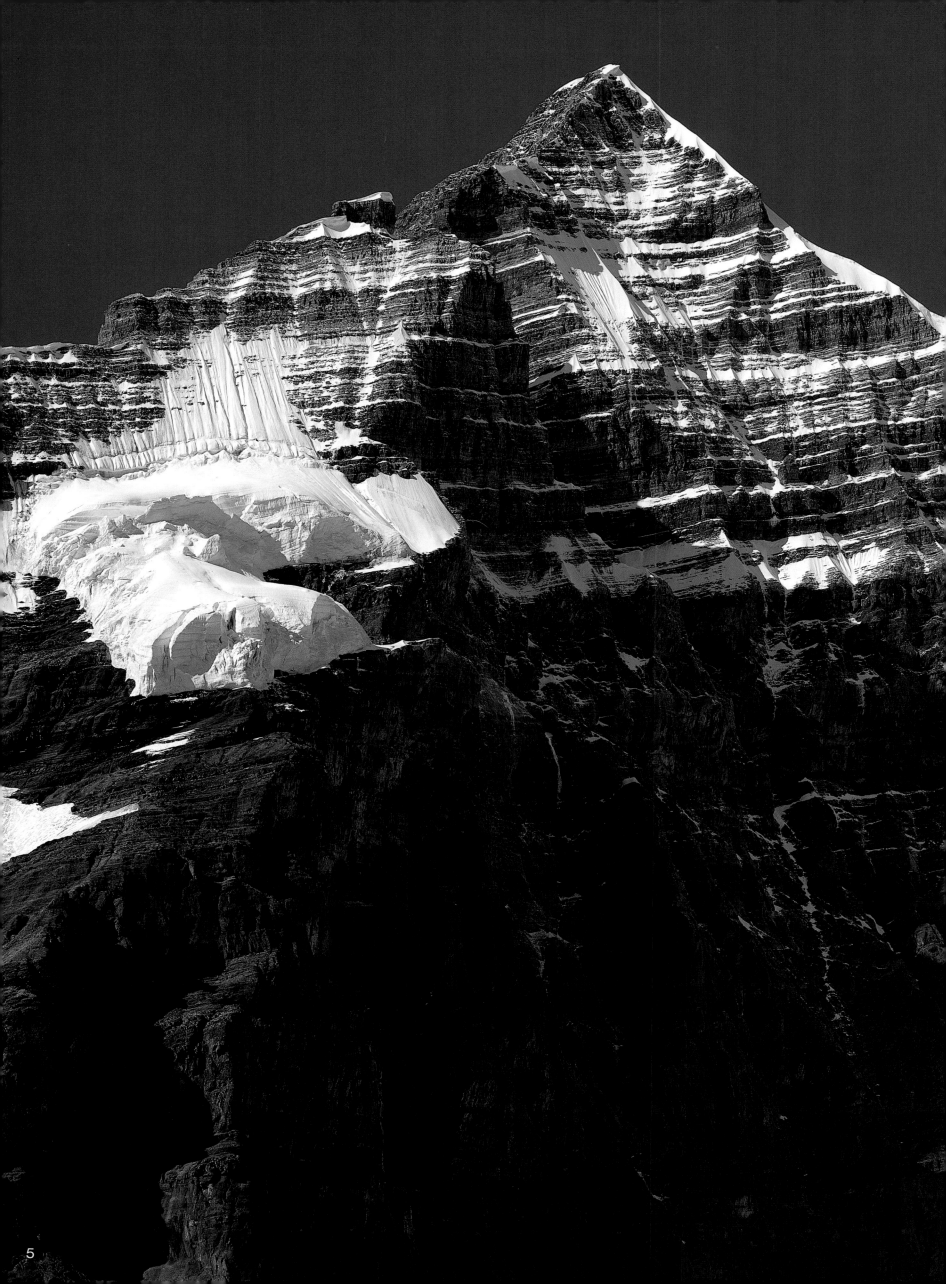

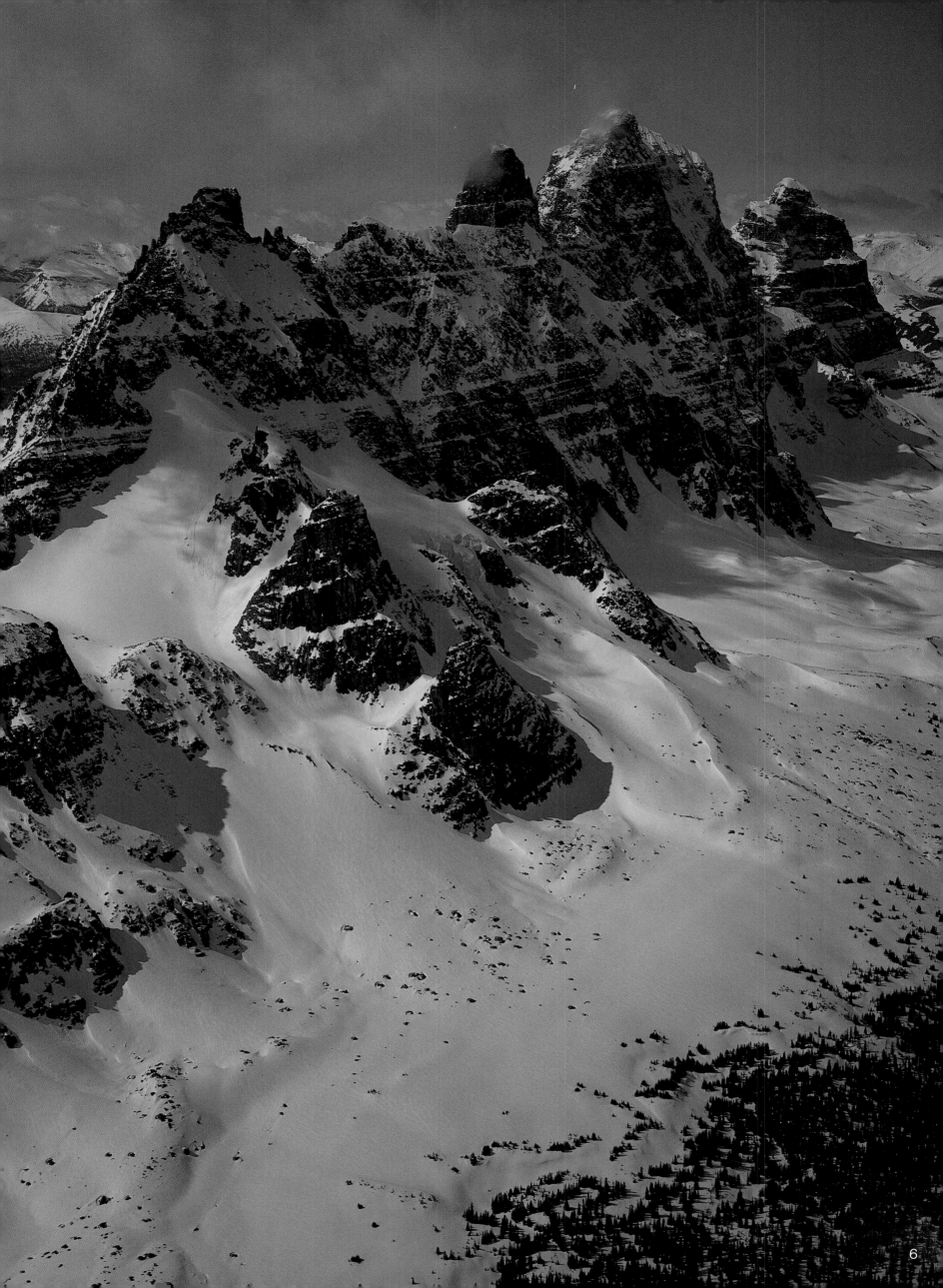

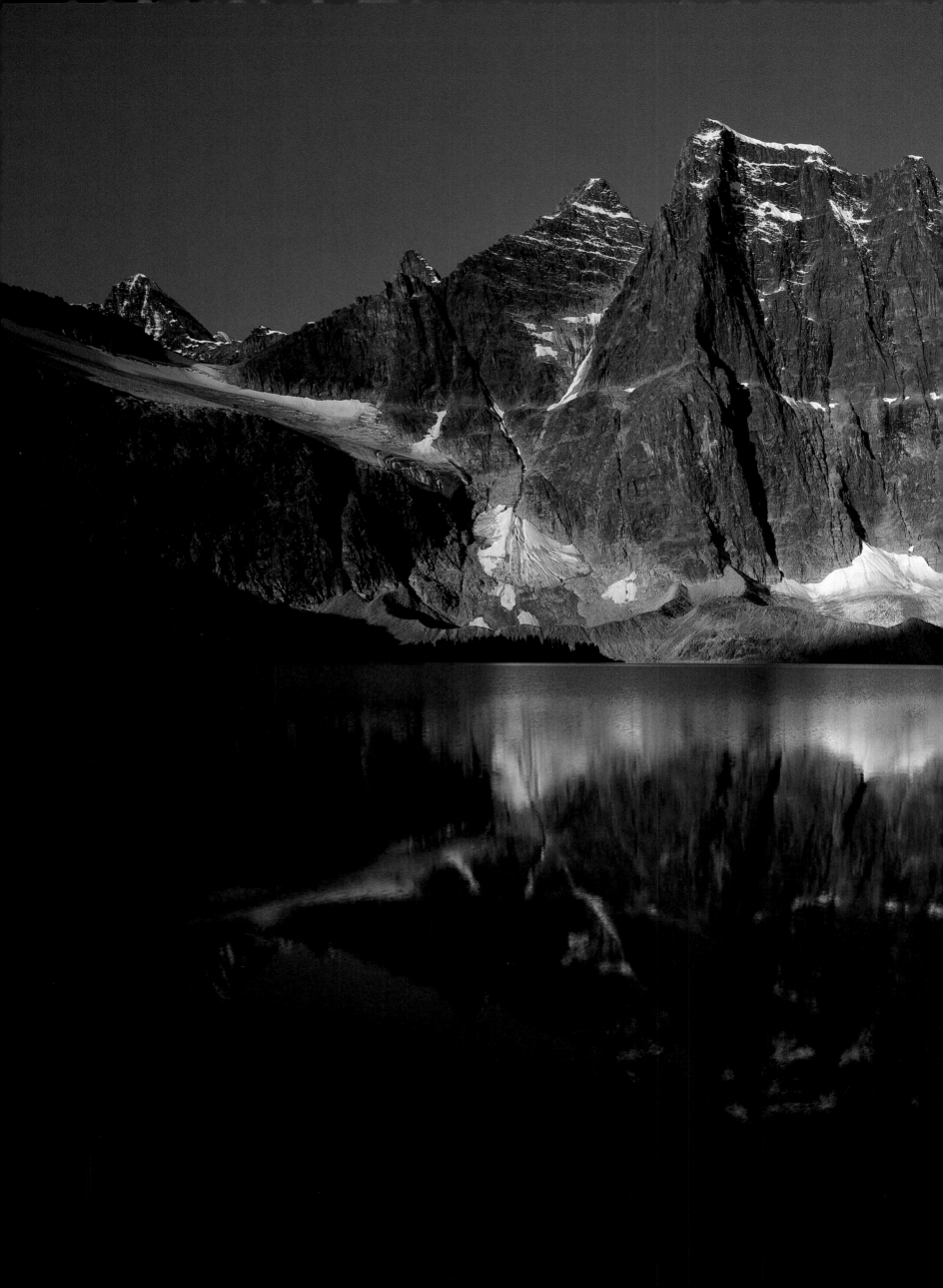

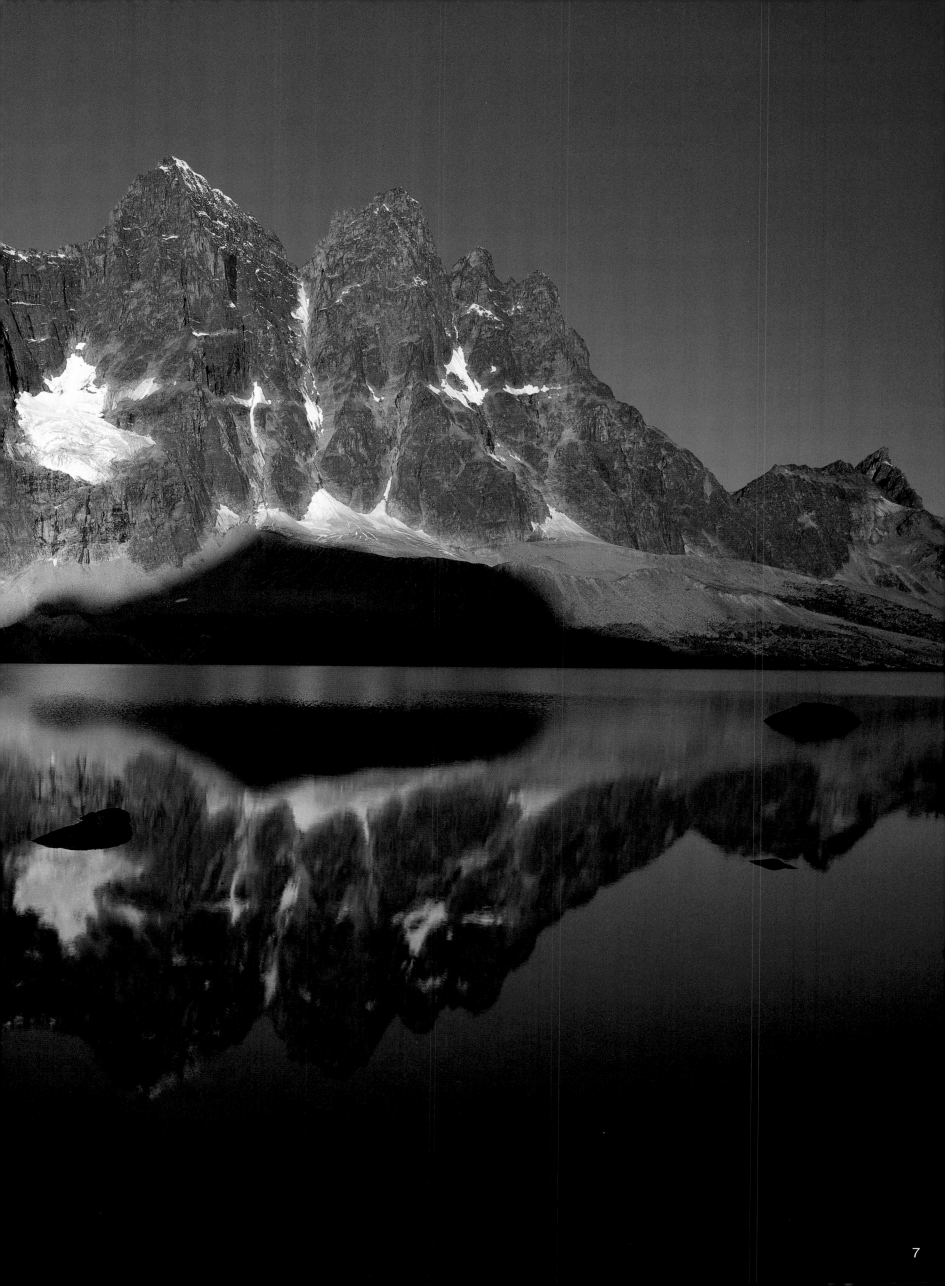

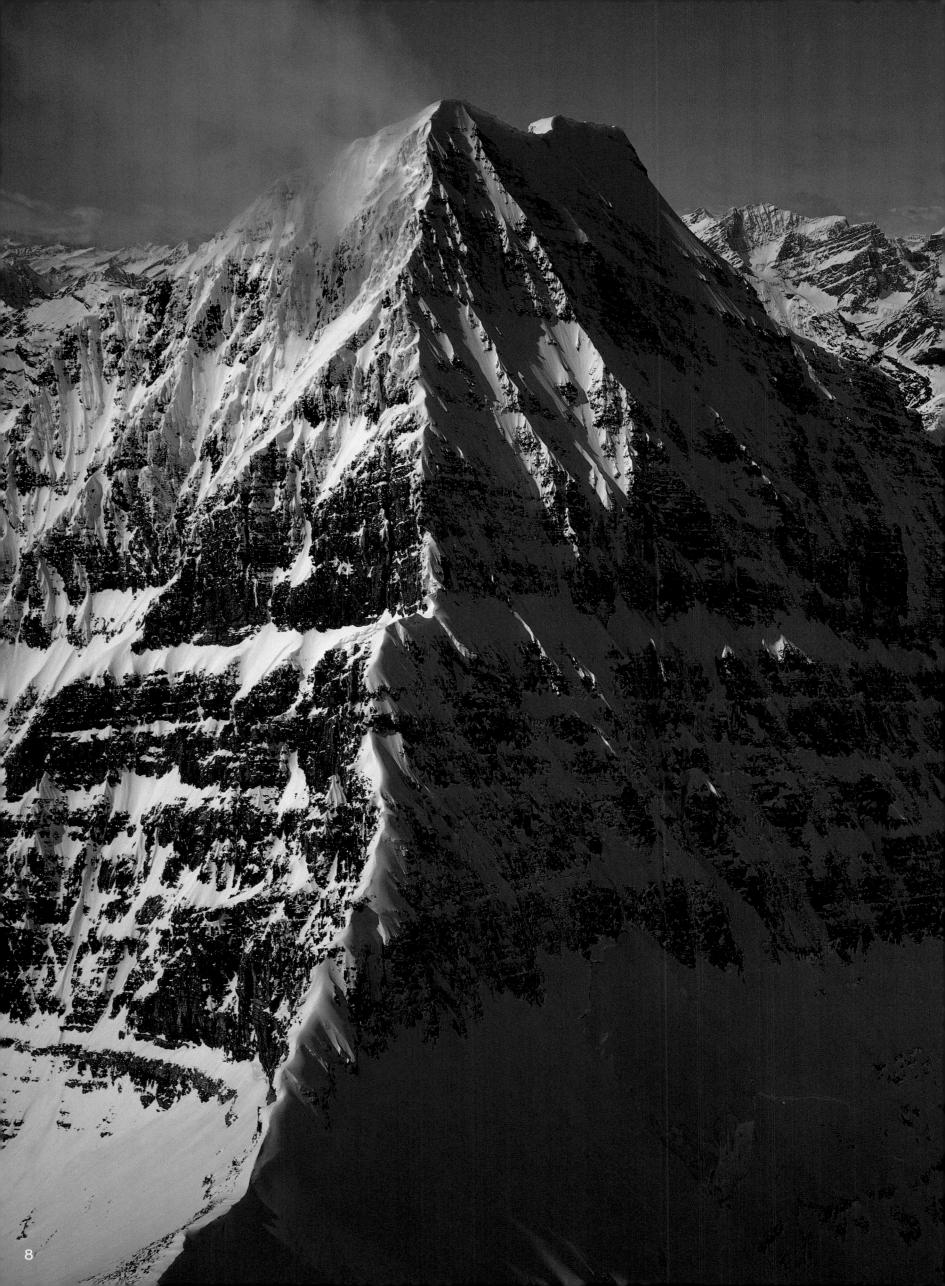

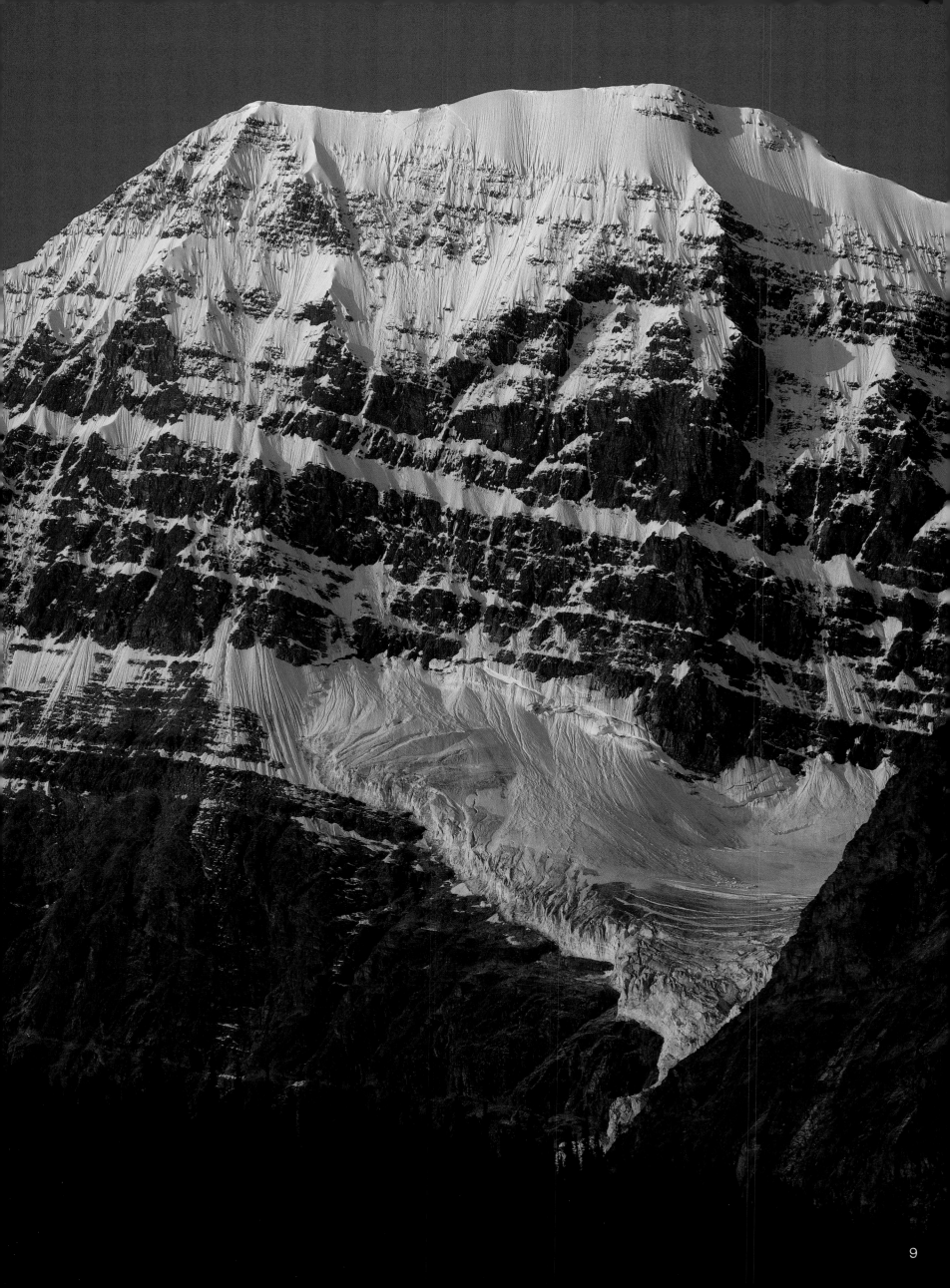

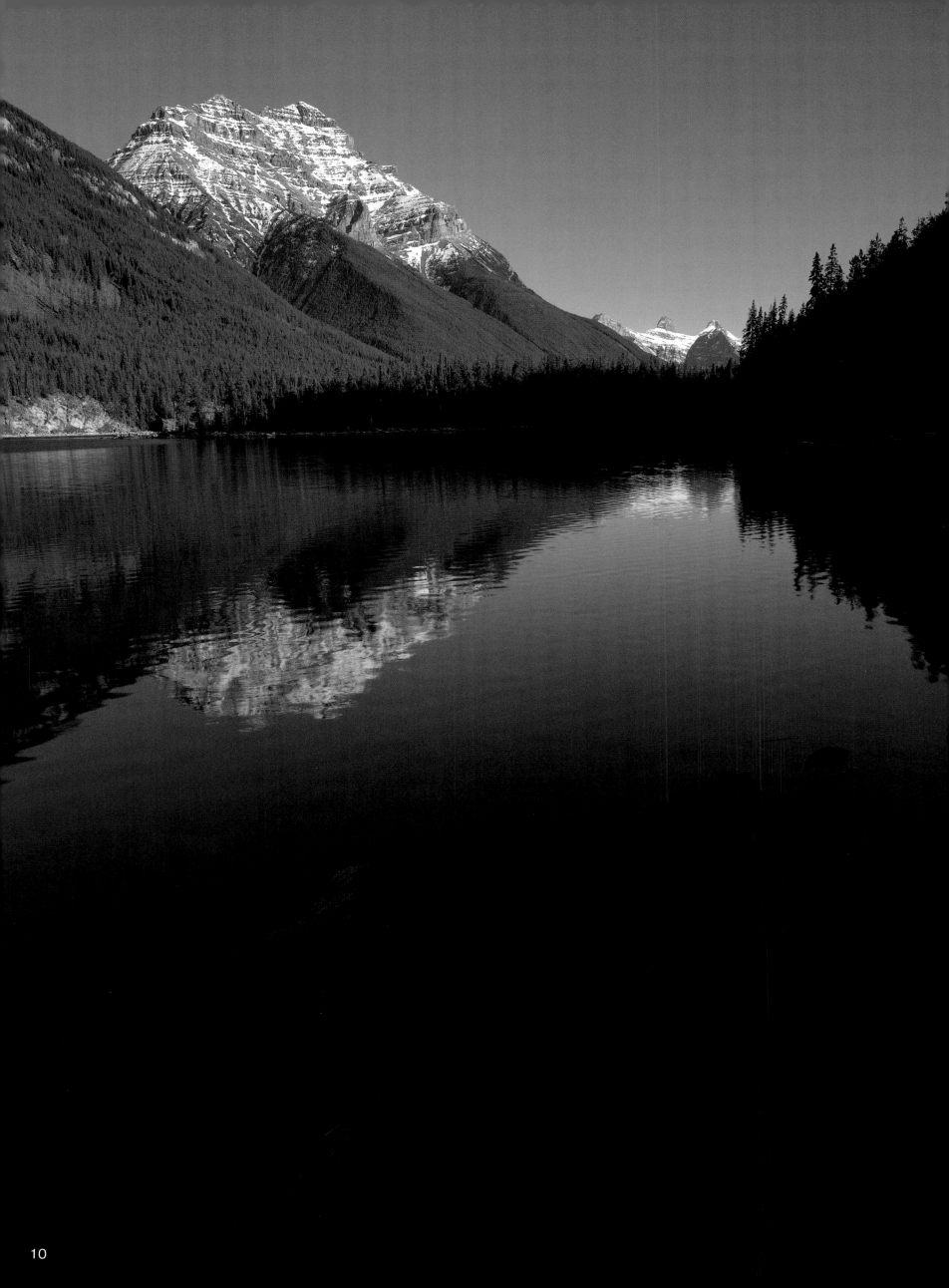

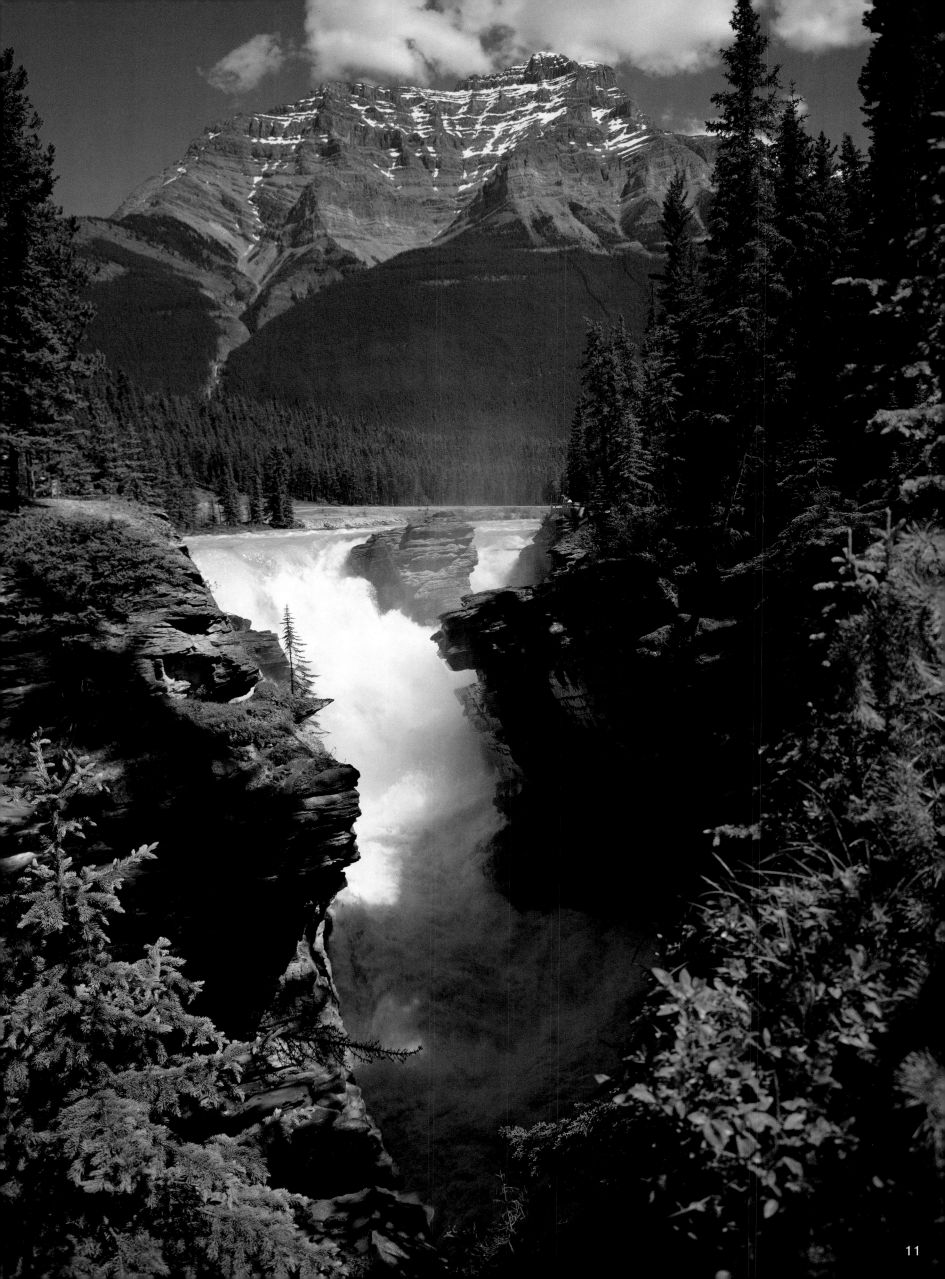

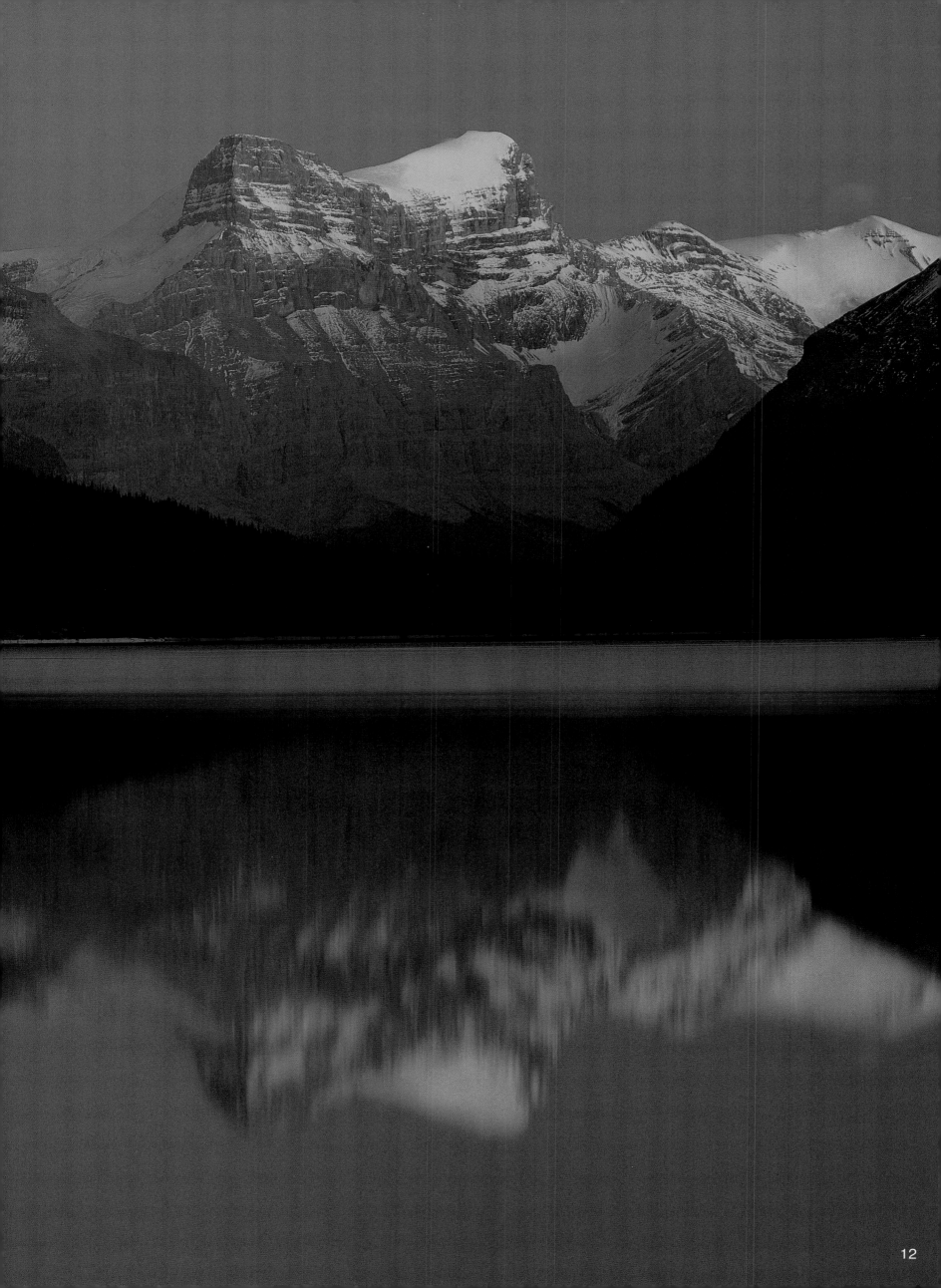

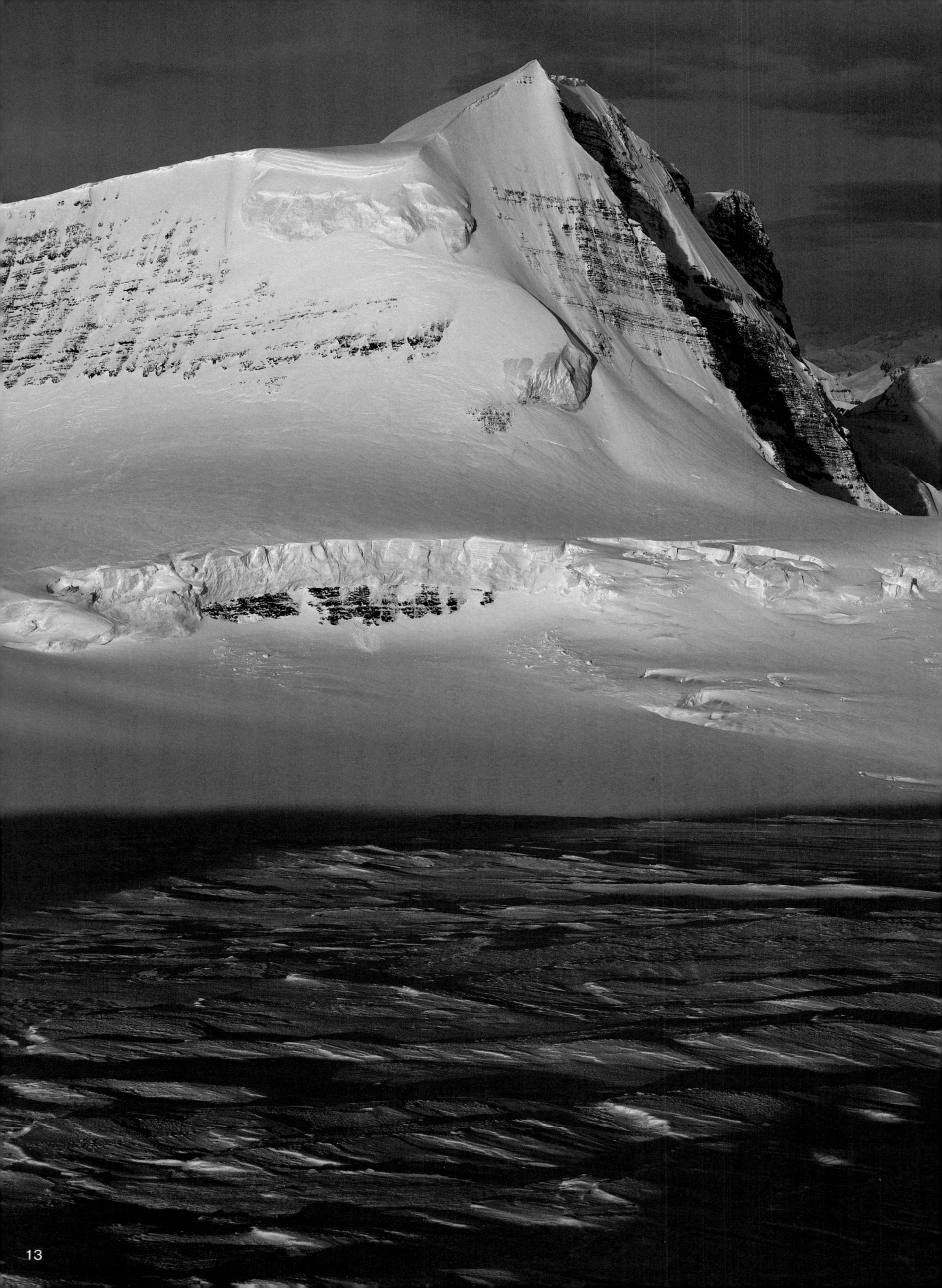

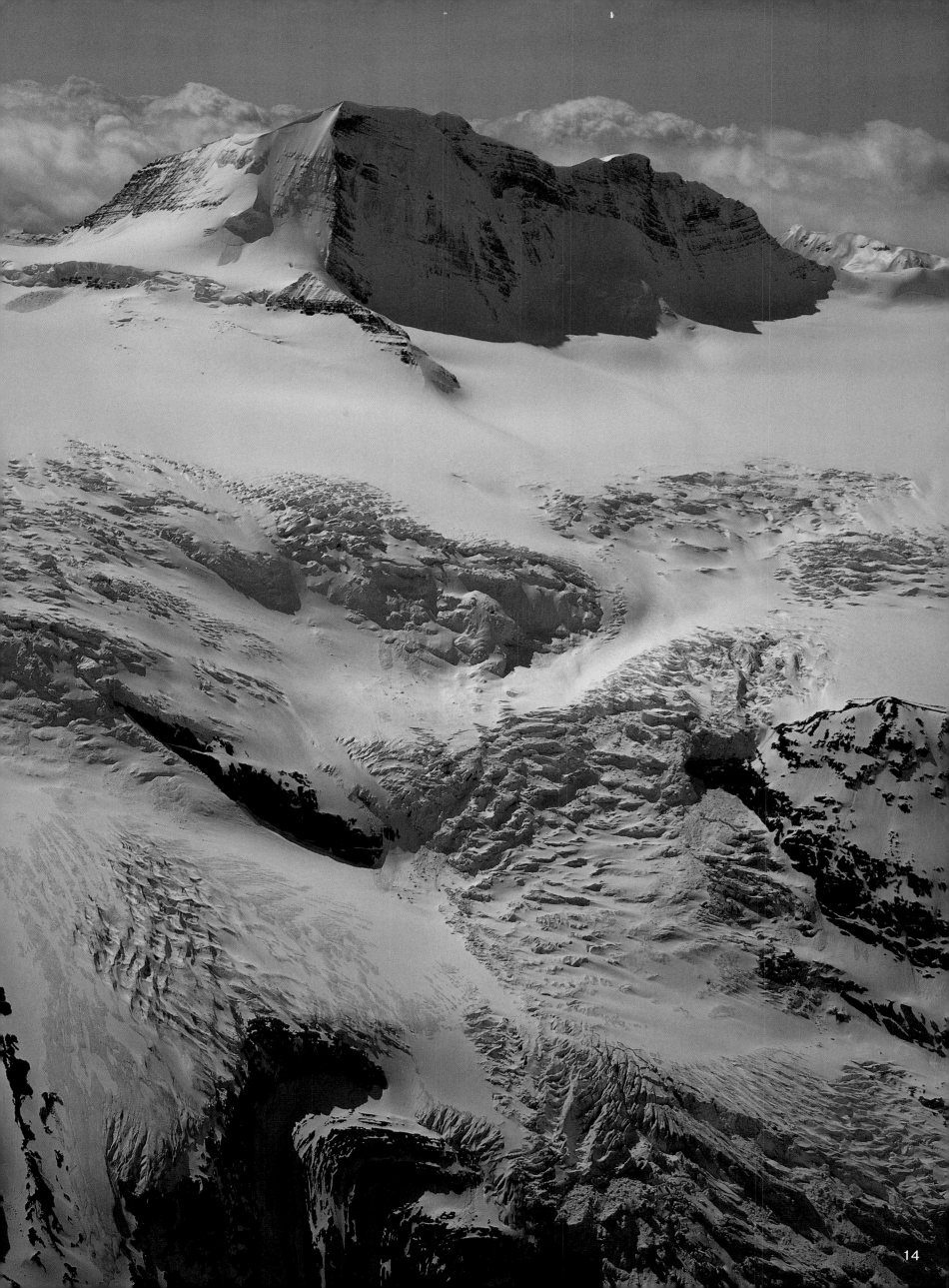

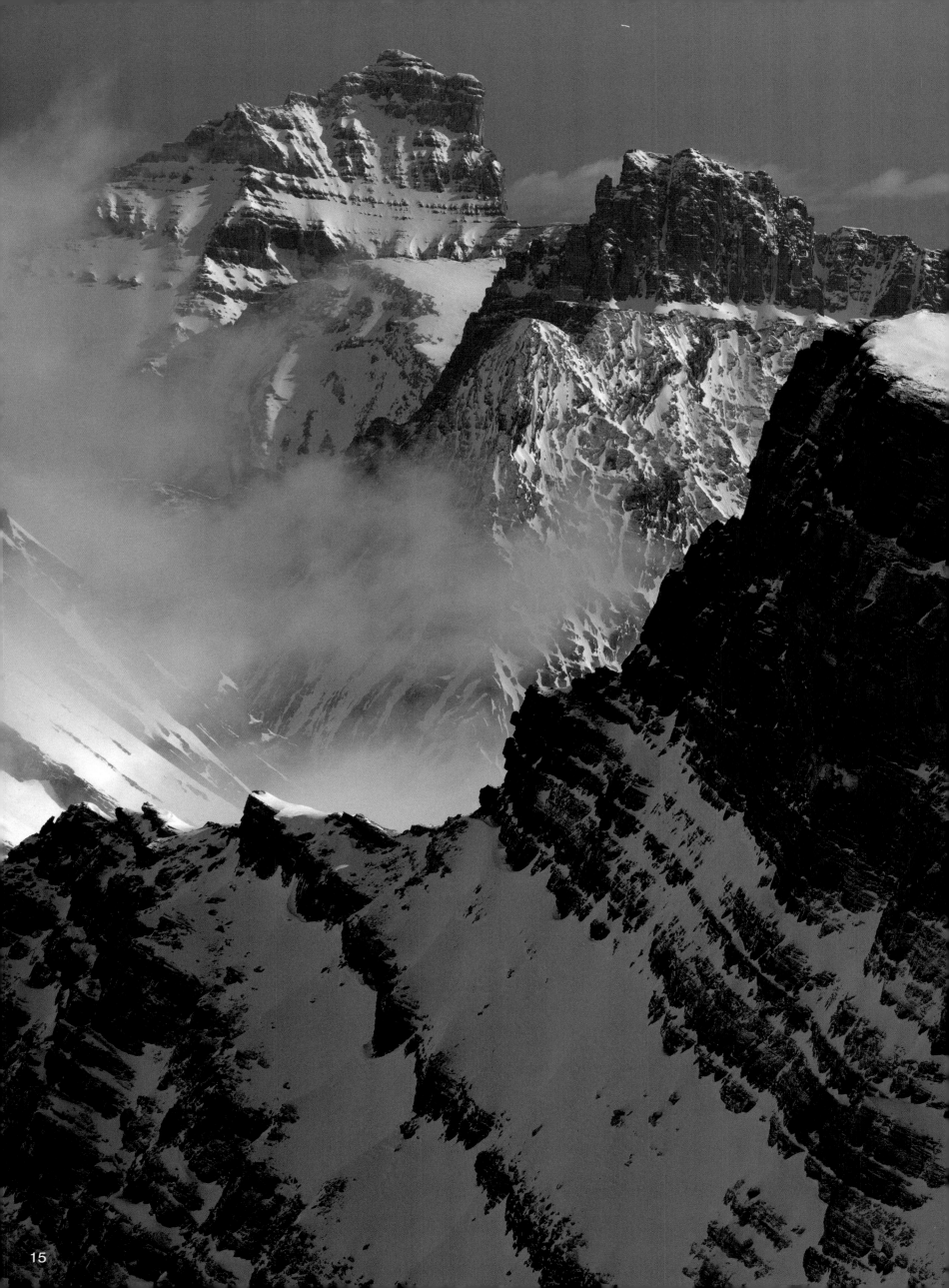

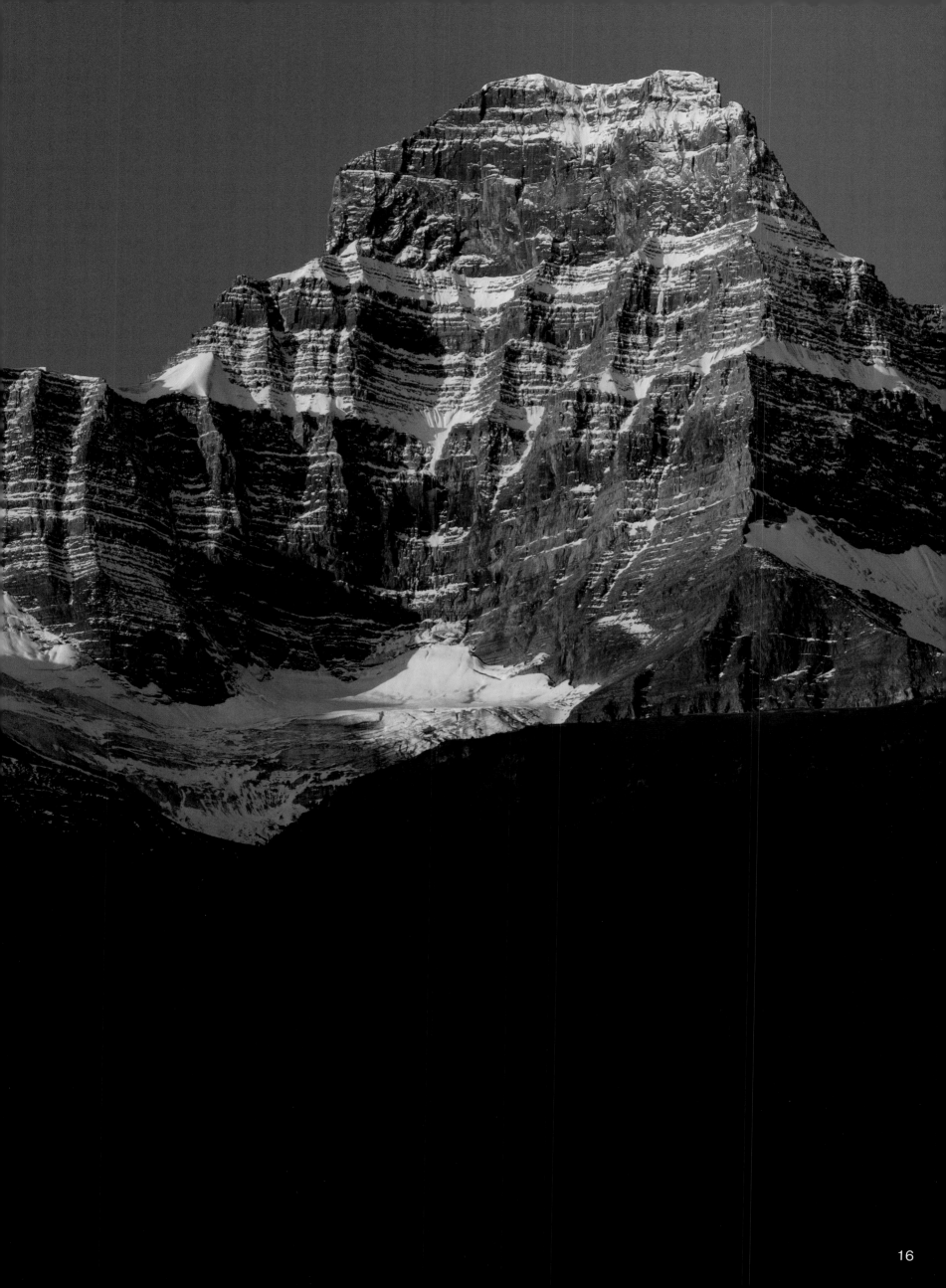

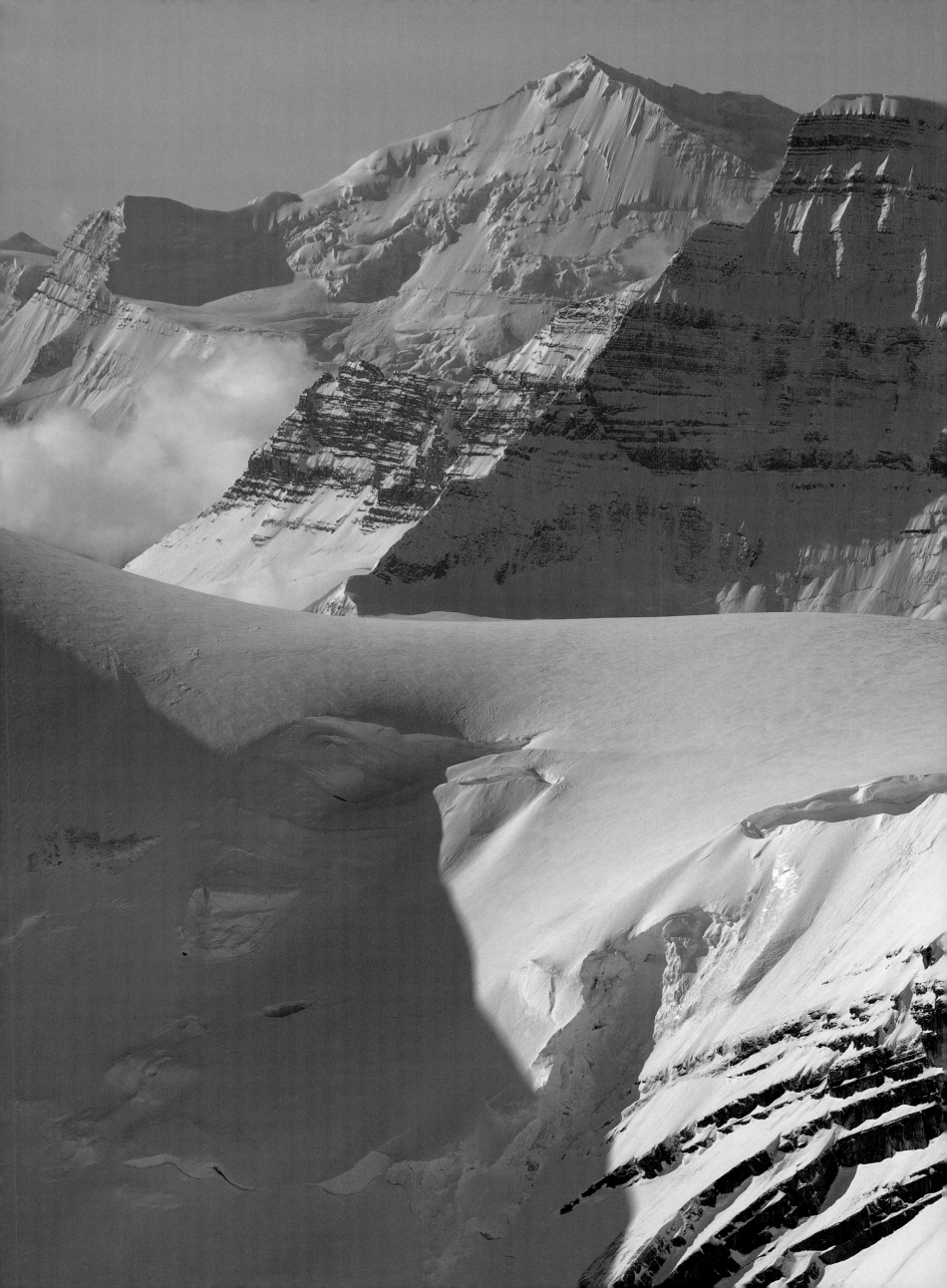

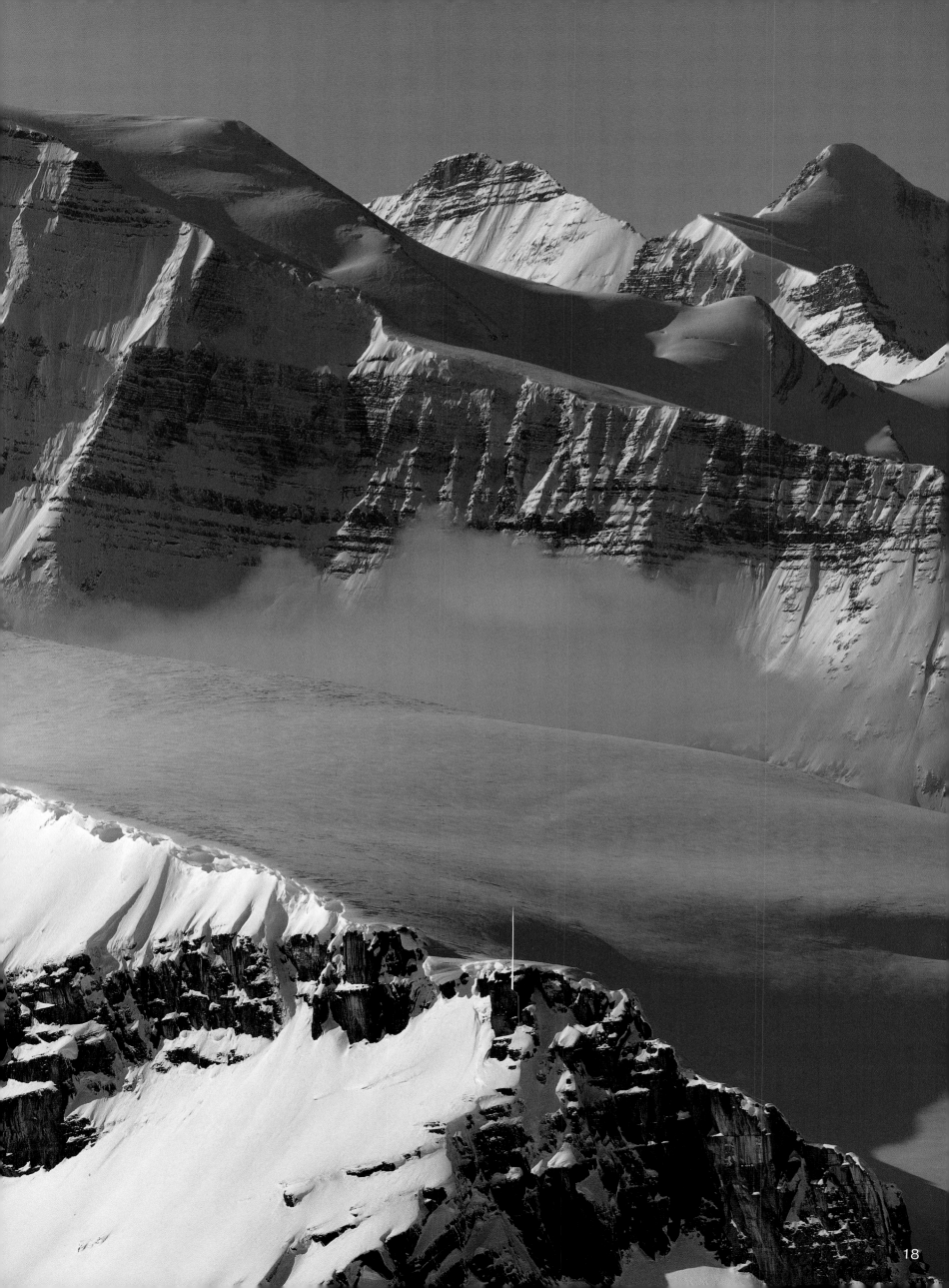

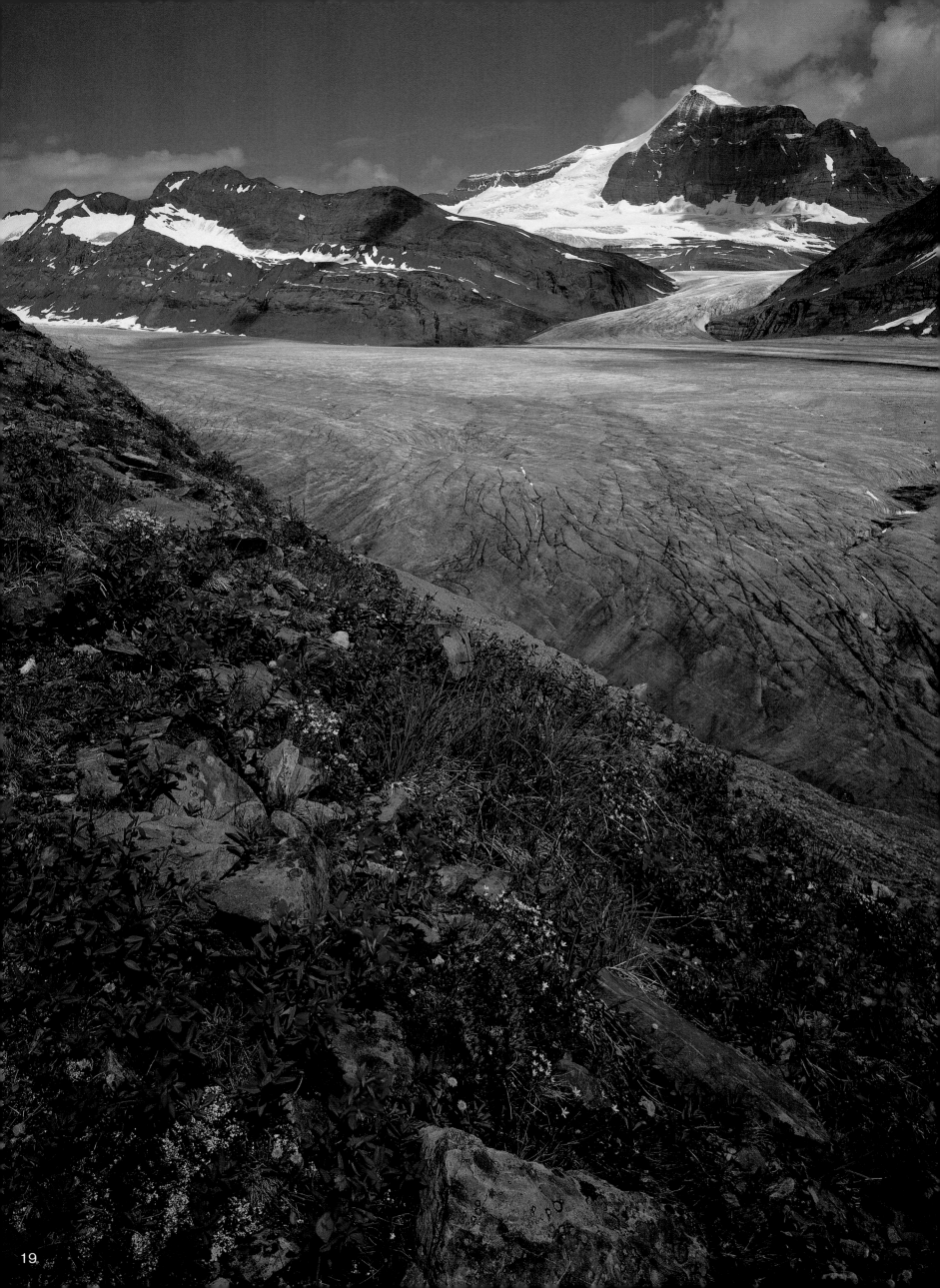

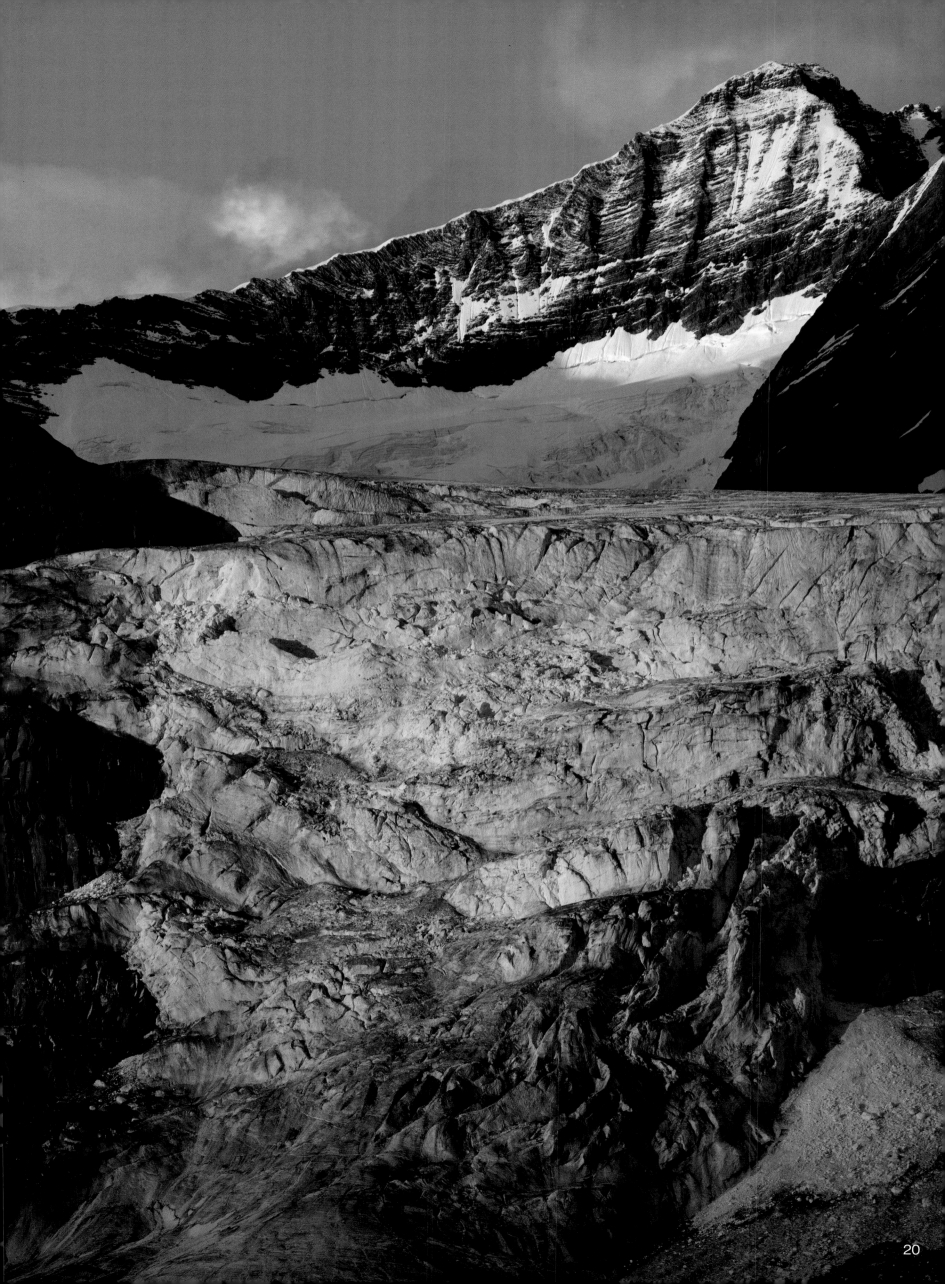

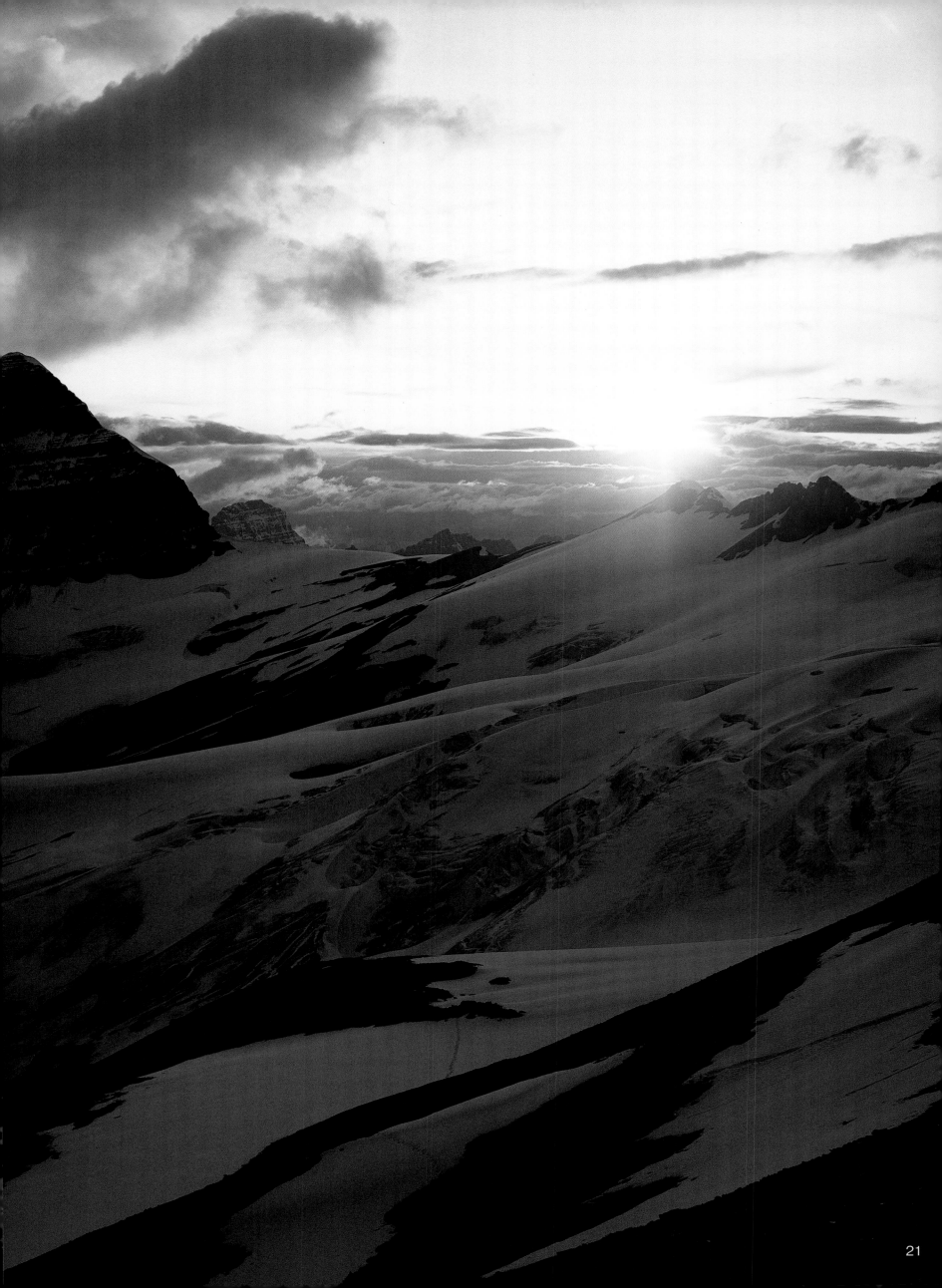

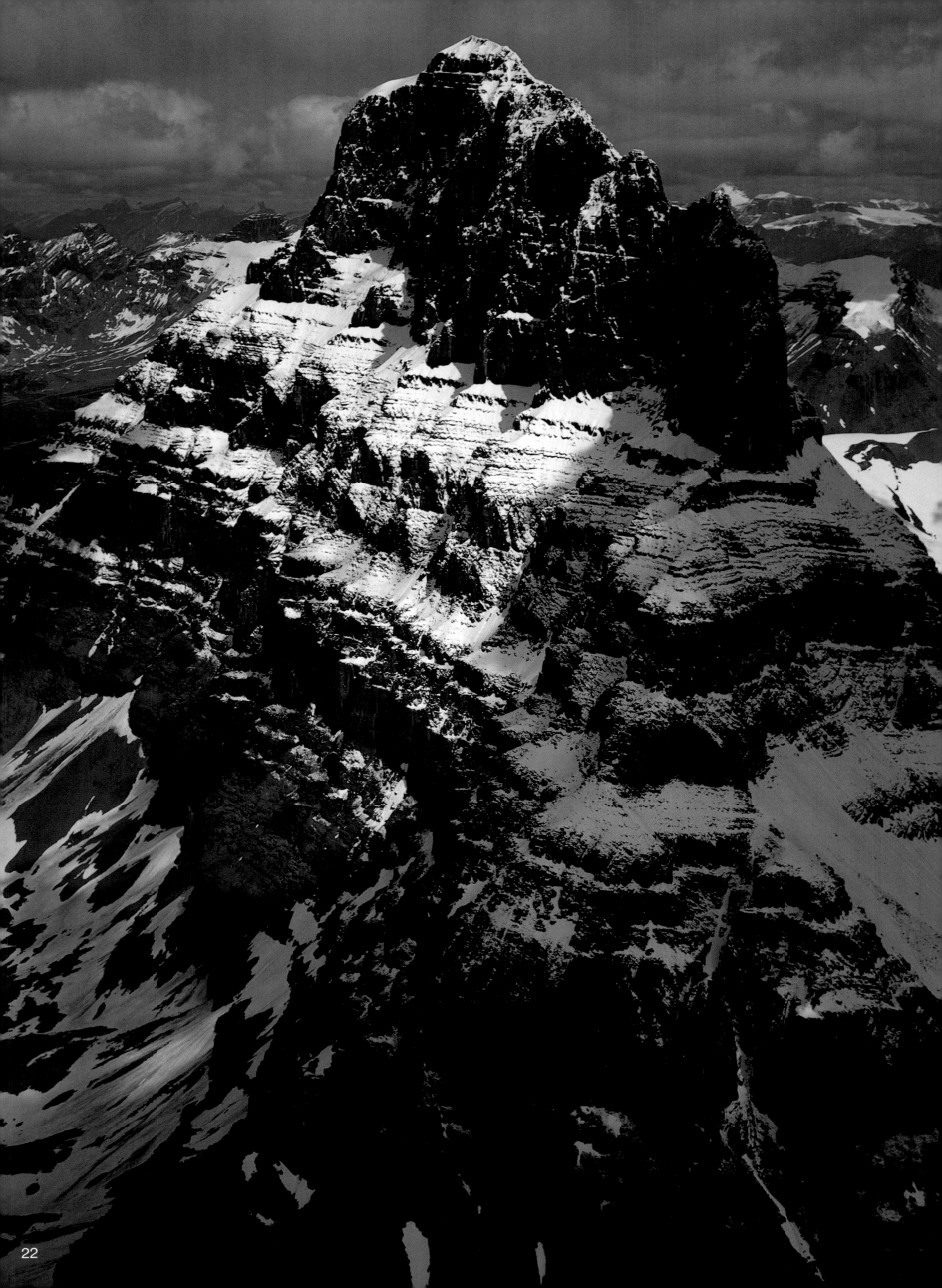

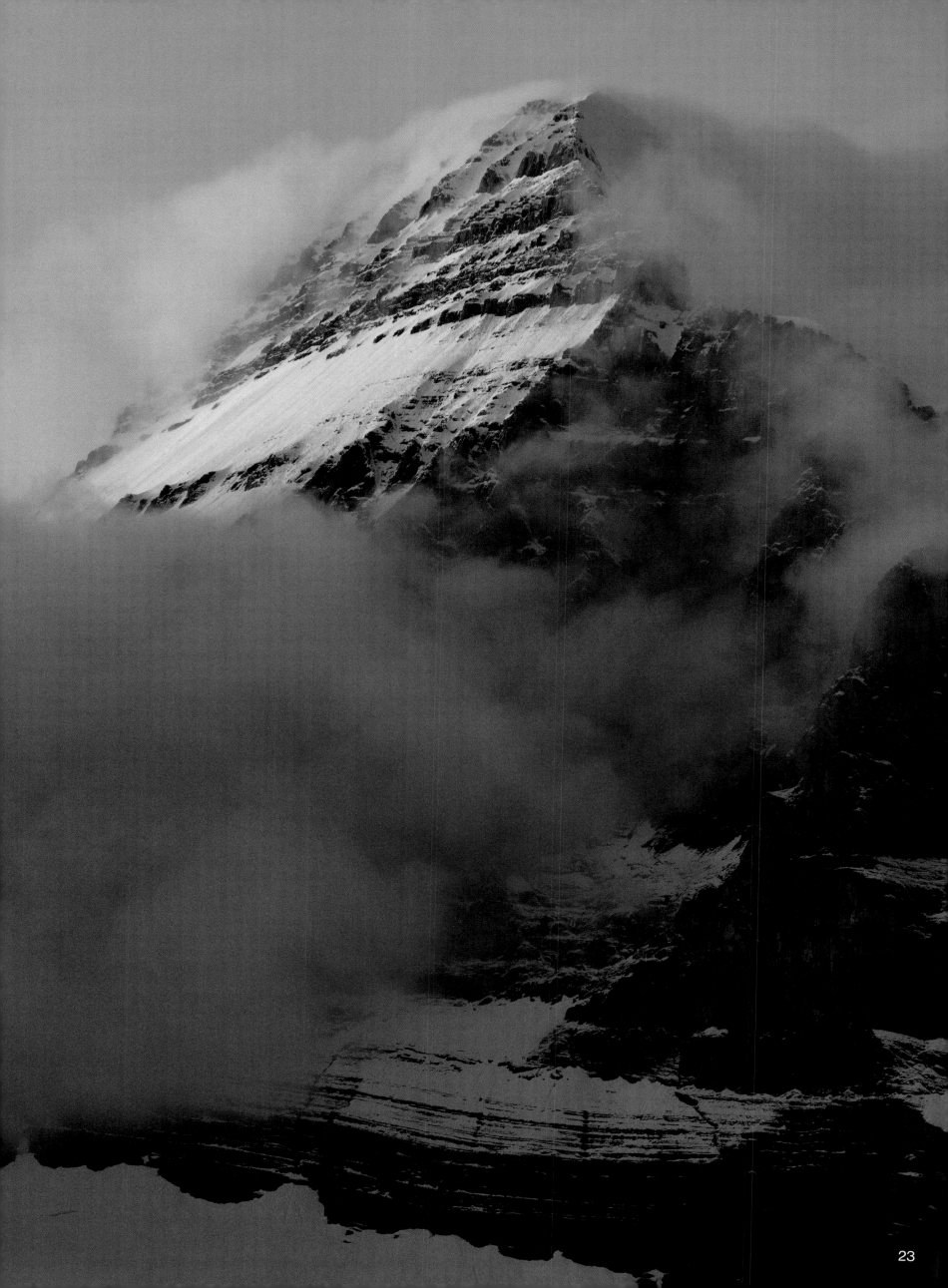

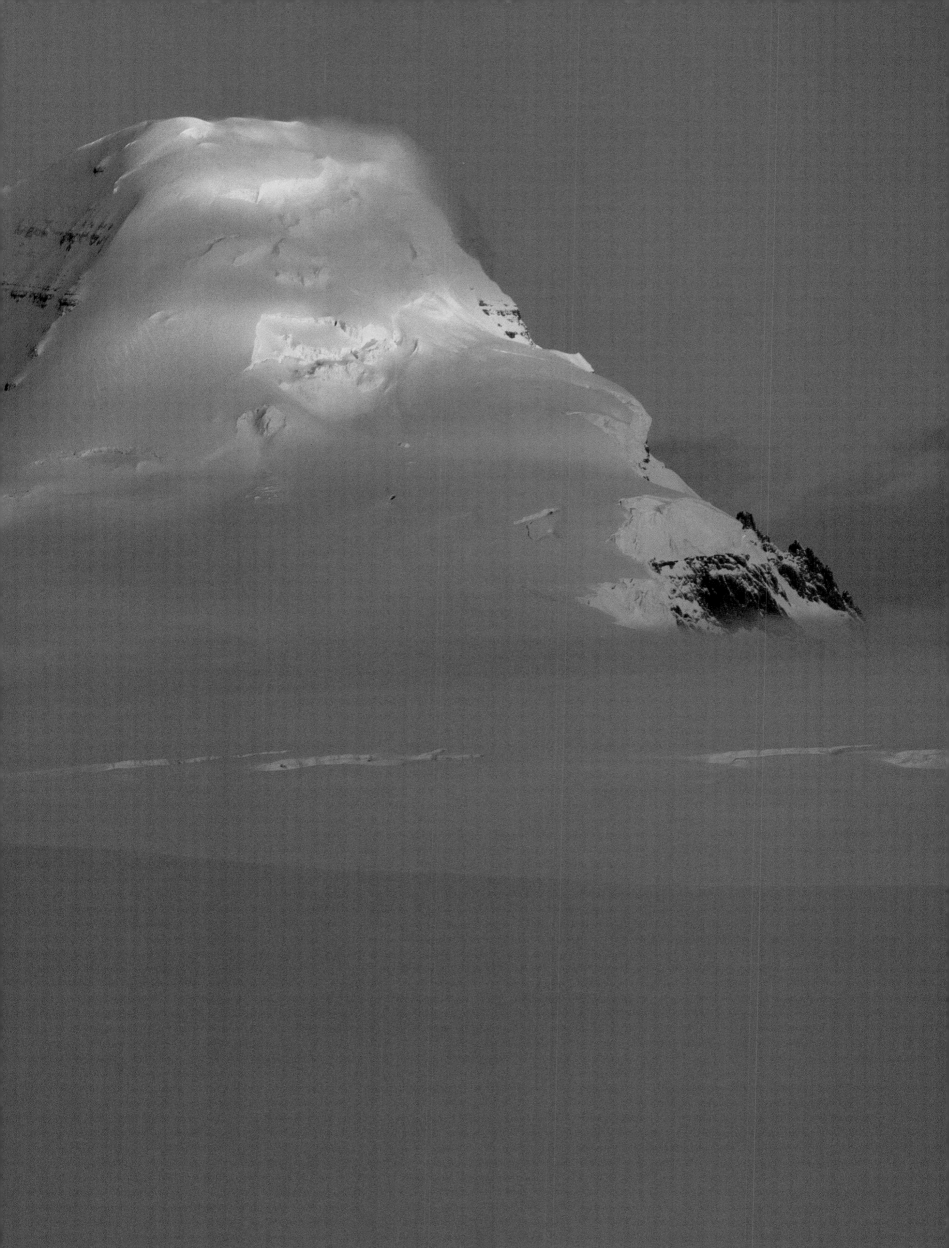

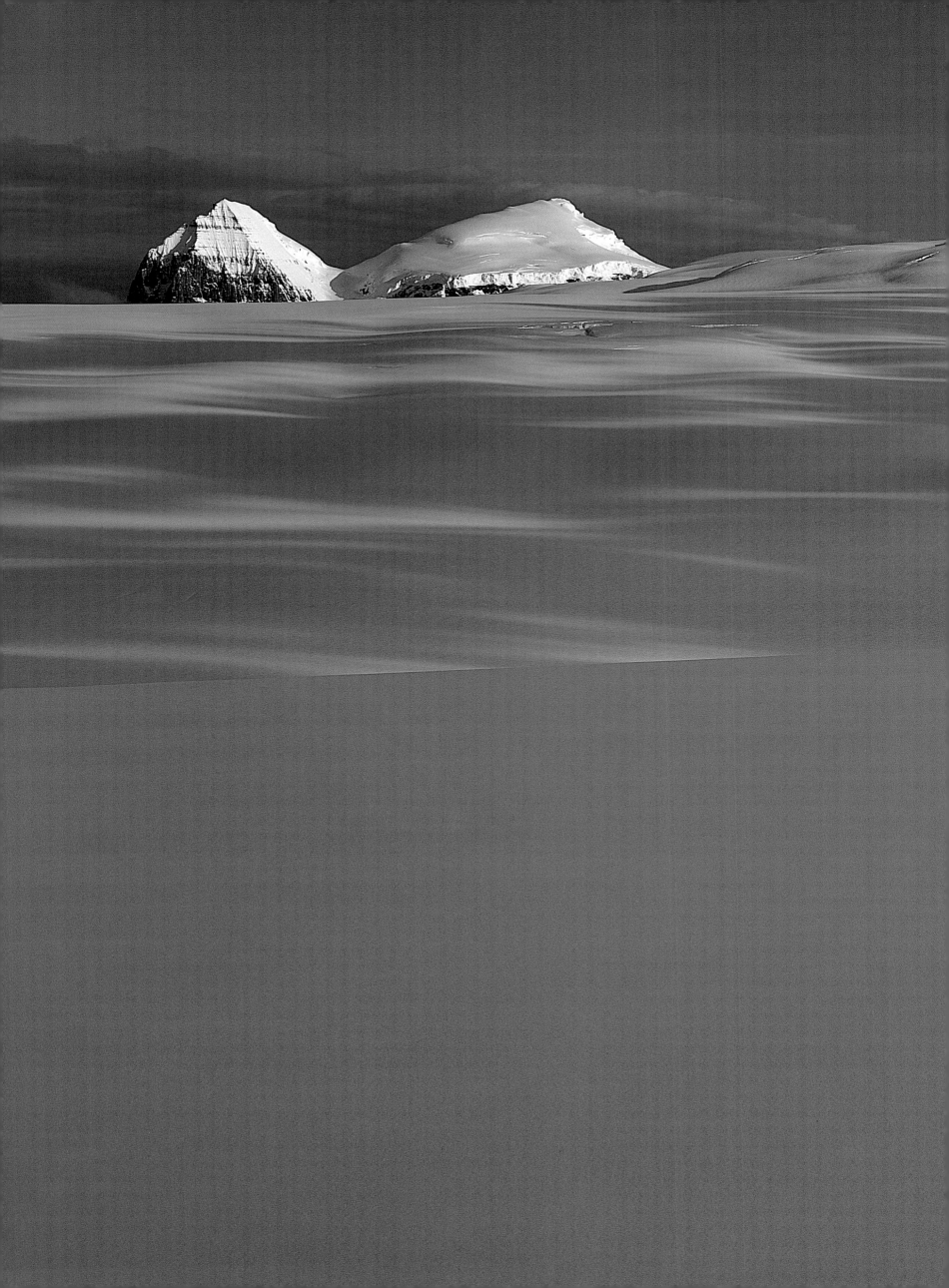

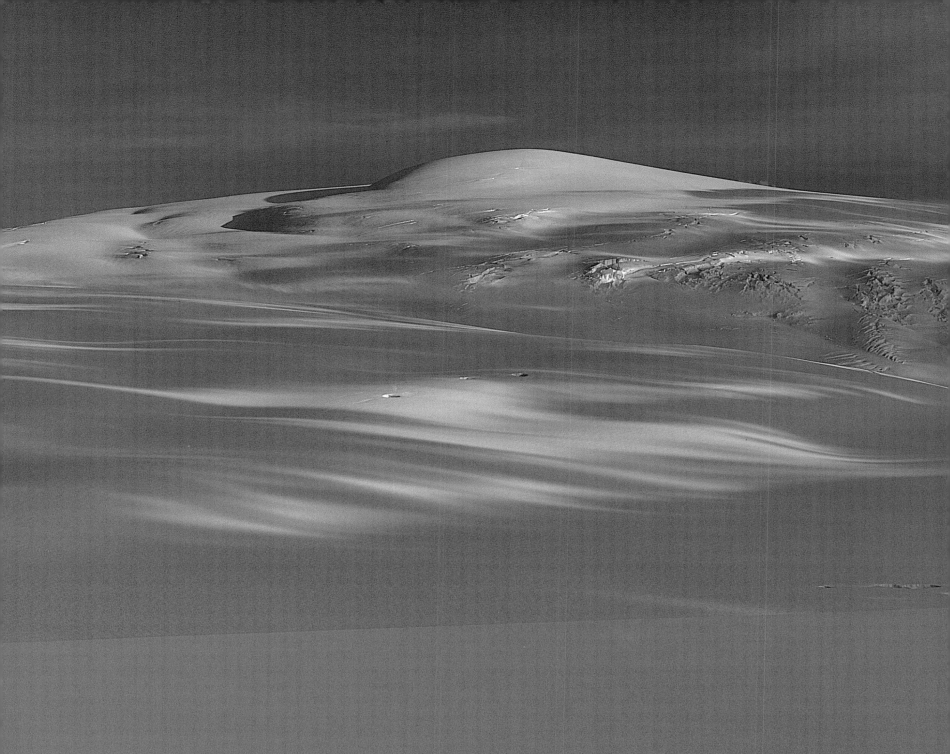

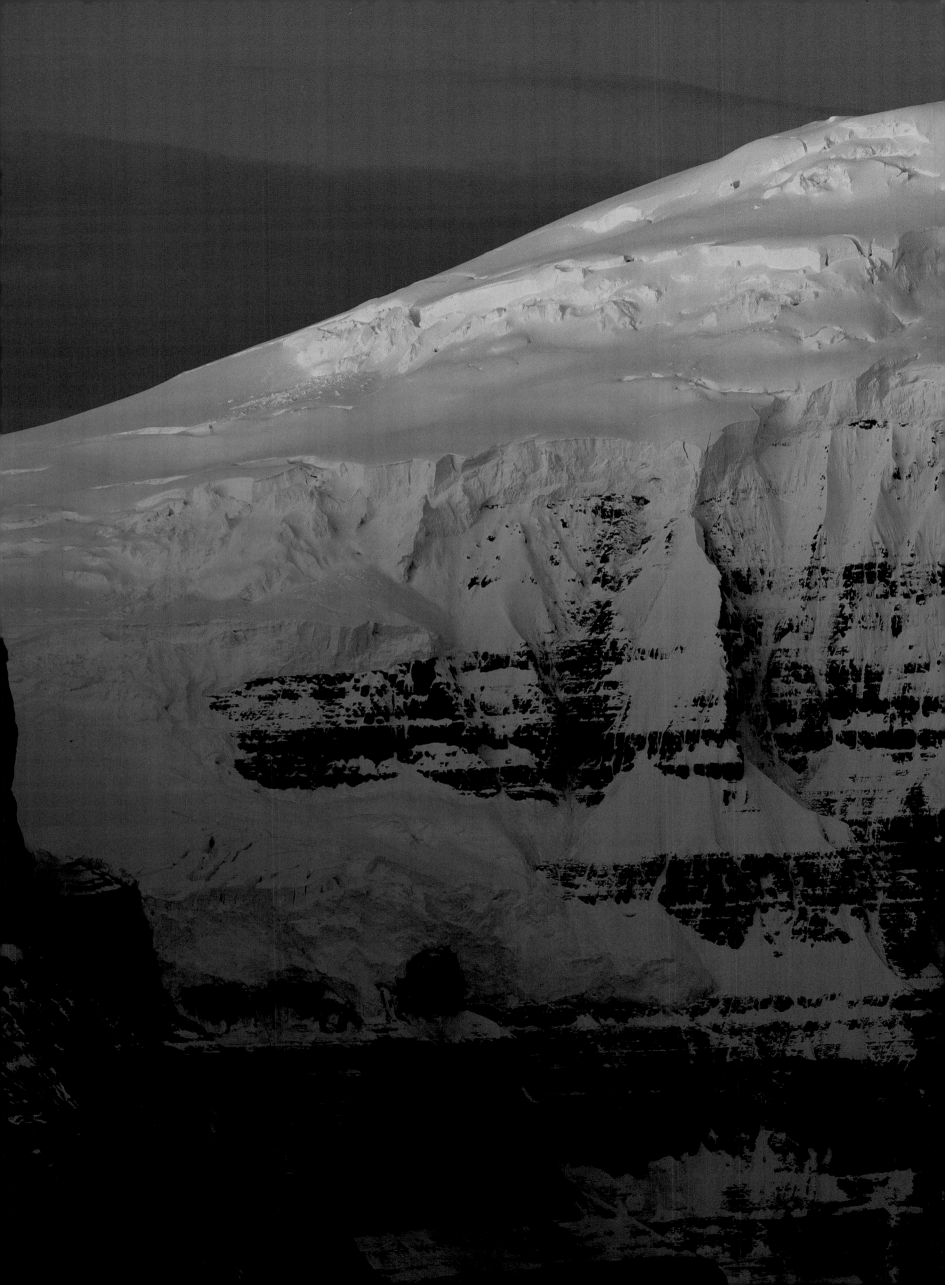

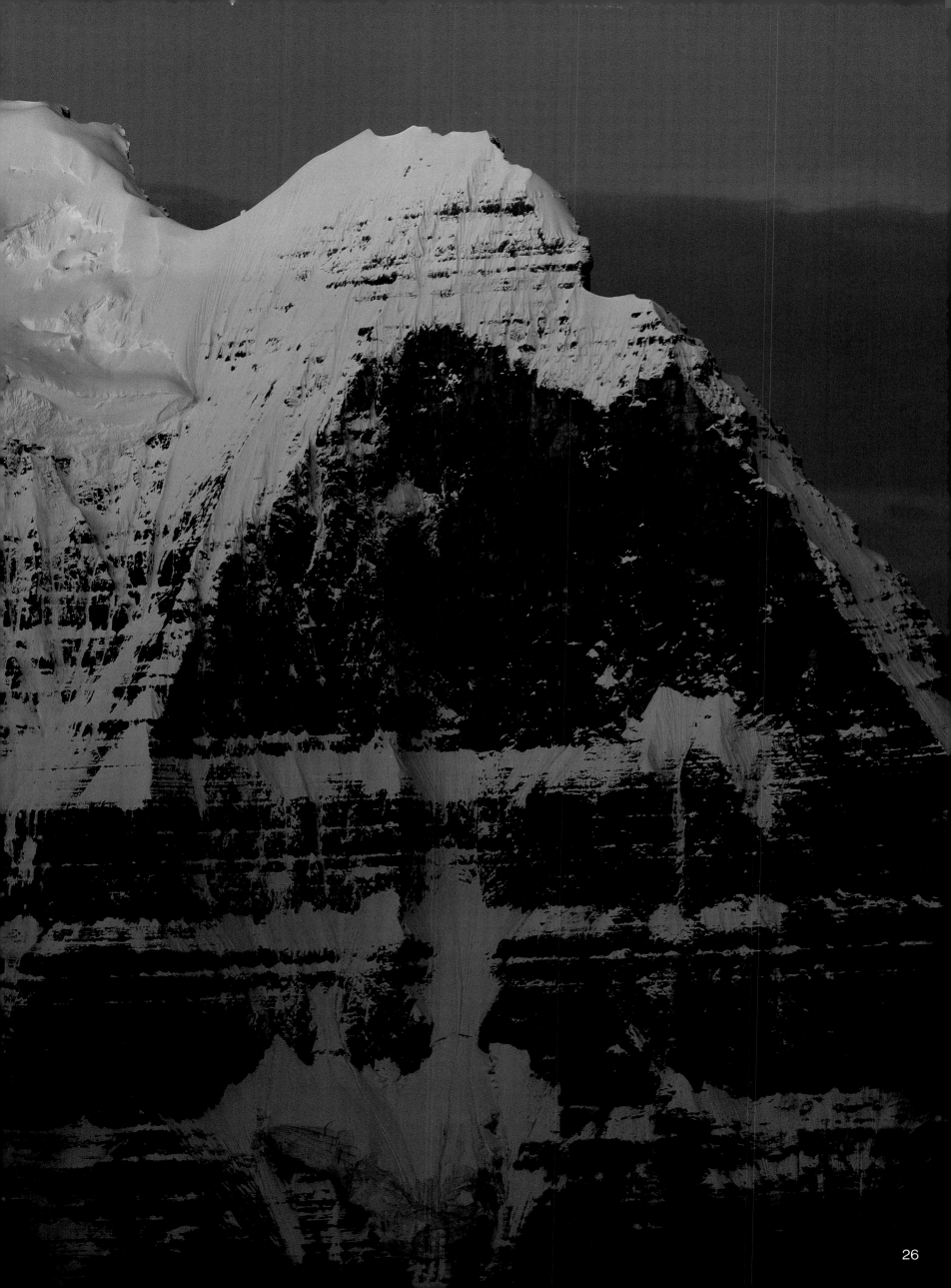

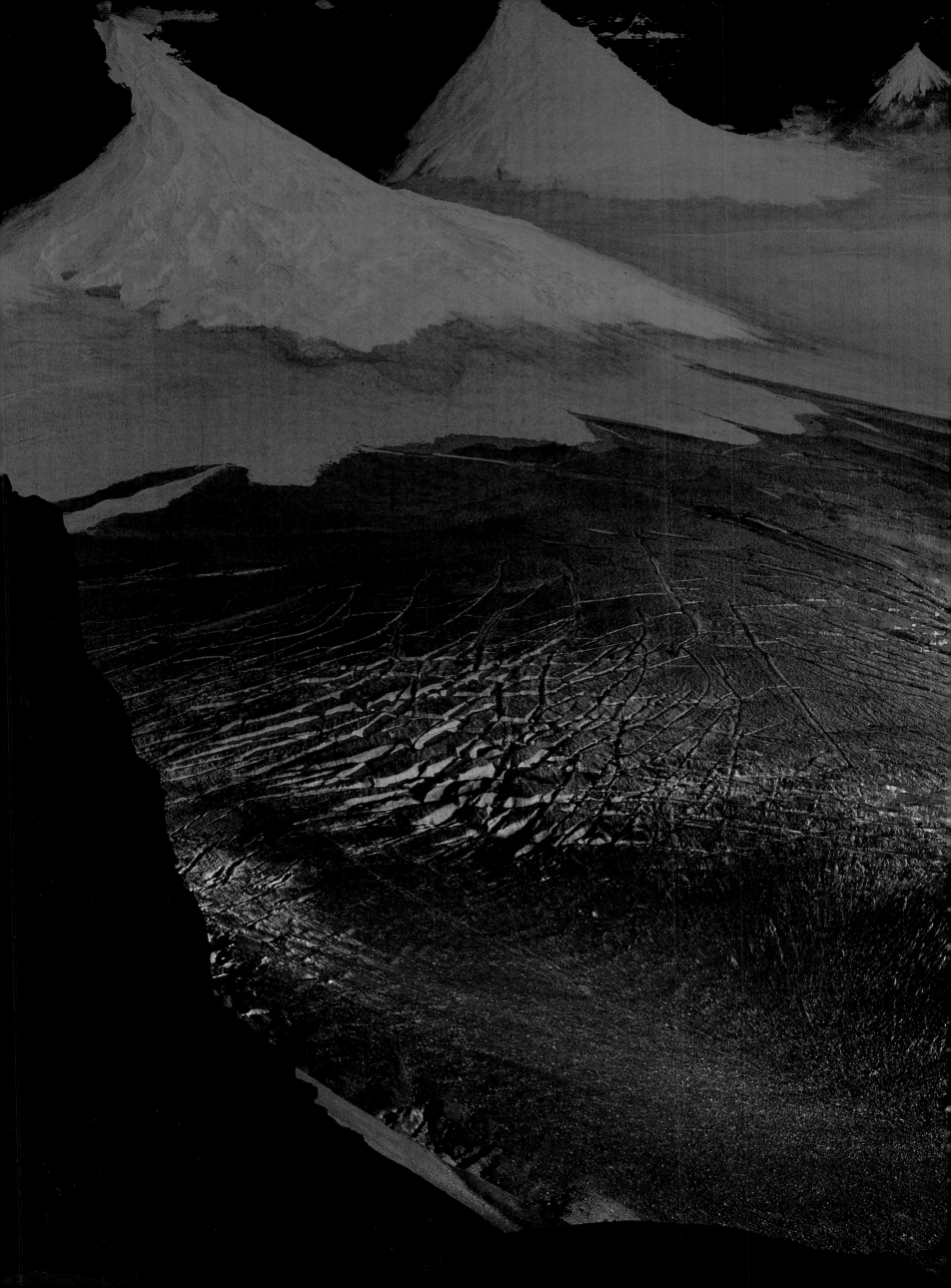

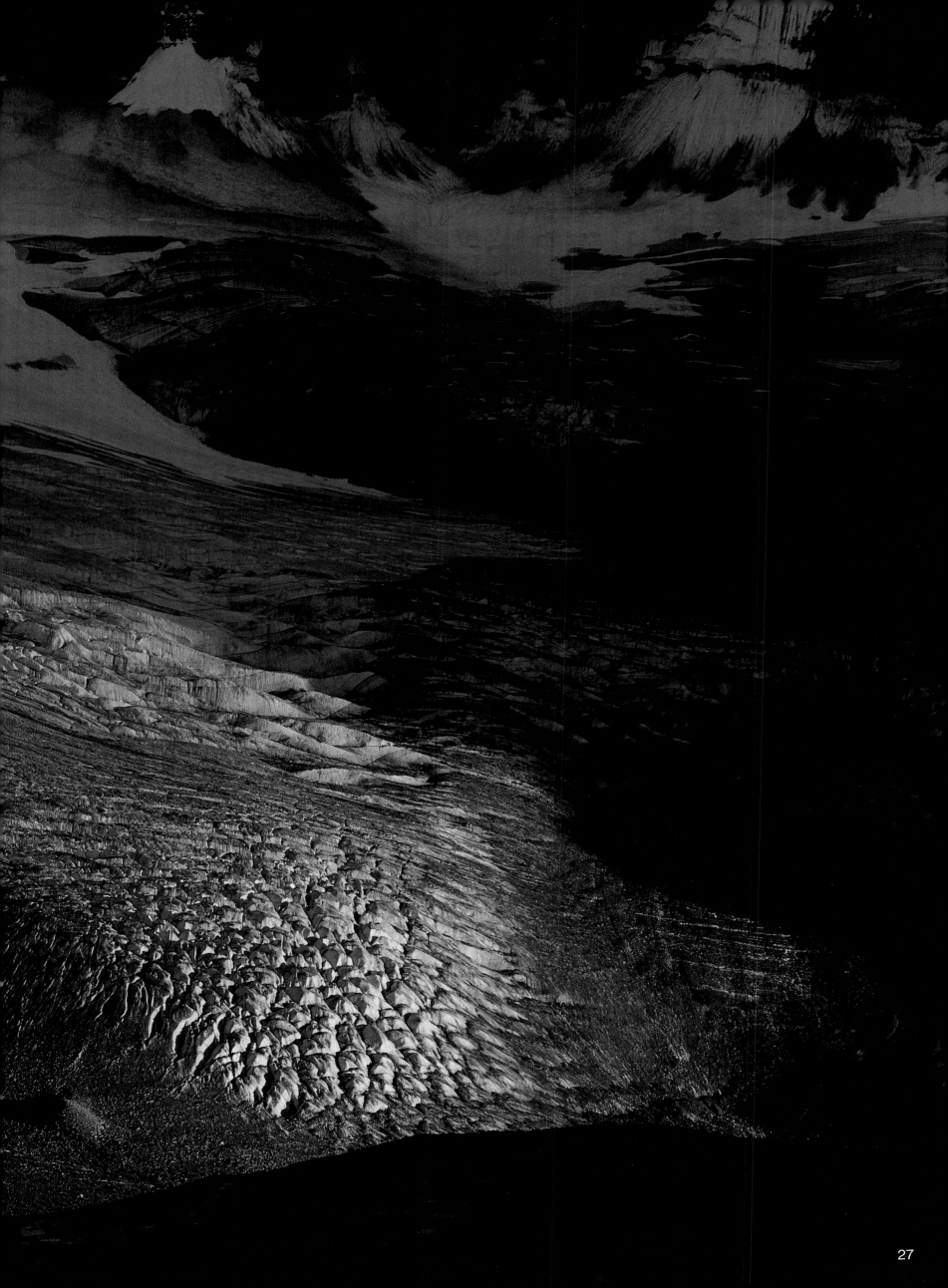

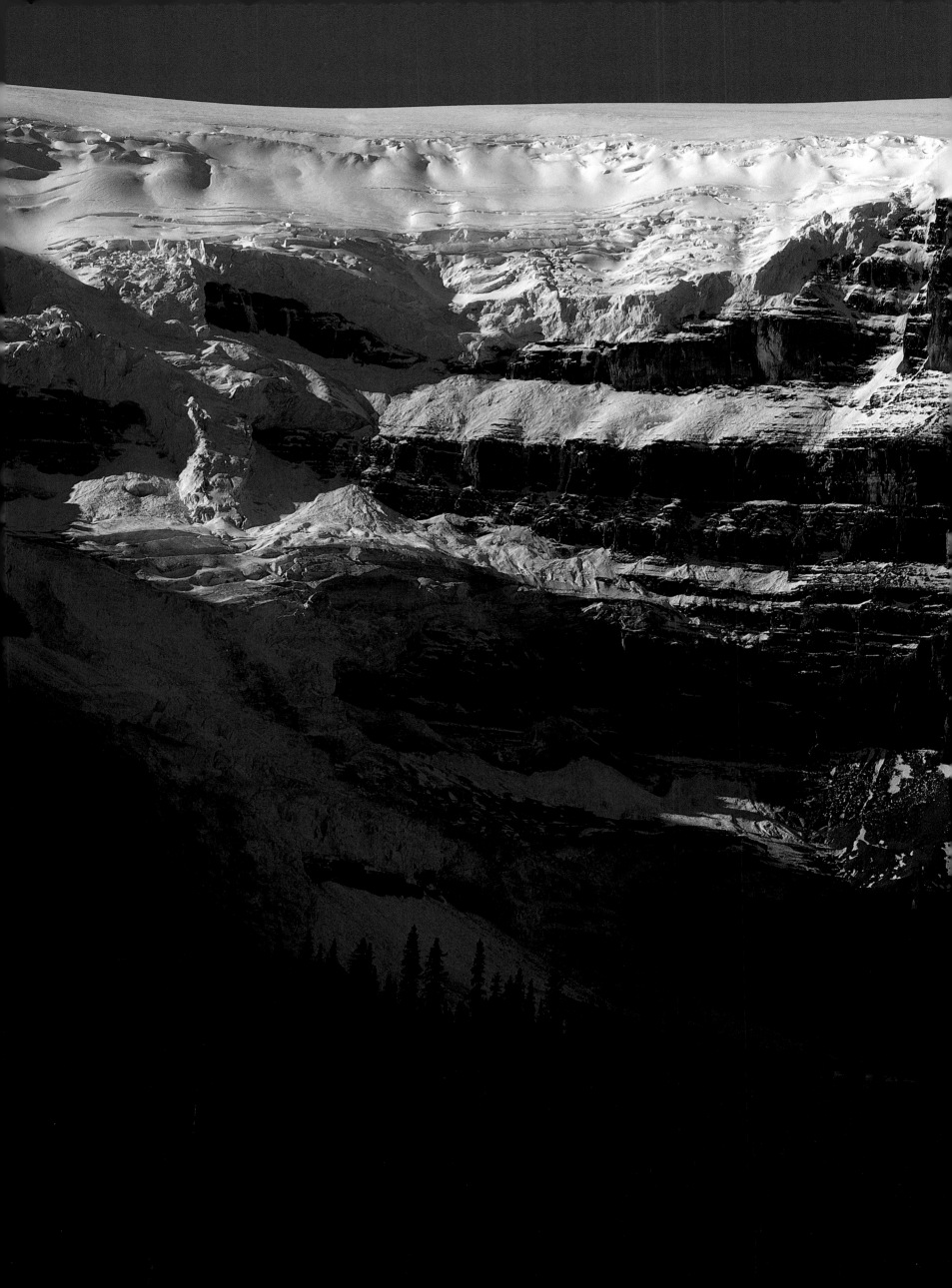

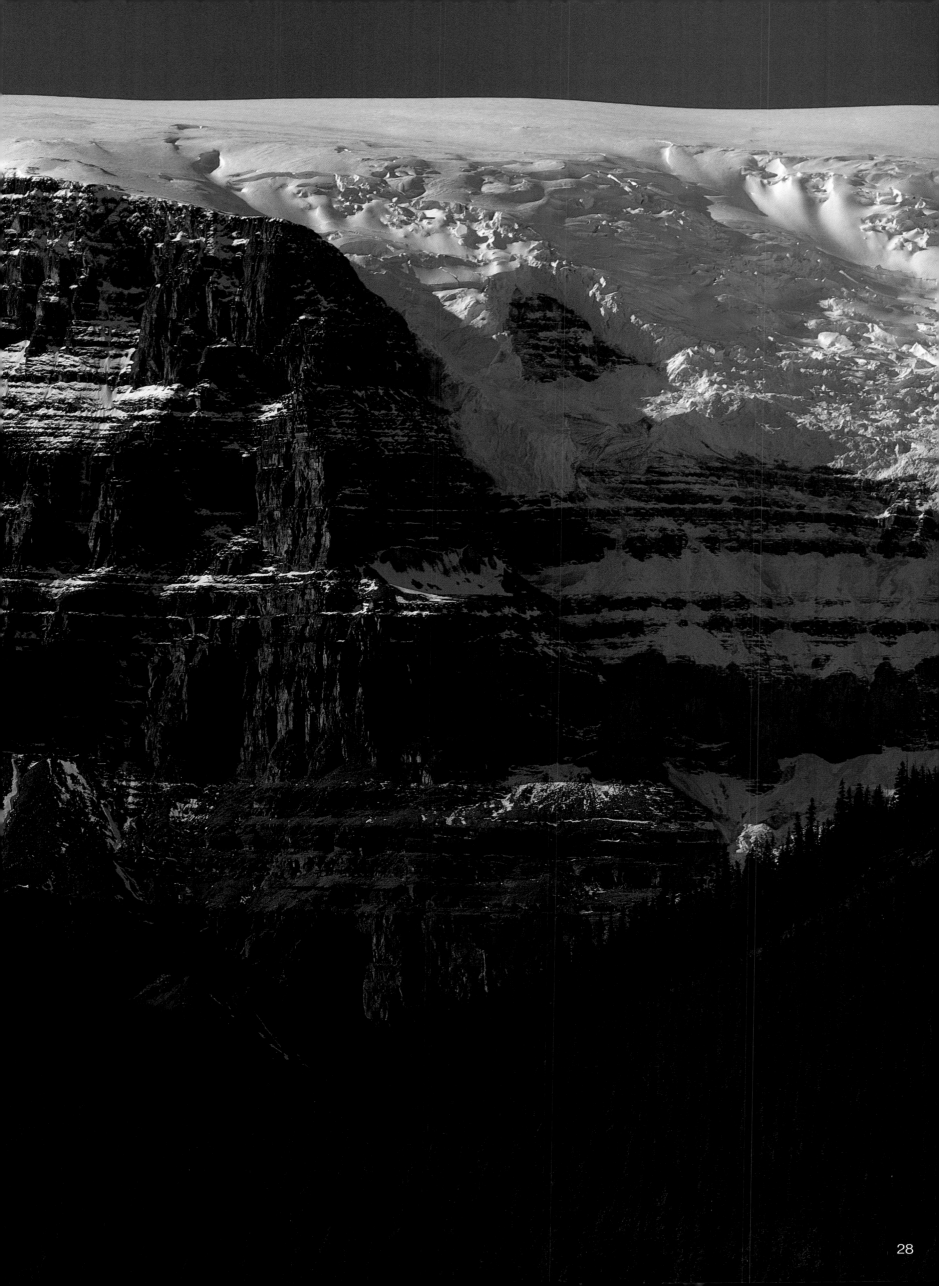

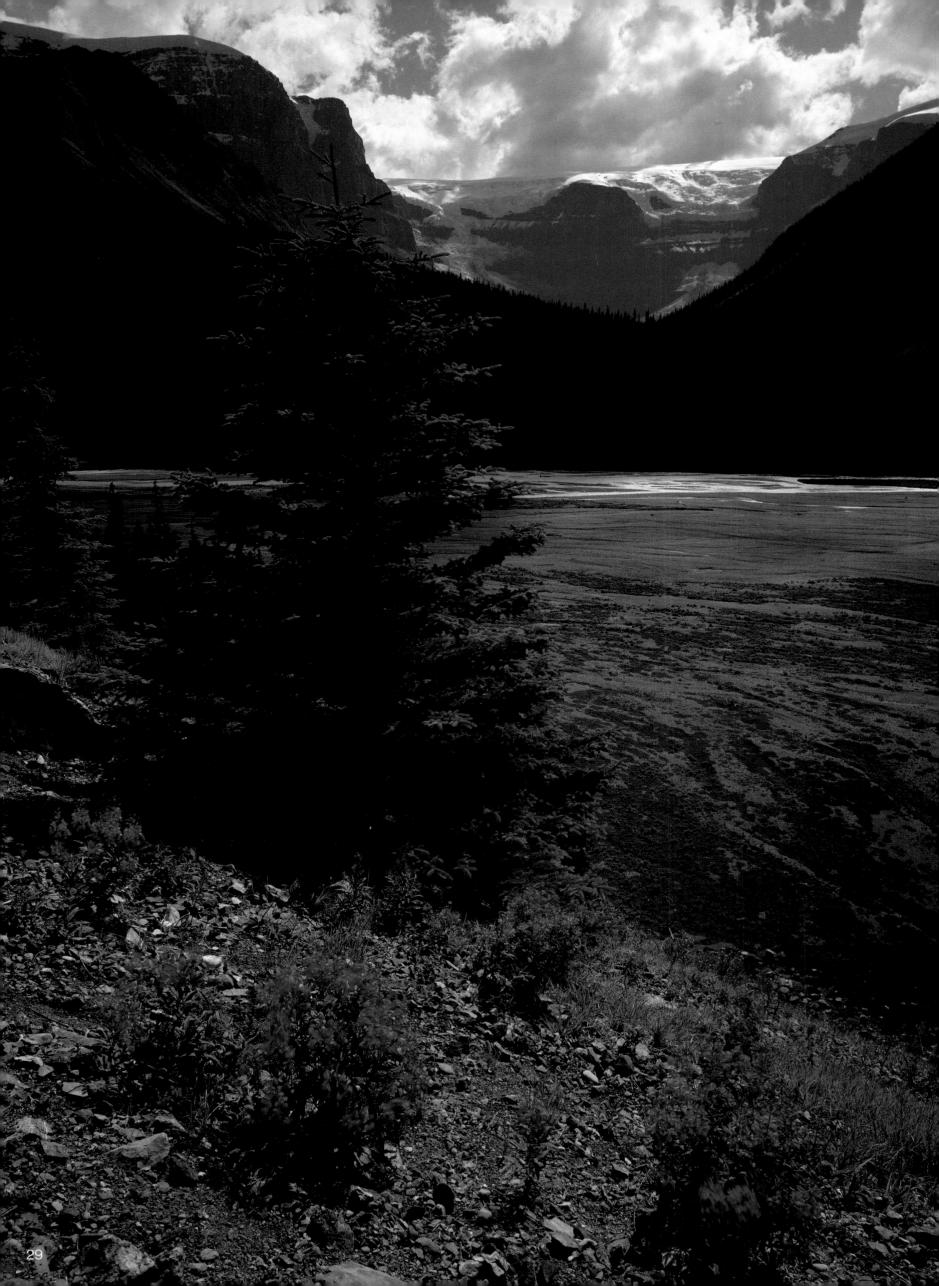

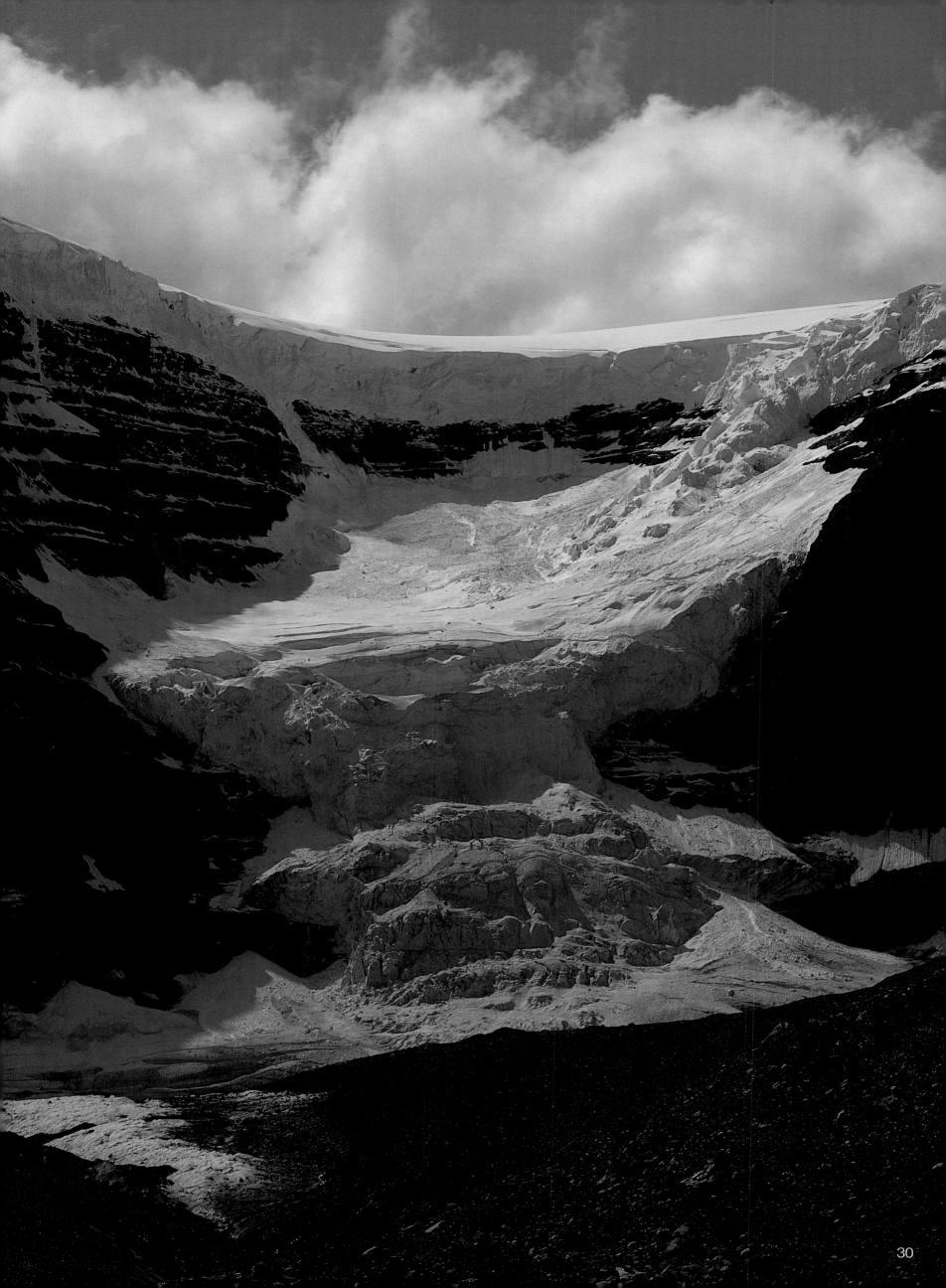

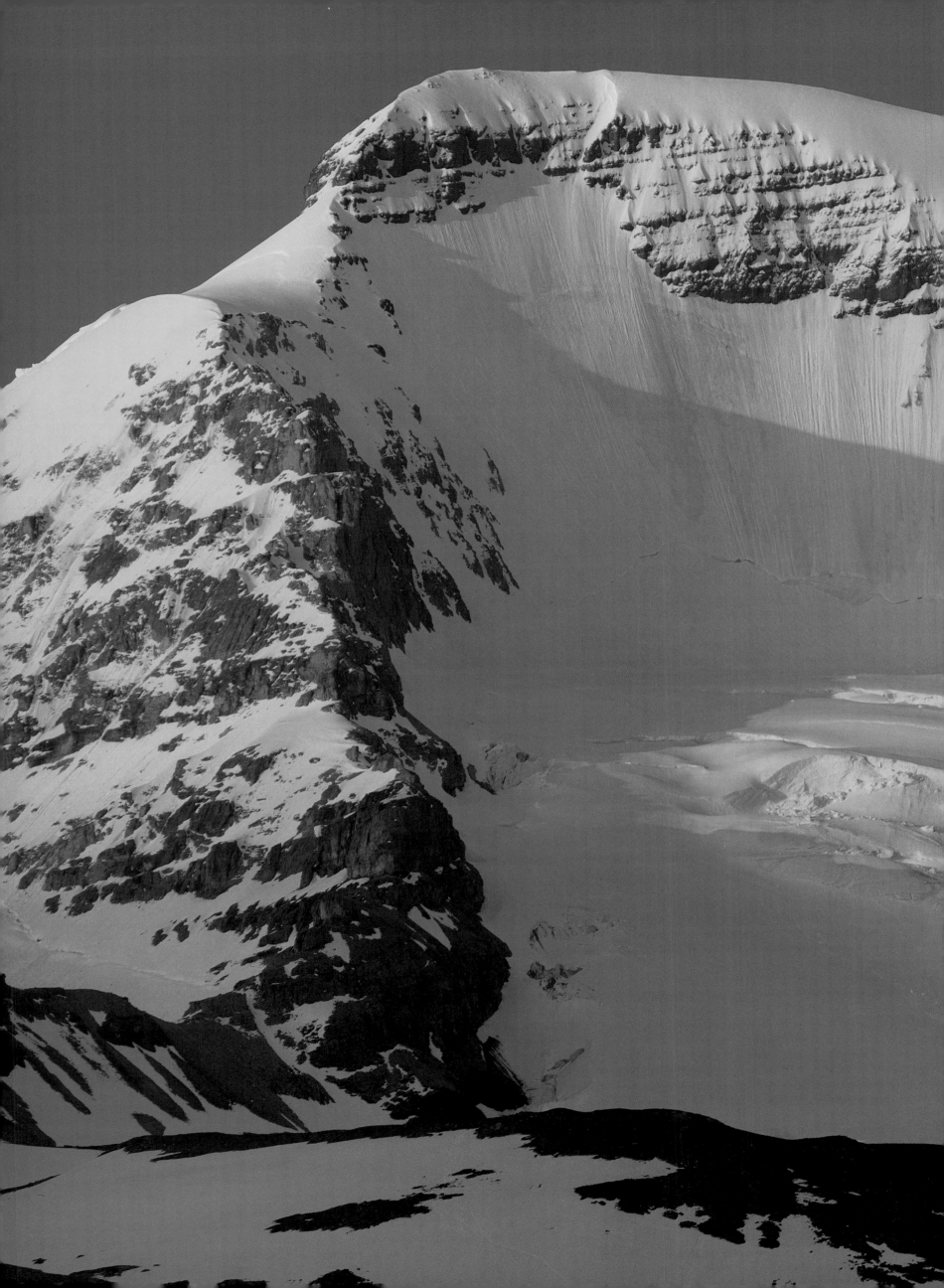

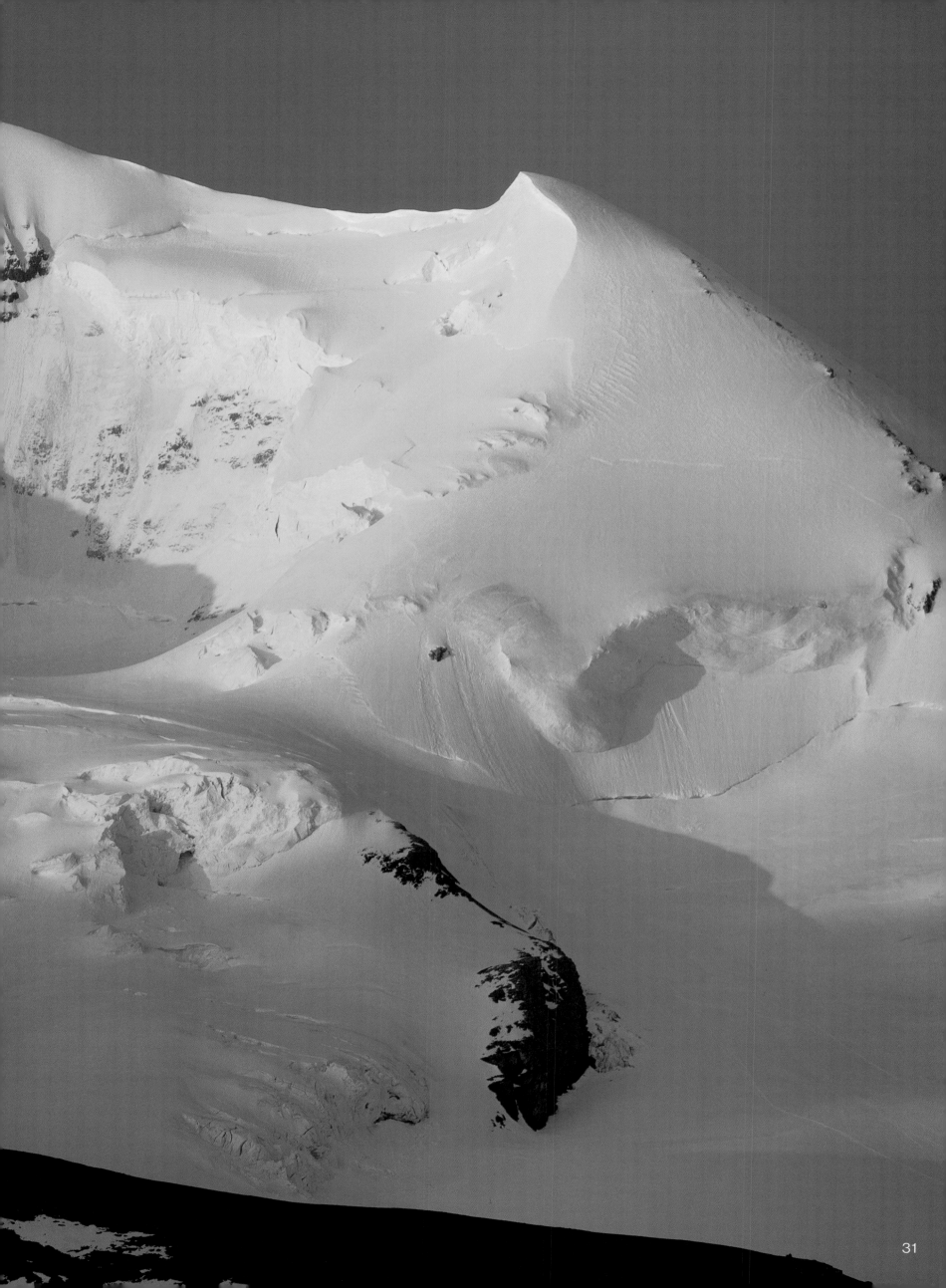

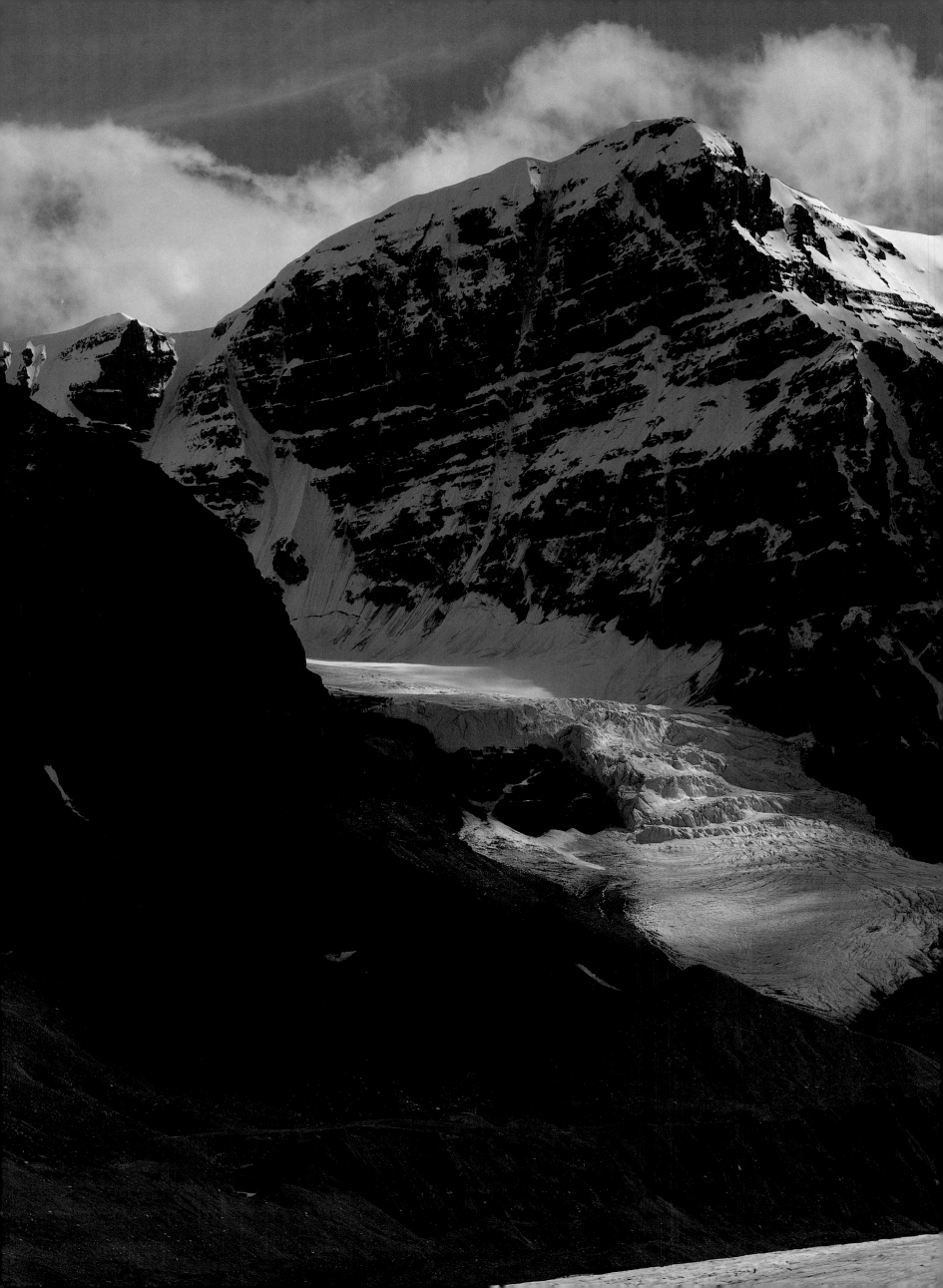

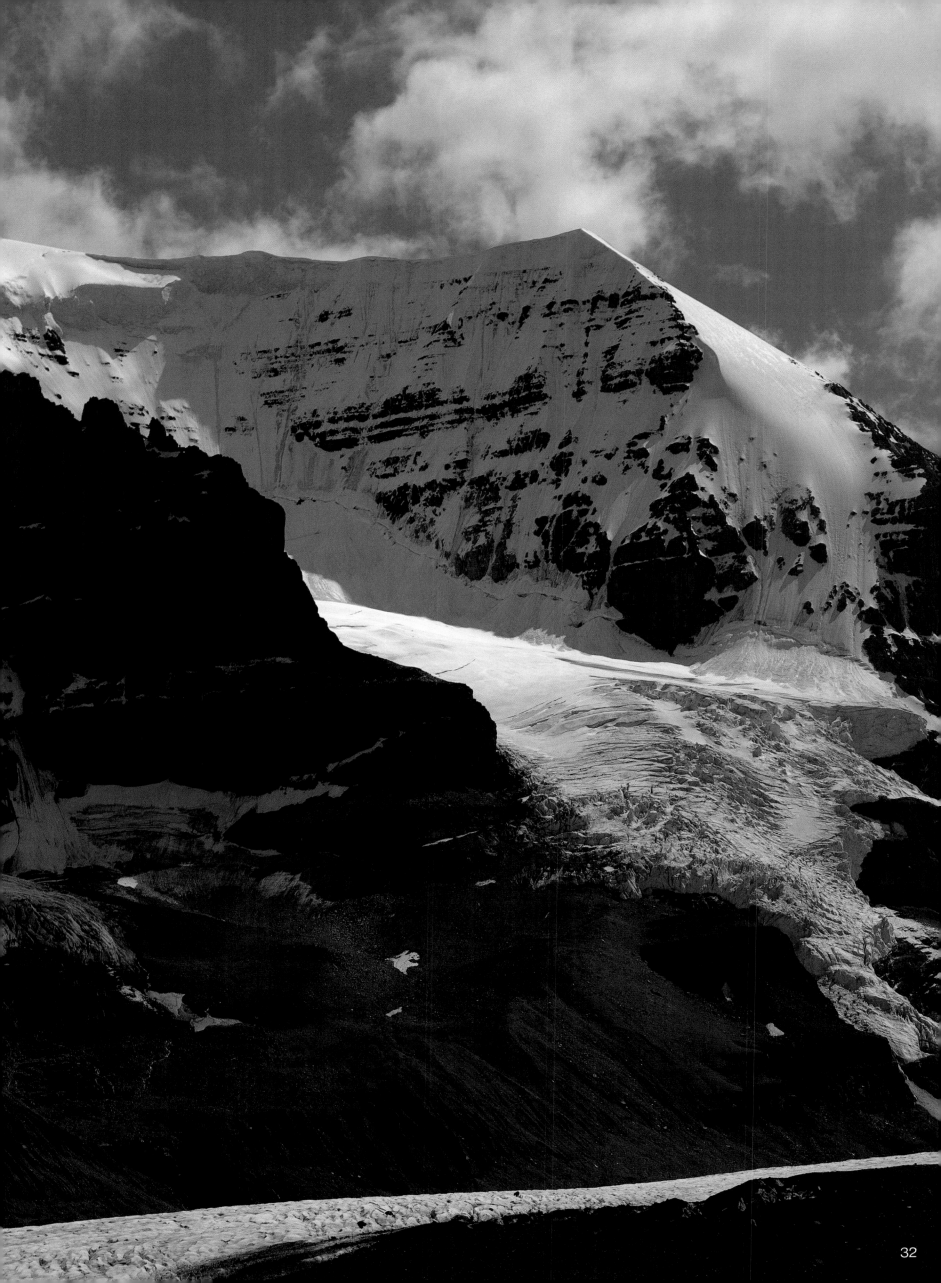

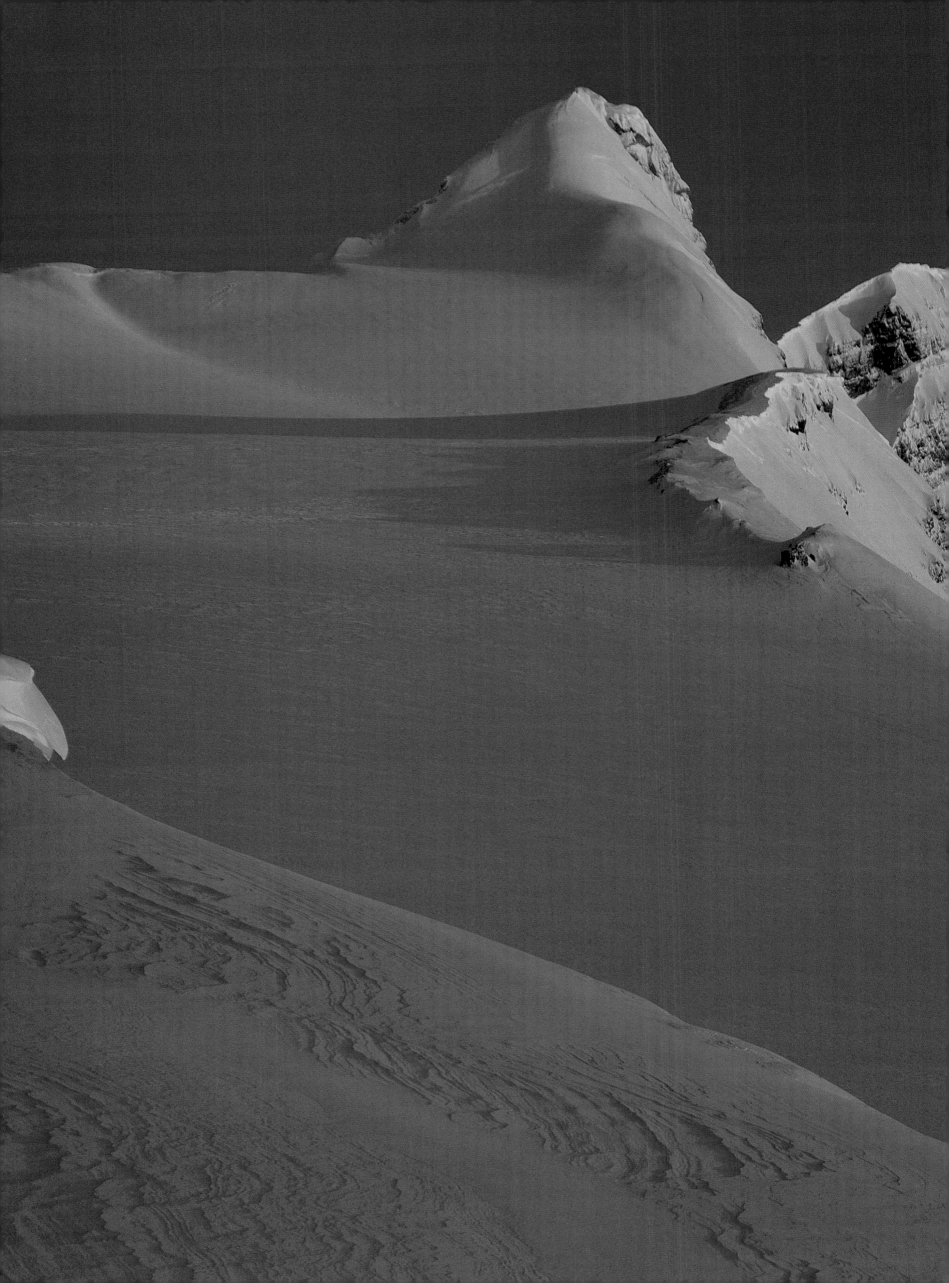

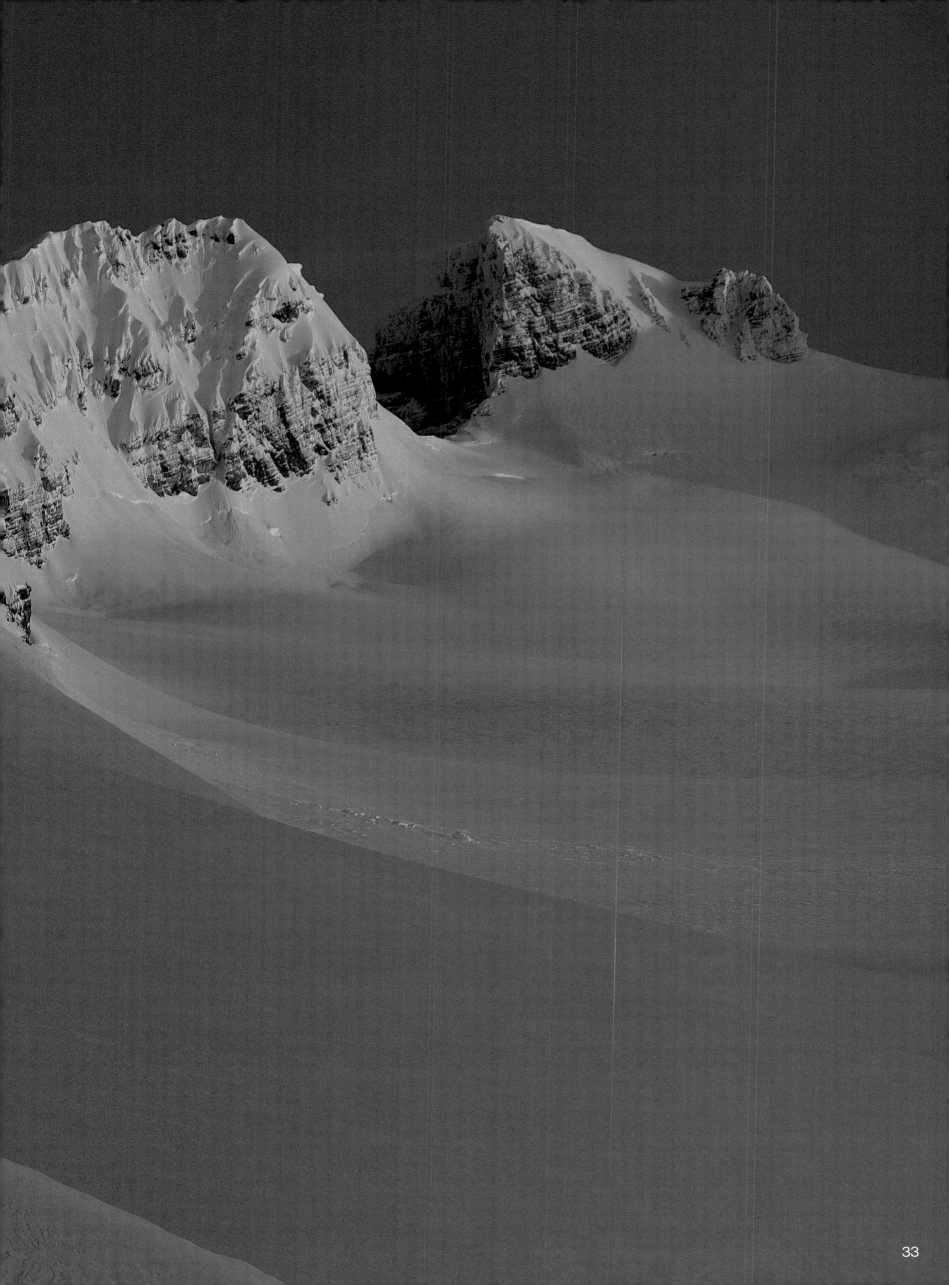

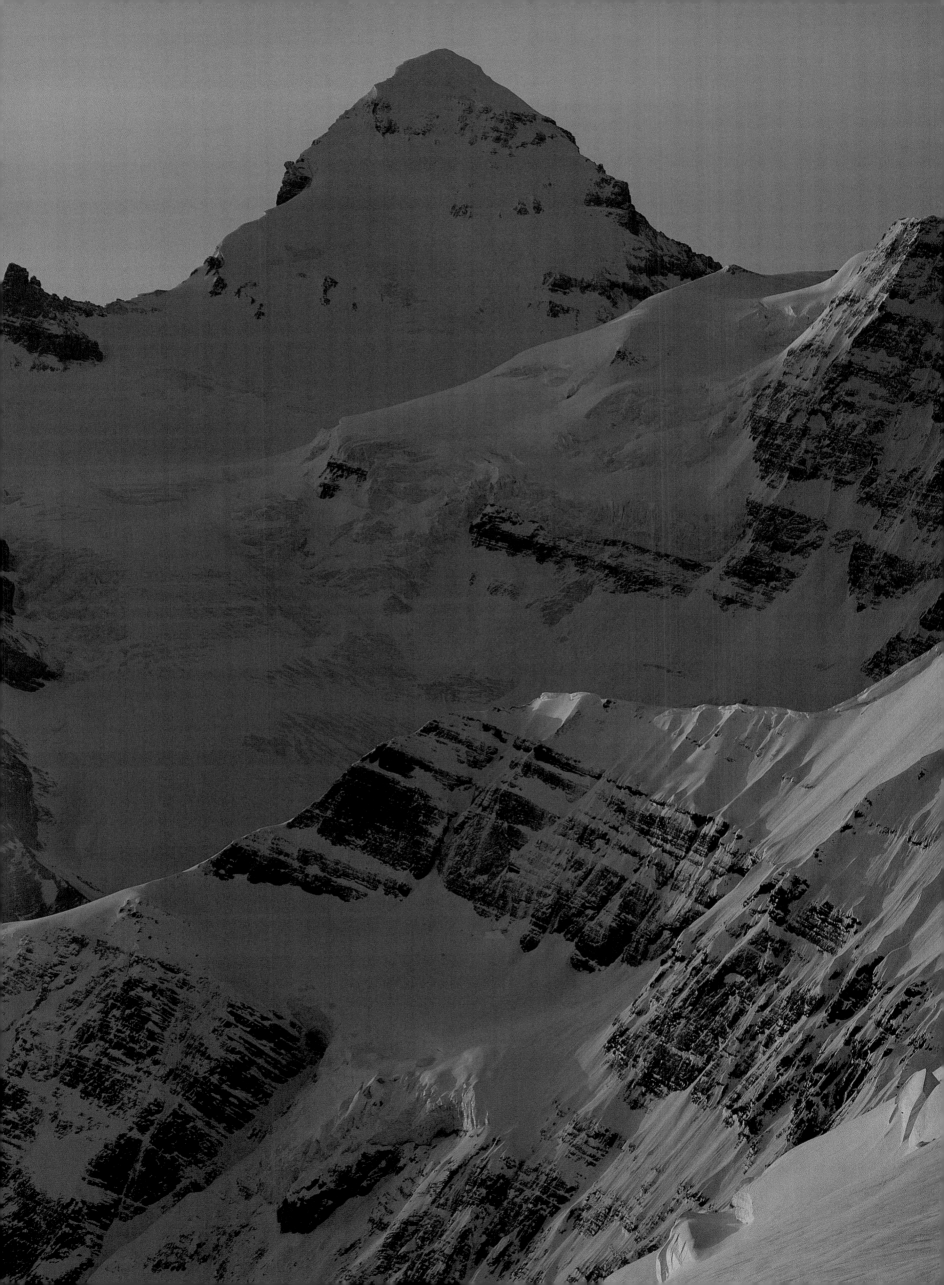

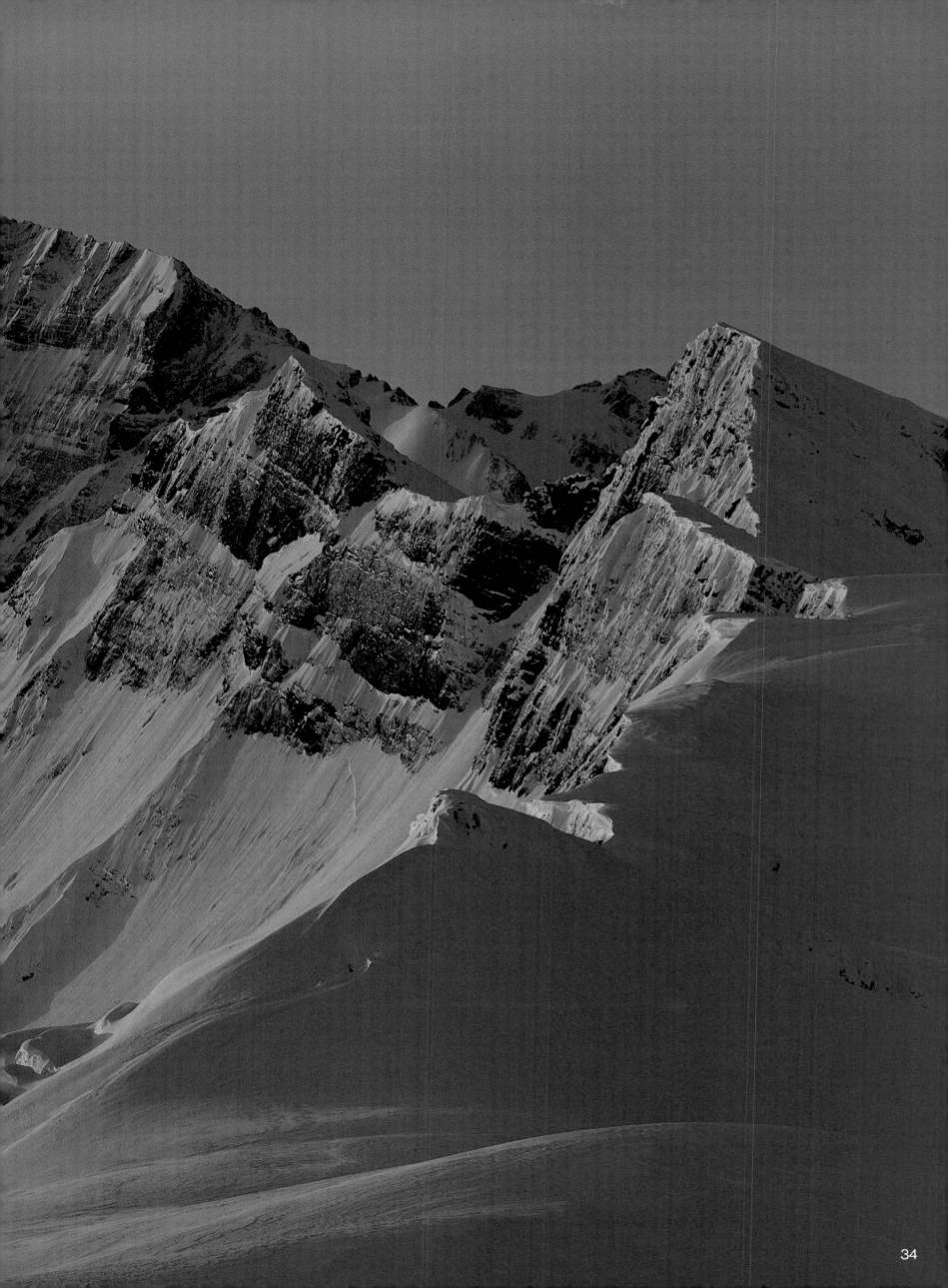

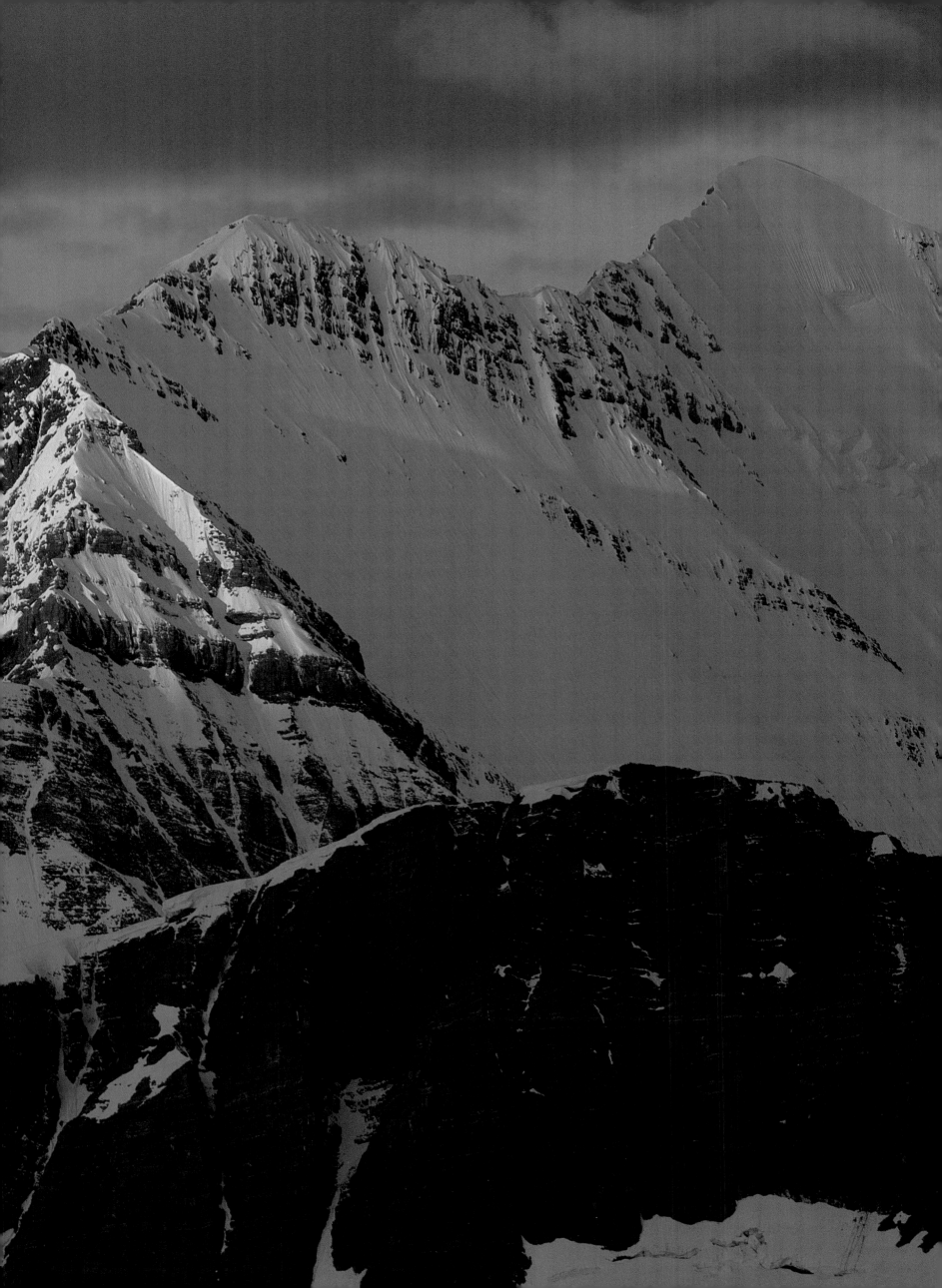

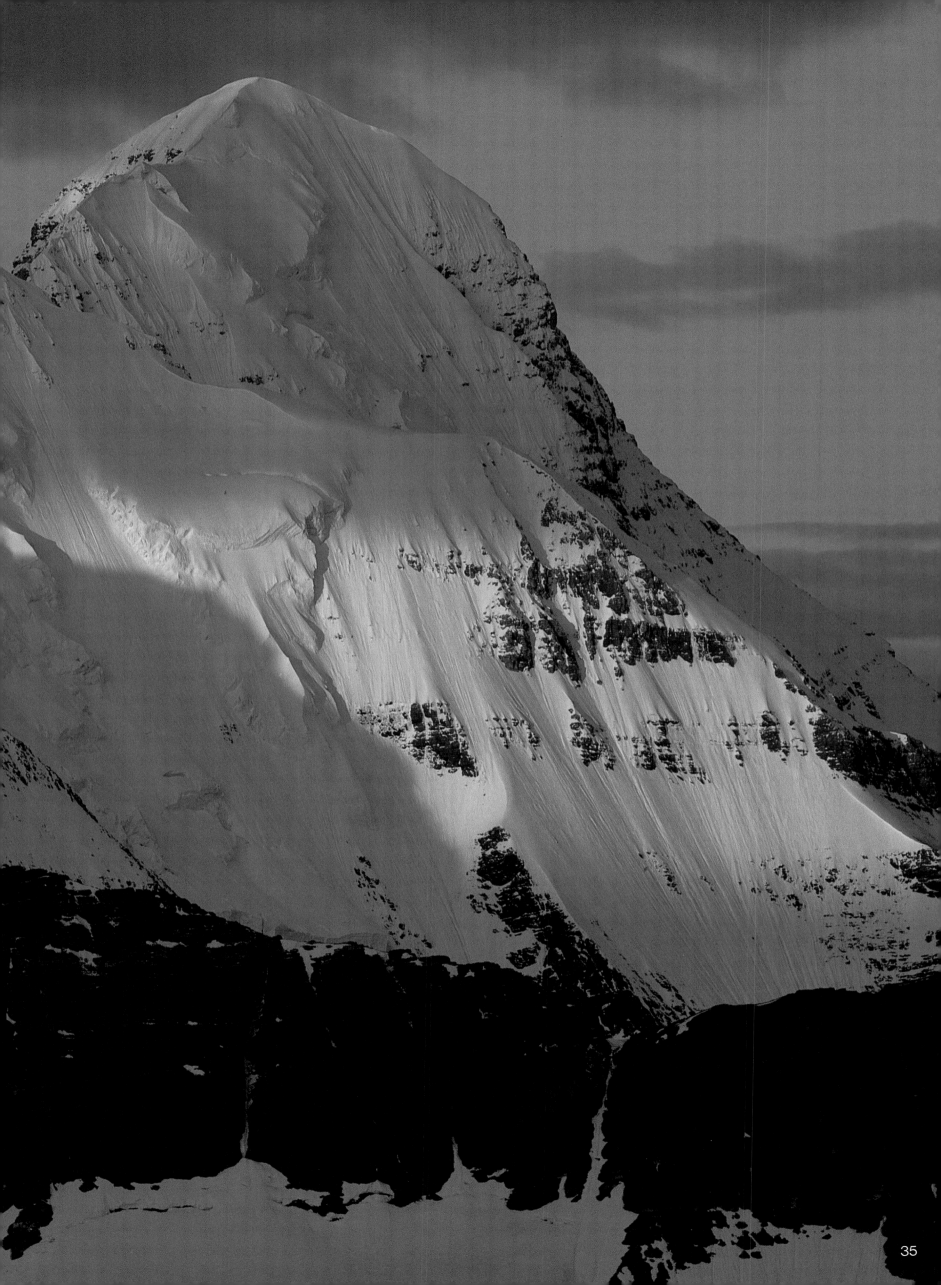

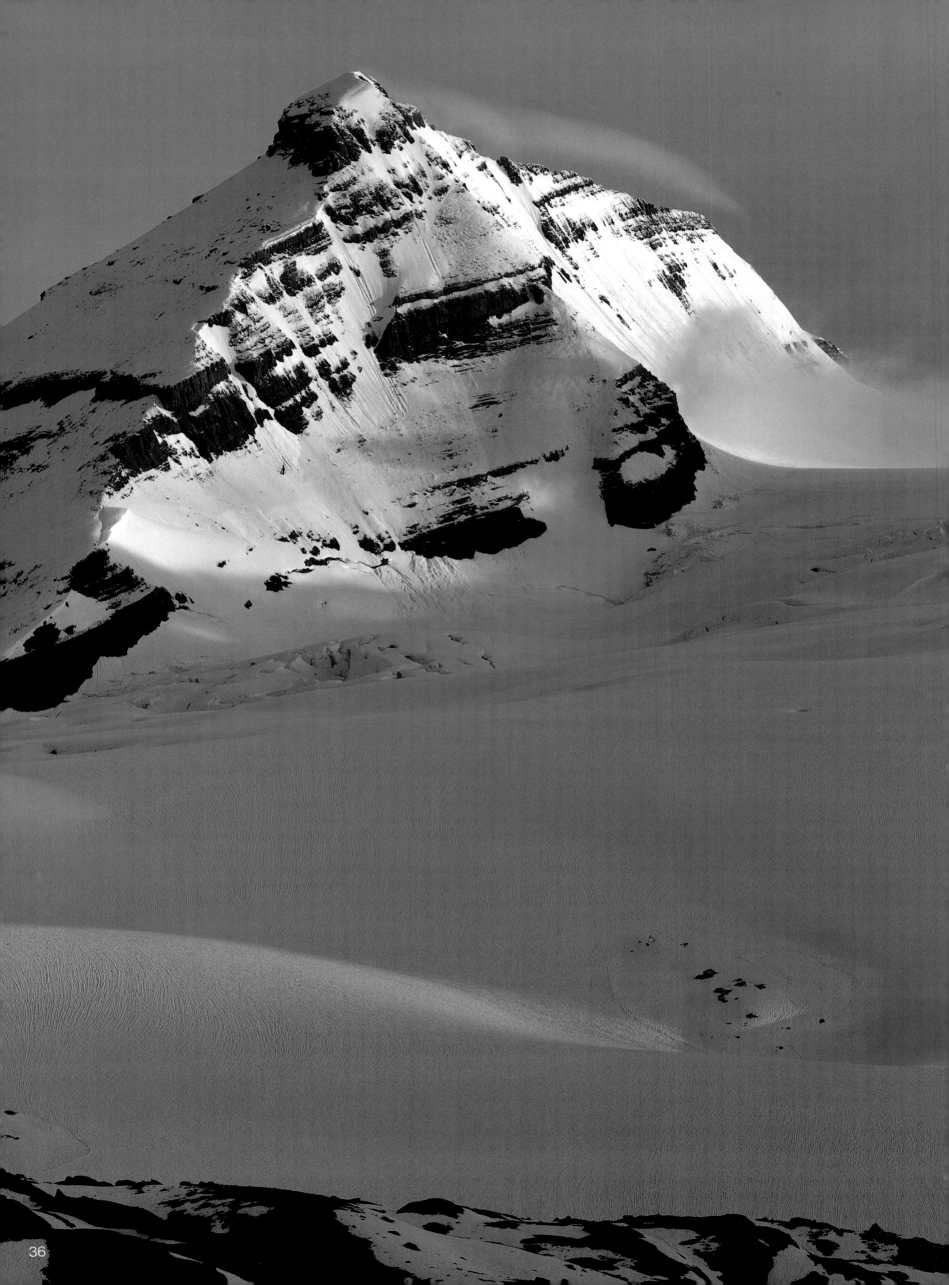

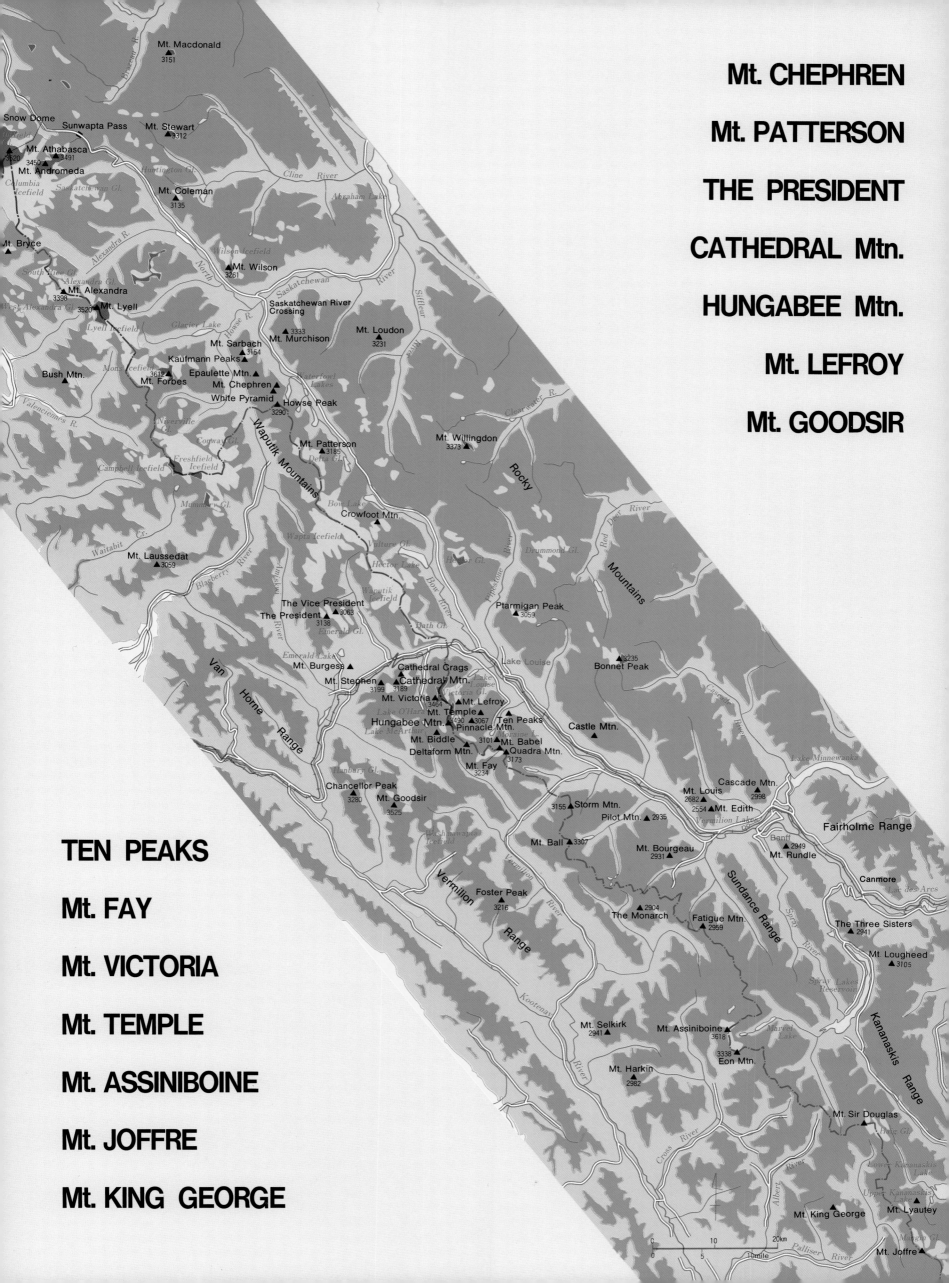

Mt. CHEPHREN

Mt. PATTERSON

THE PRESIDENT

CATHEDRAL Mtn.

HUNGABEE Mtn.

Mt. LEFROY

Mt. GOODSIR

TEN PEAKS

Mt. FAY

Mt. VICTORIA

Mt. TEMPLE

Mt. ASSINIBOINE

Mt. JOFFRE

Mt. KING GEORGE

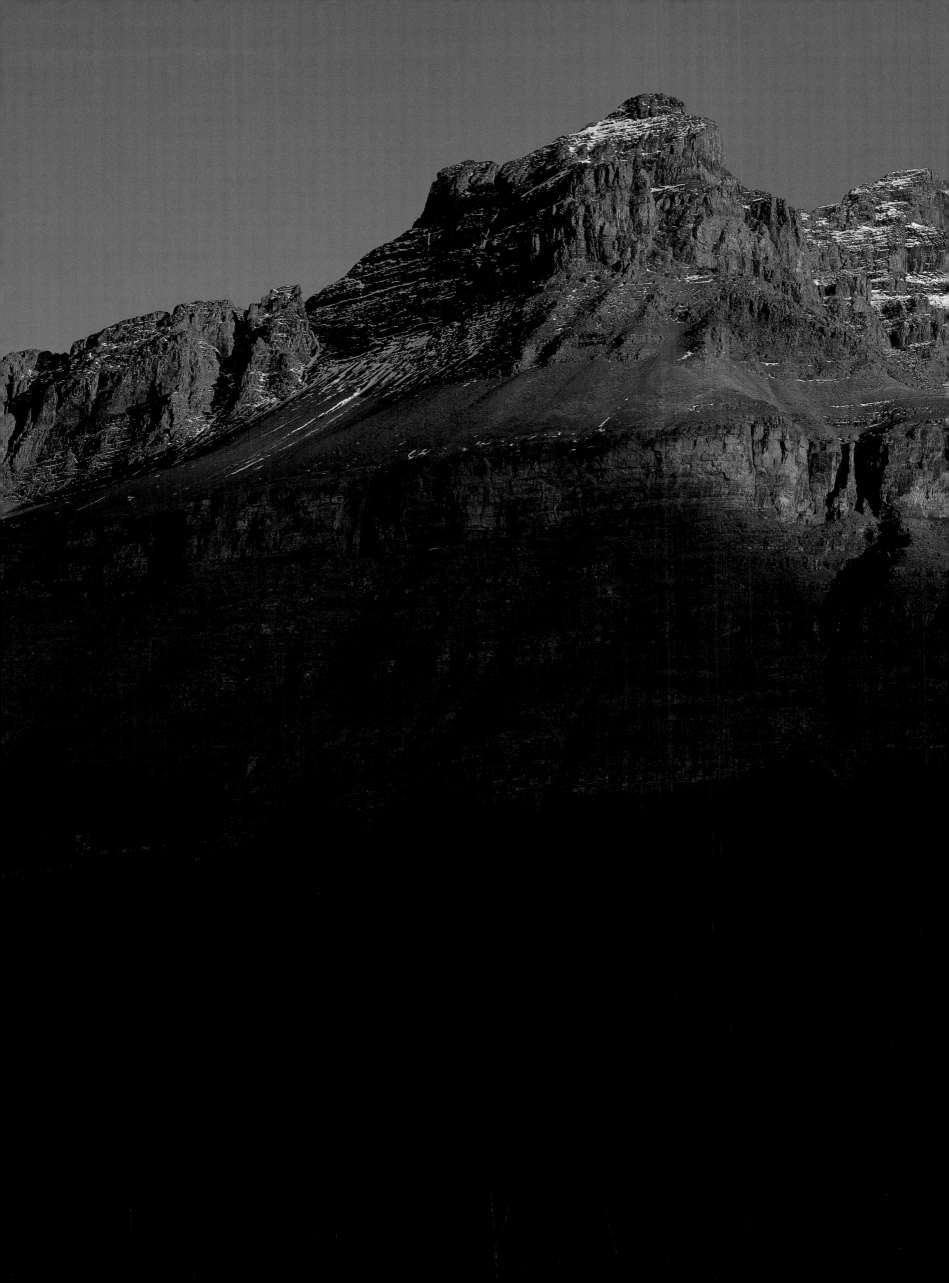

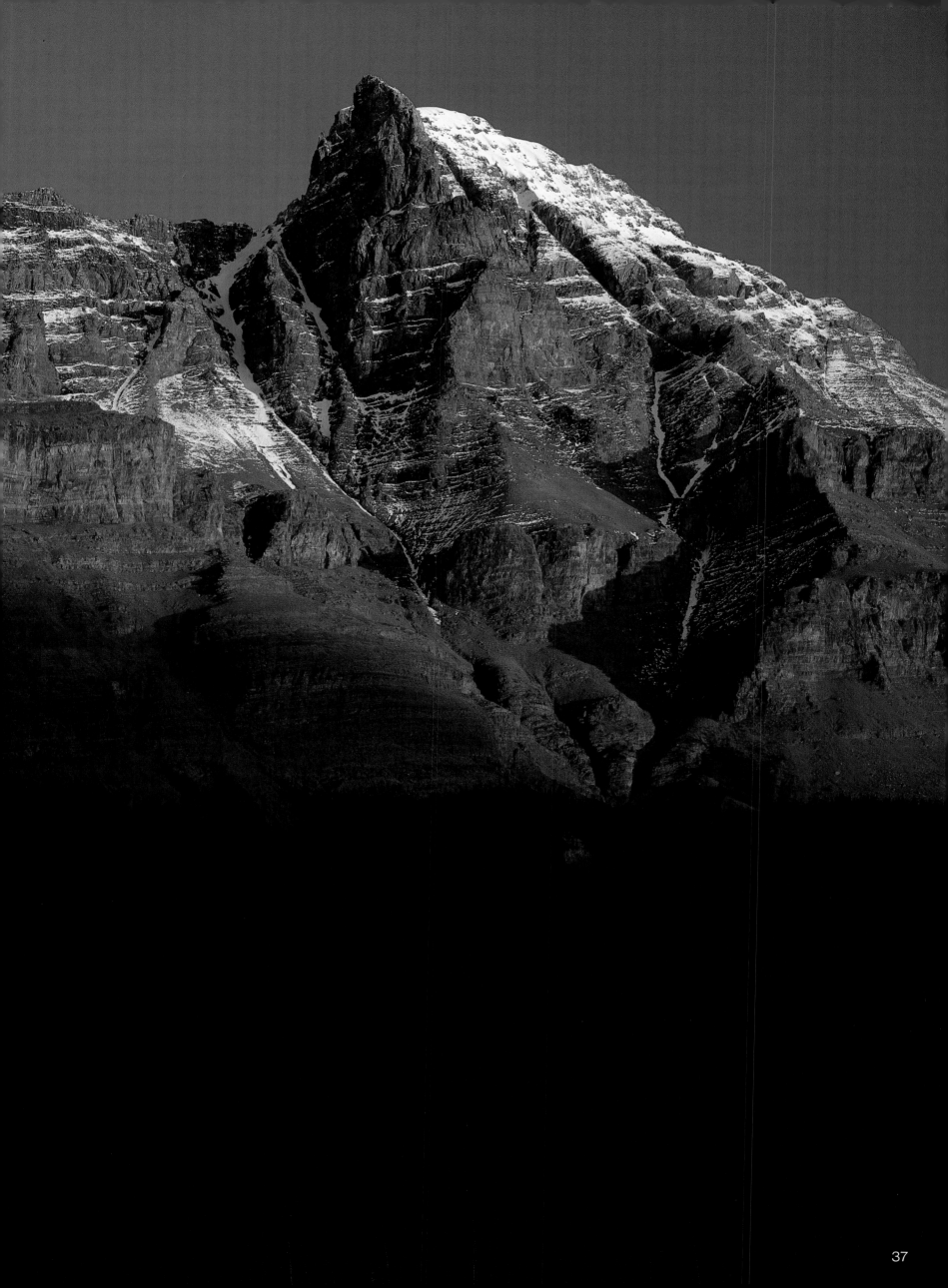

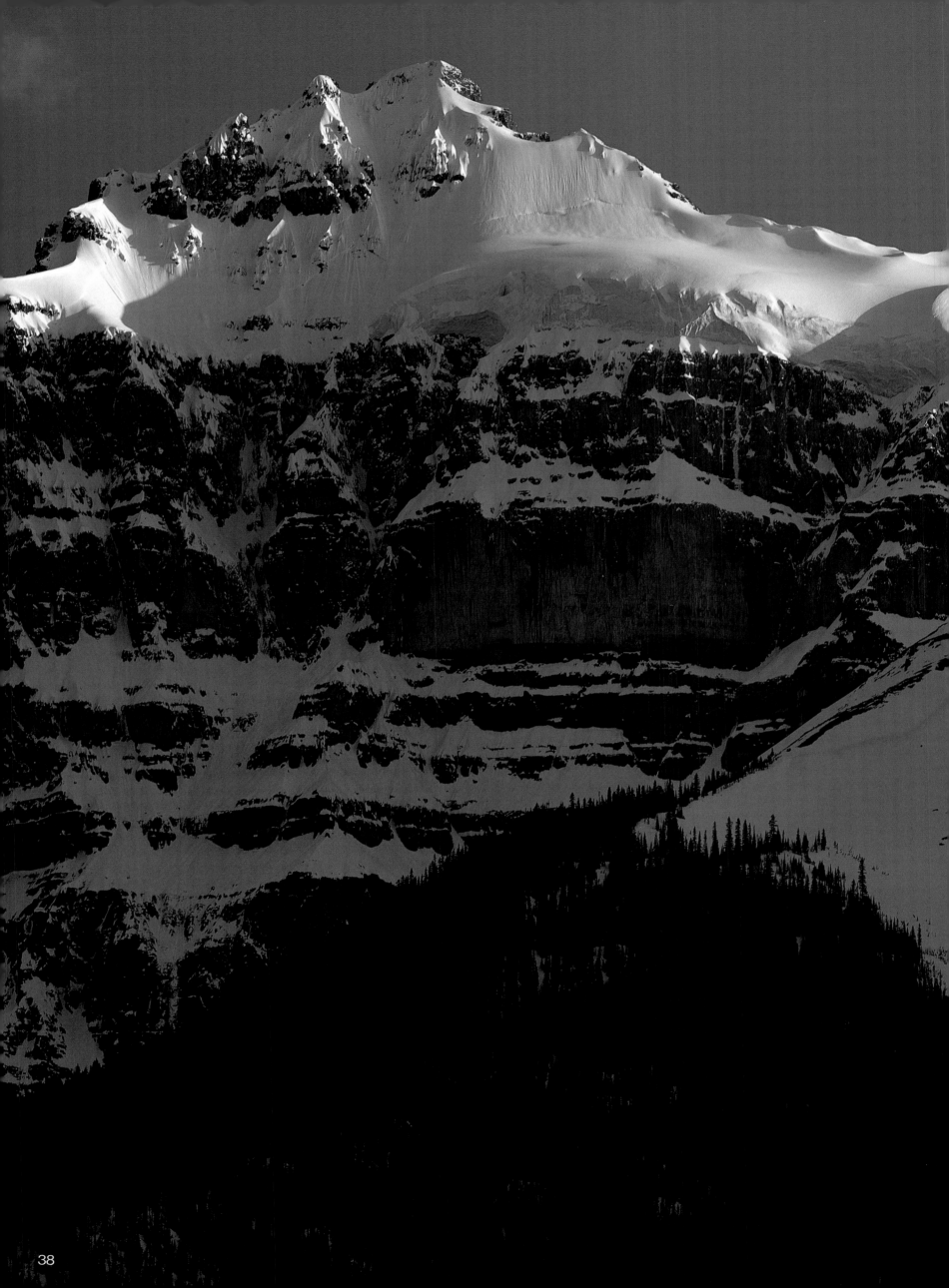

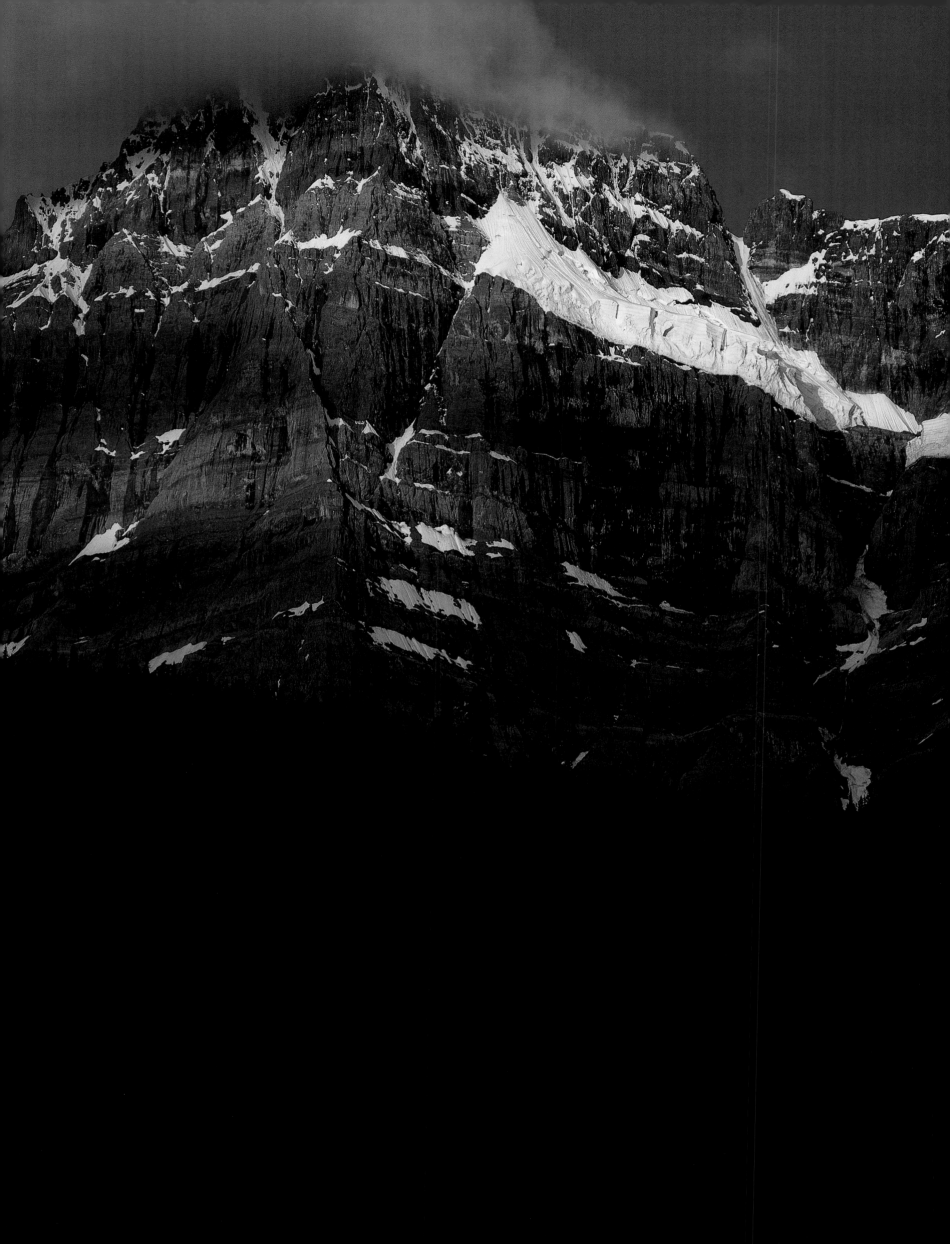

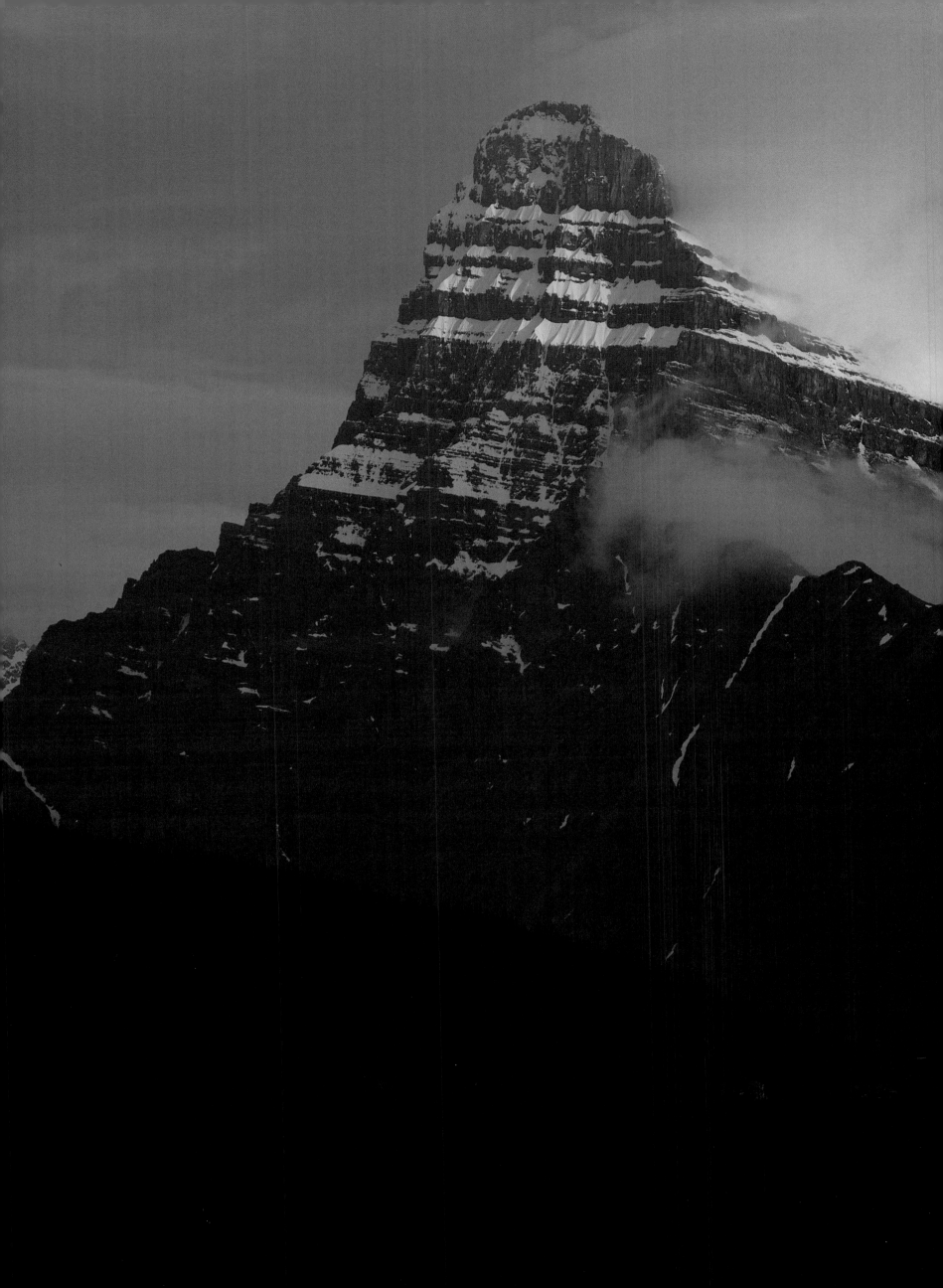

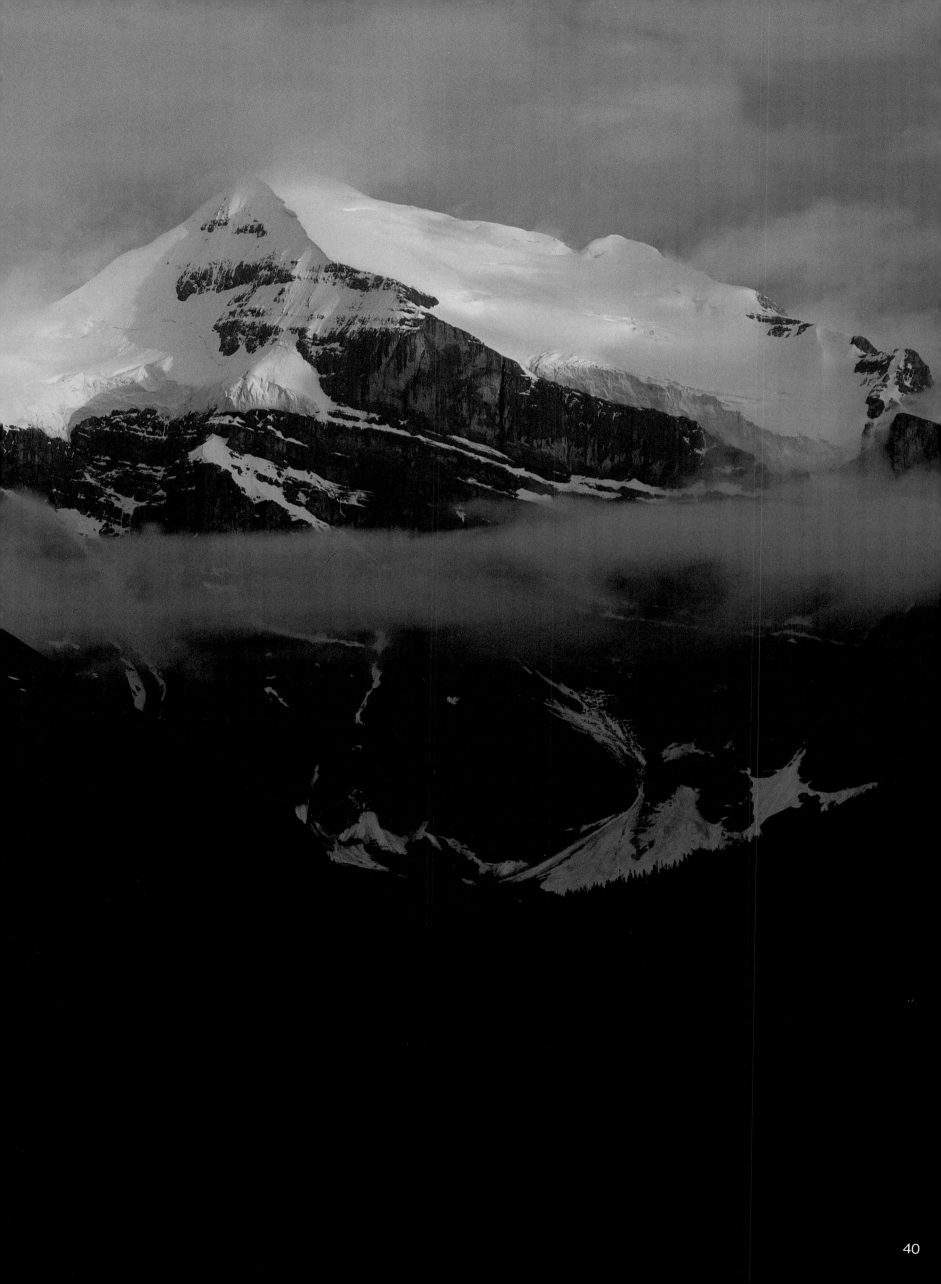

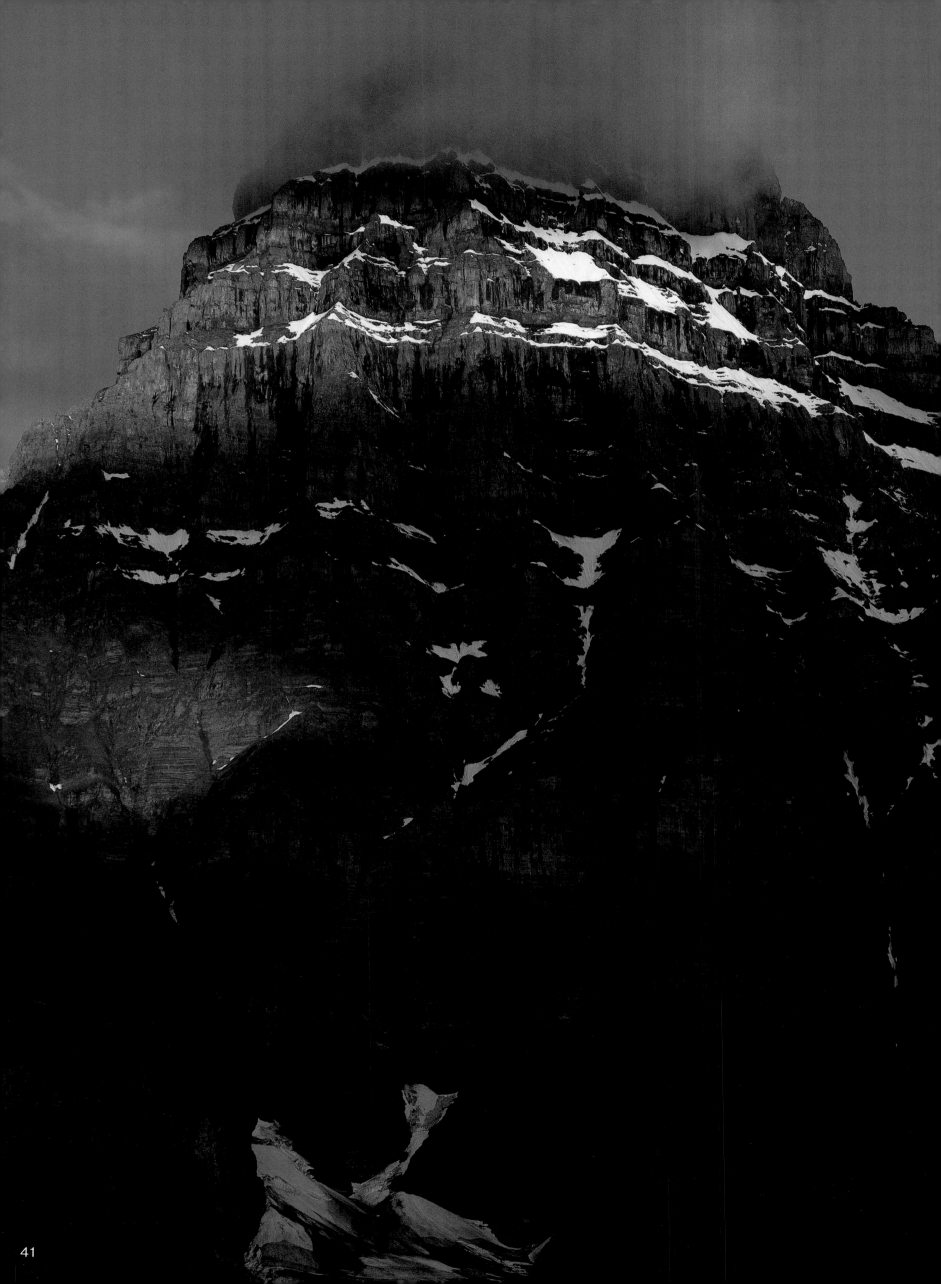

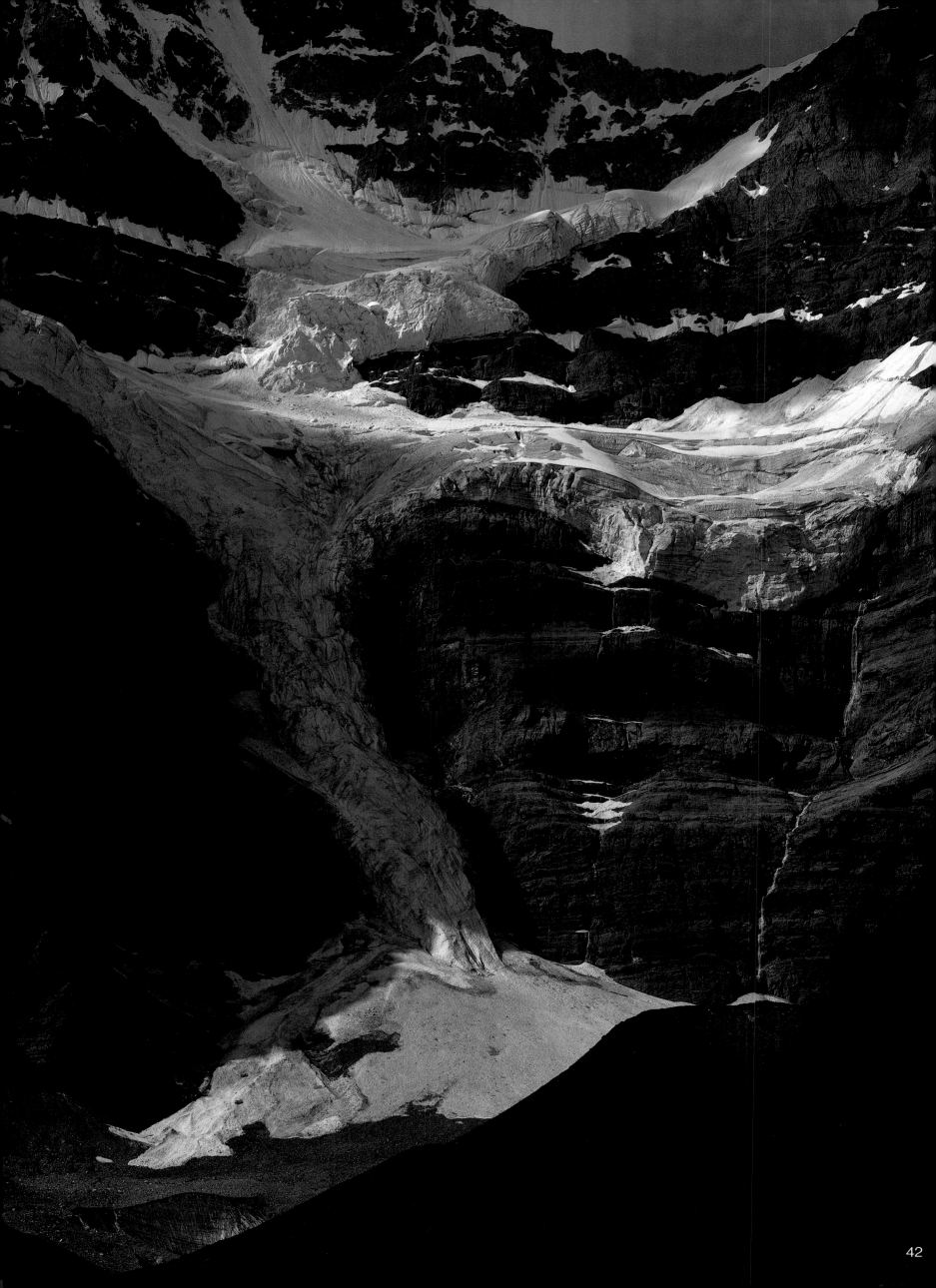

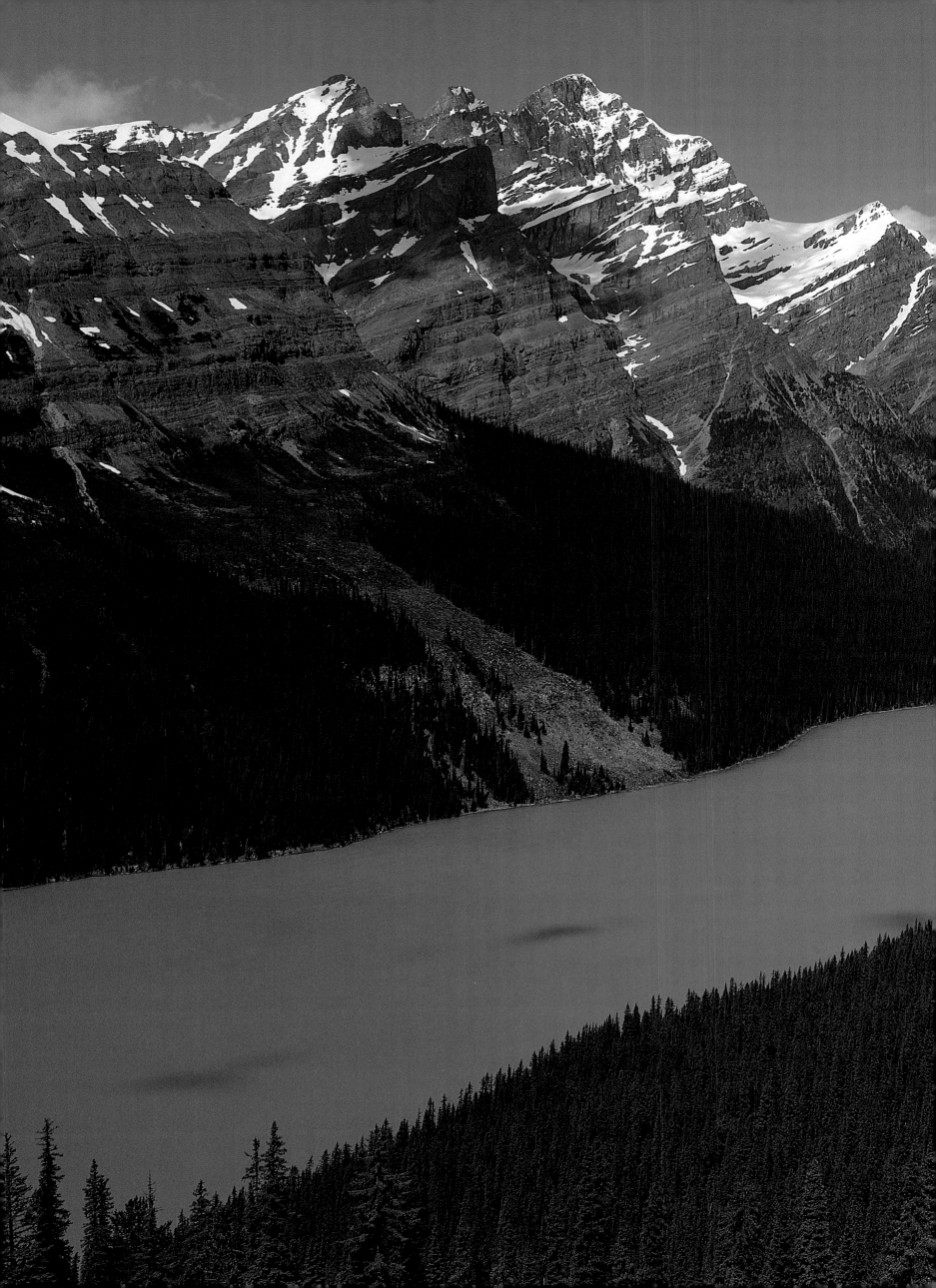

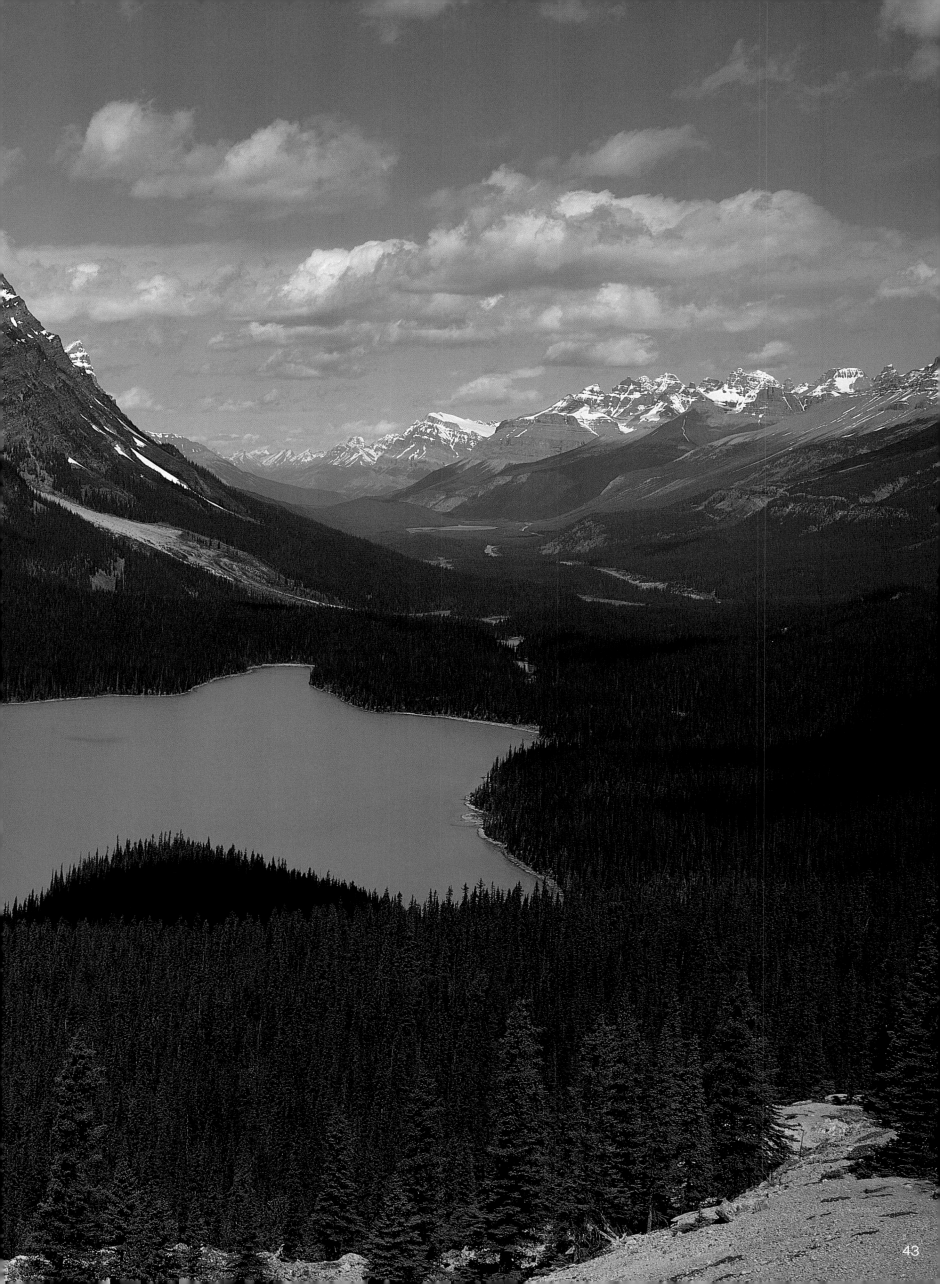

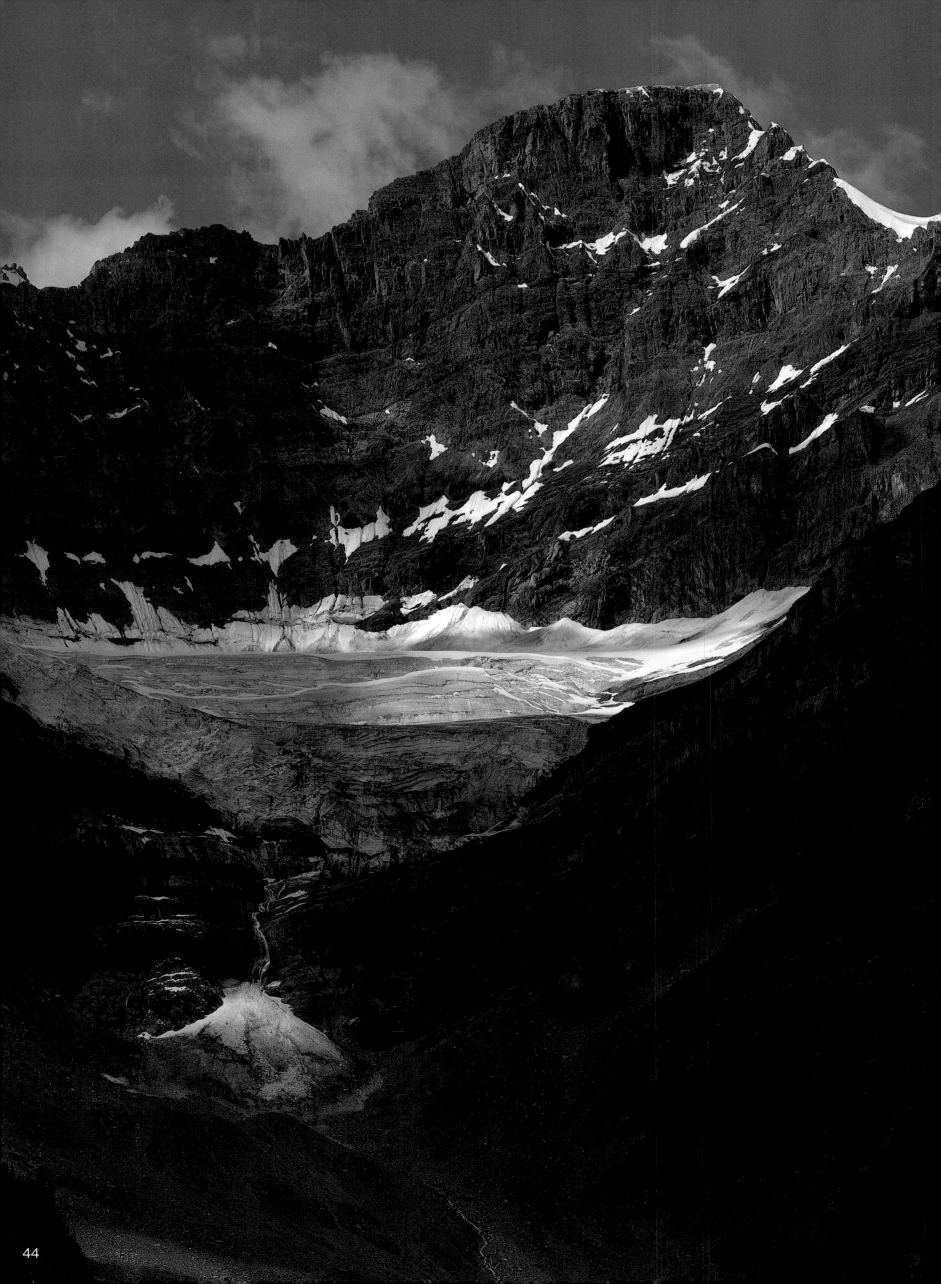

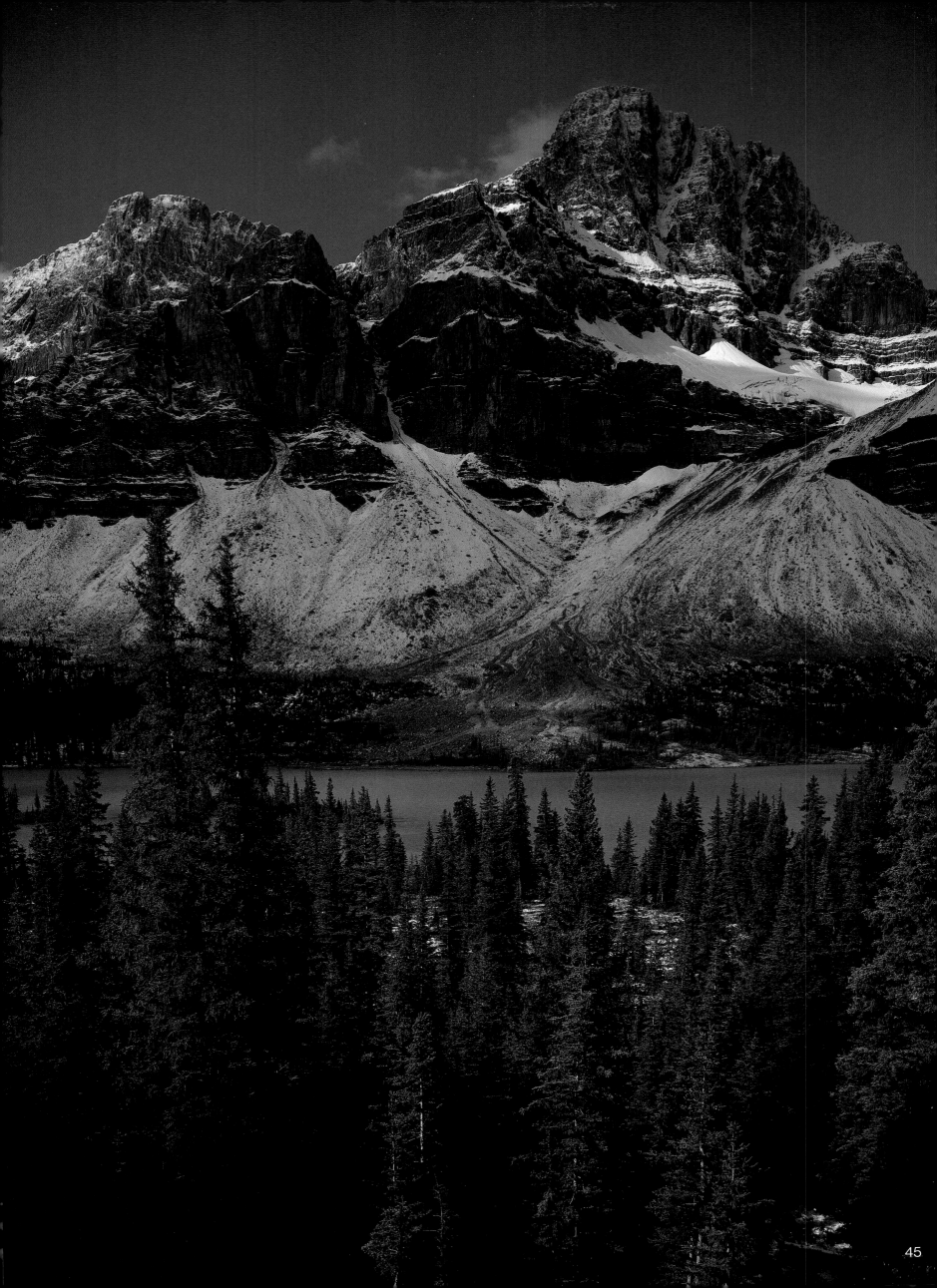

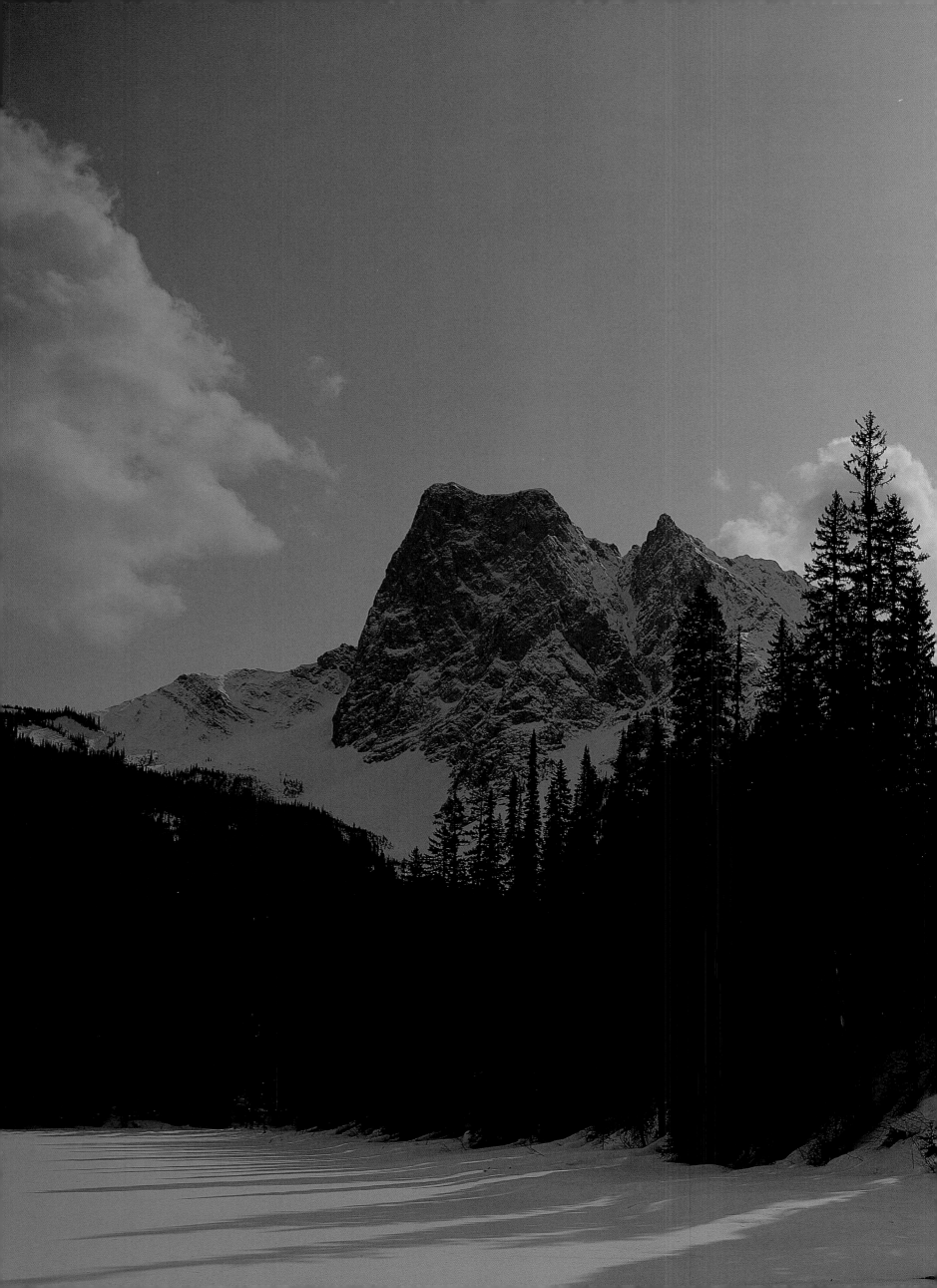

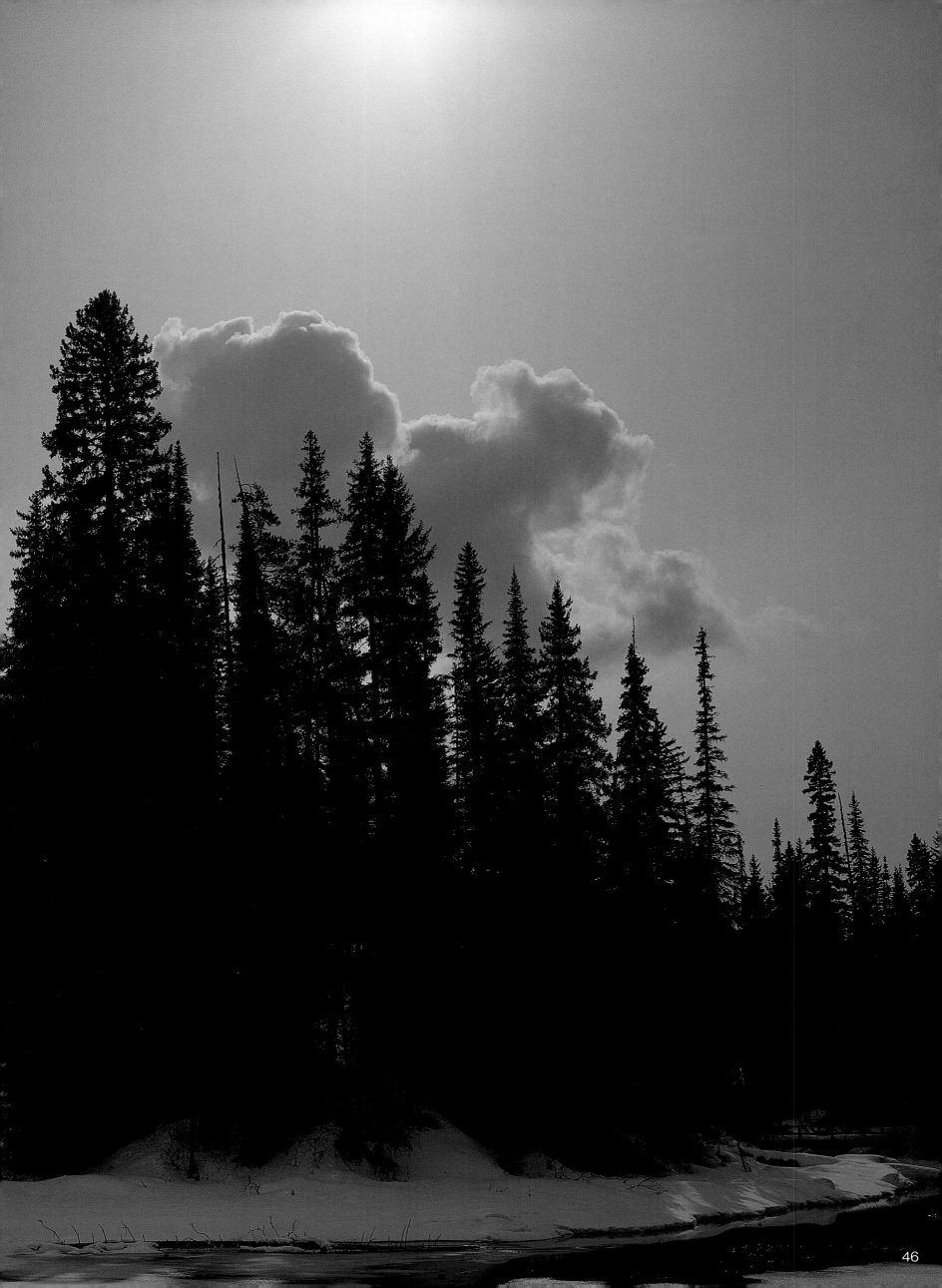

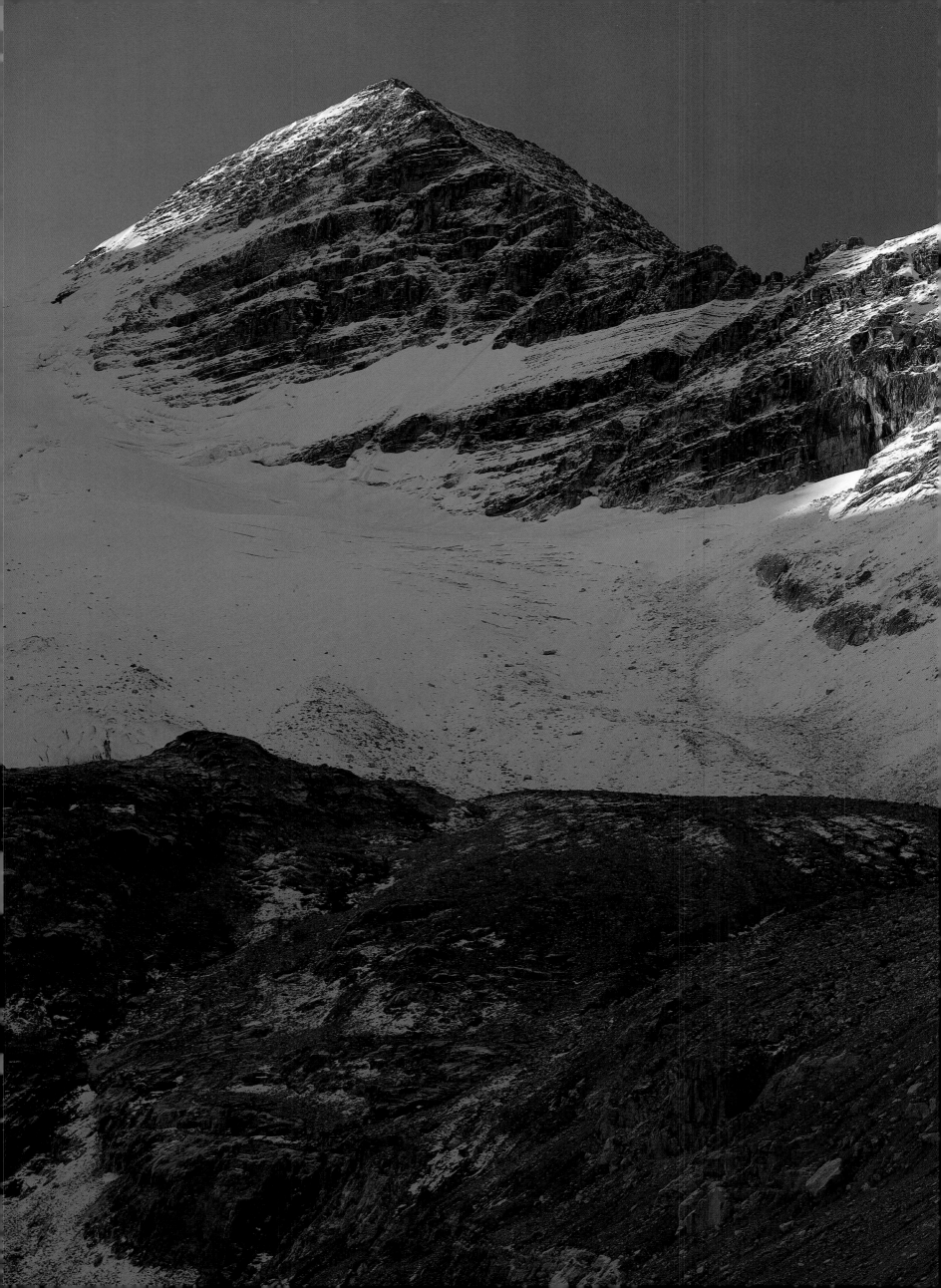

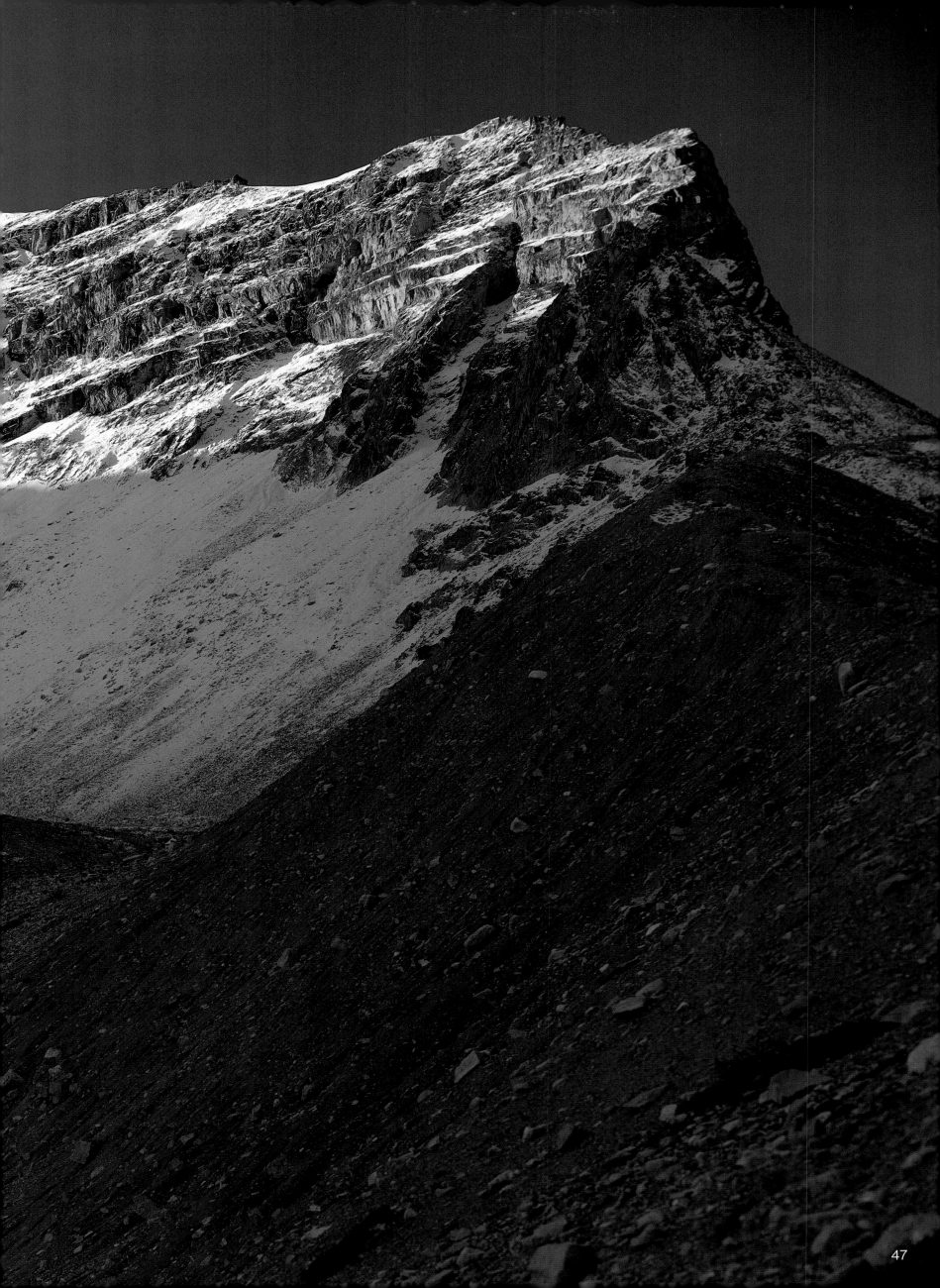

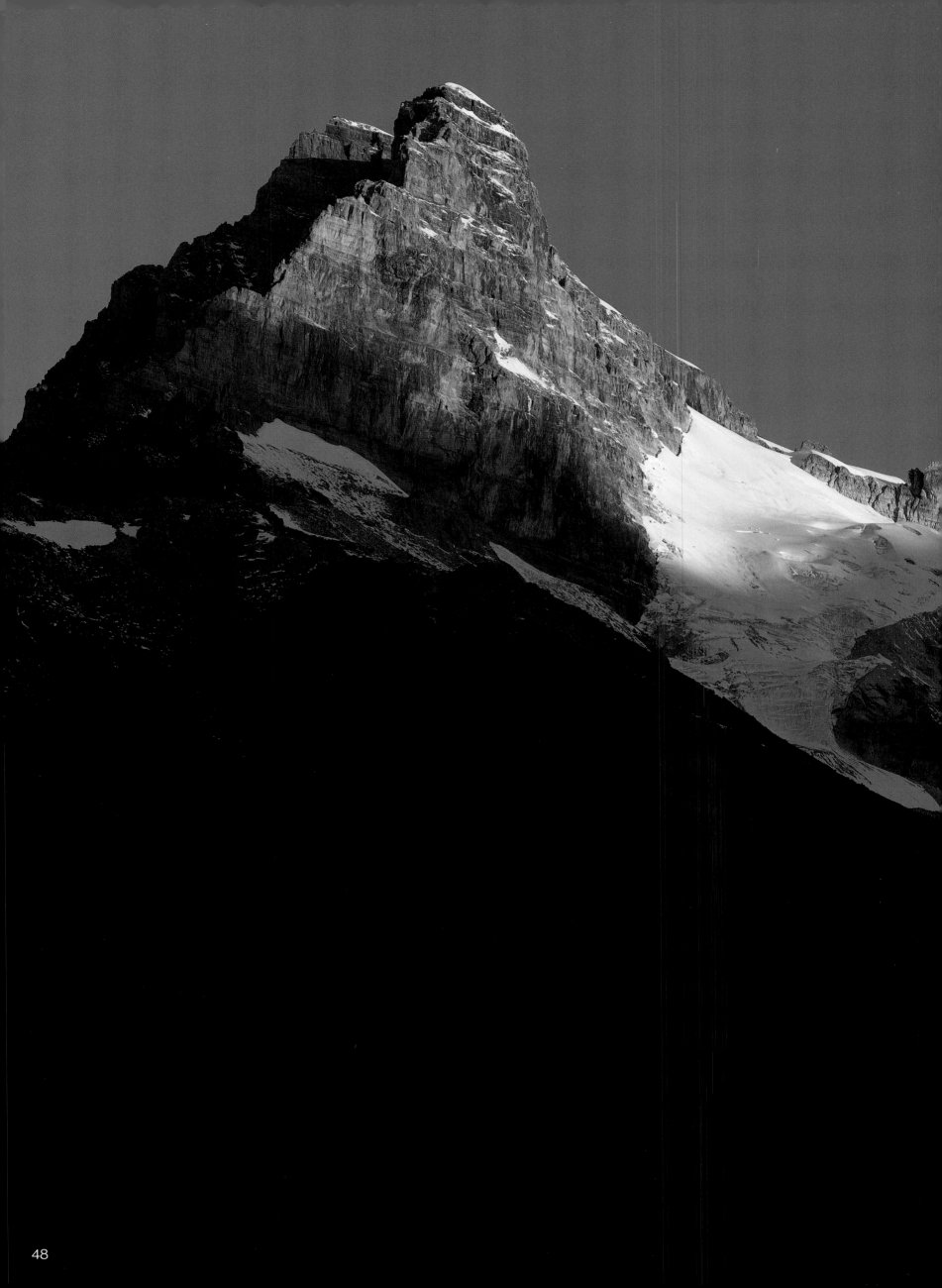

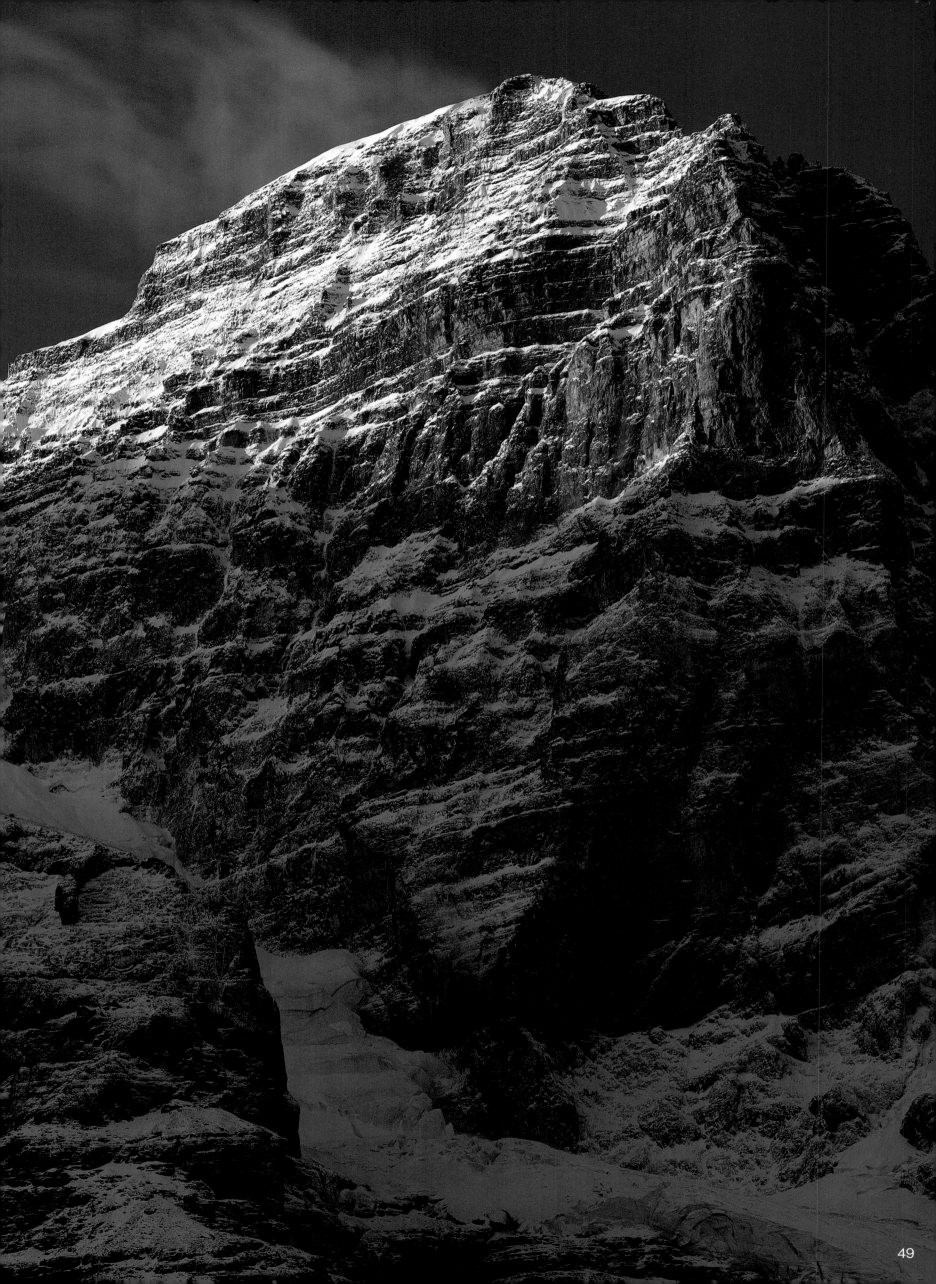

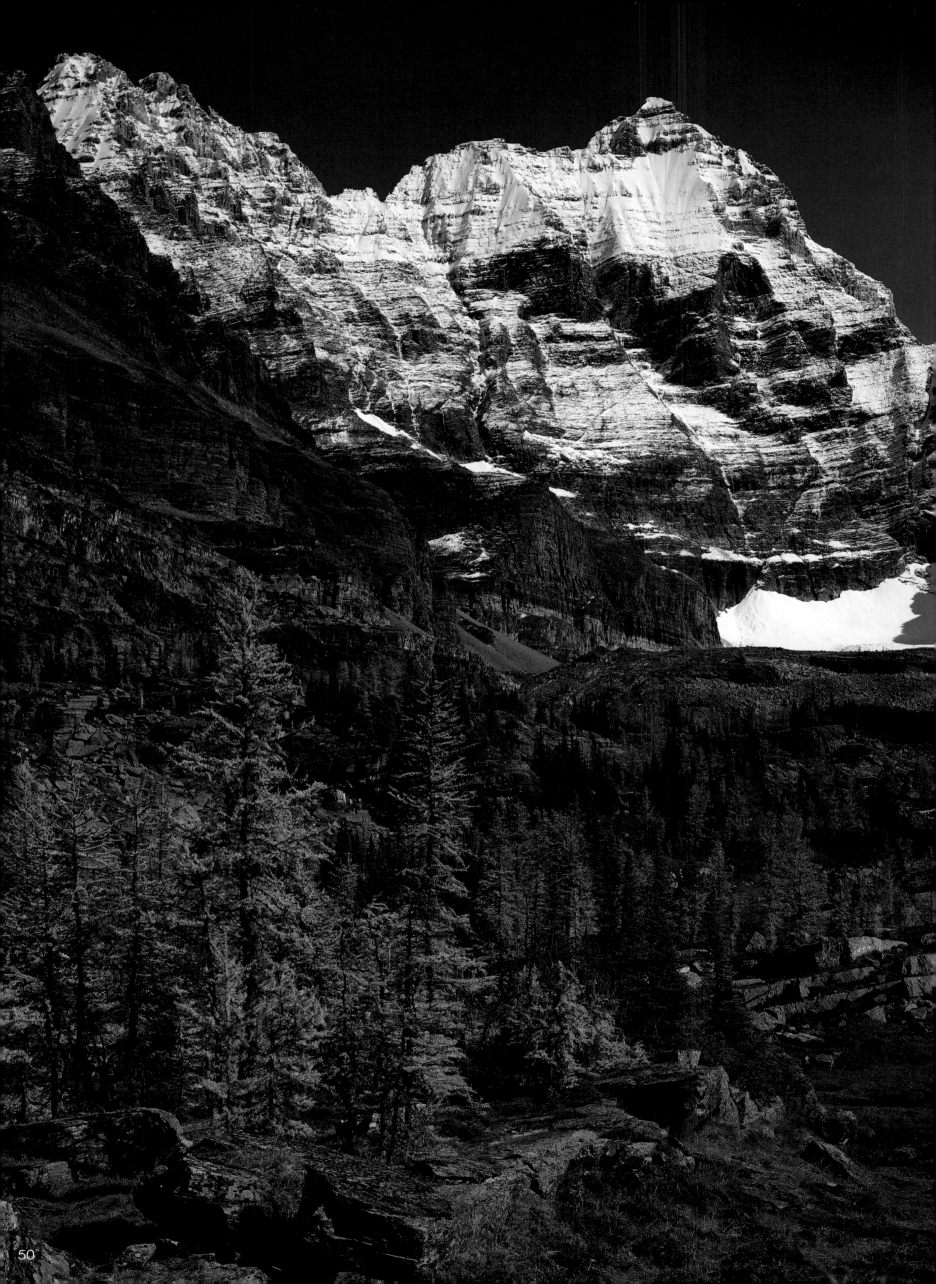

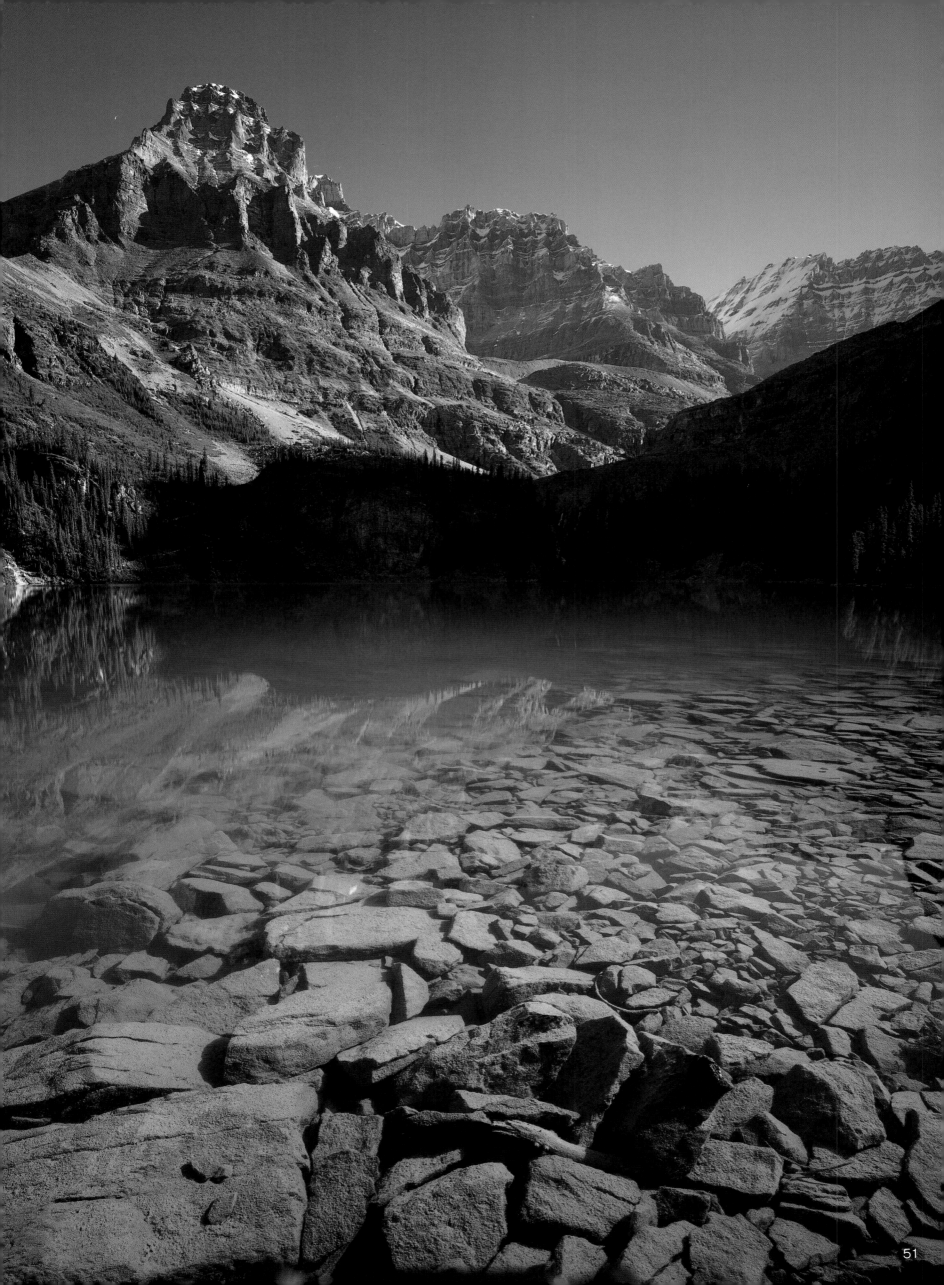

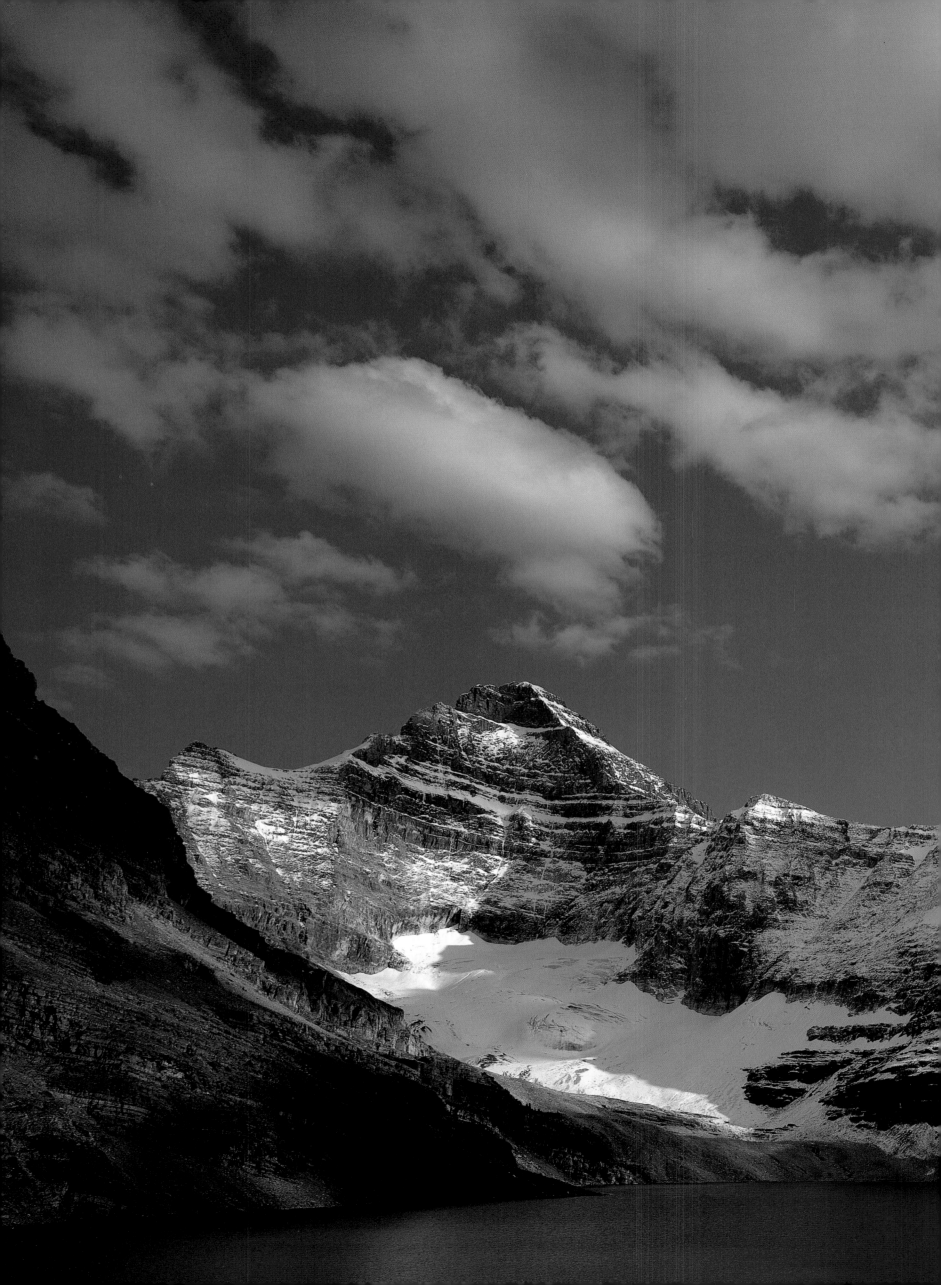

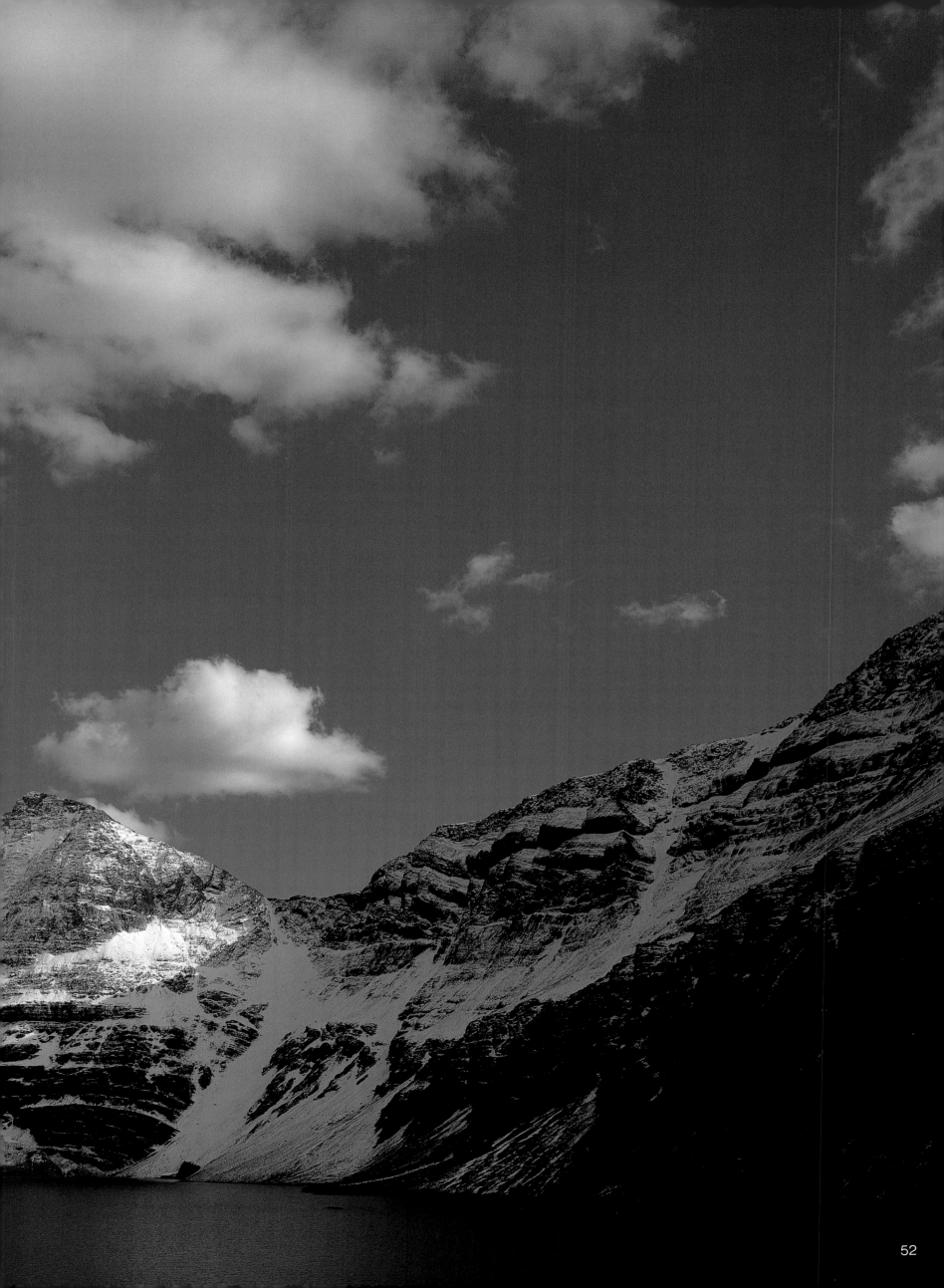

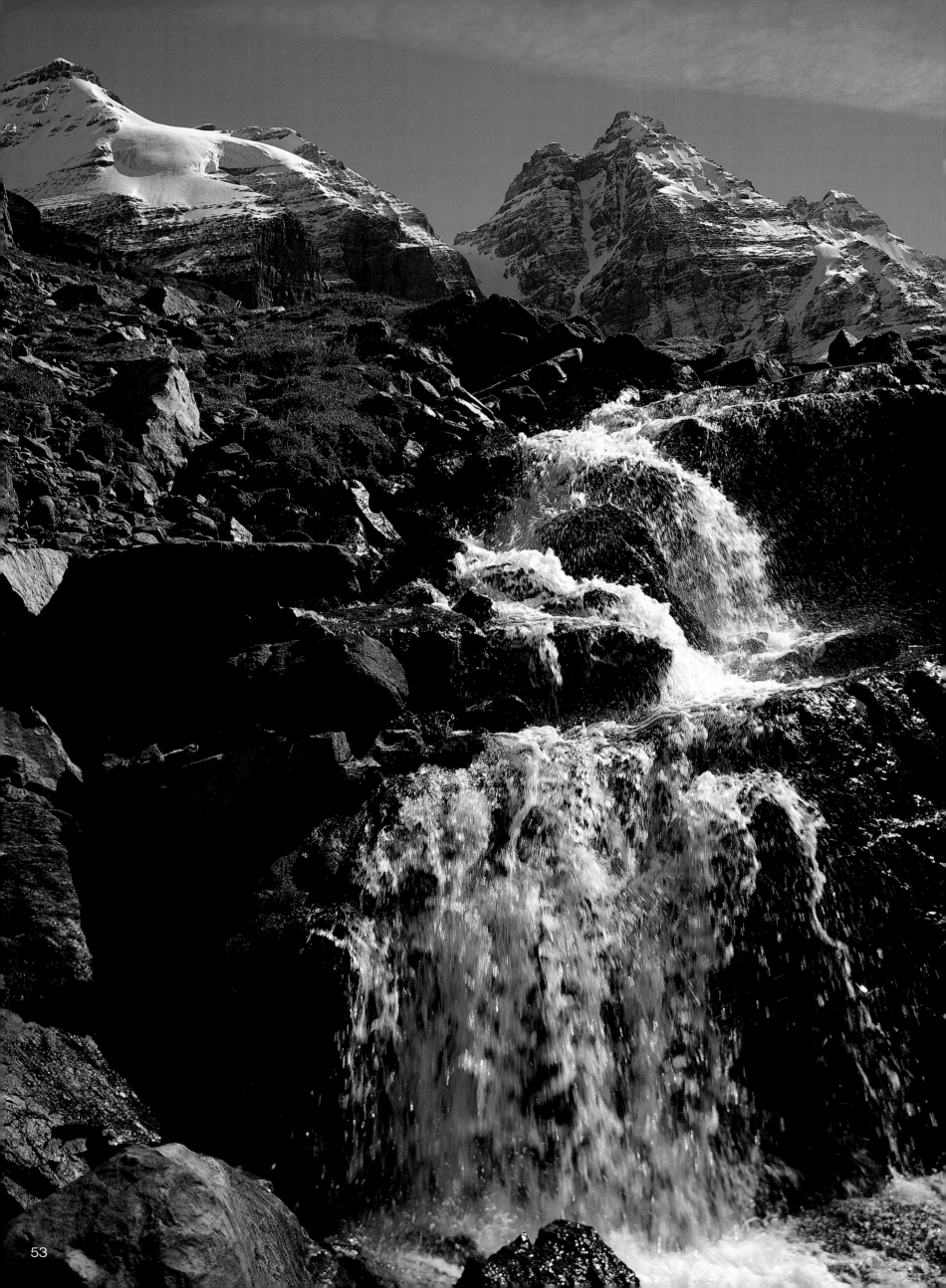

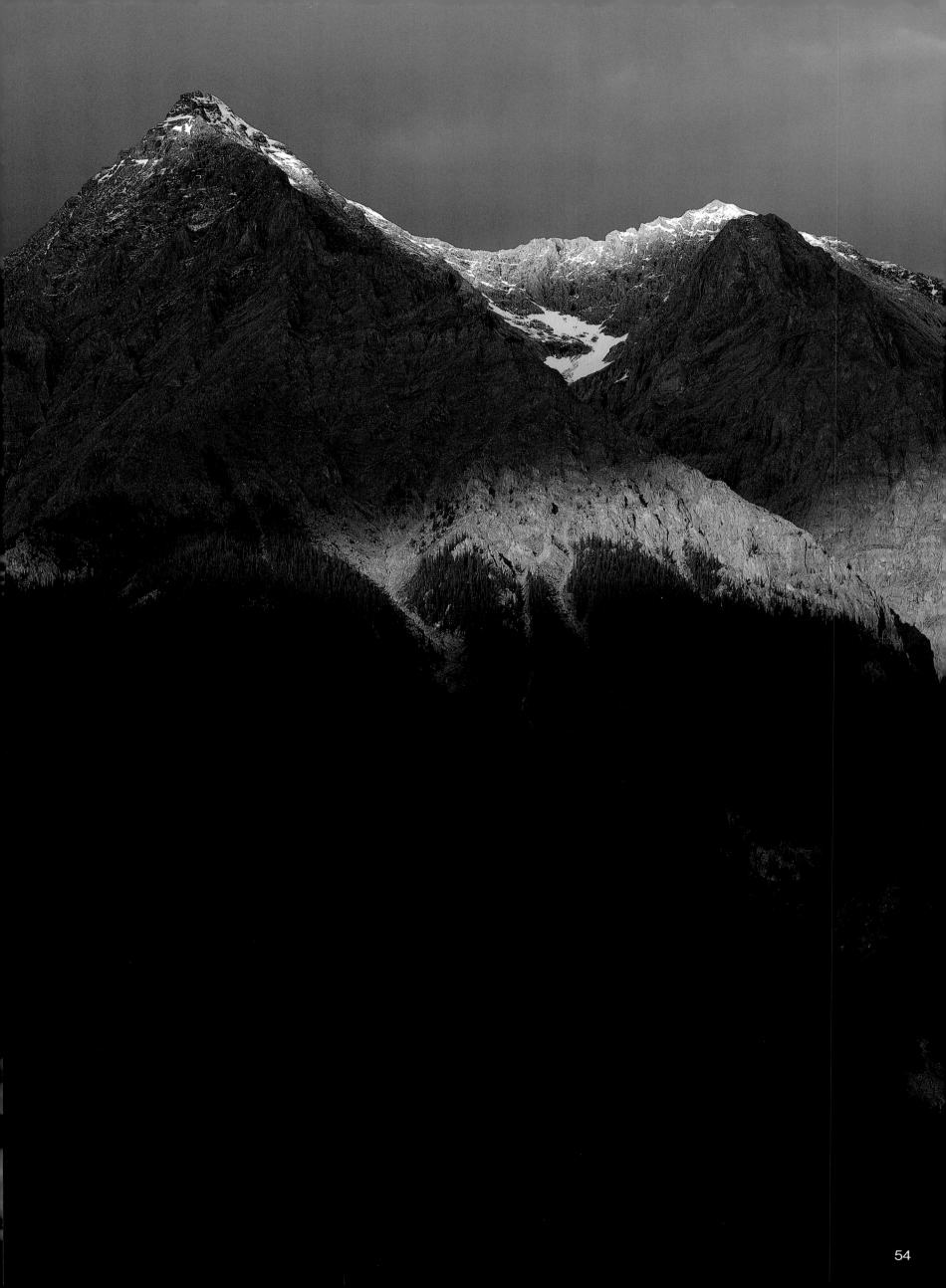

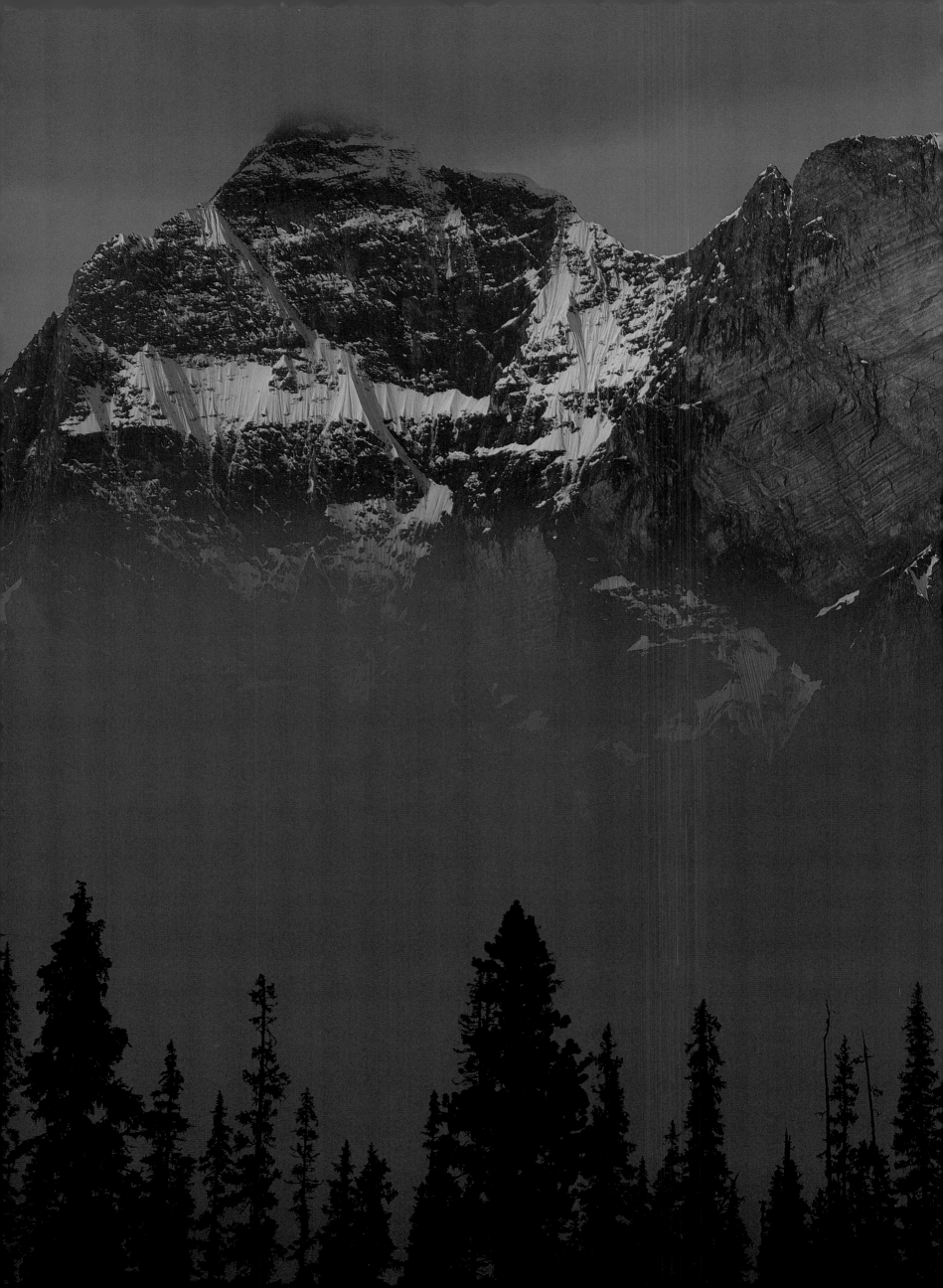

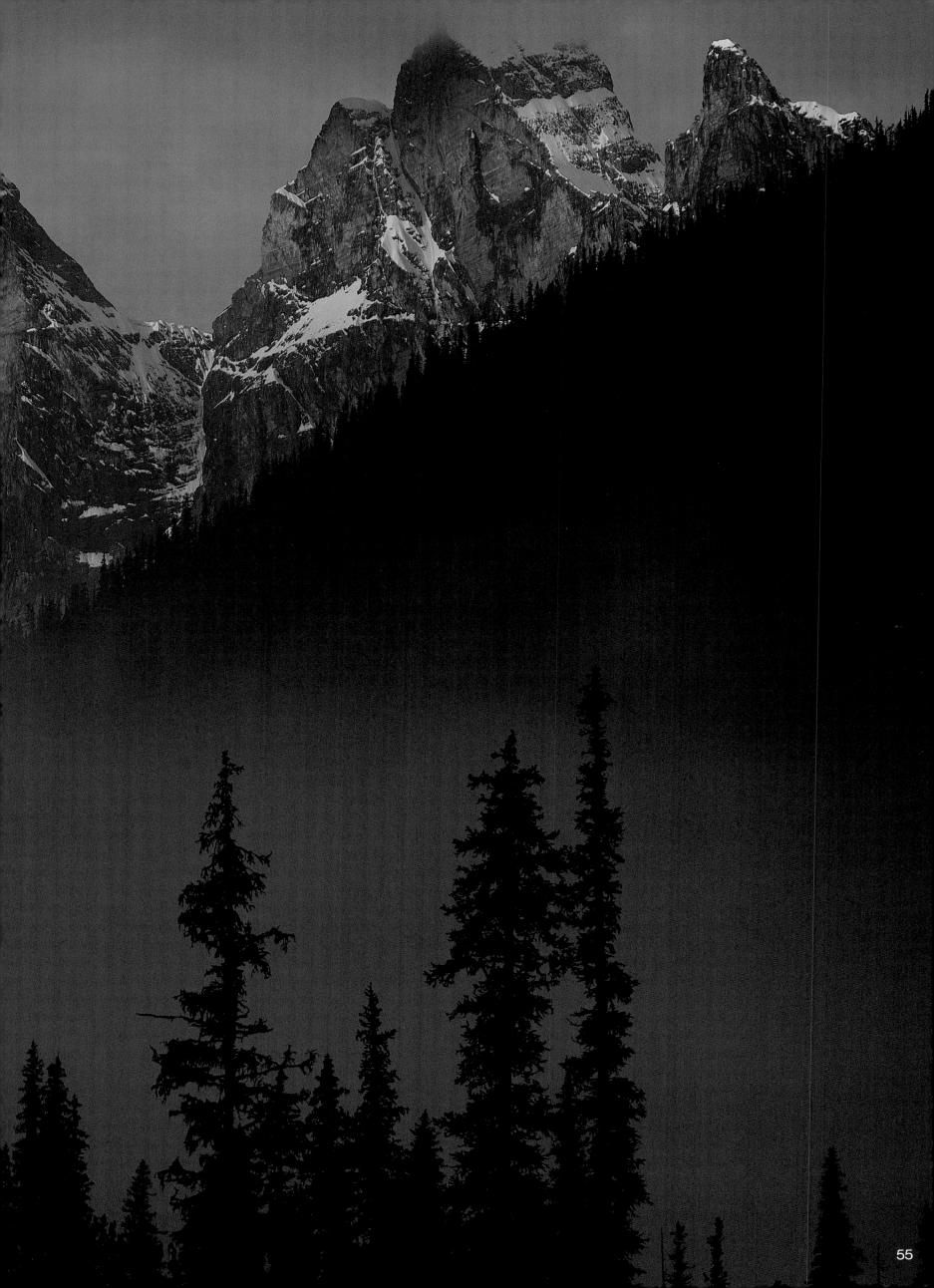

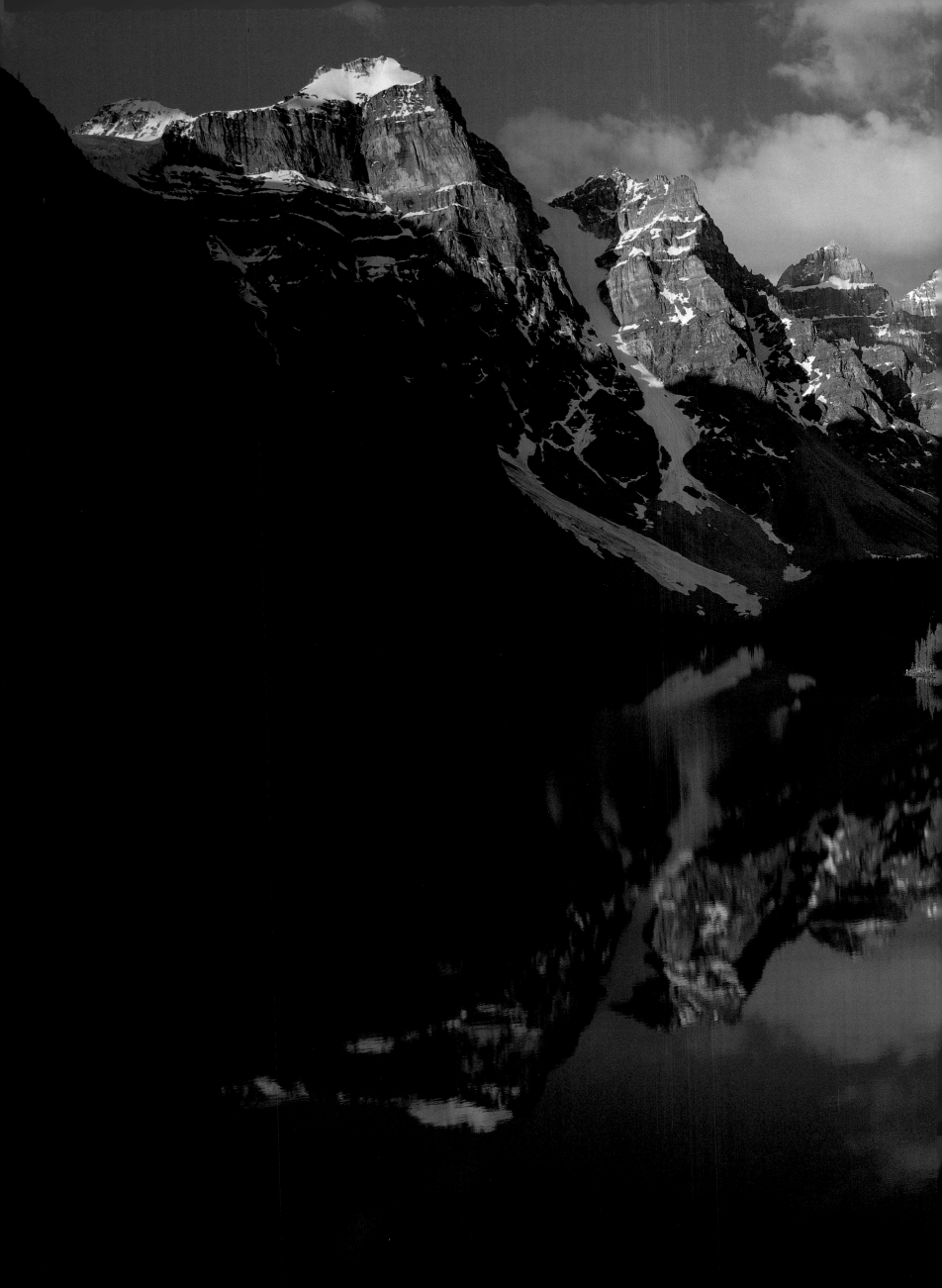

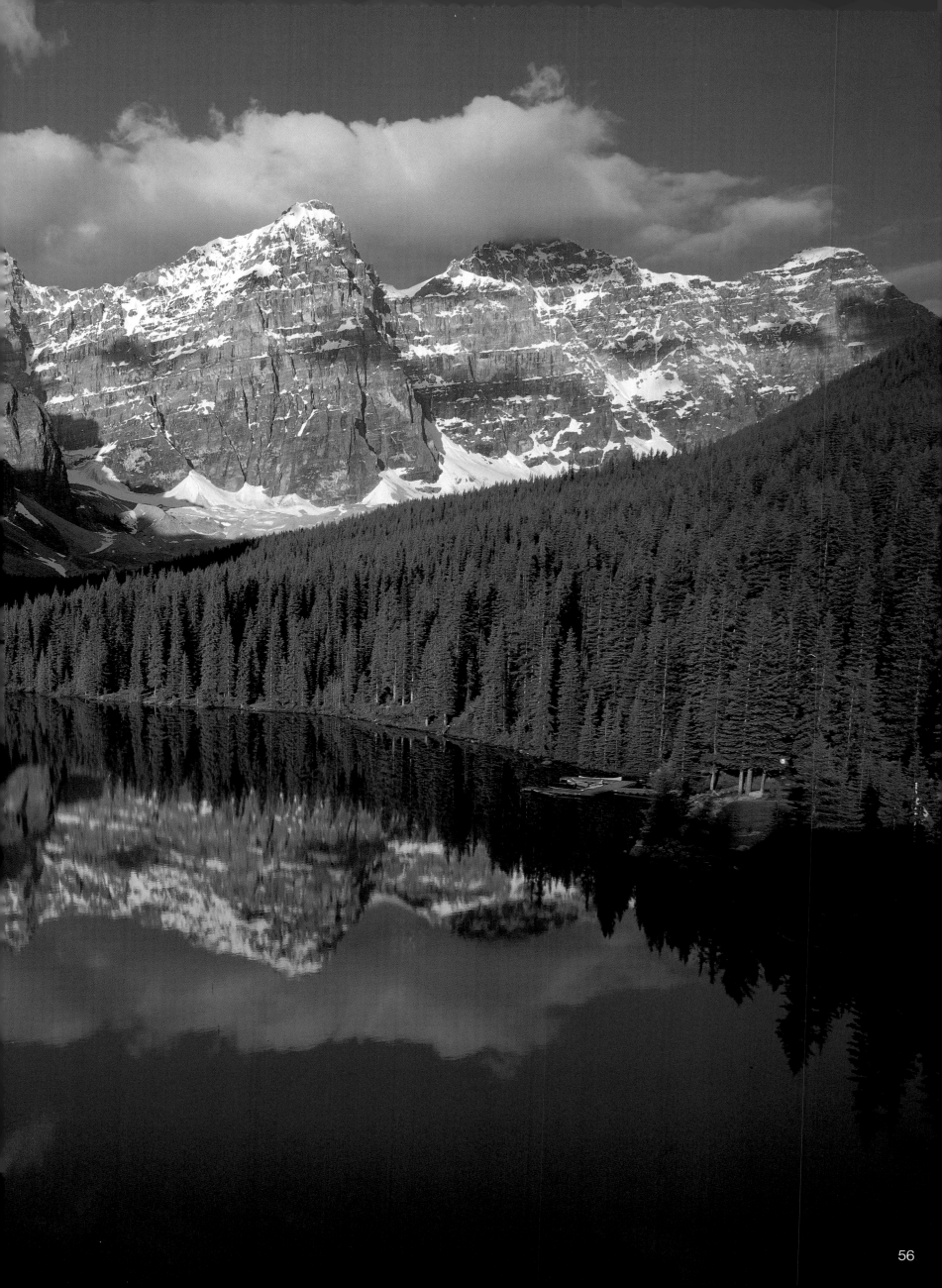

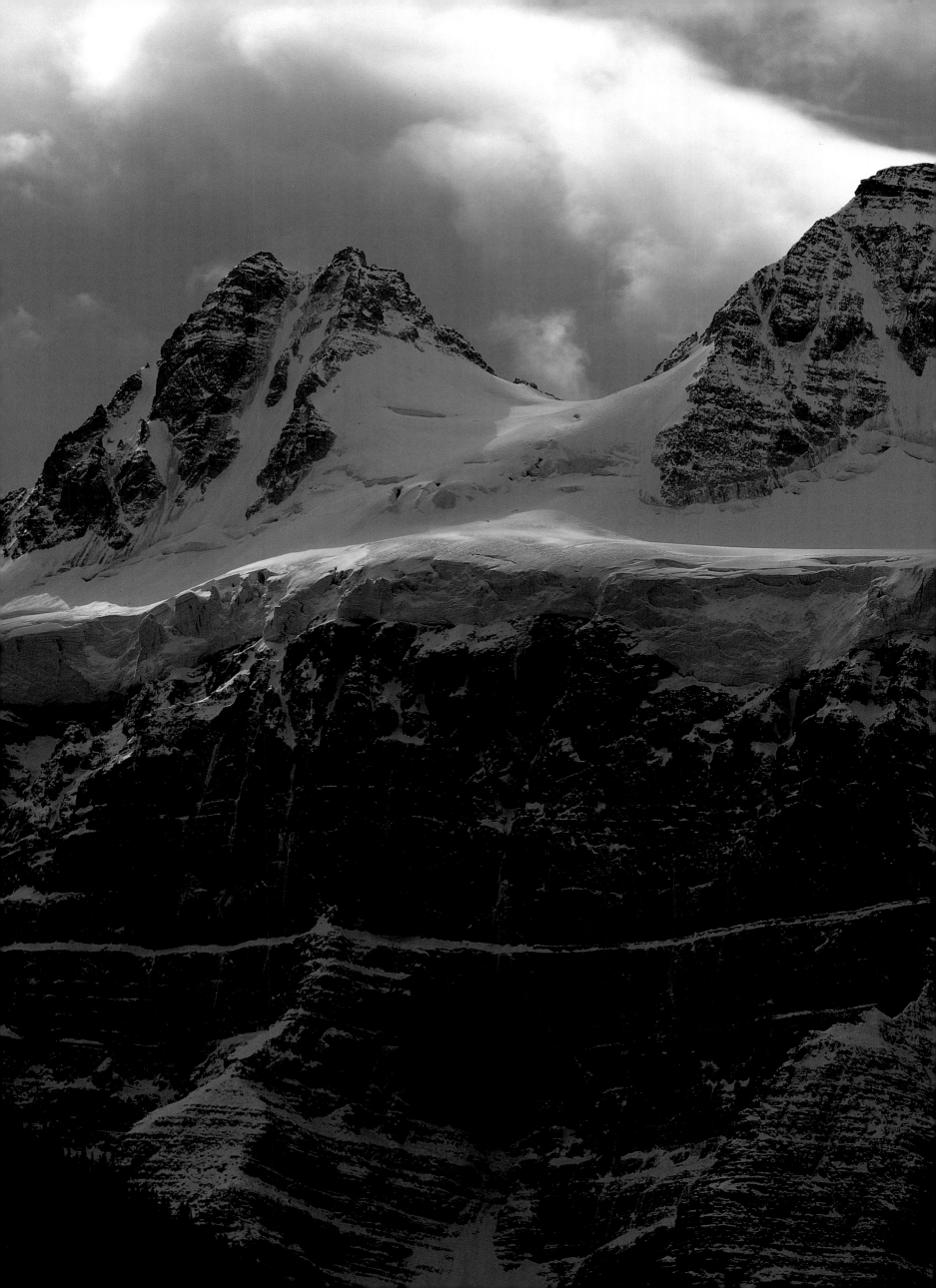

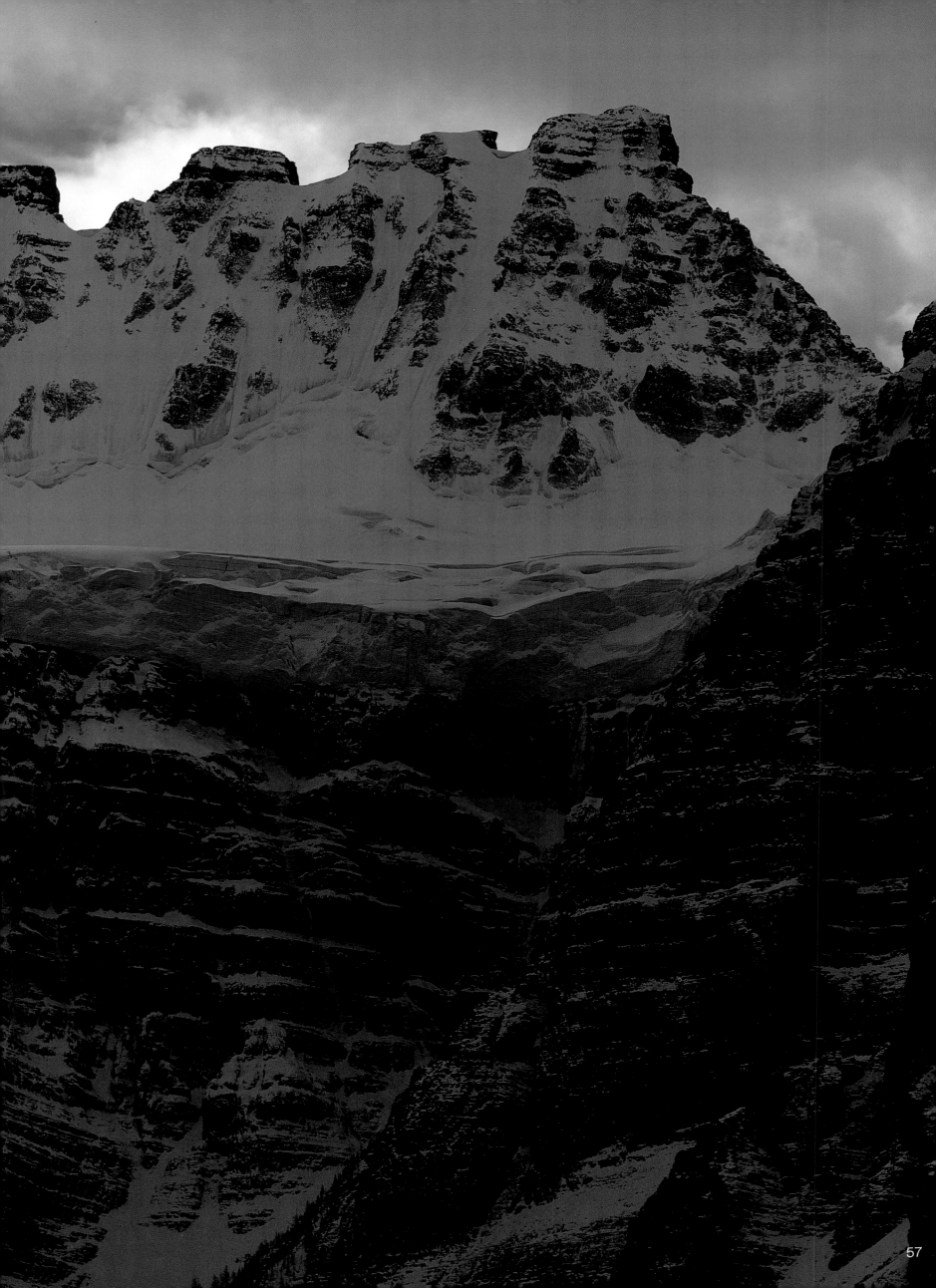

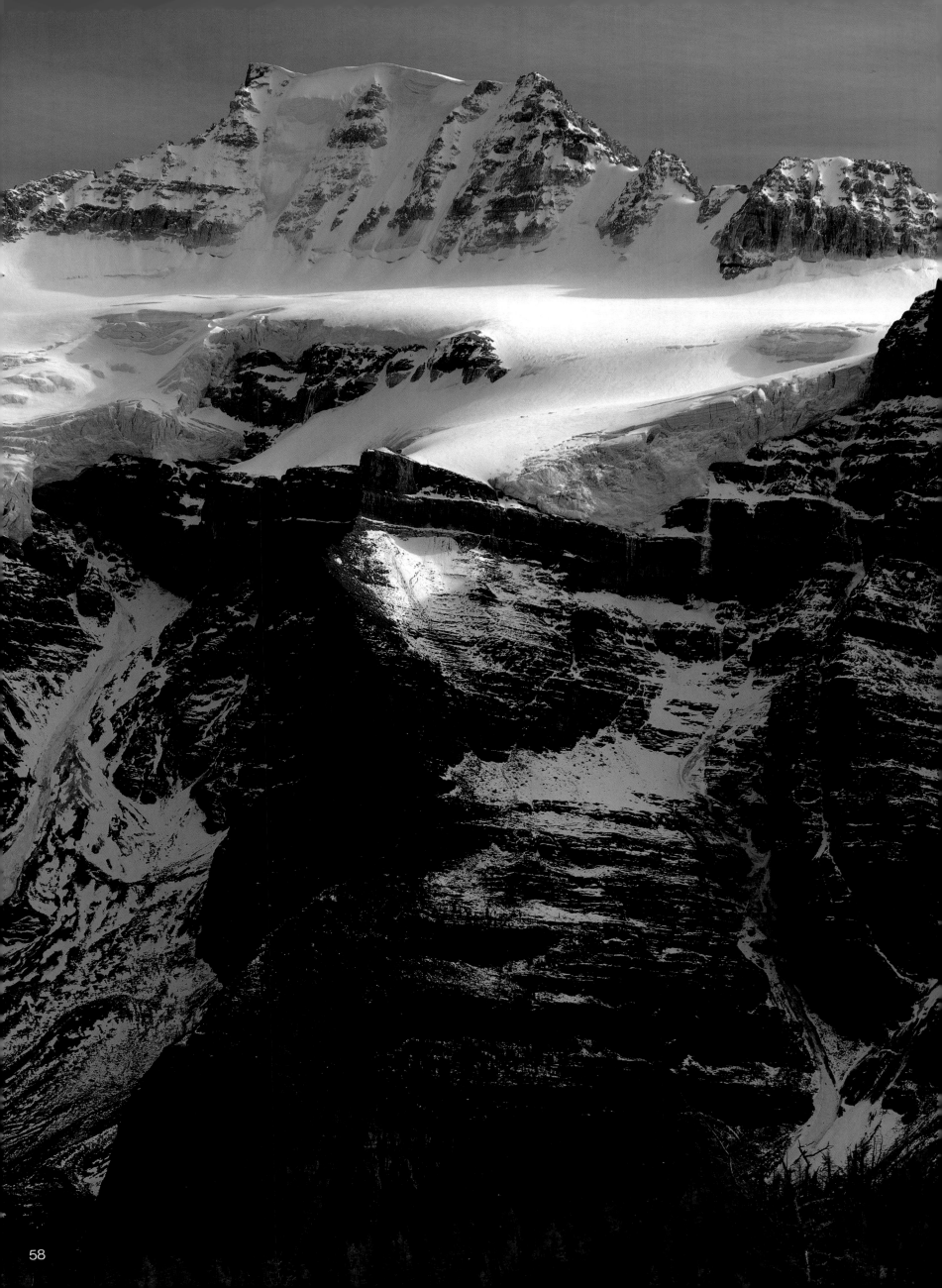

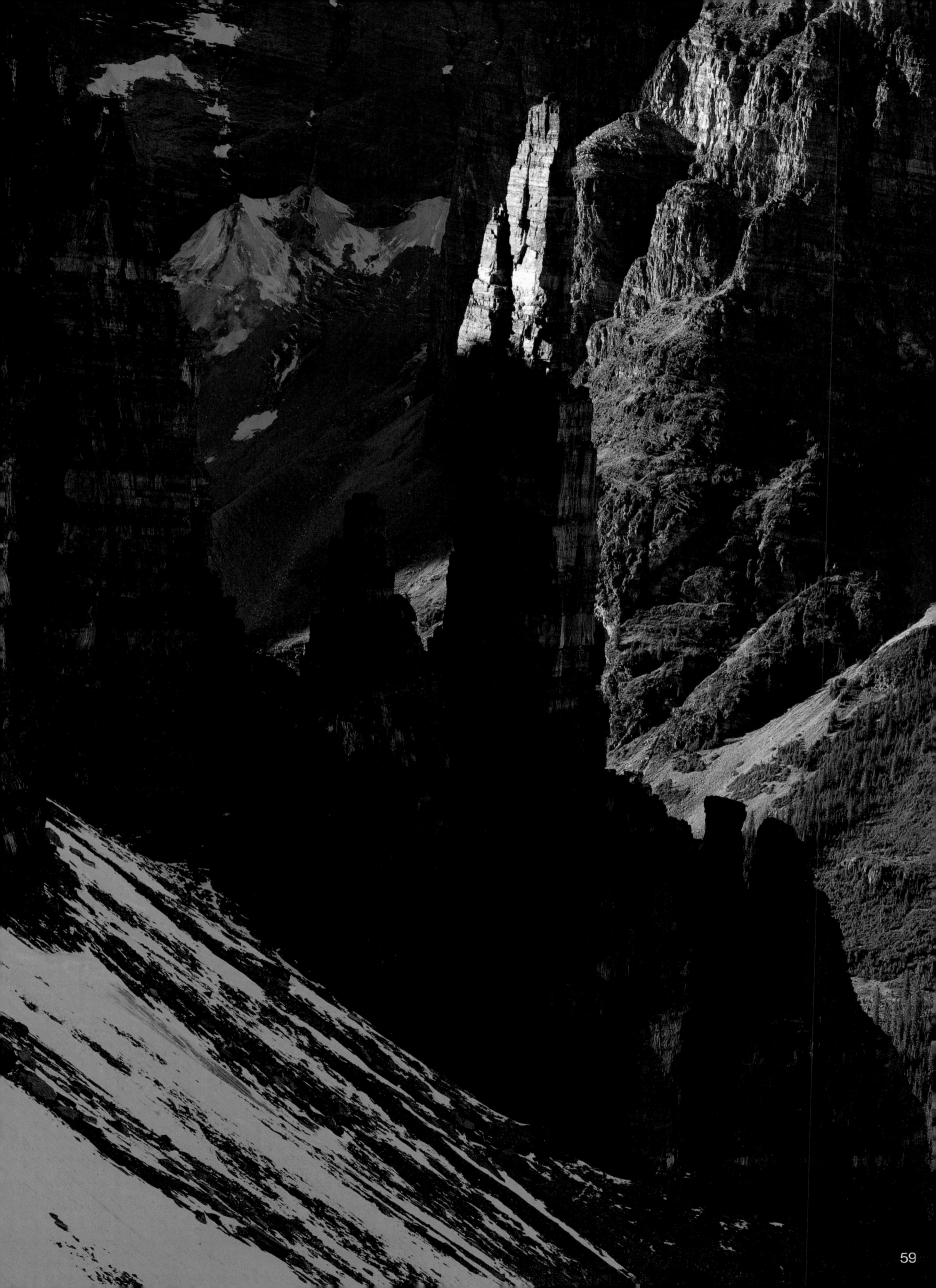

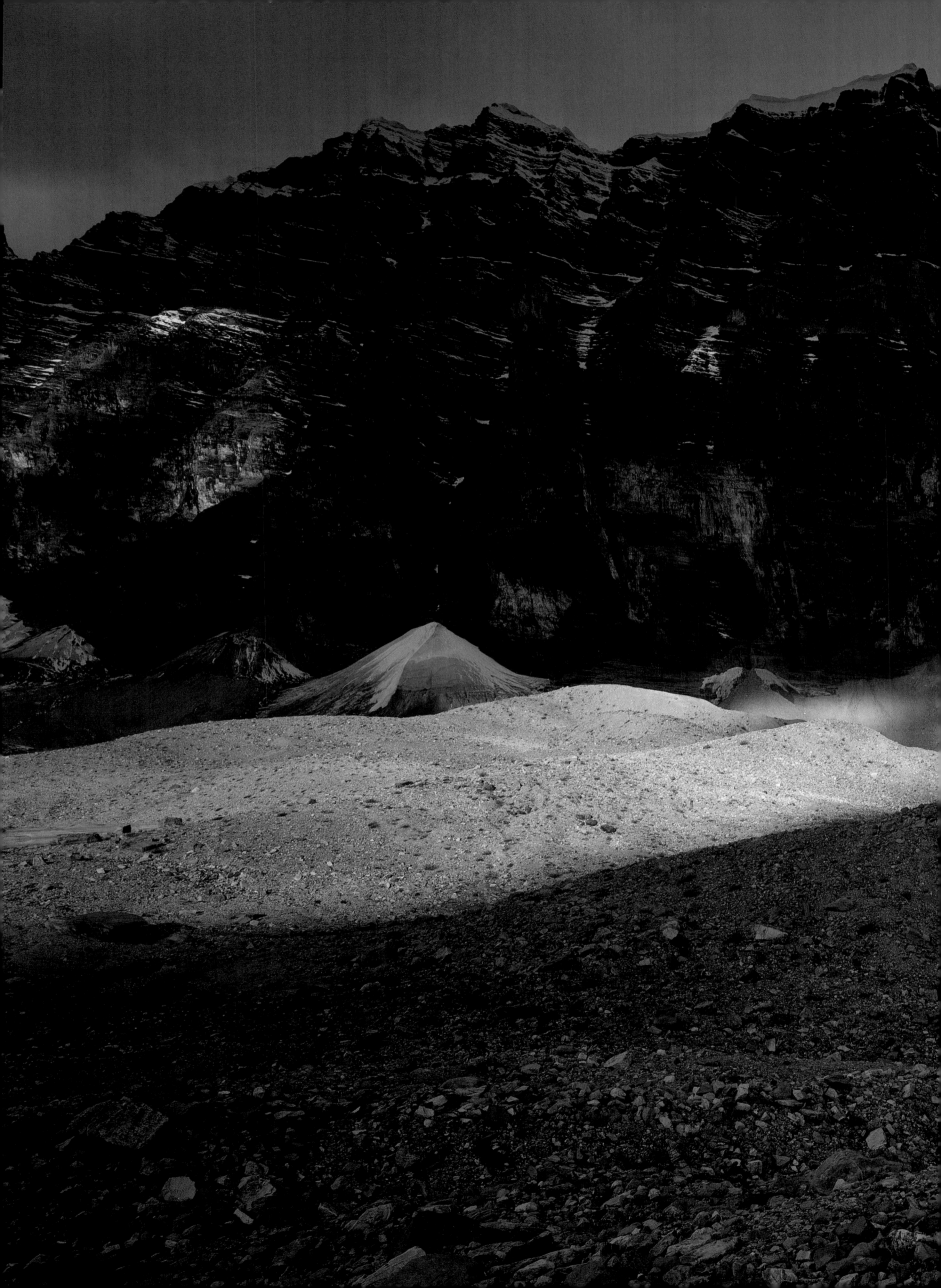

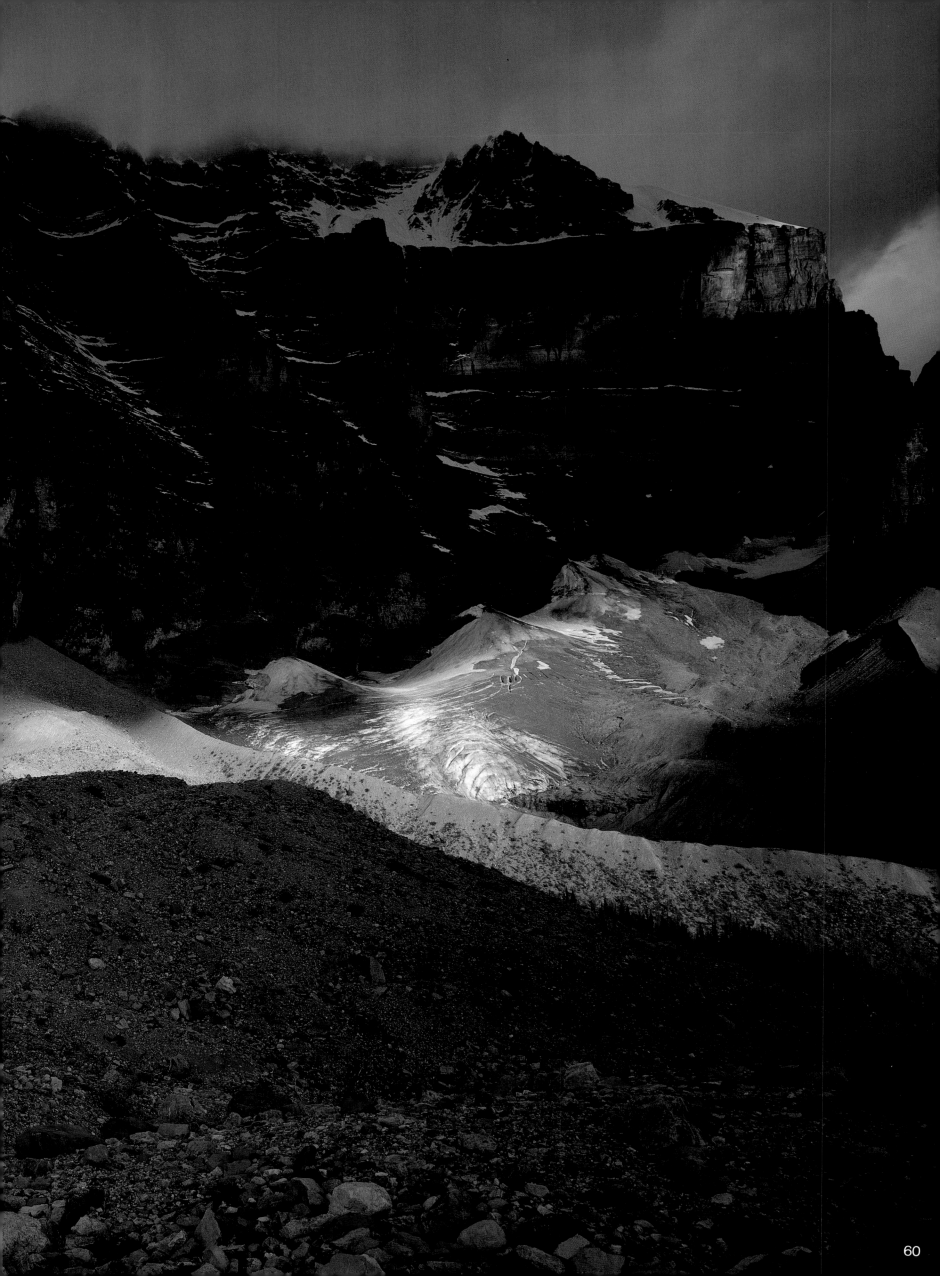

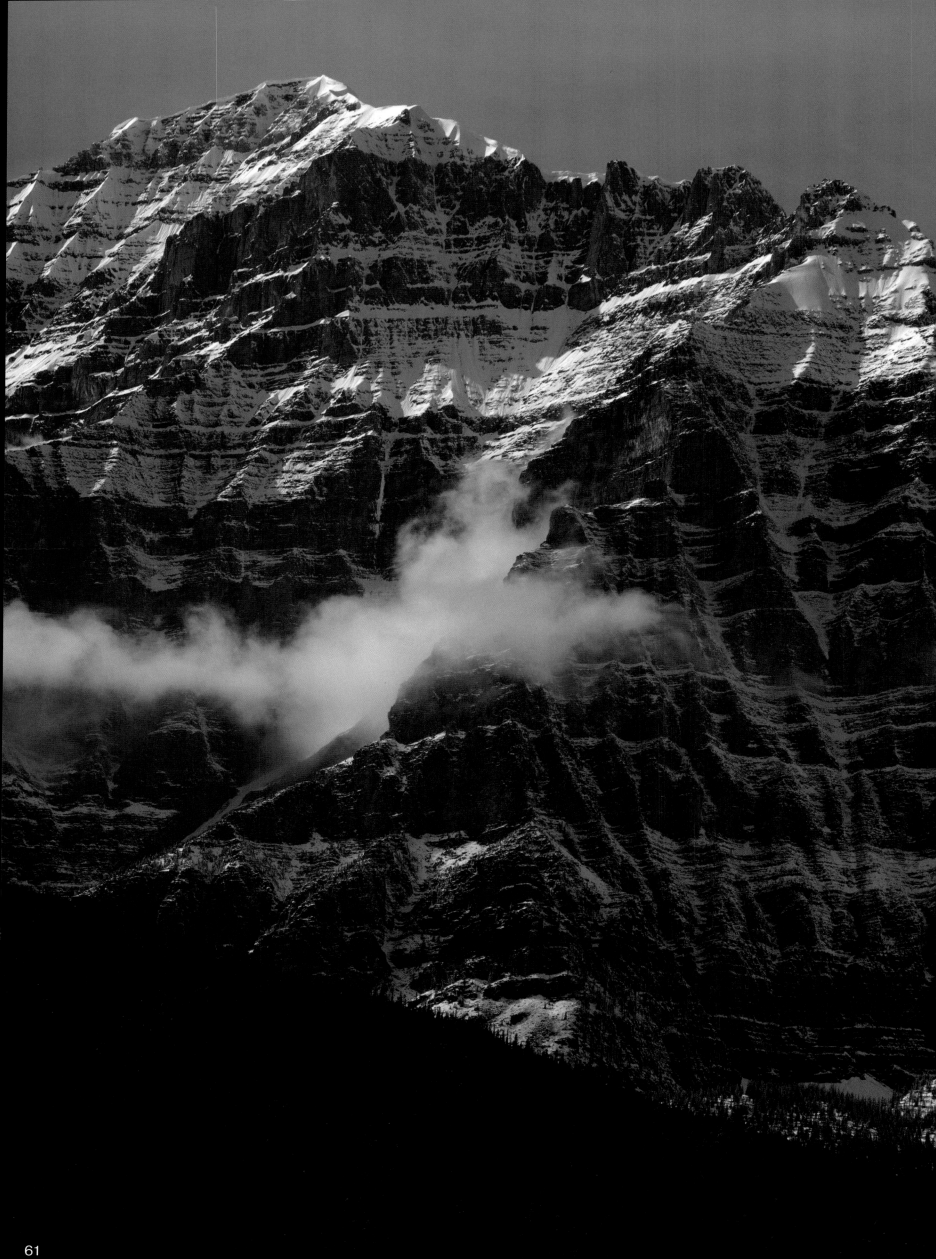

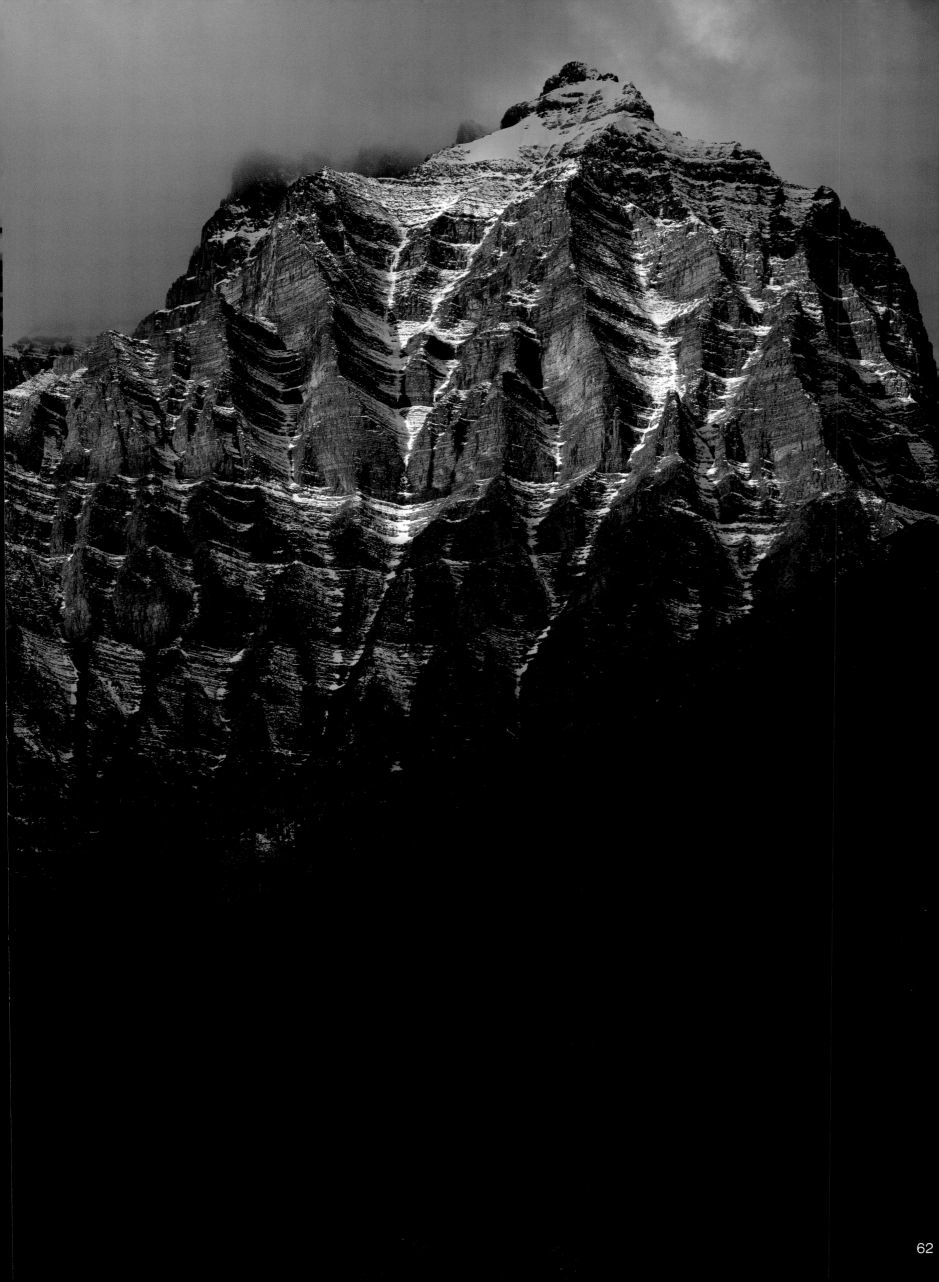

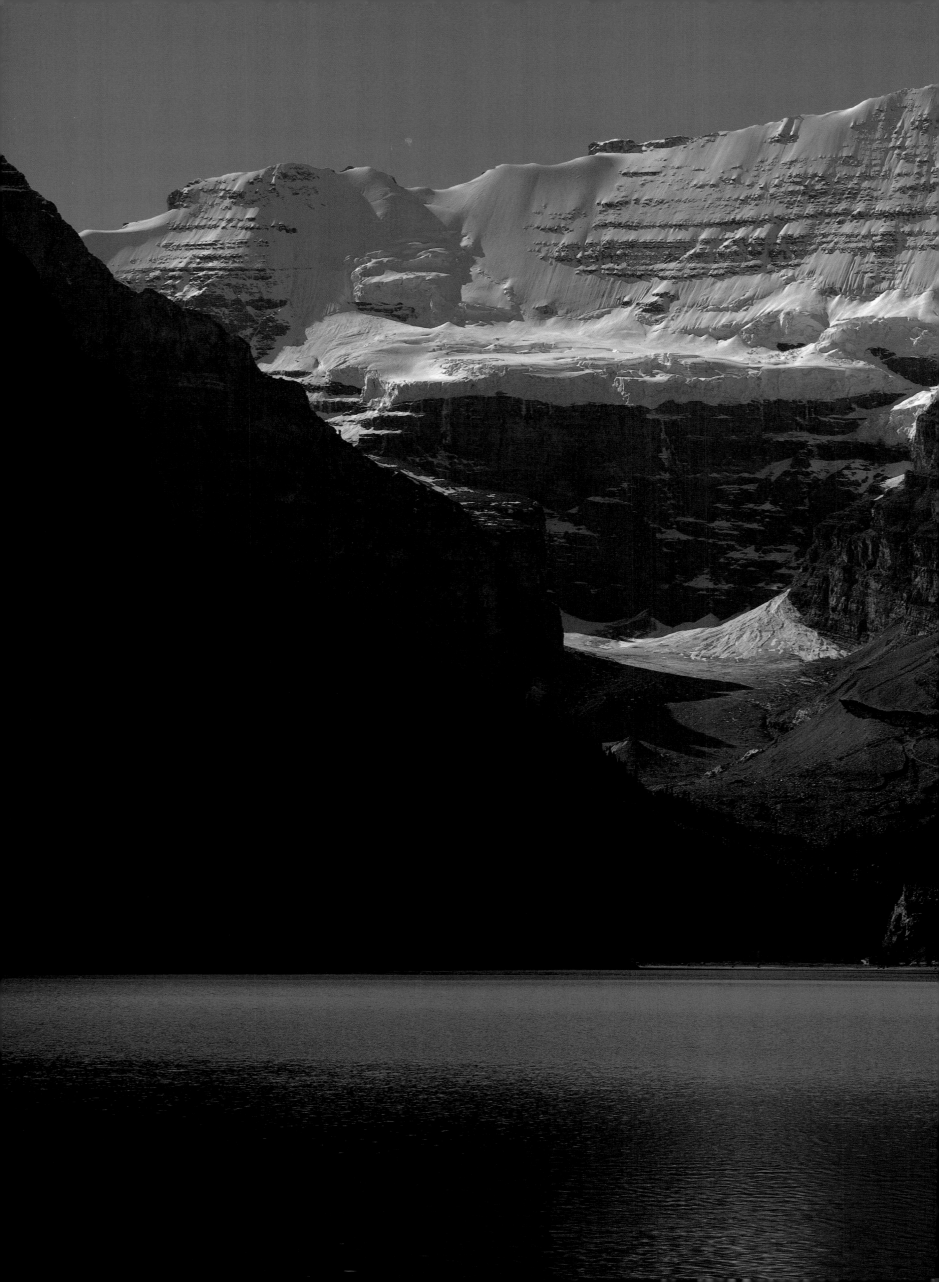

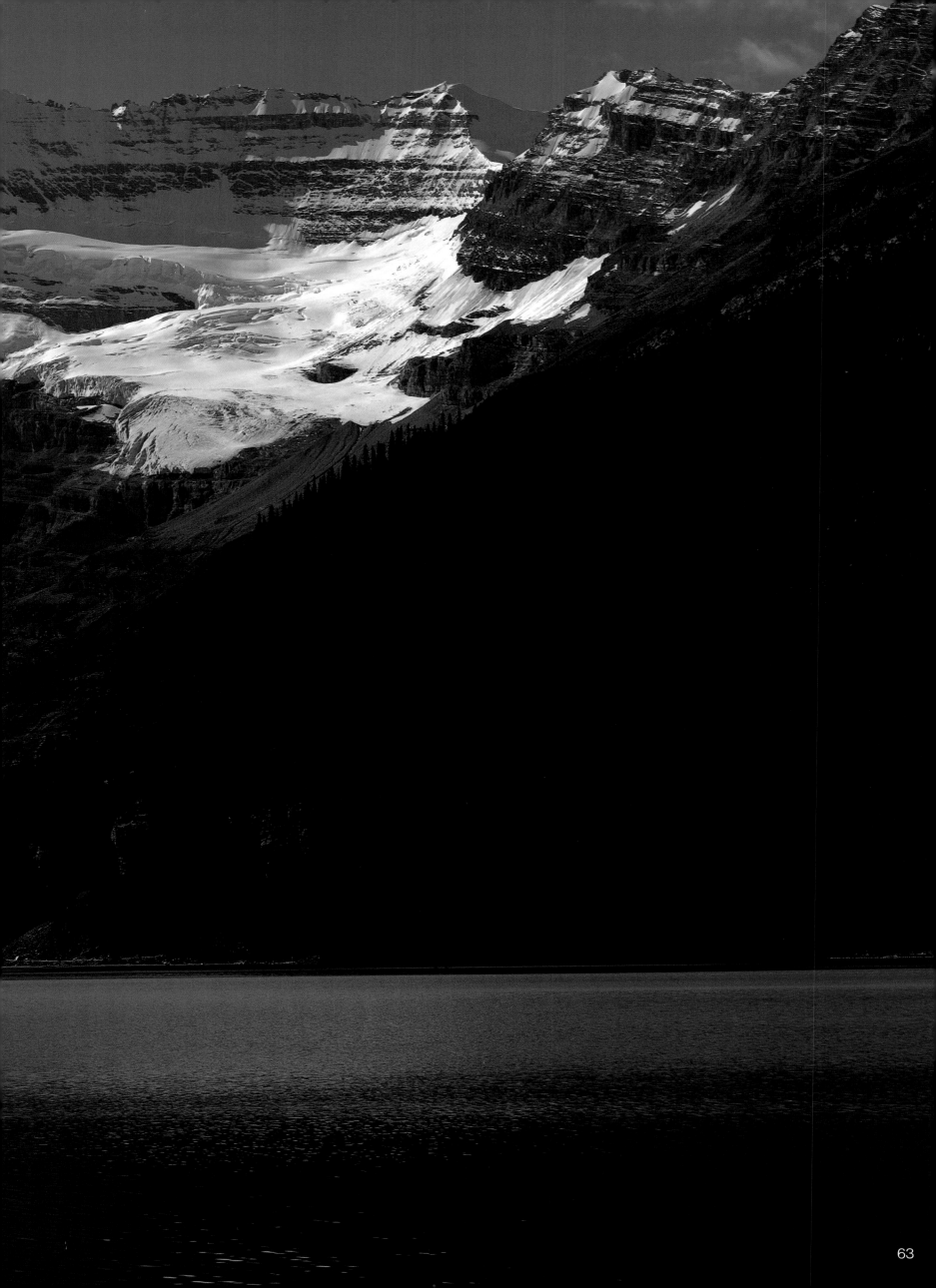

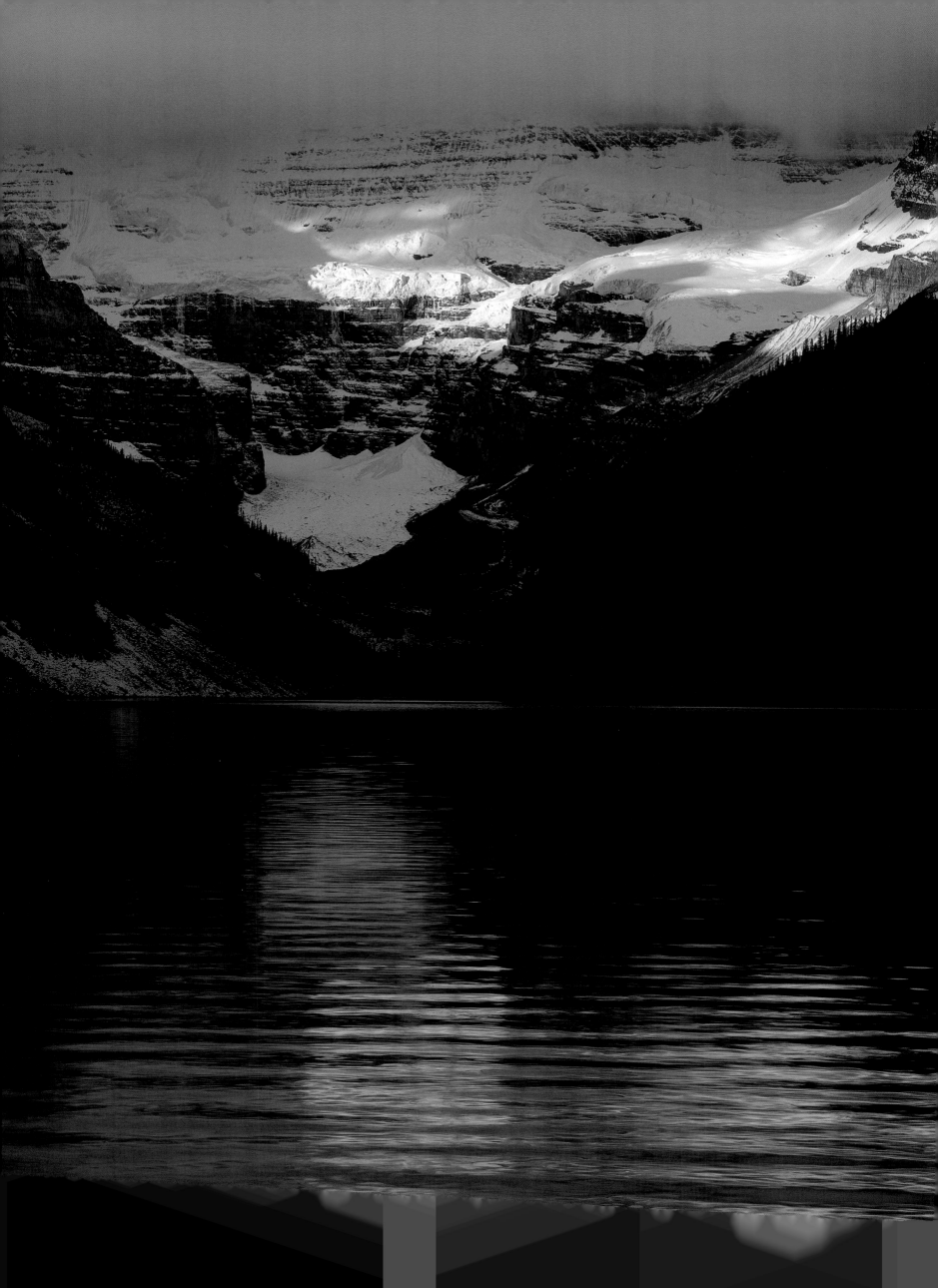

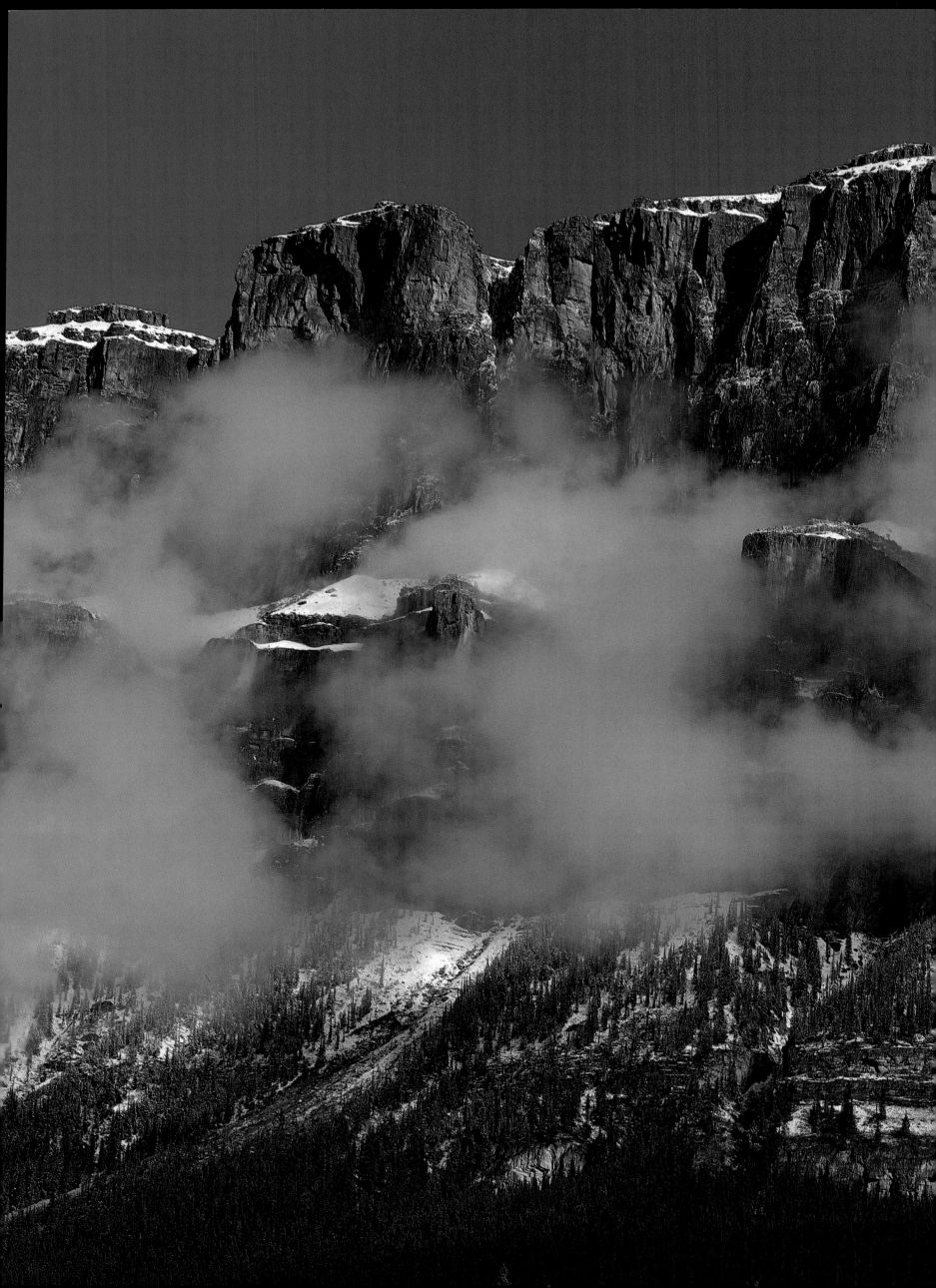

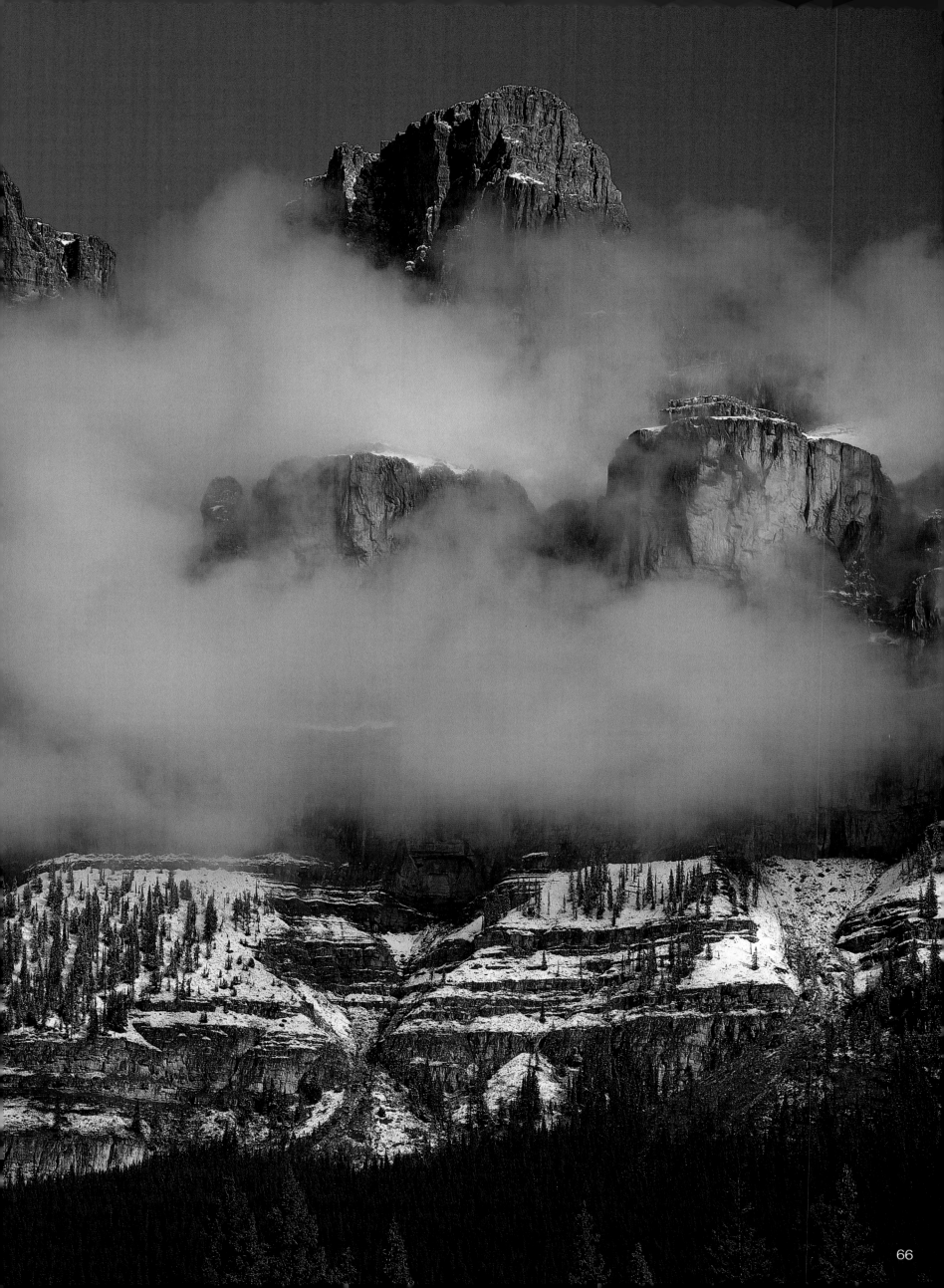

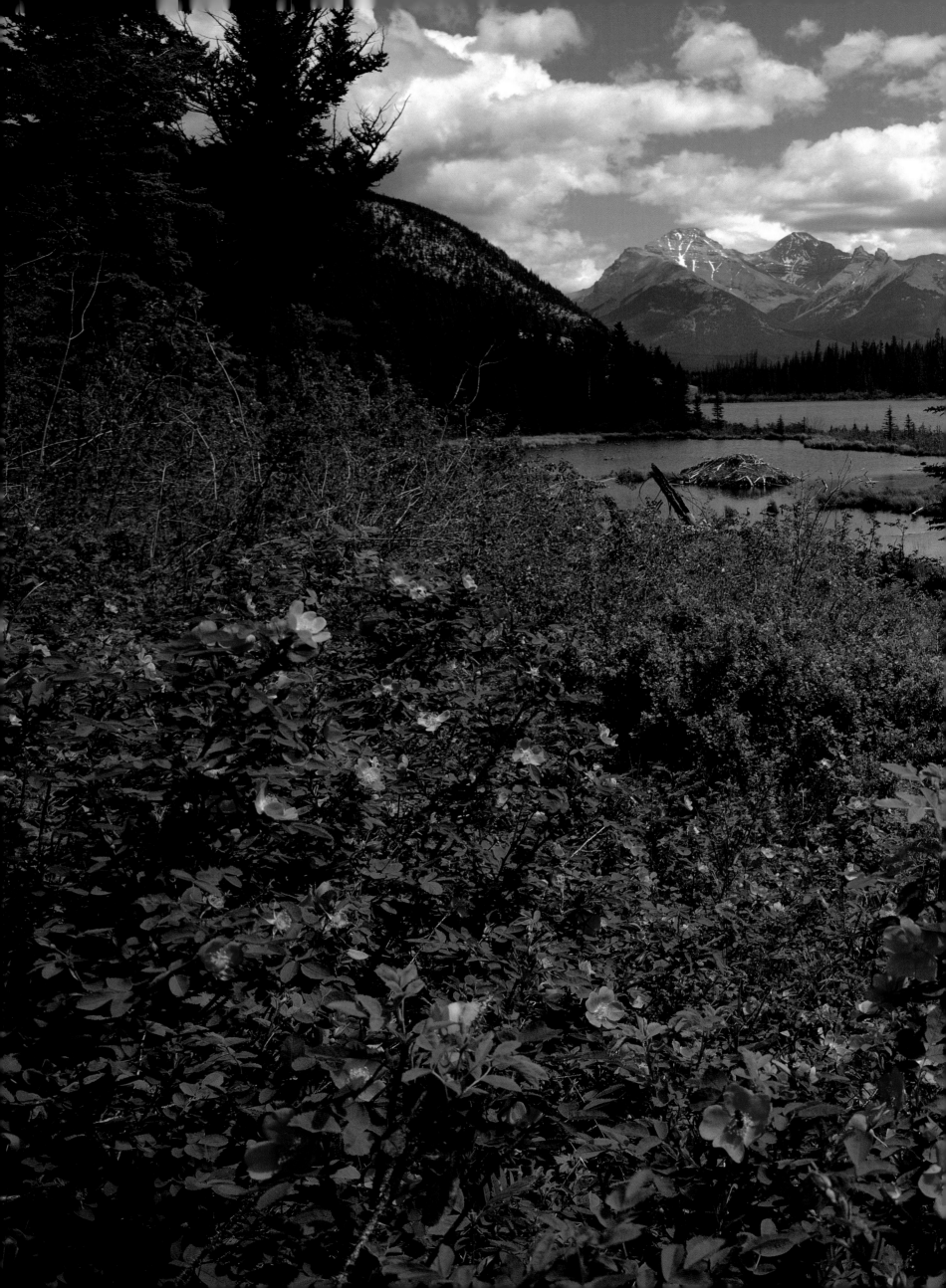

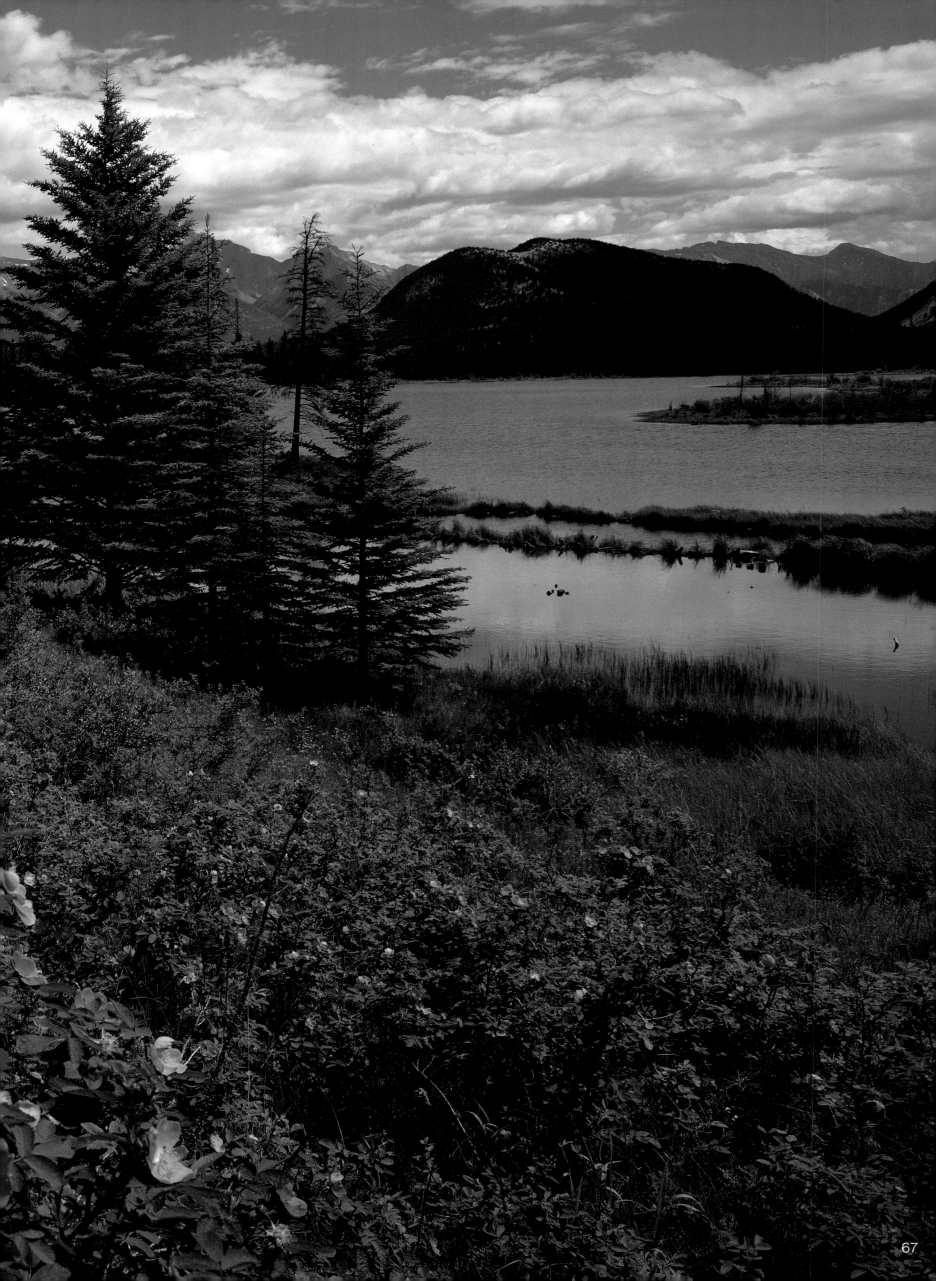

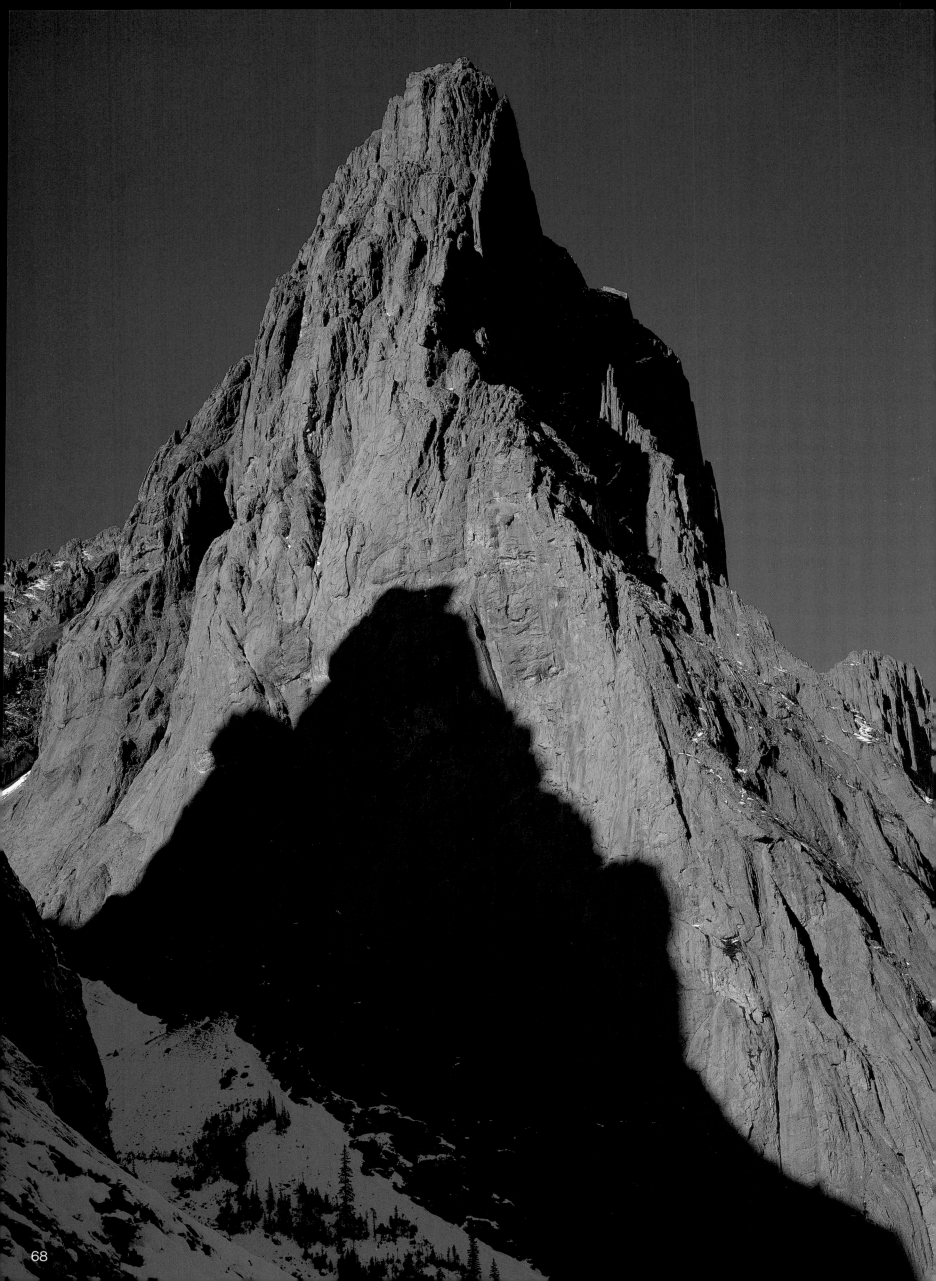

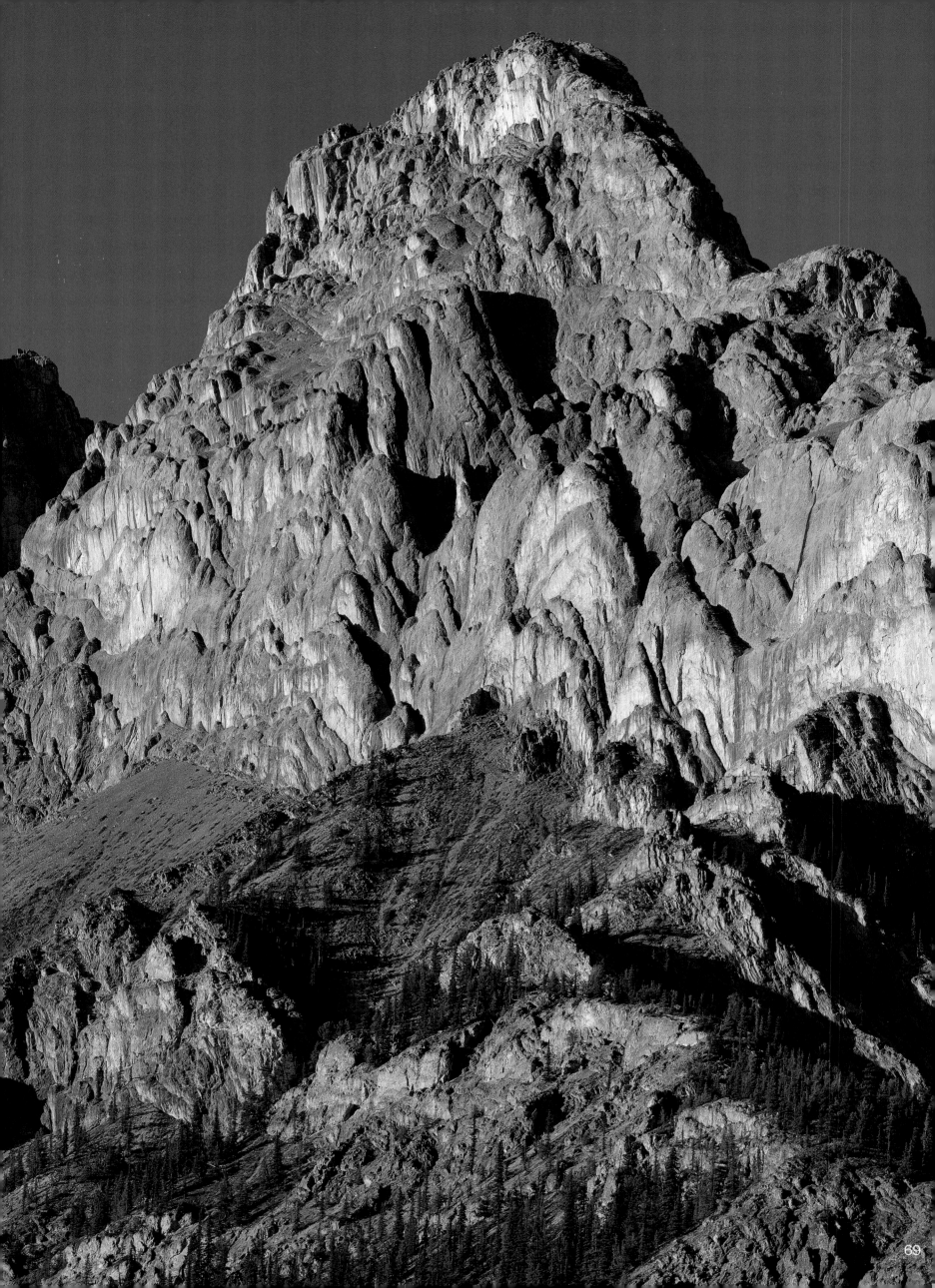

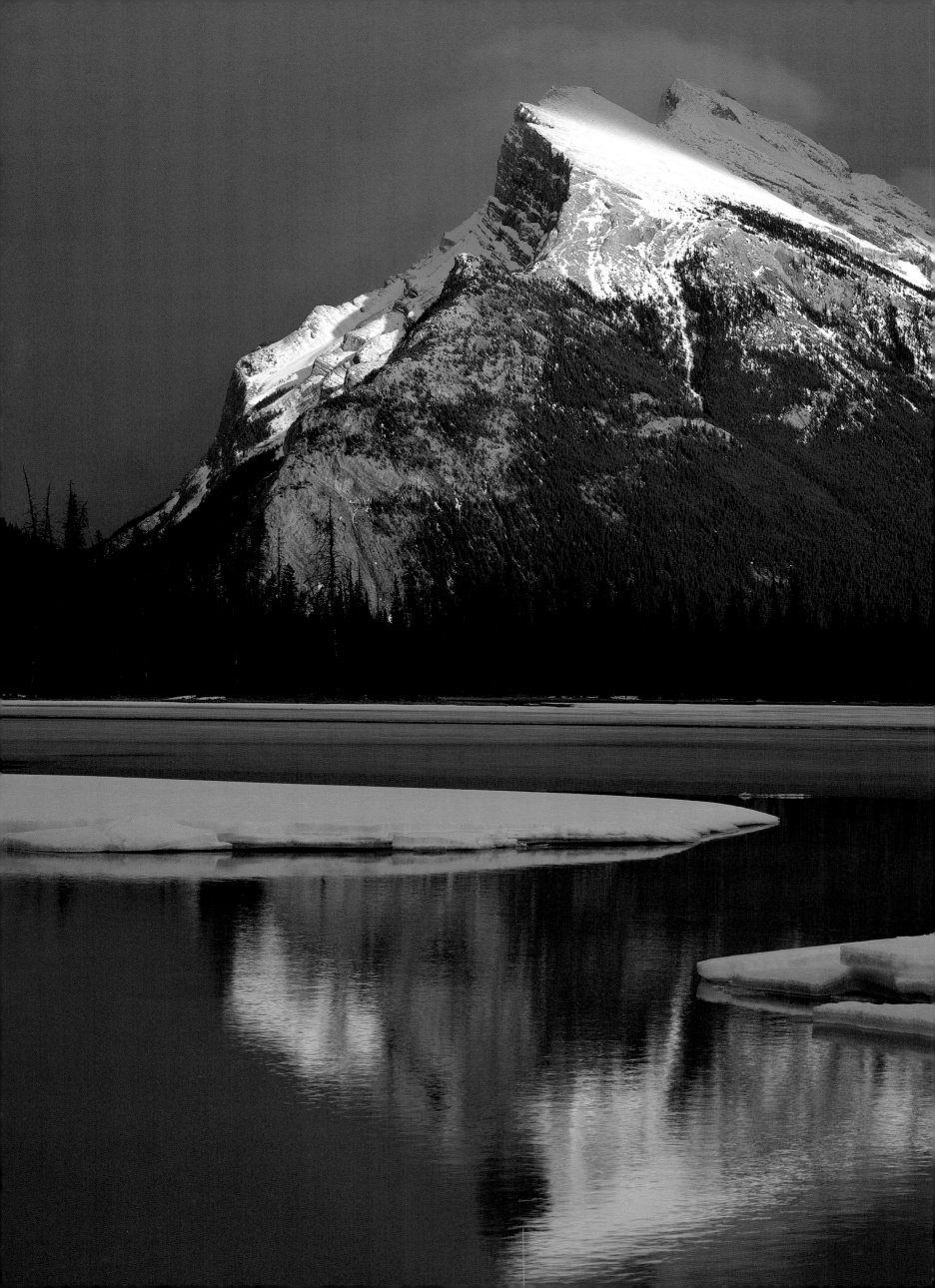

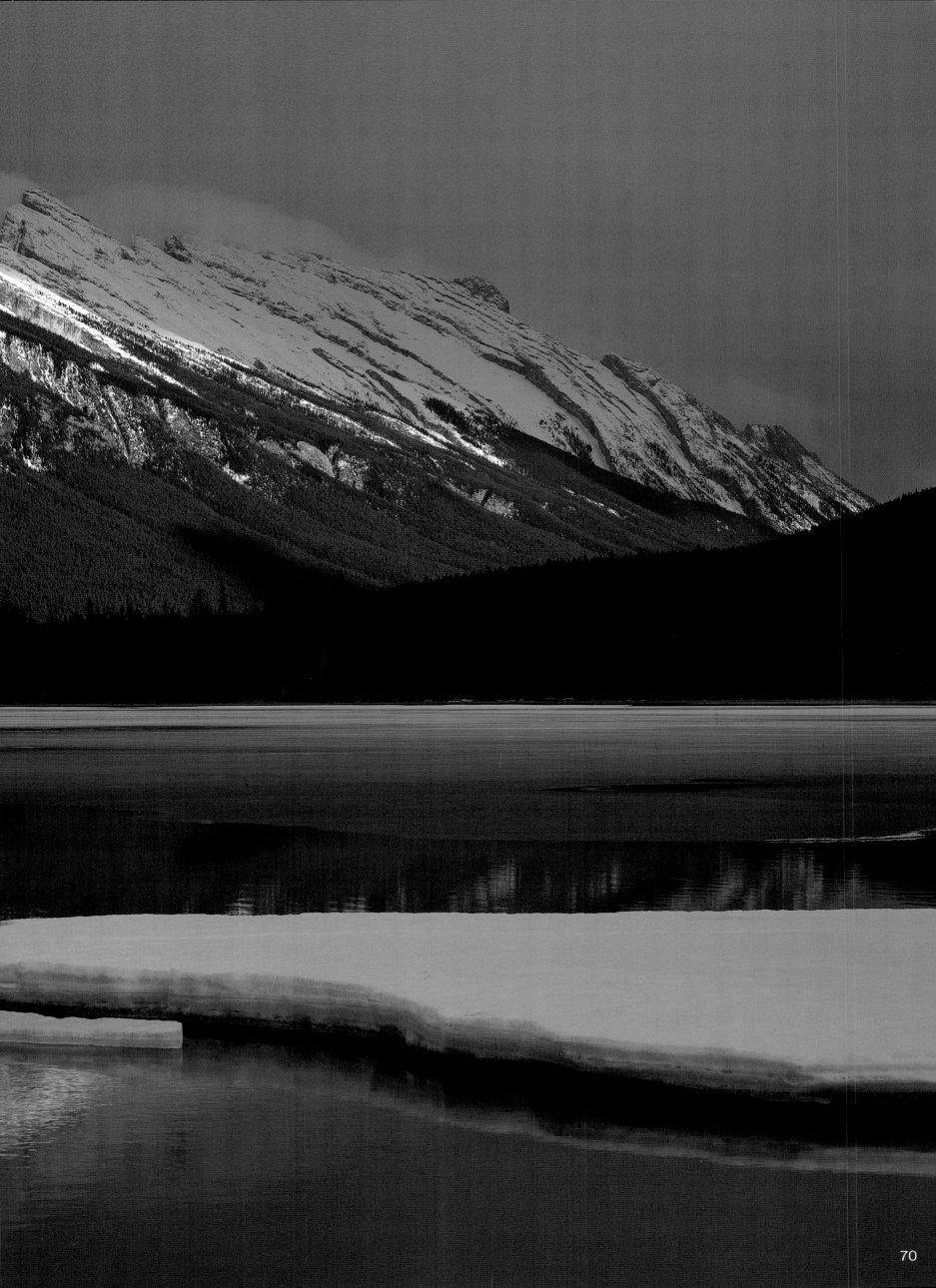

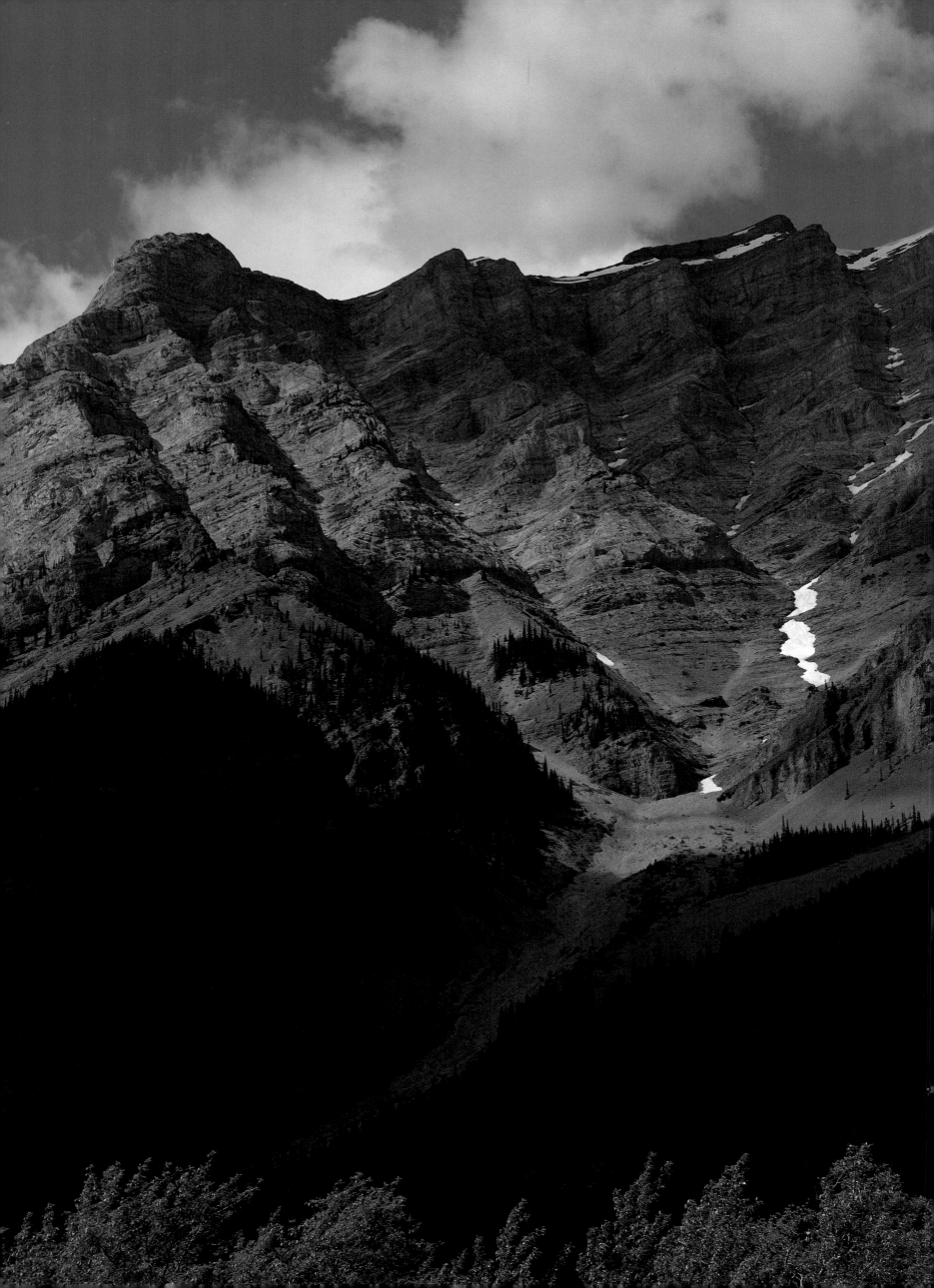

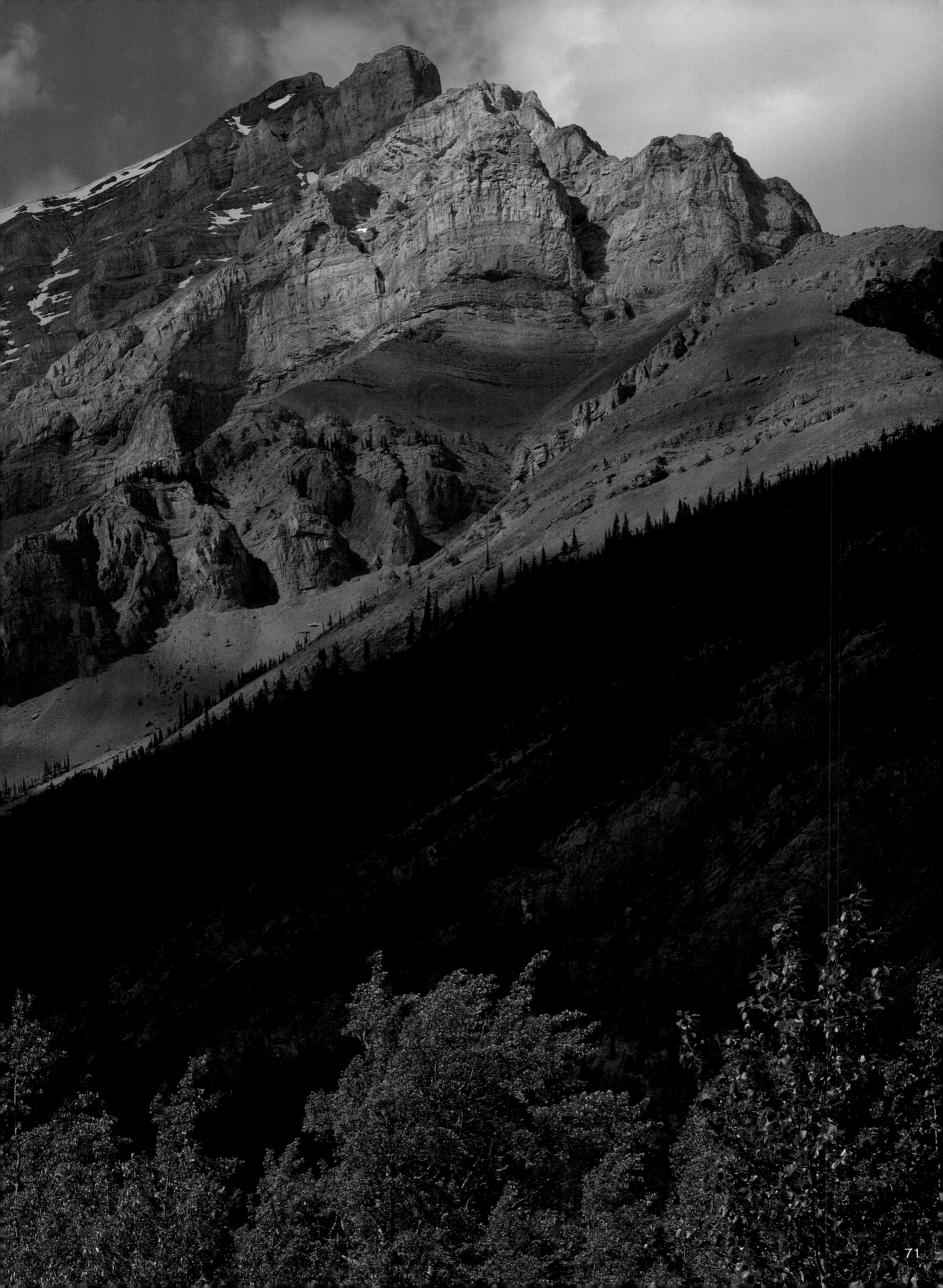

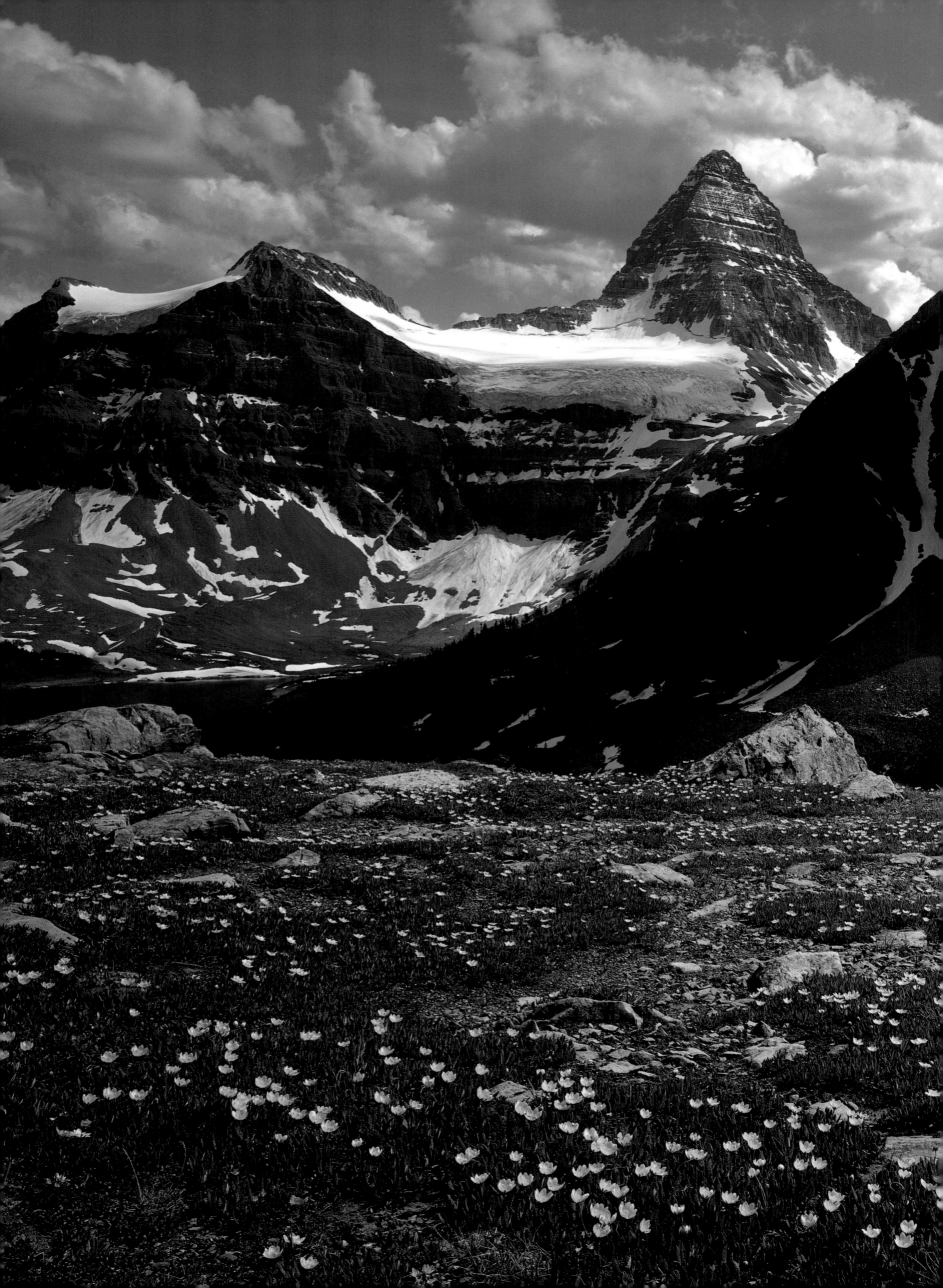

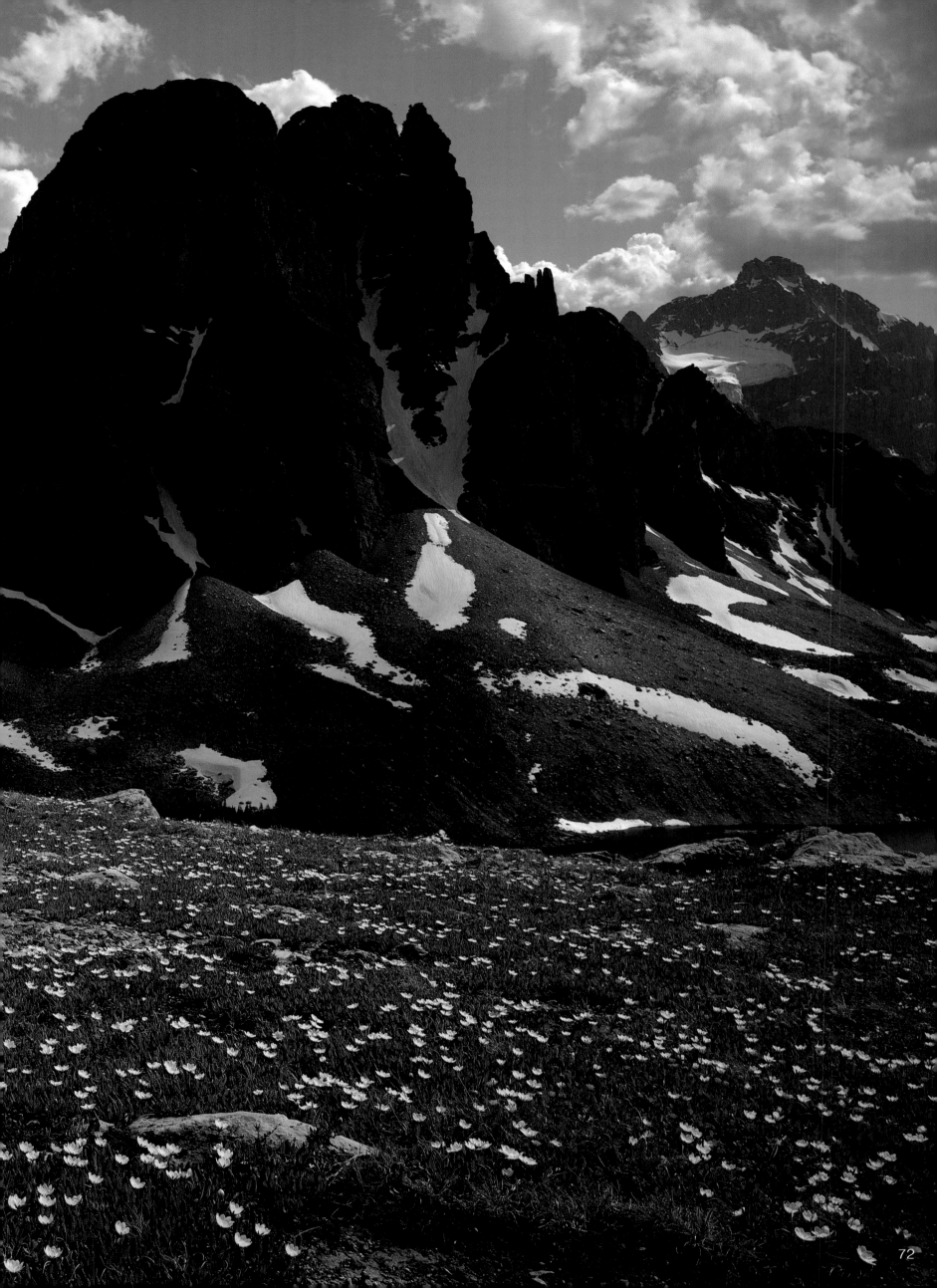

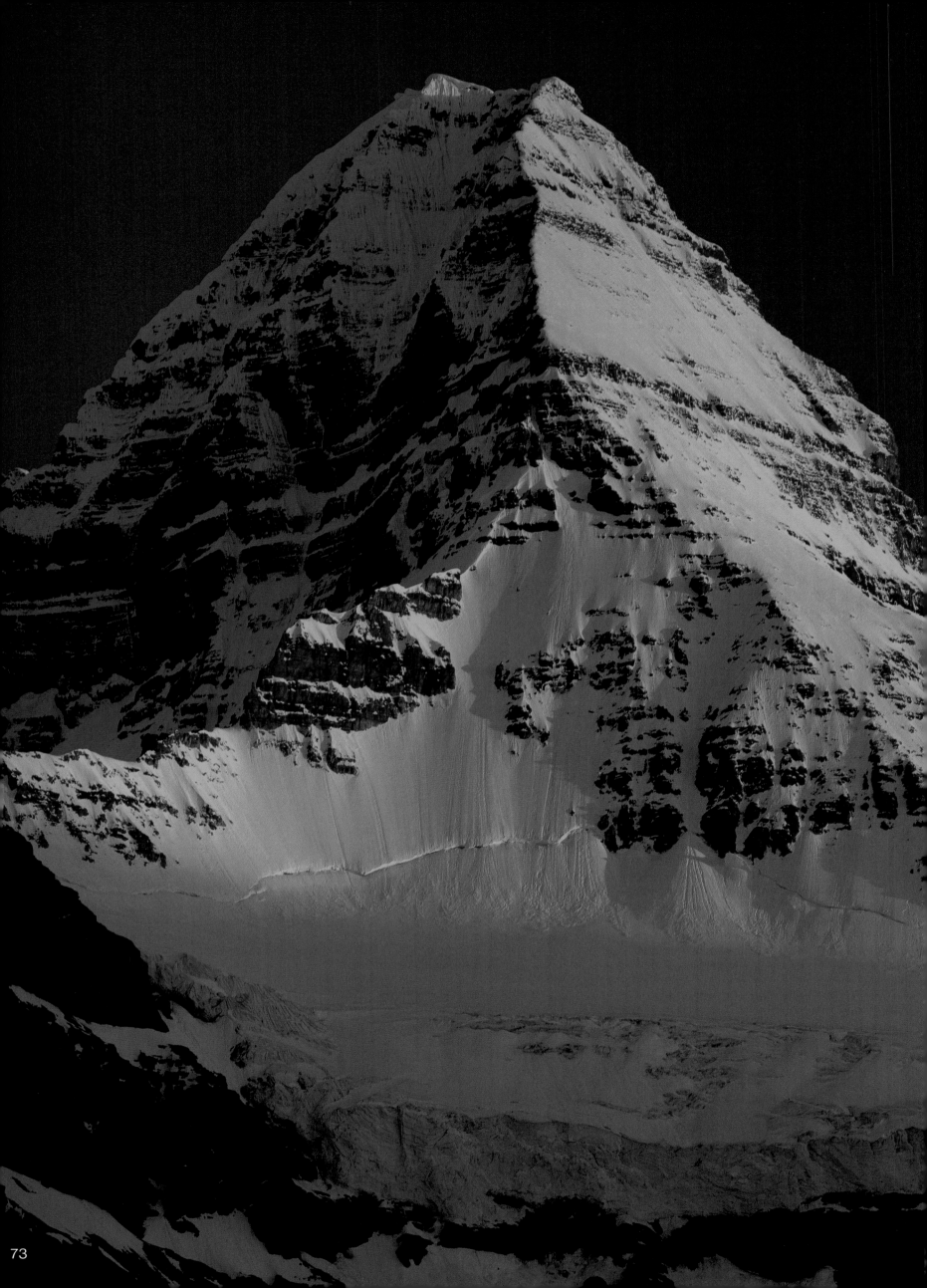

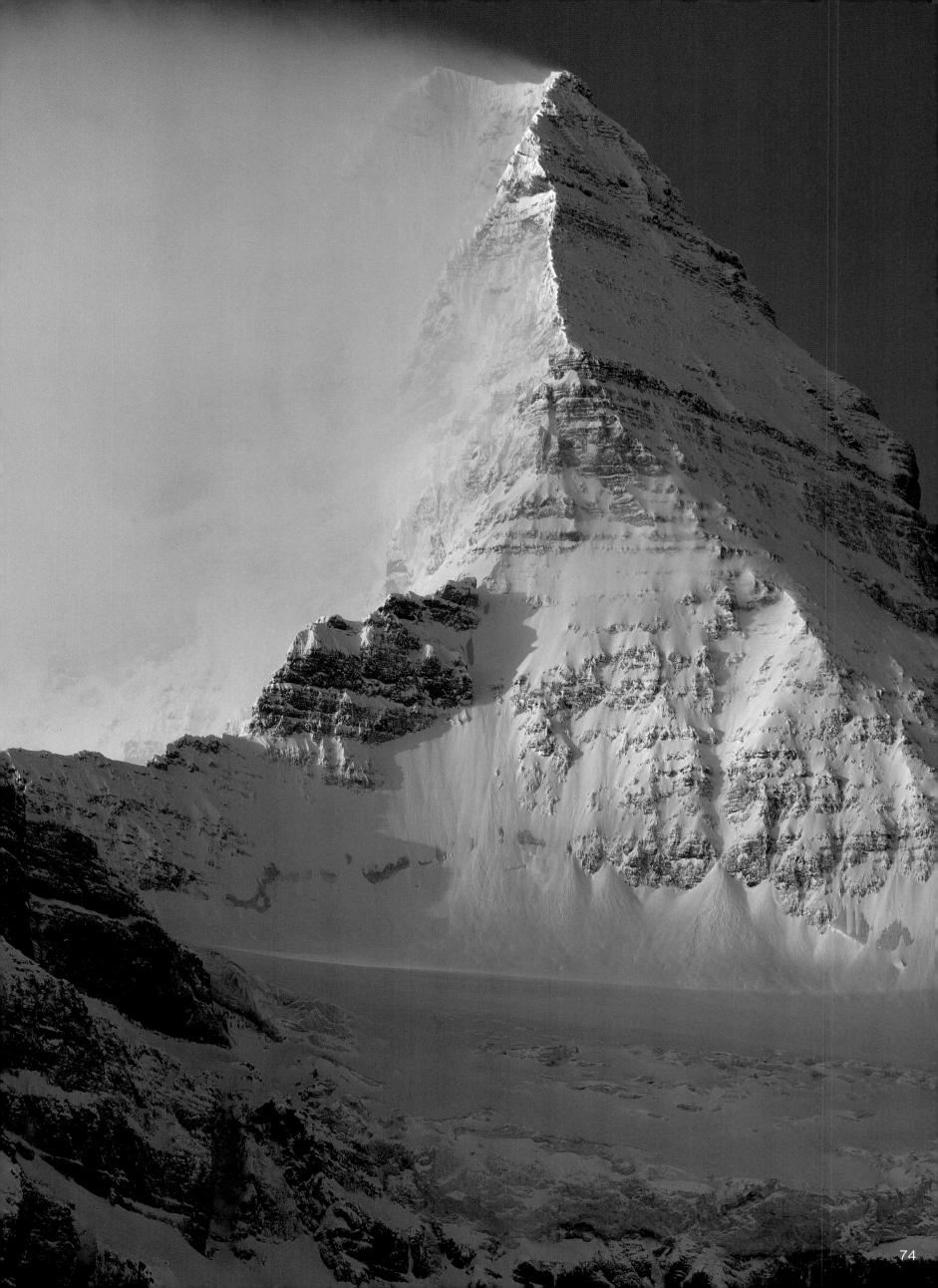

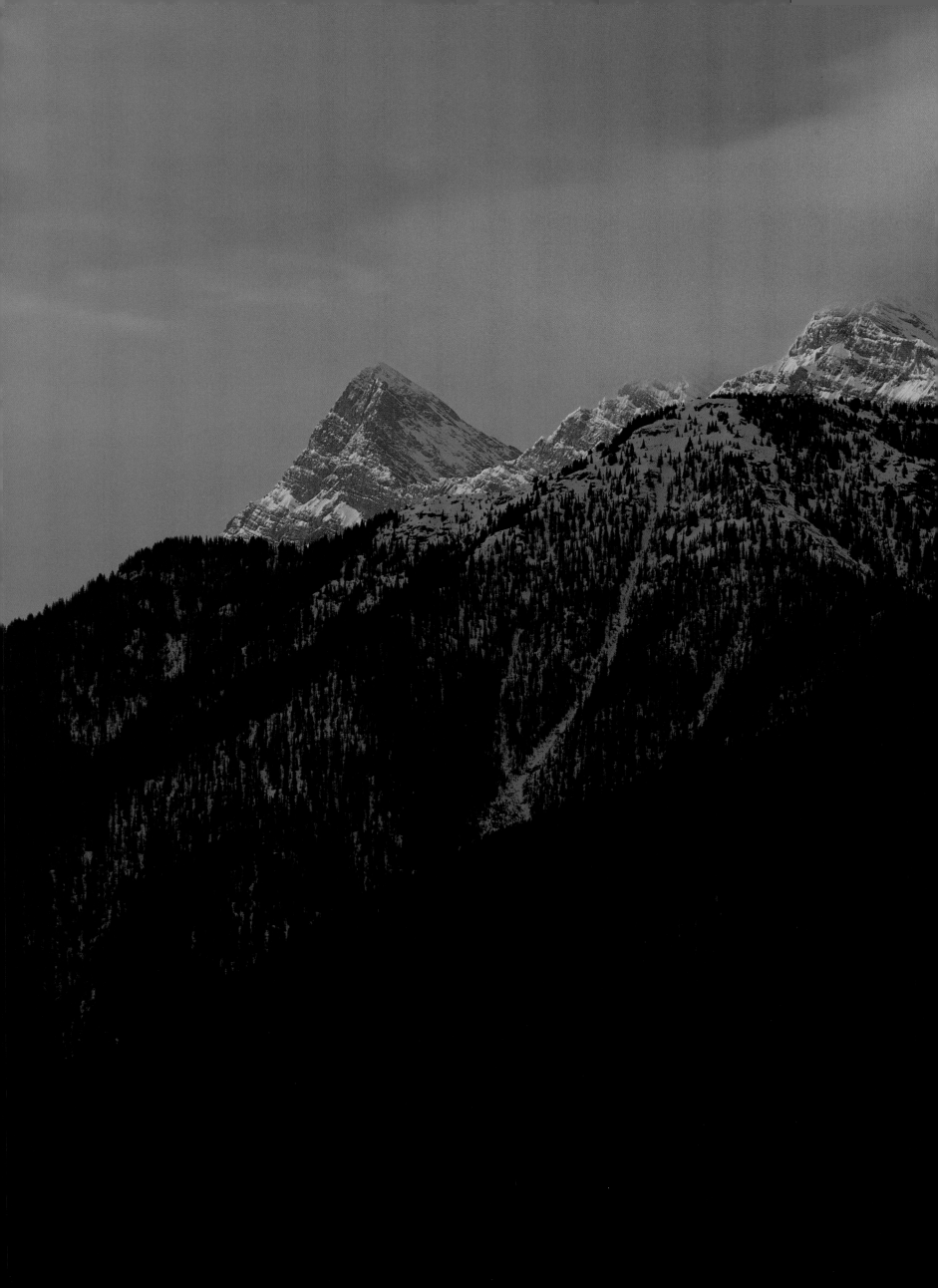

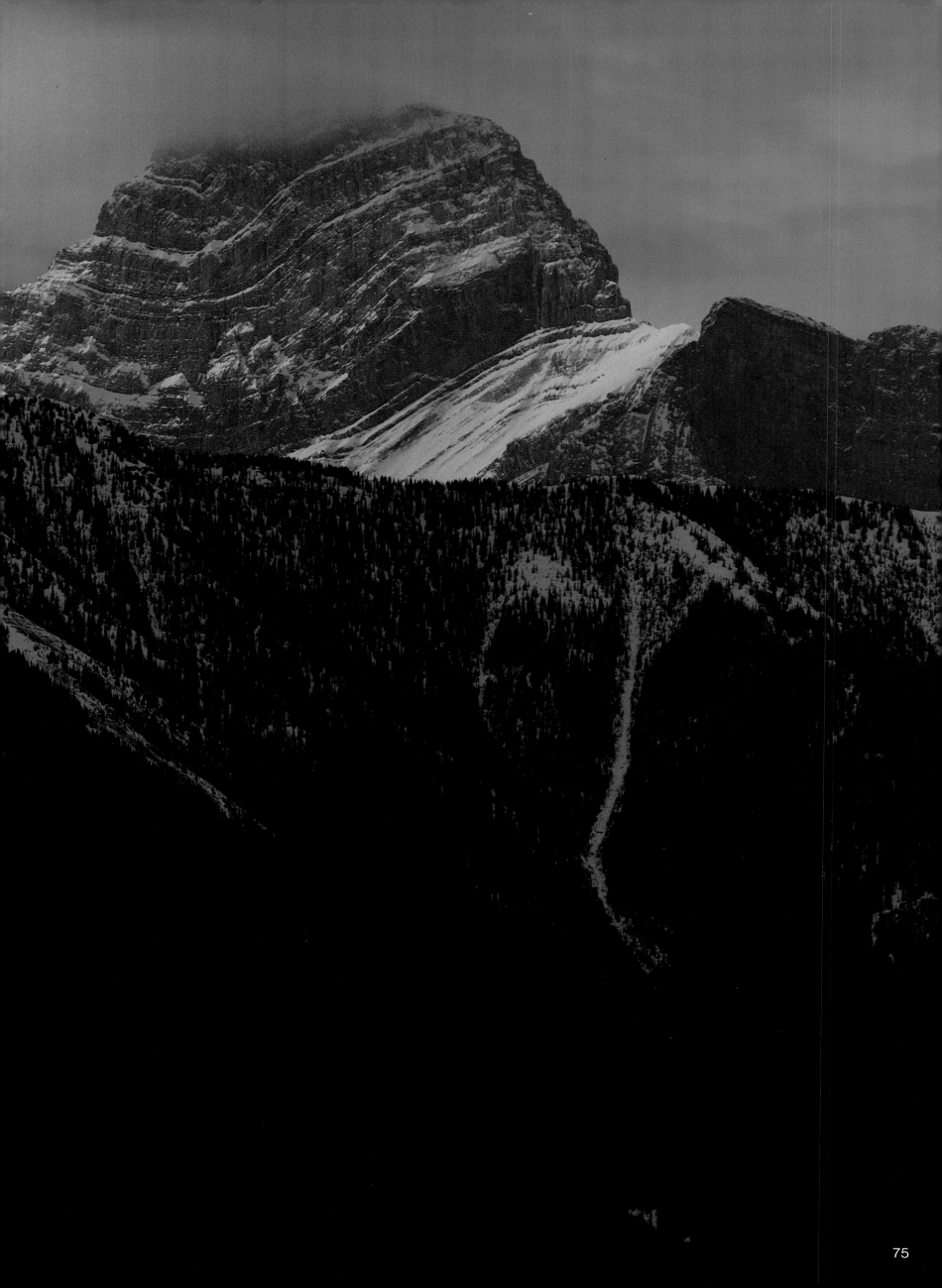

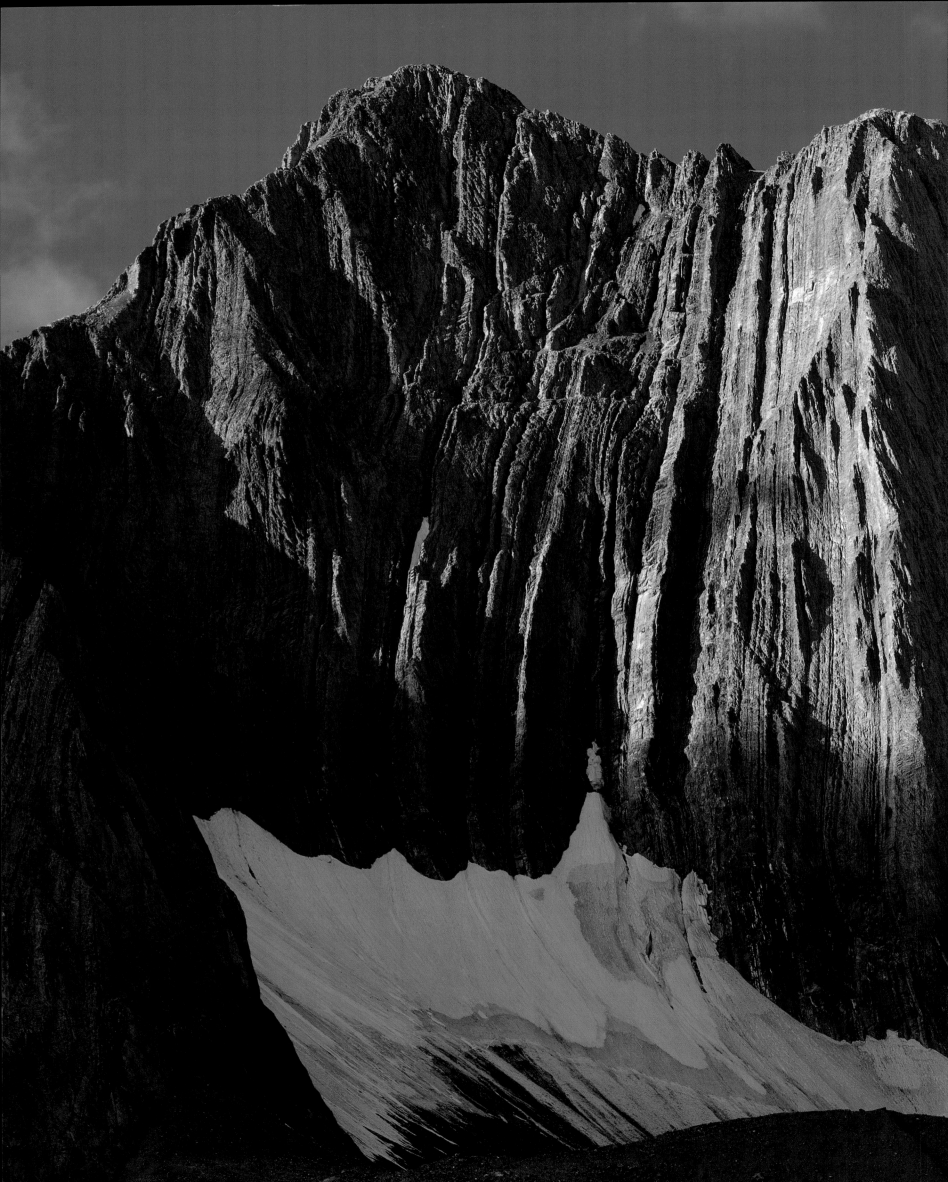

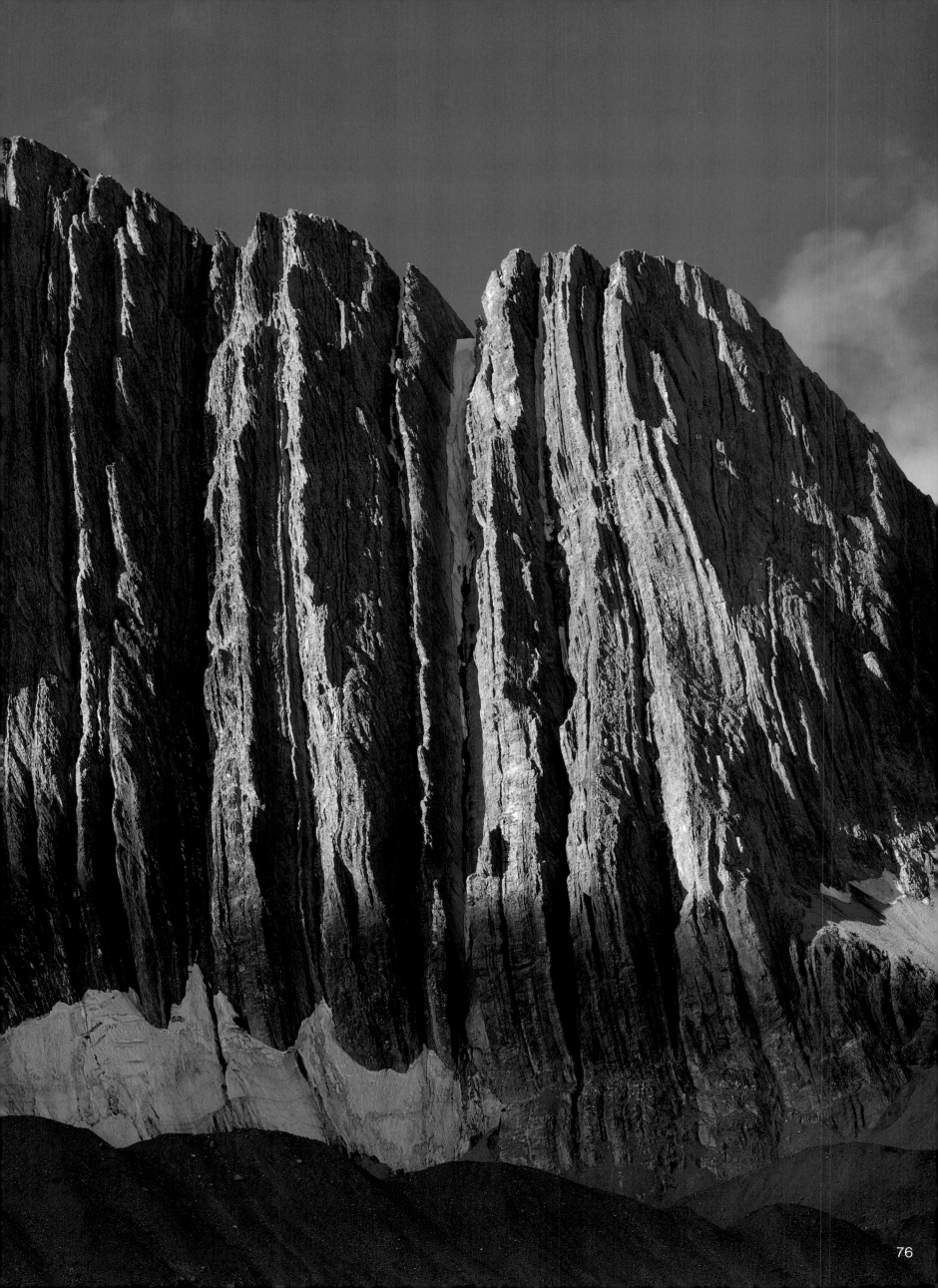

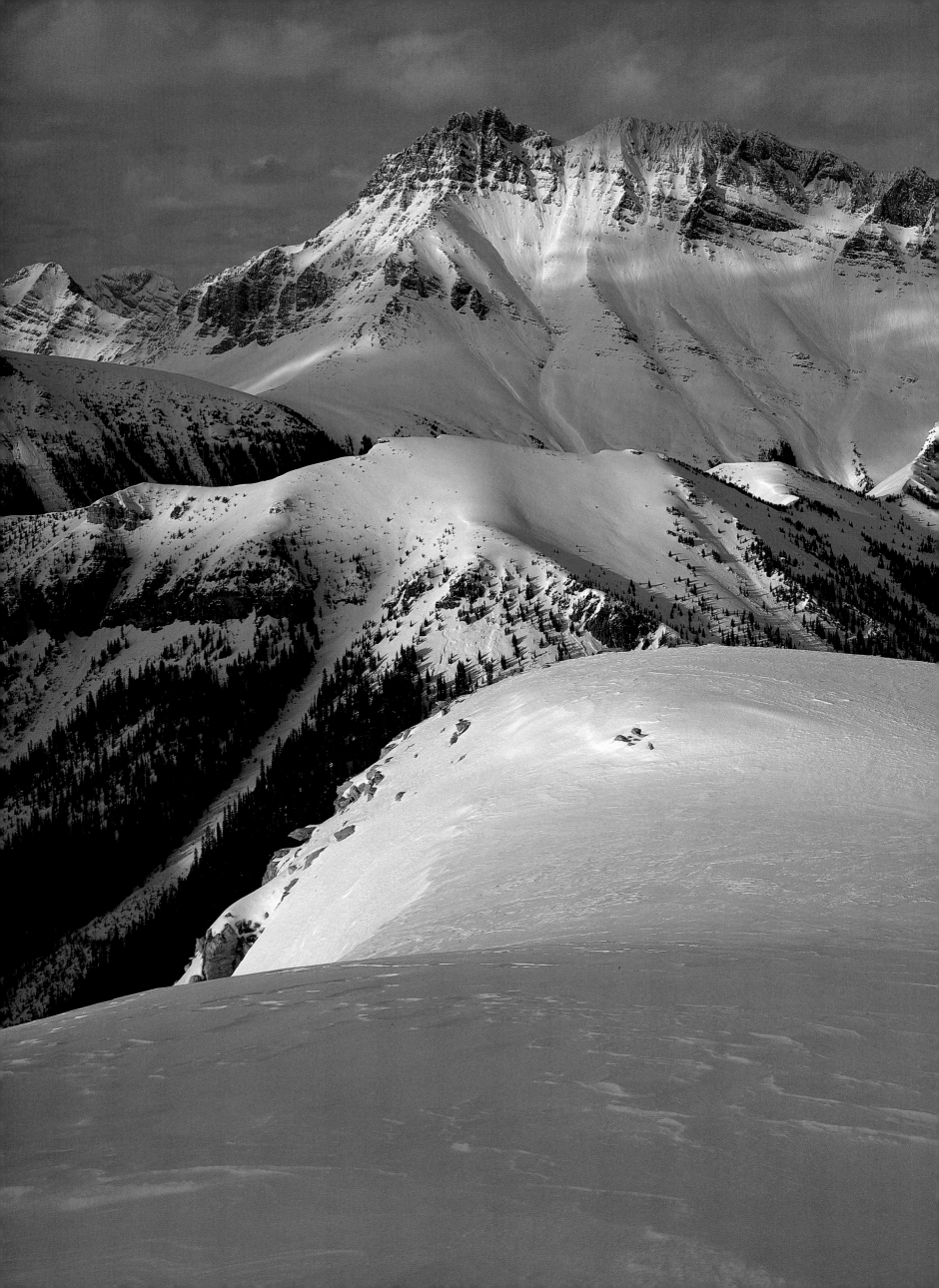

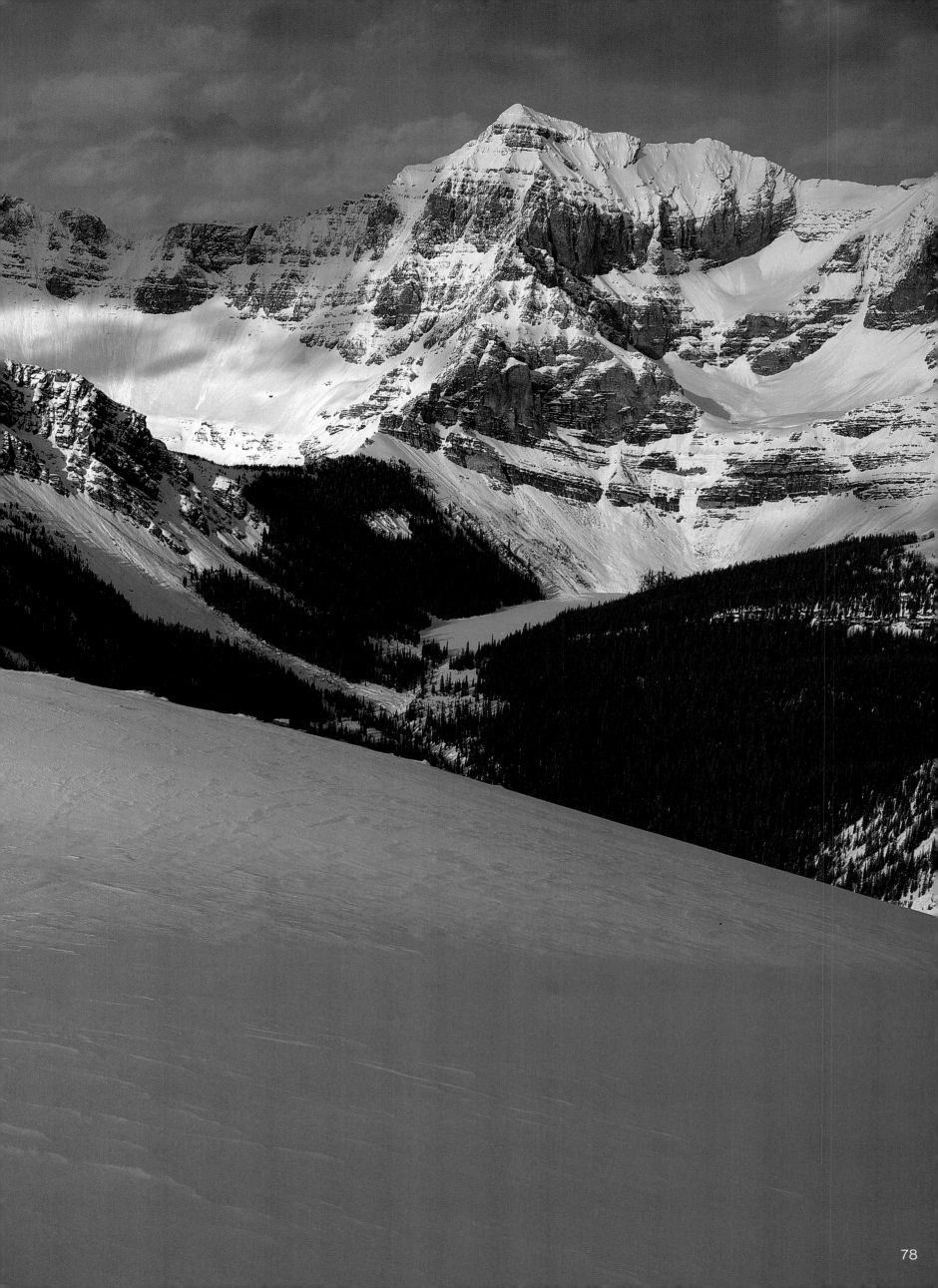

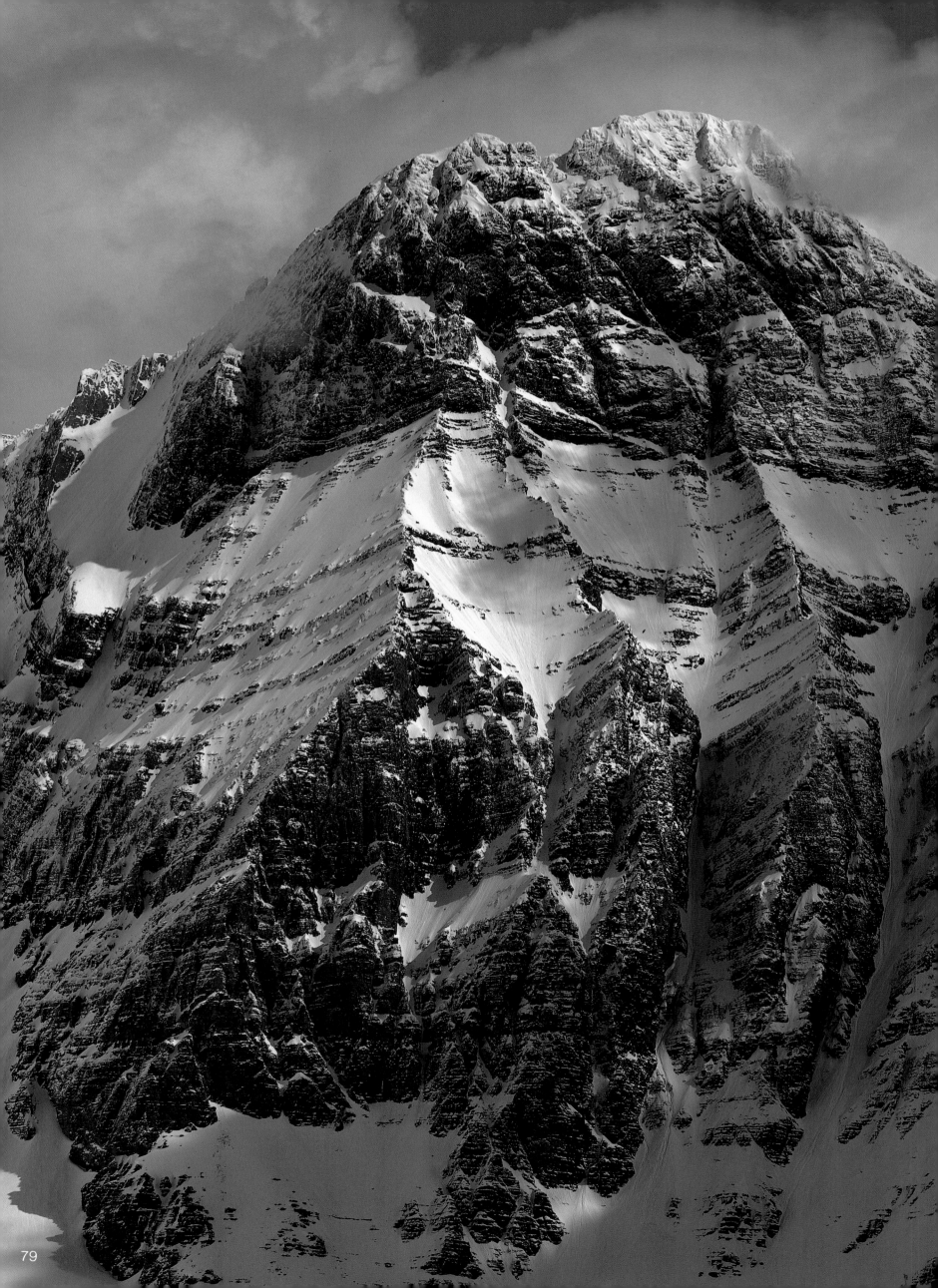

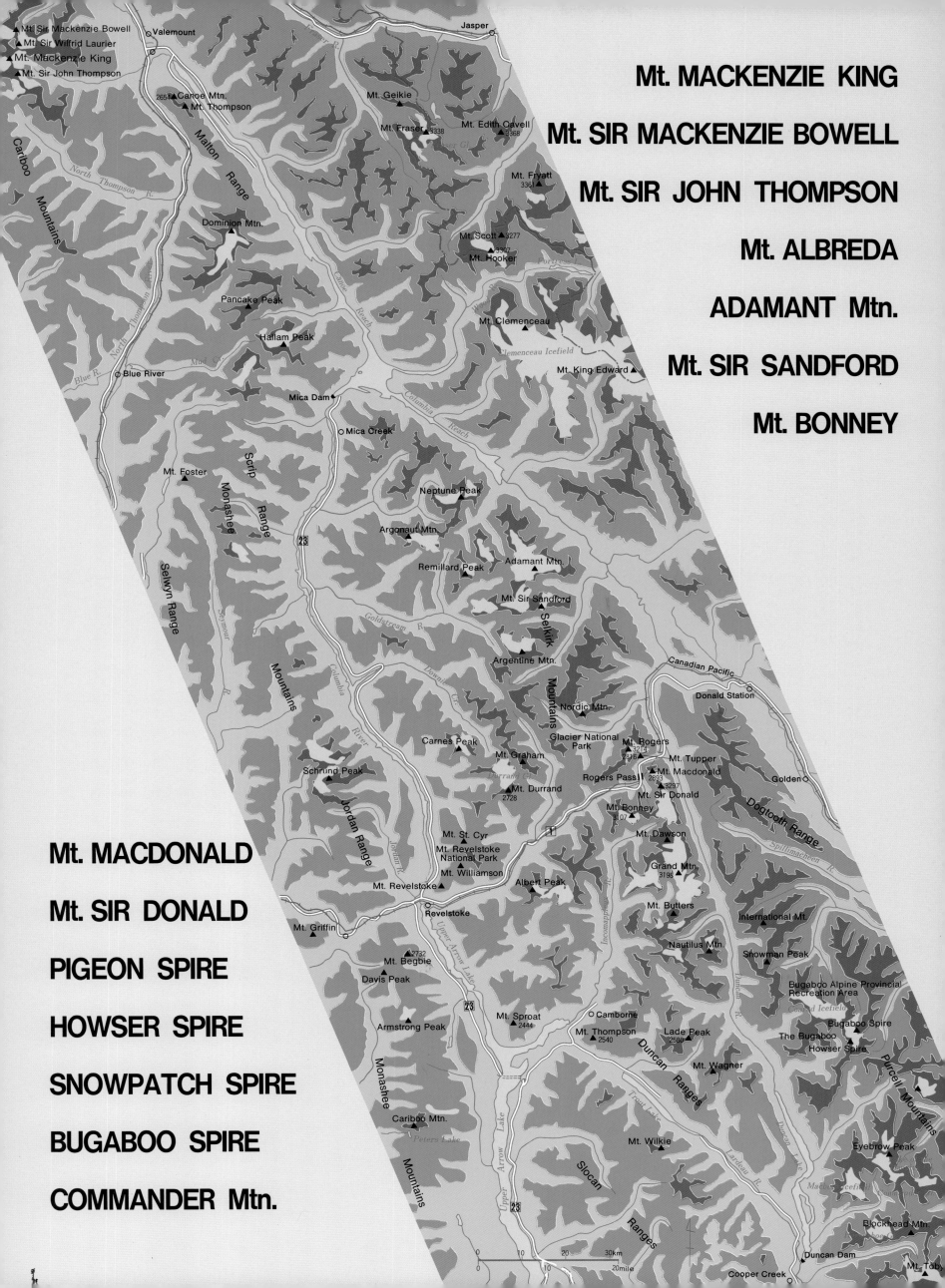

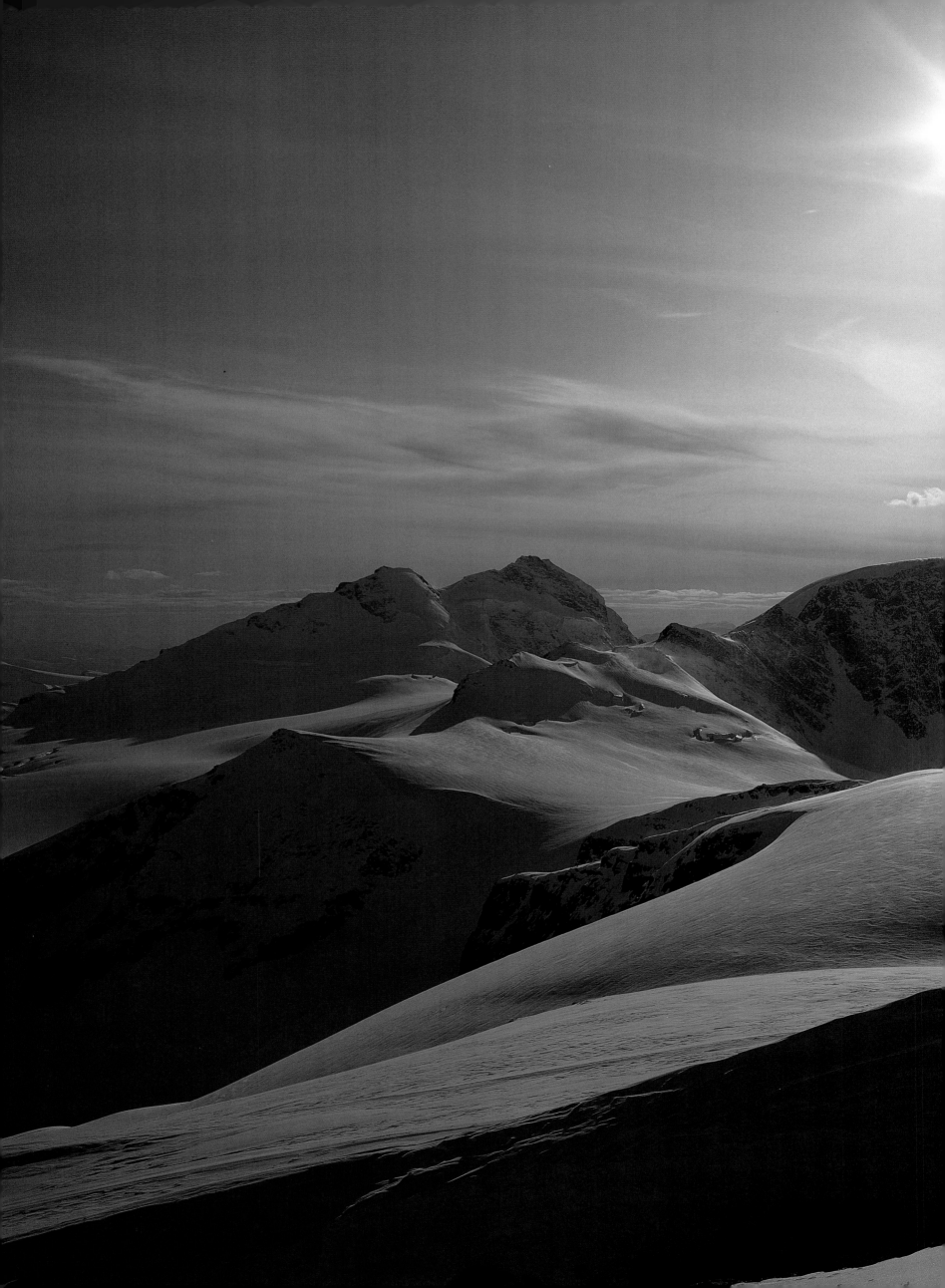

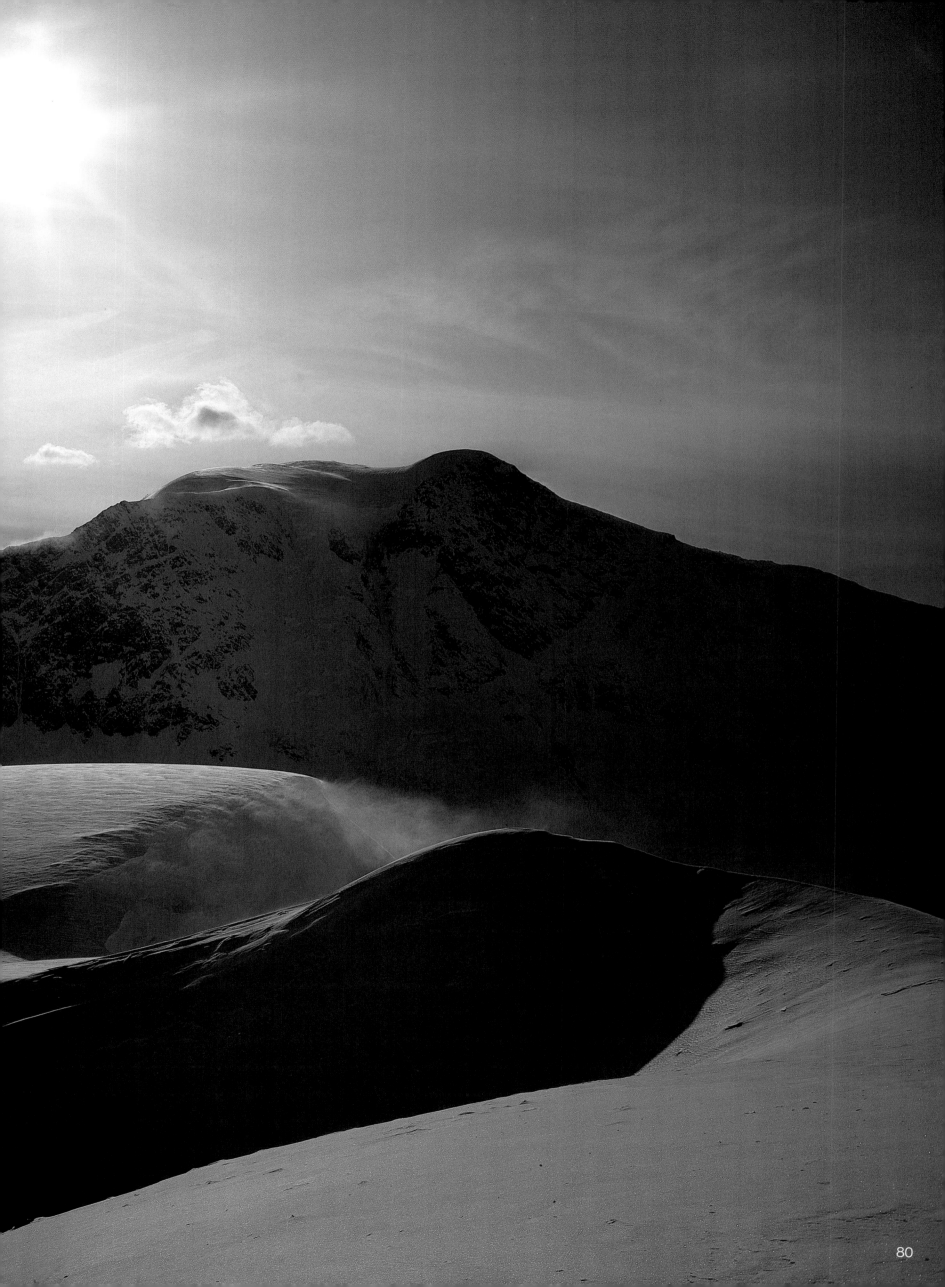

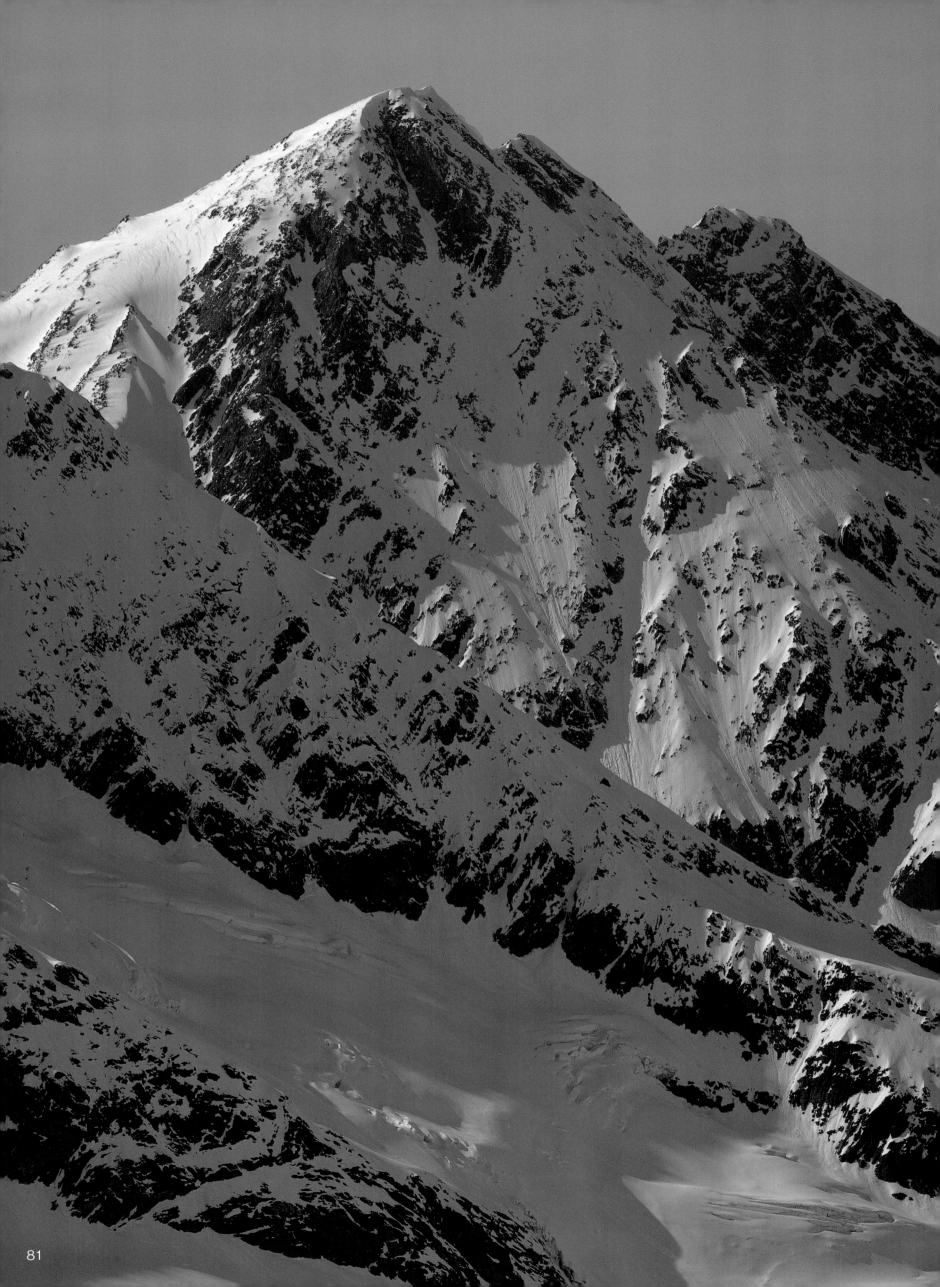

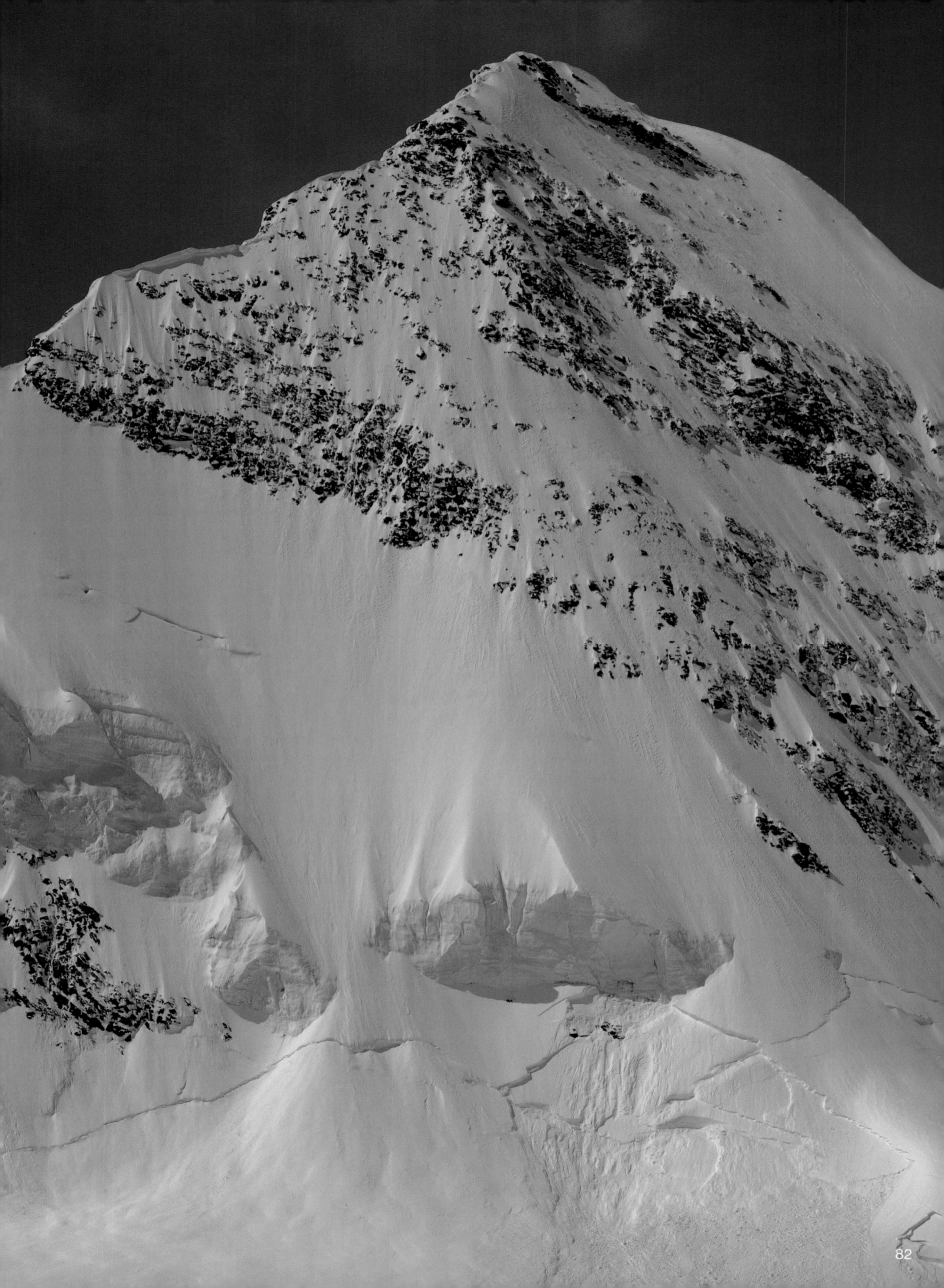

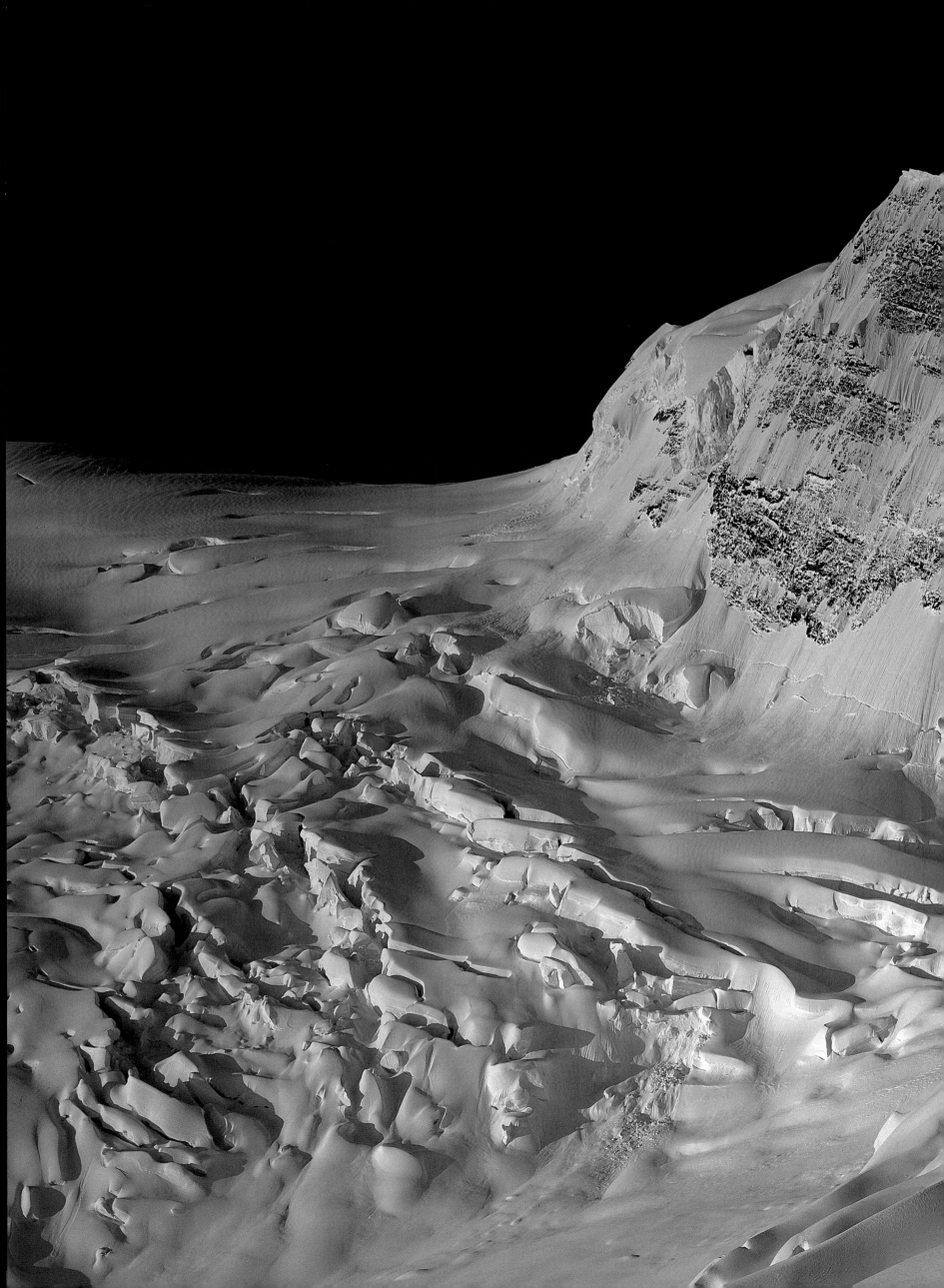

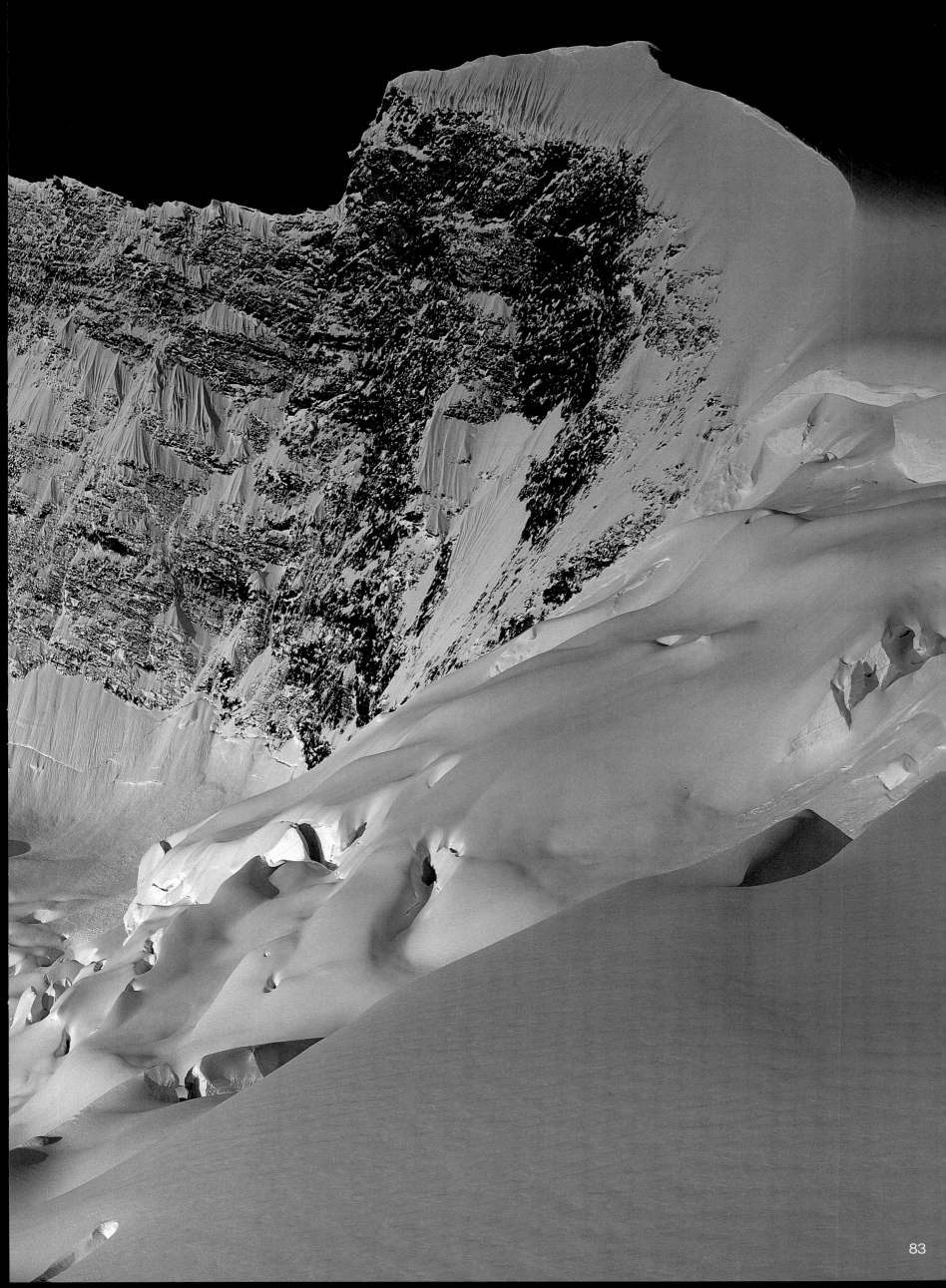

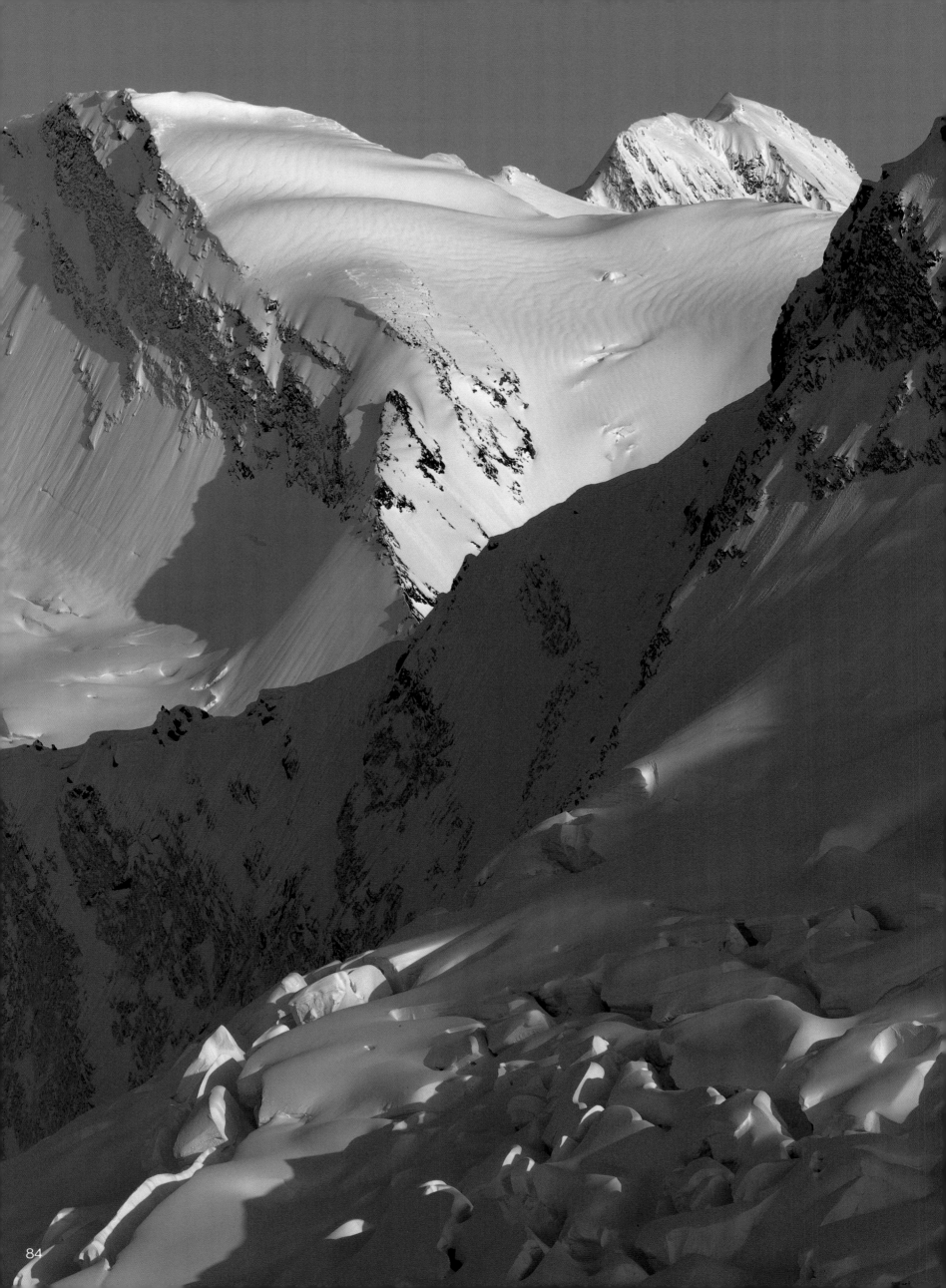

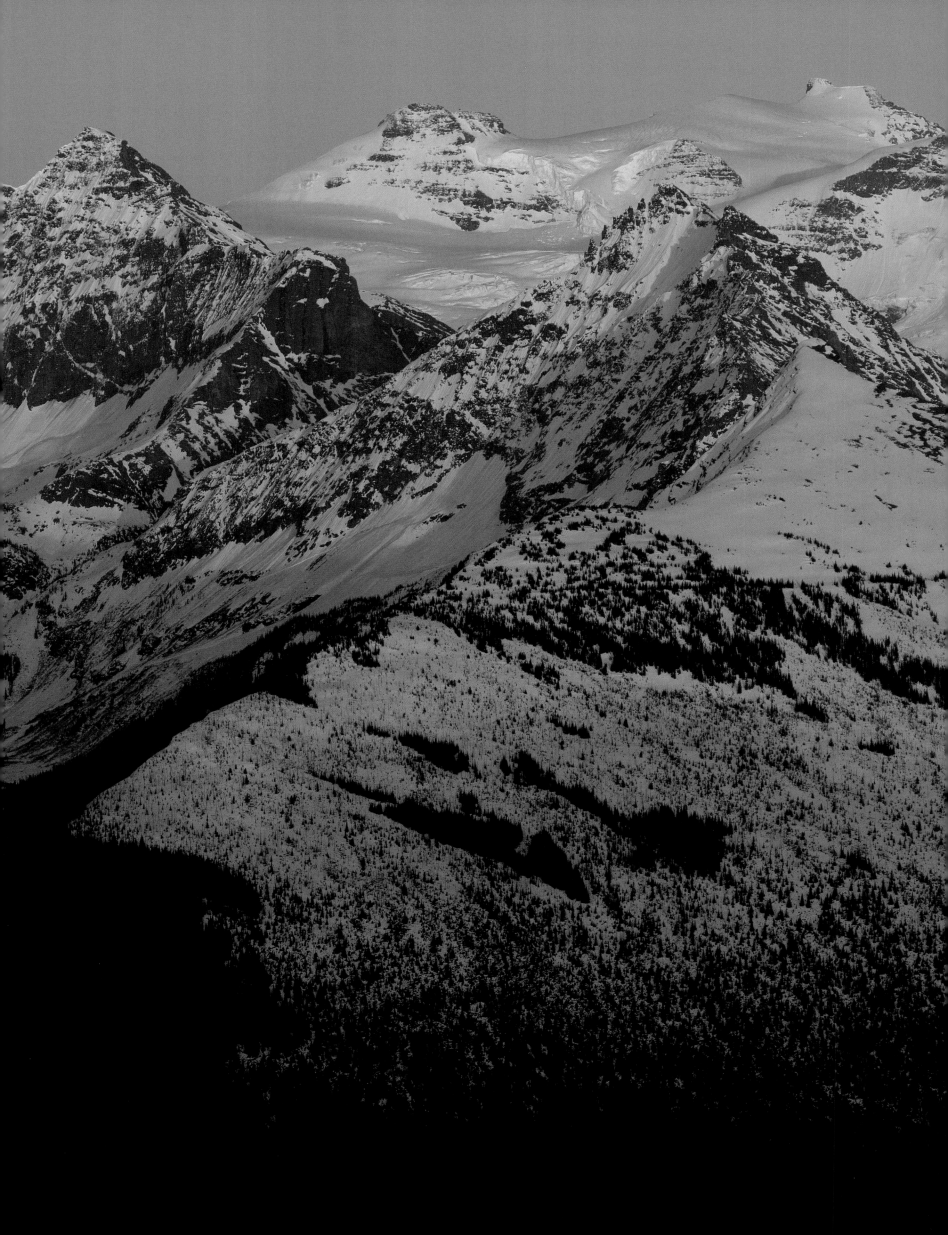

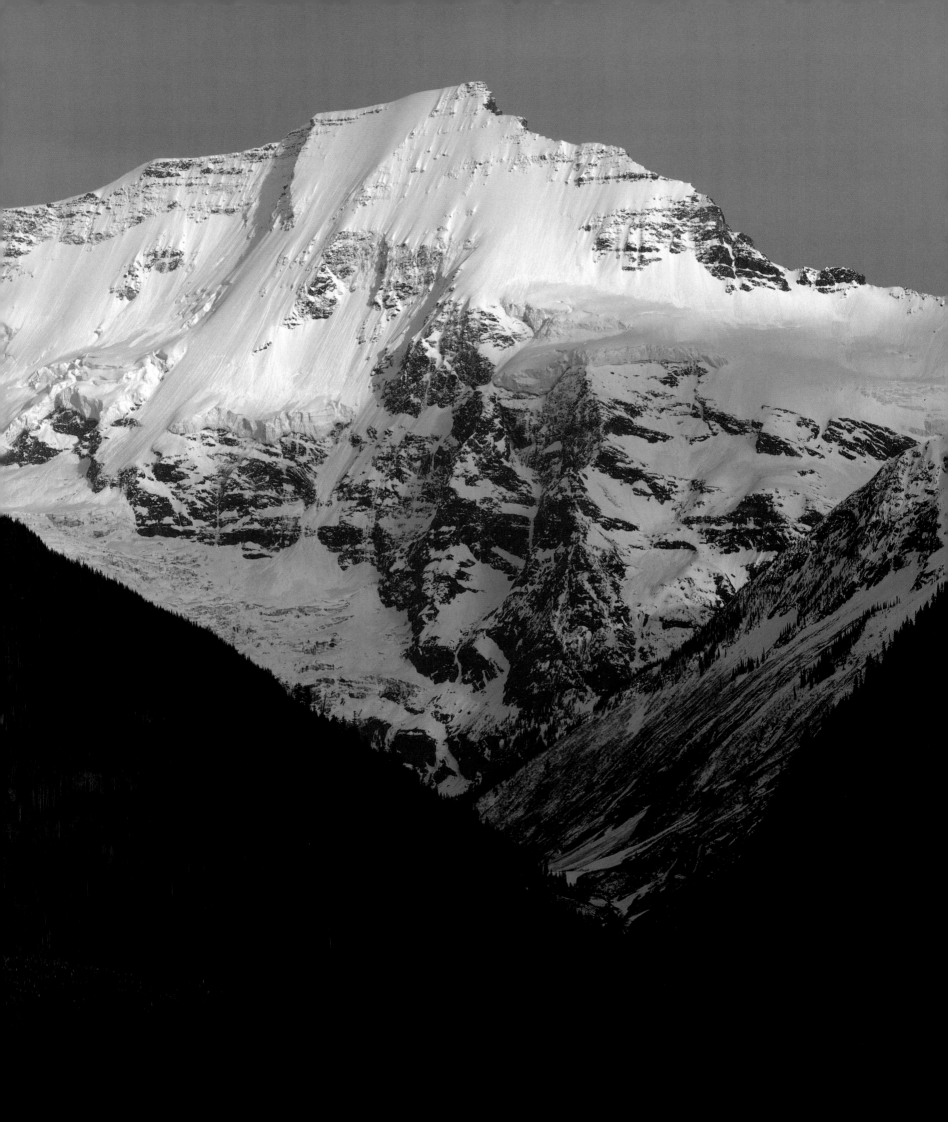

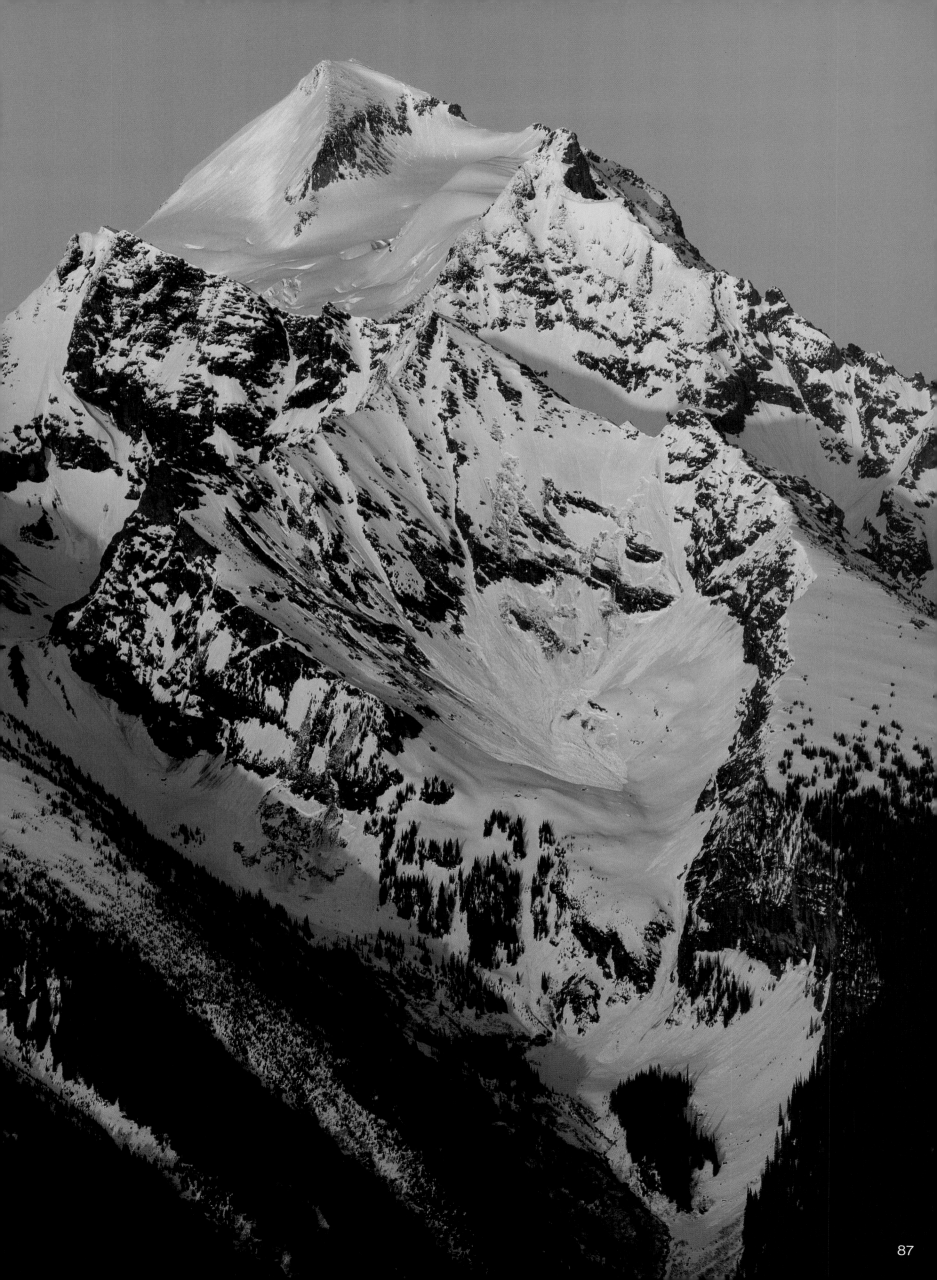

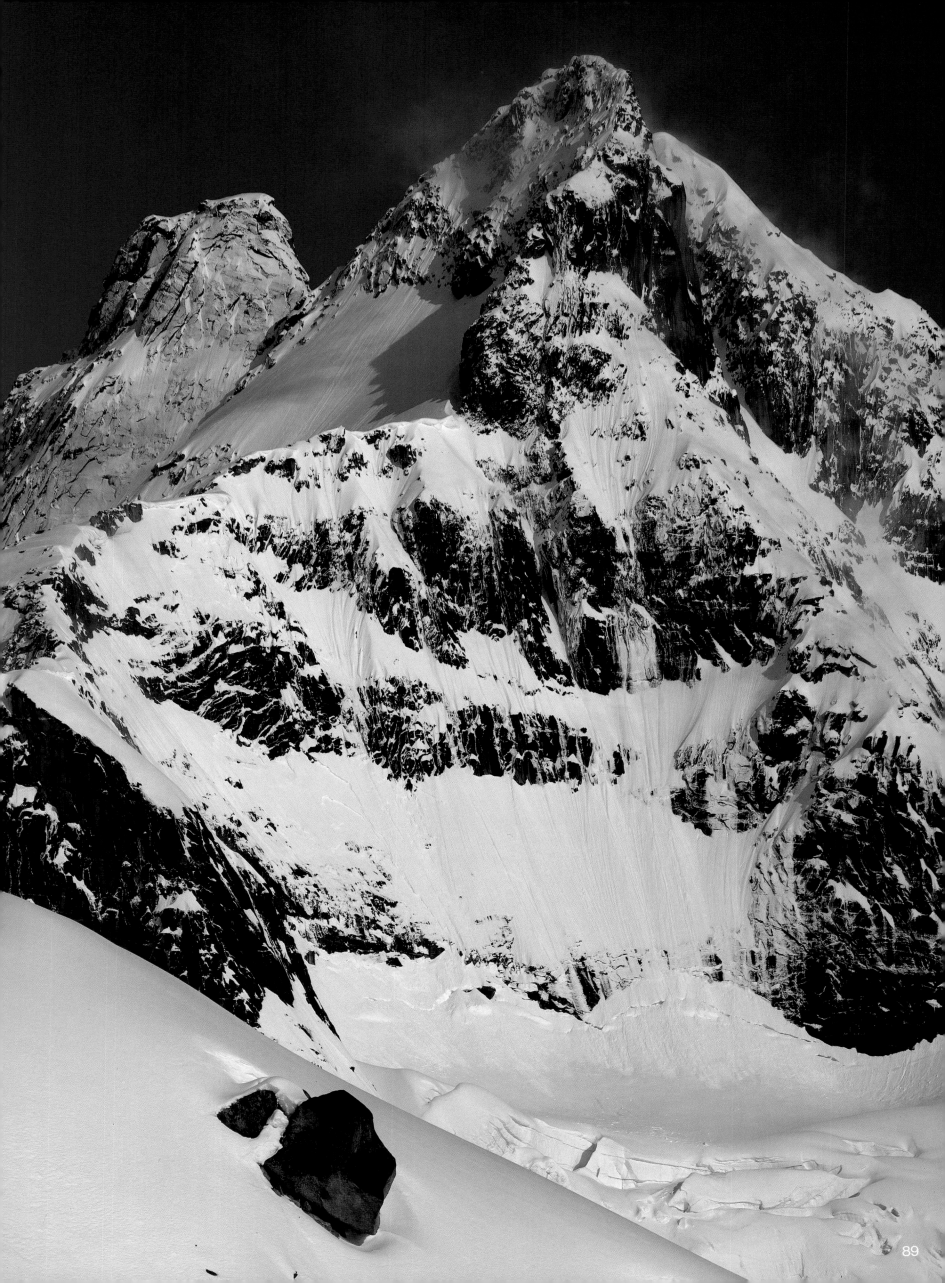

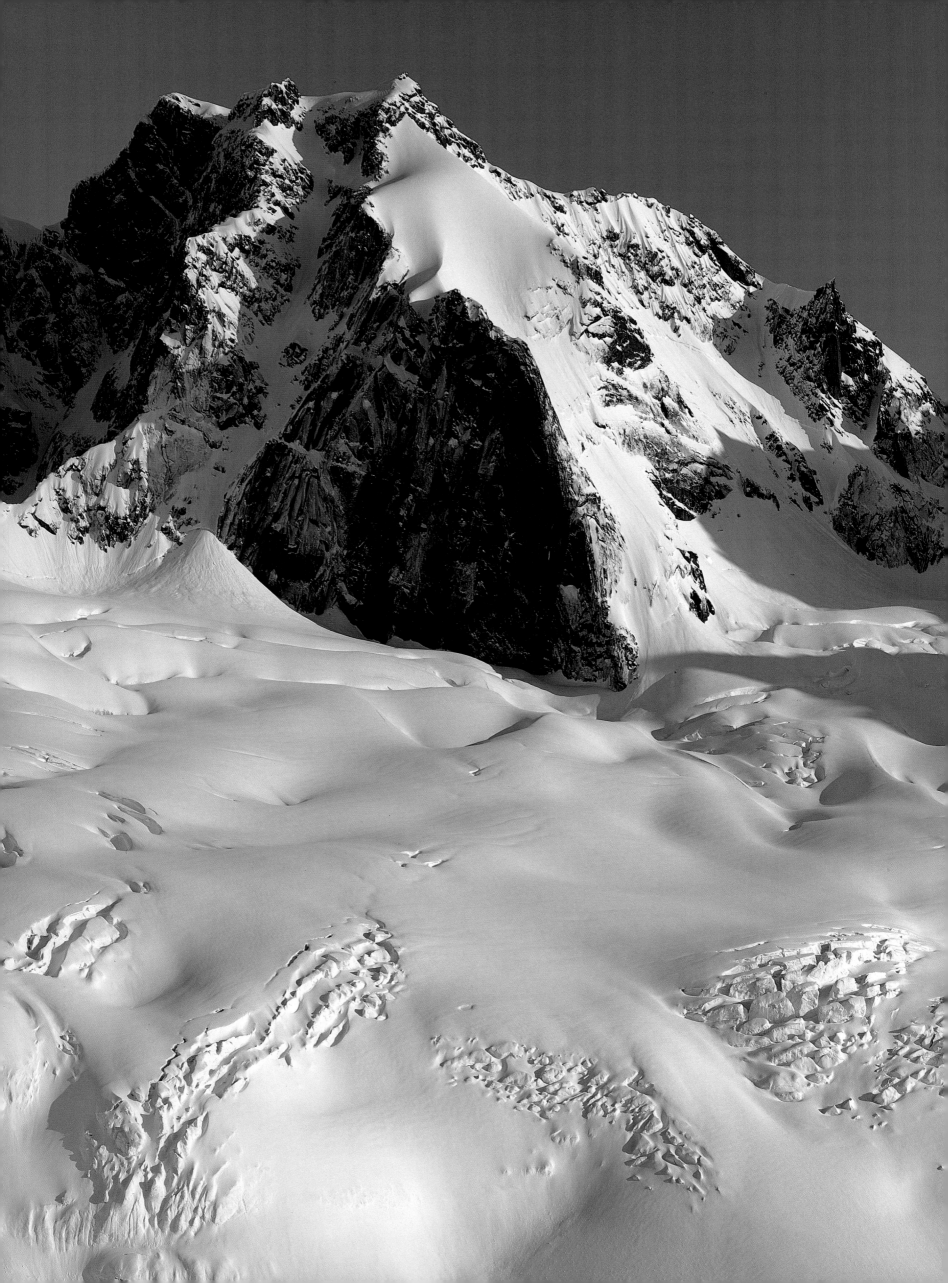

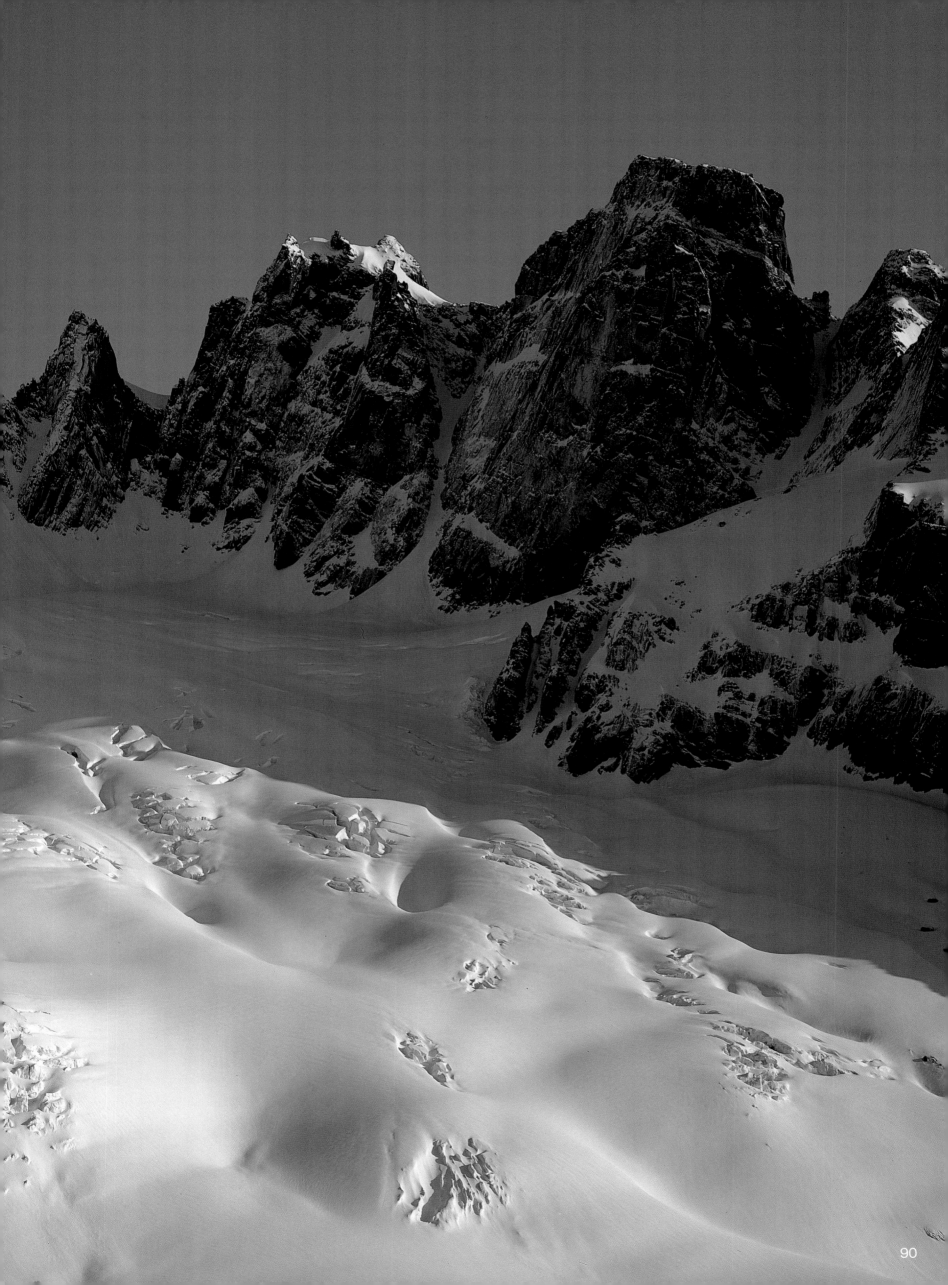

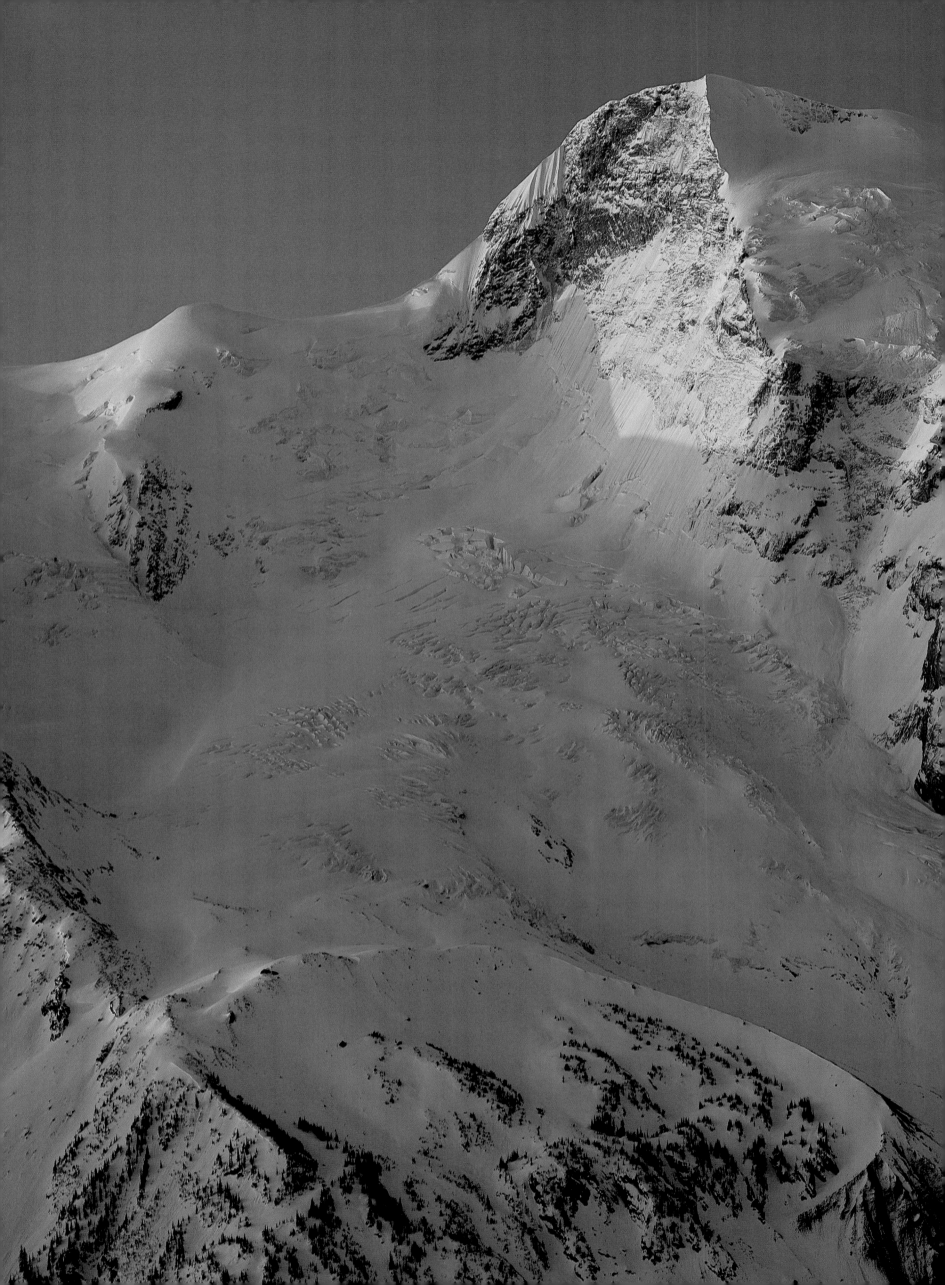

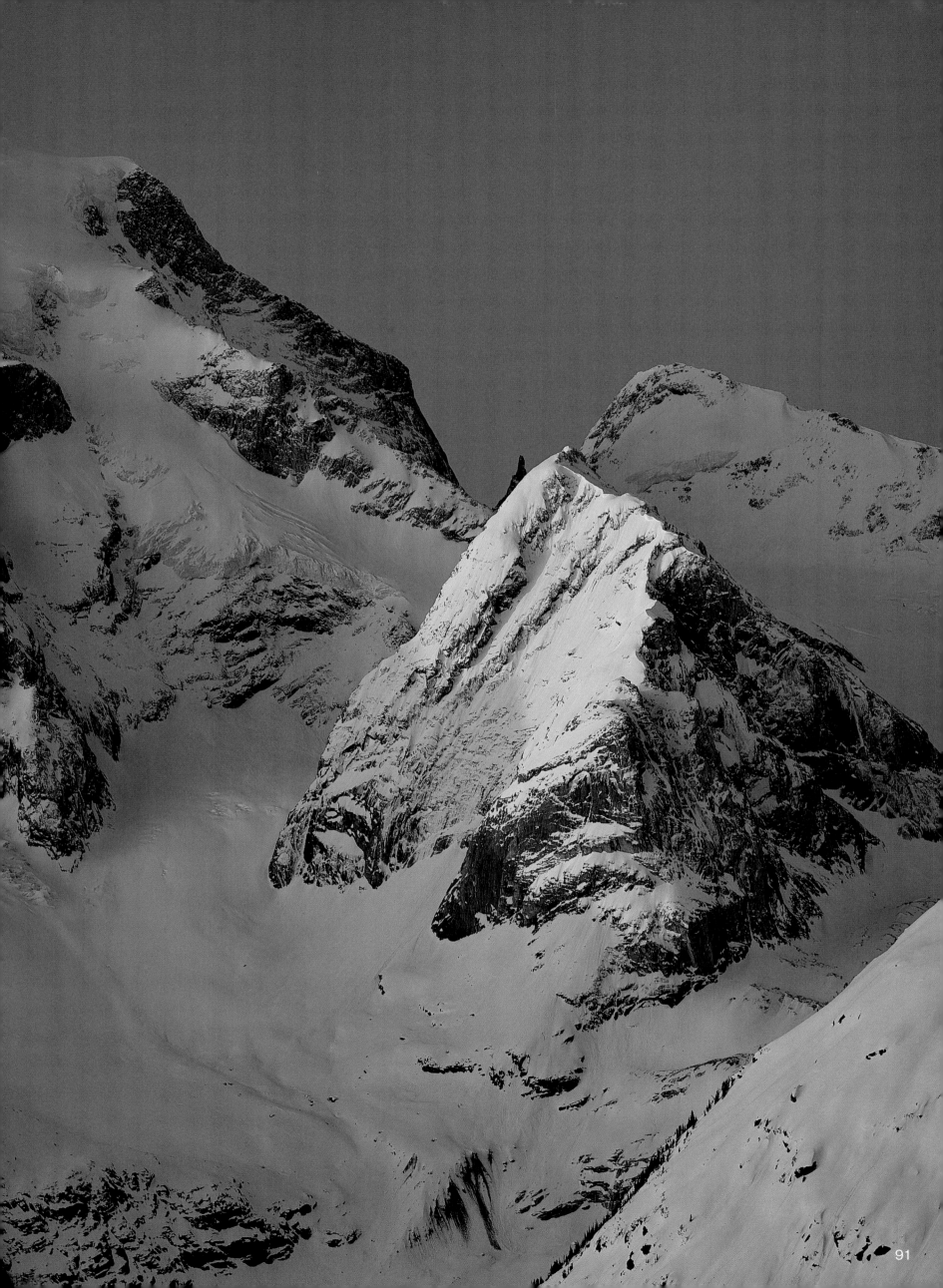

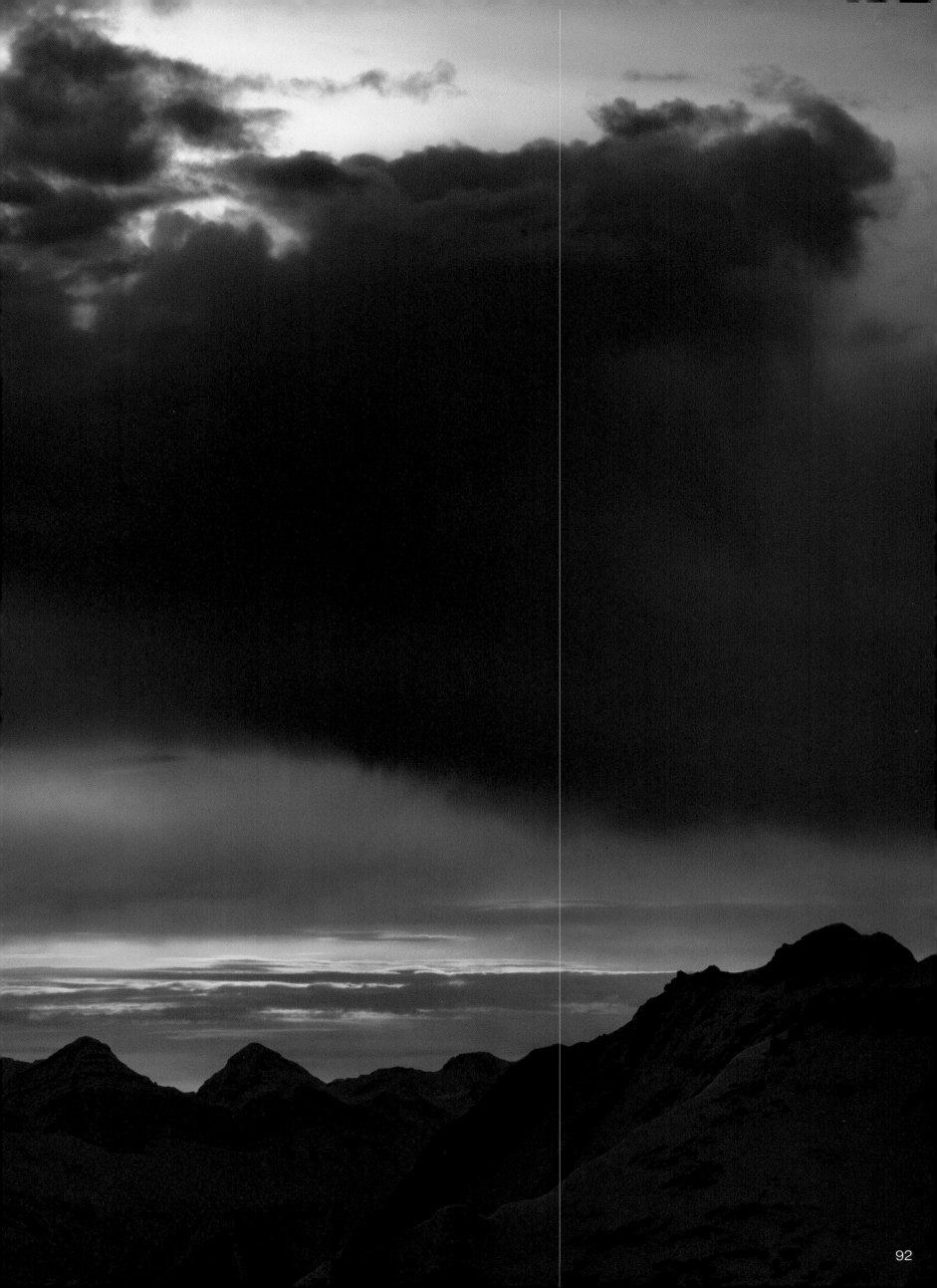

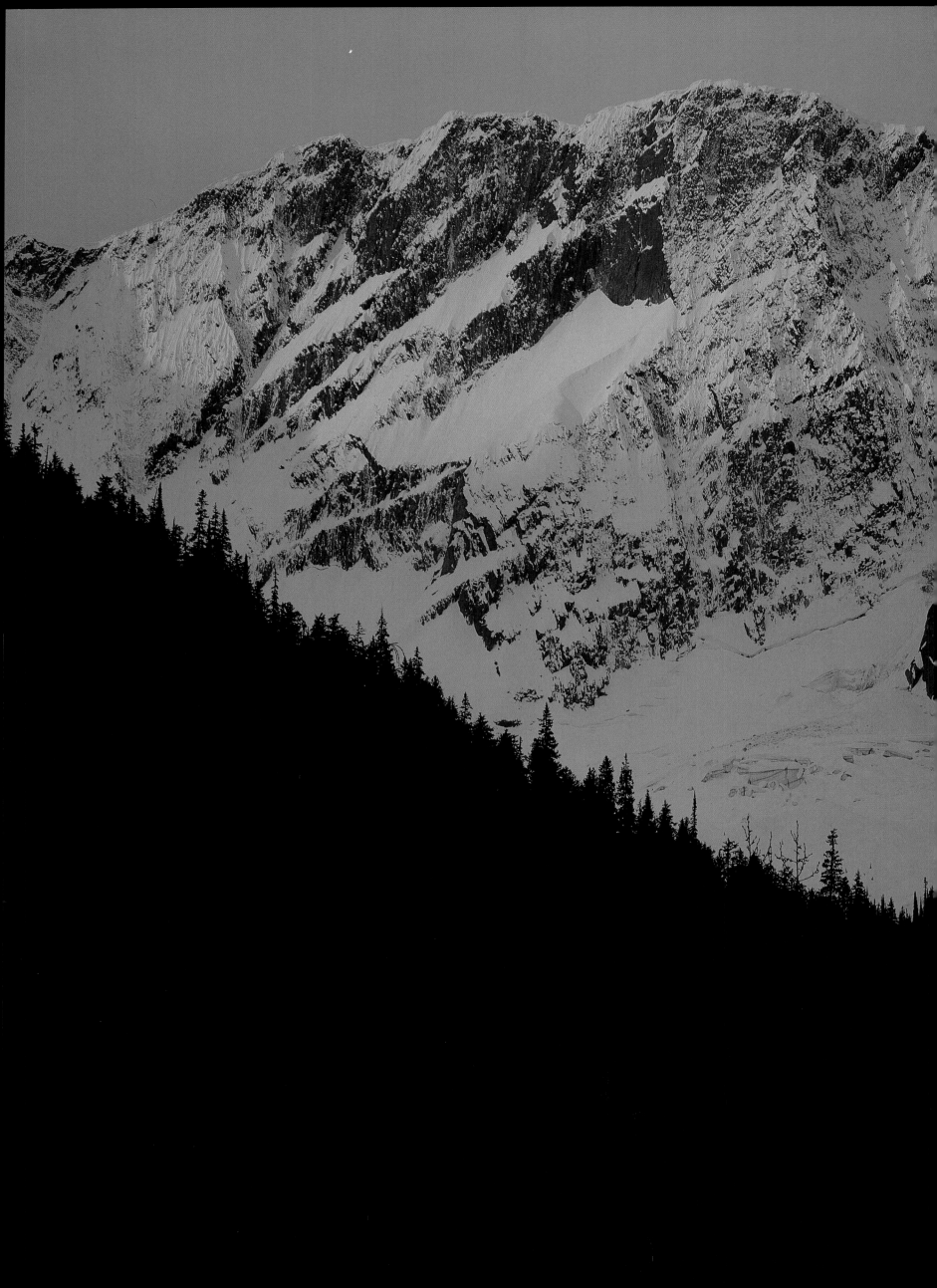

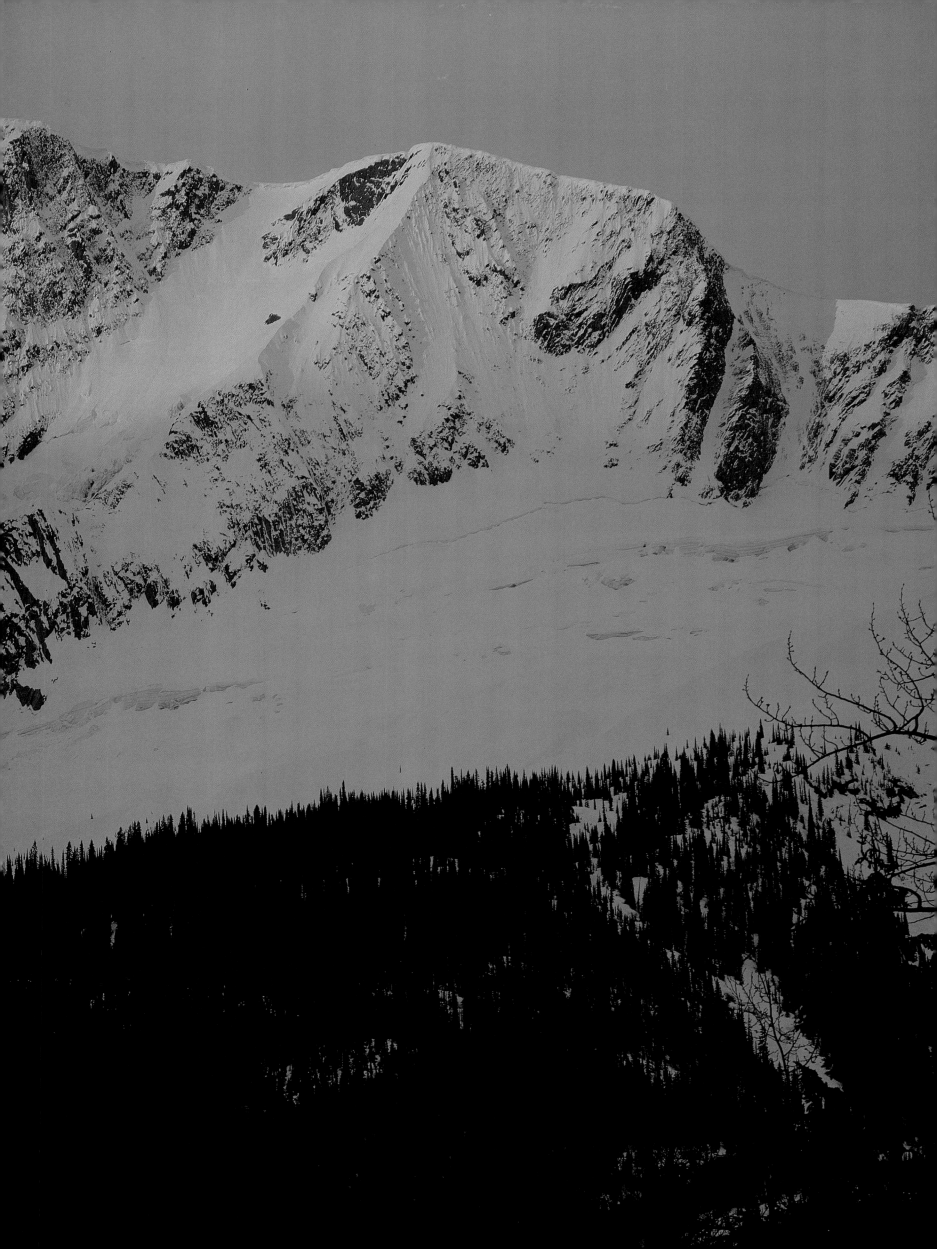

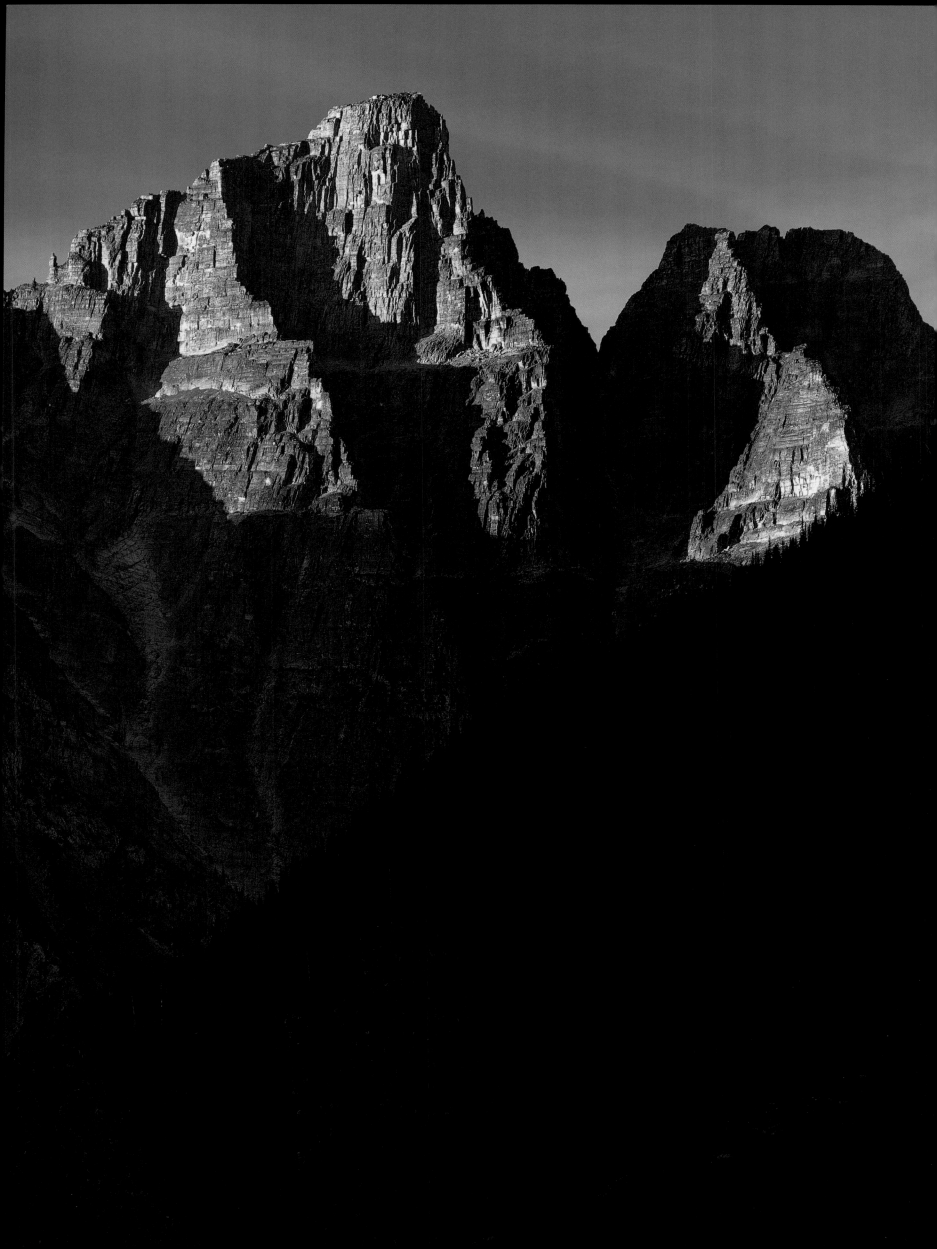

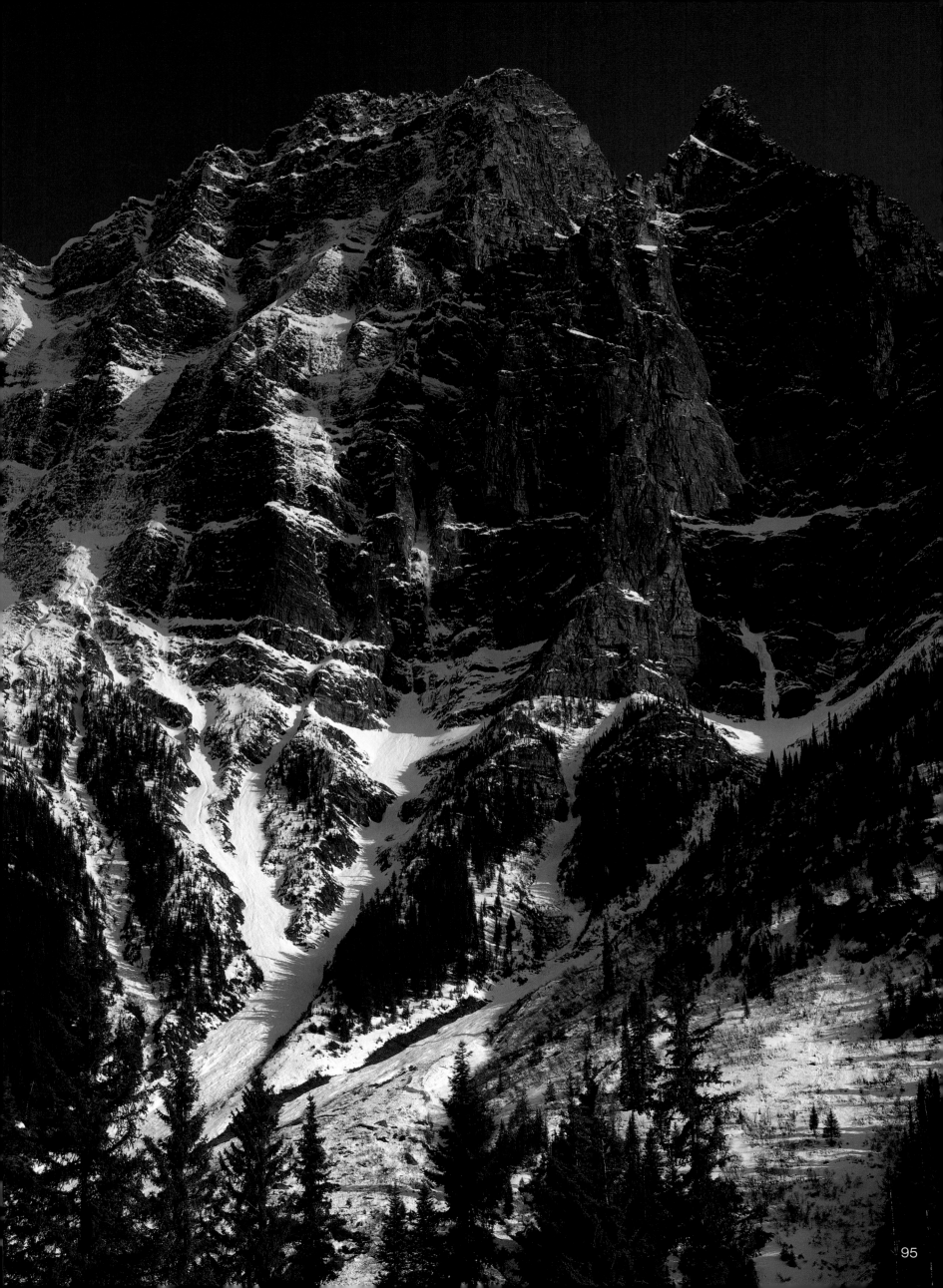

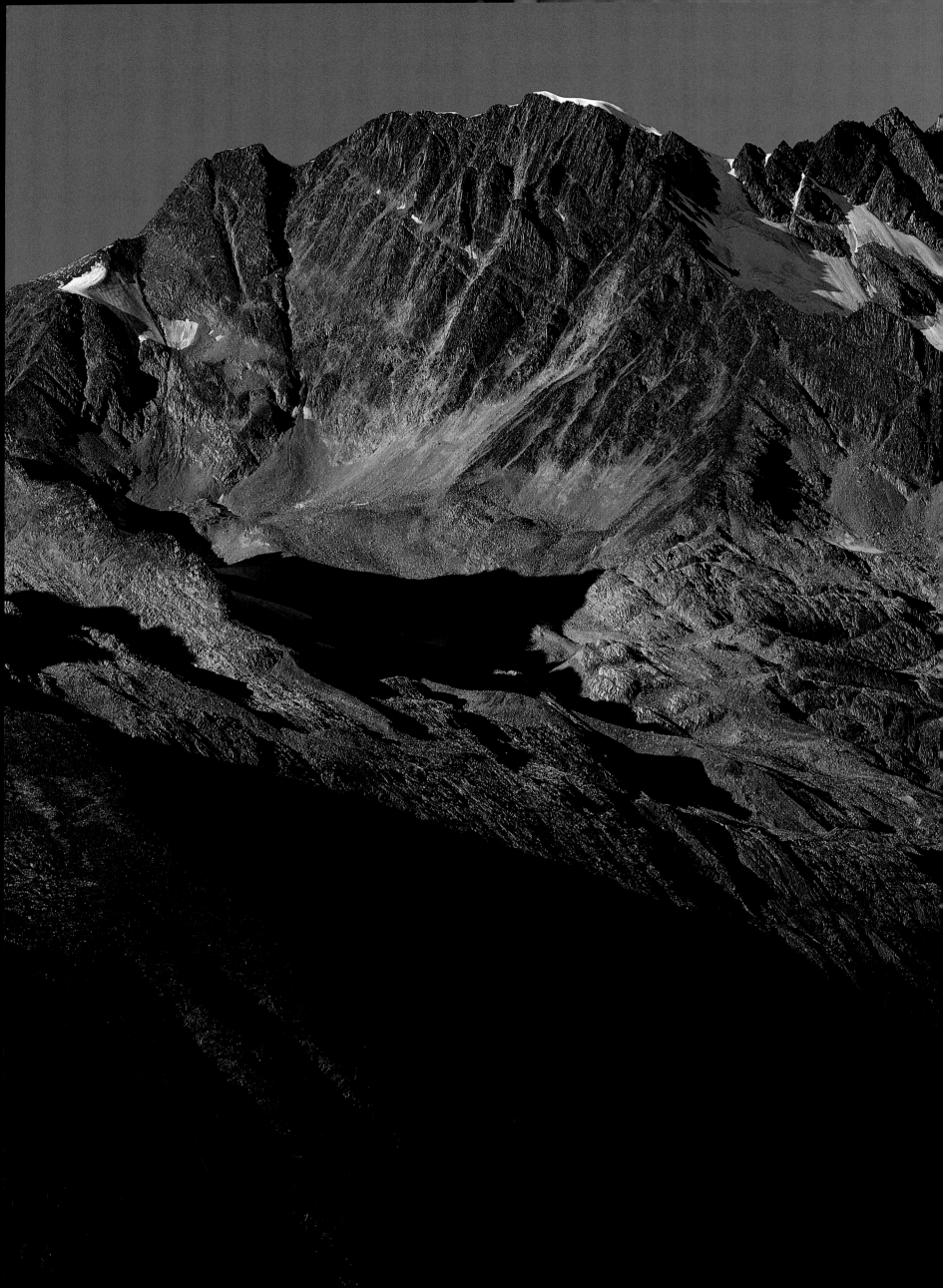

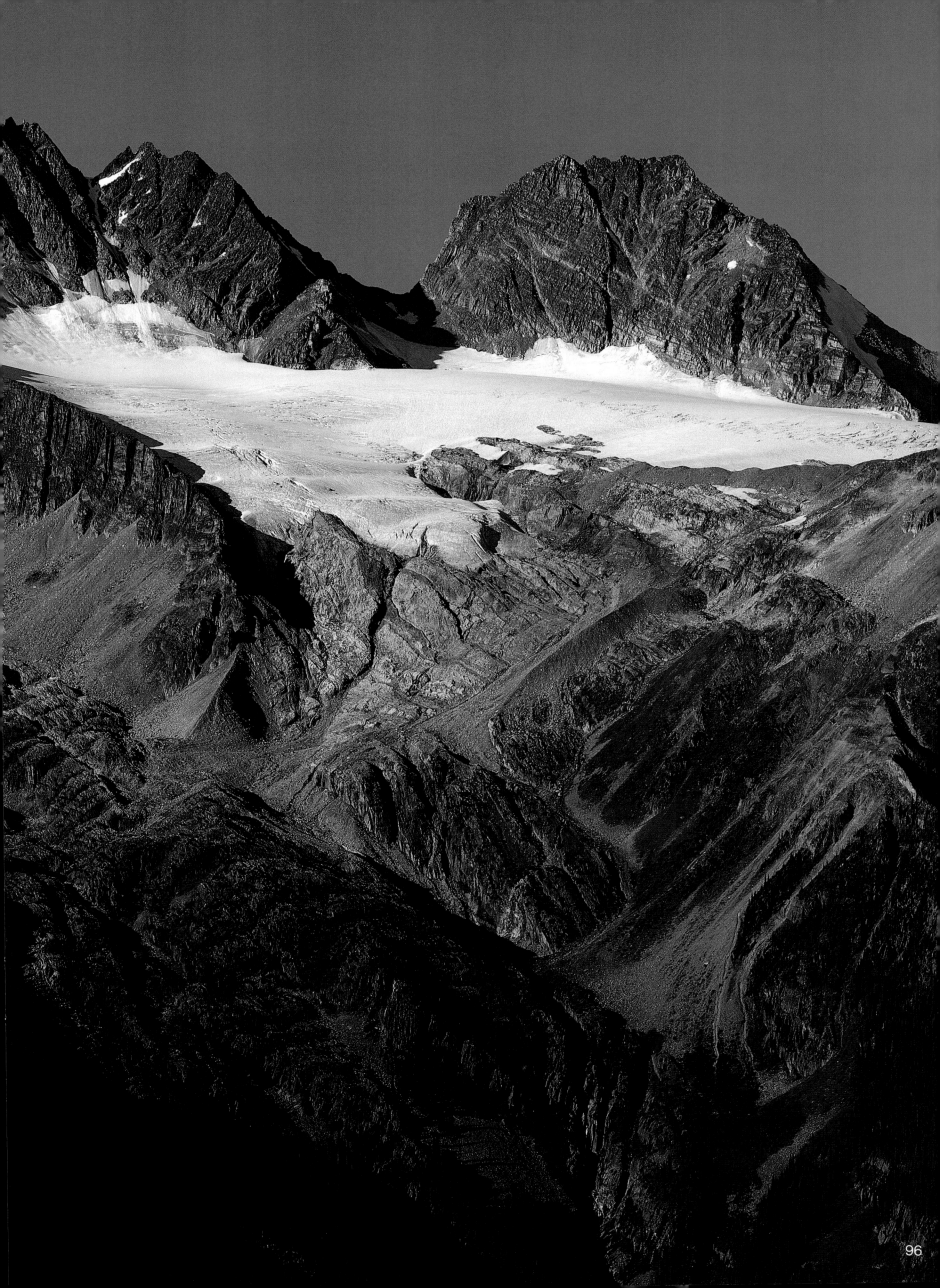

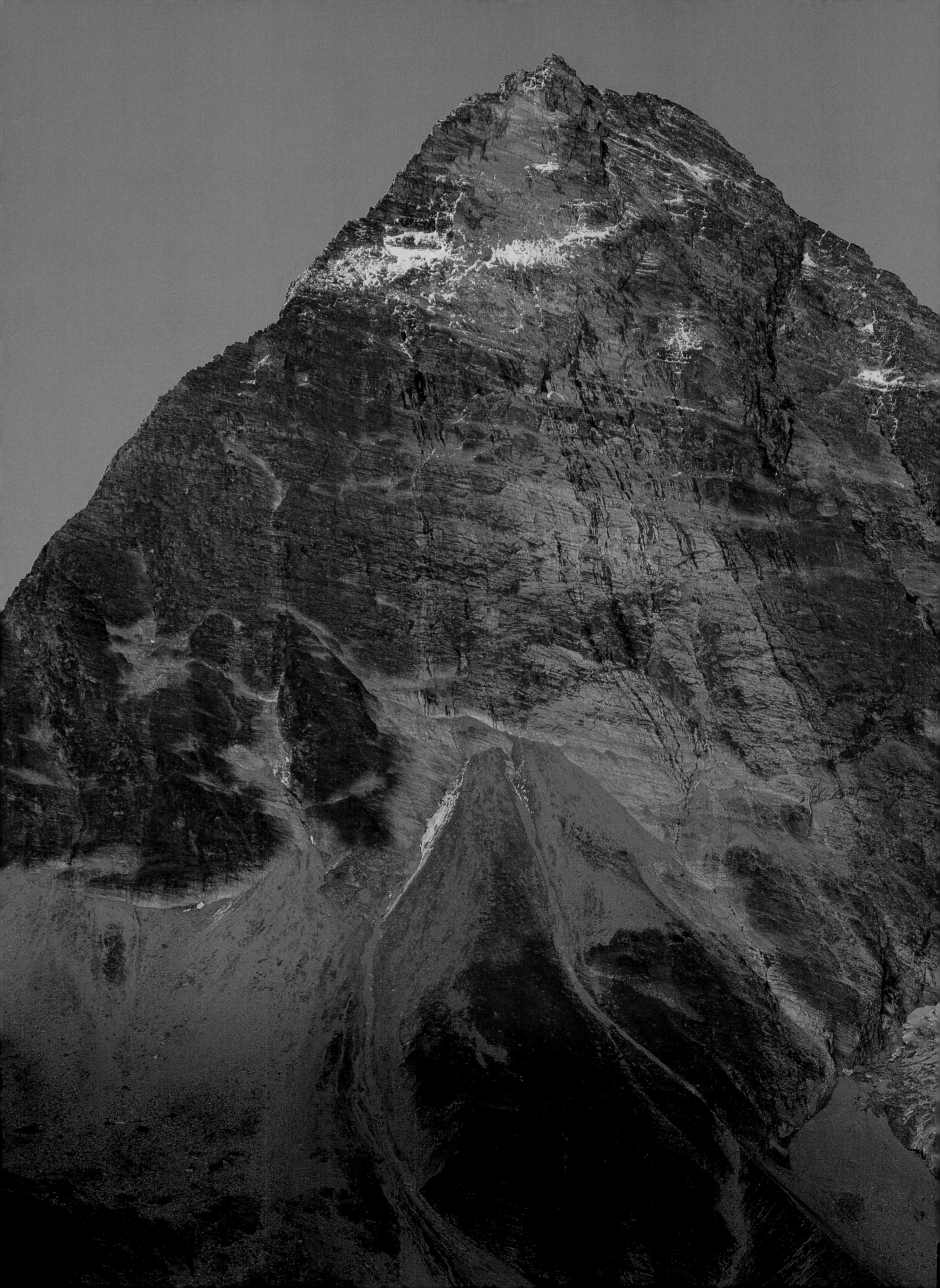

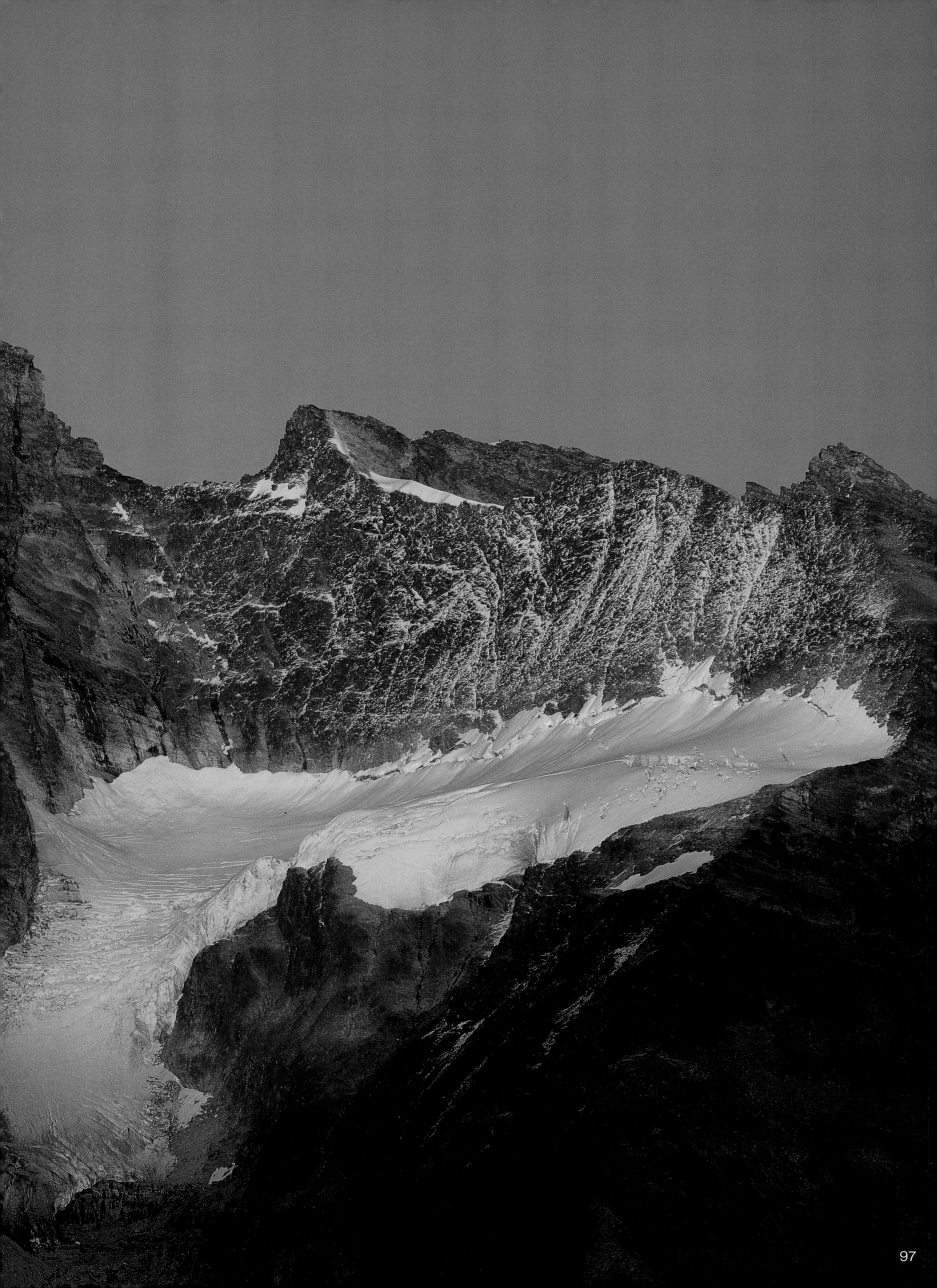

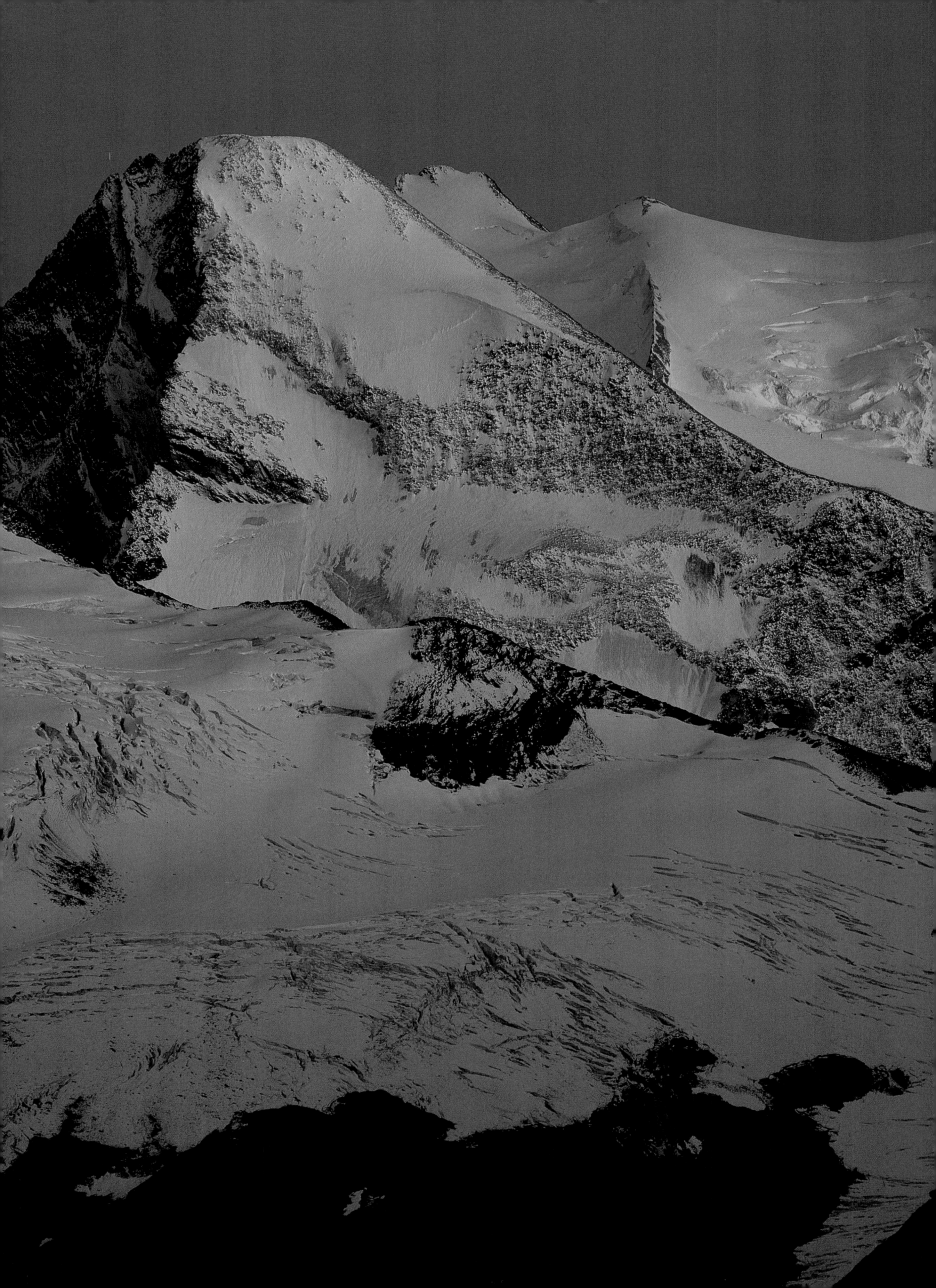

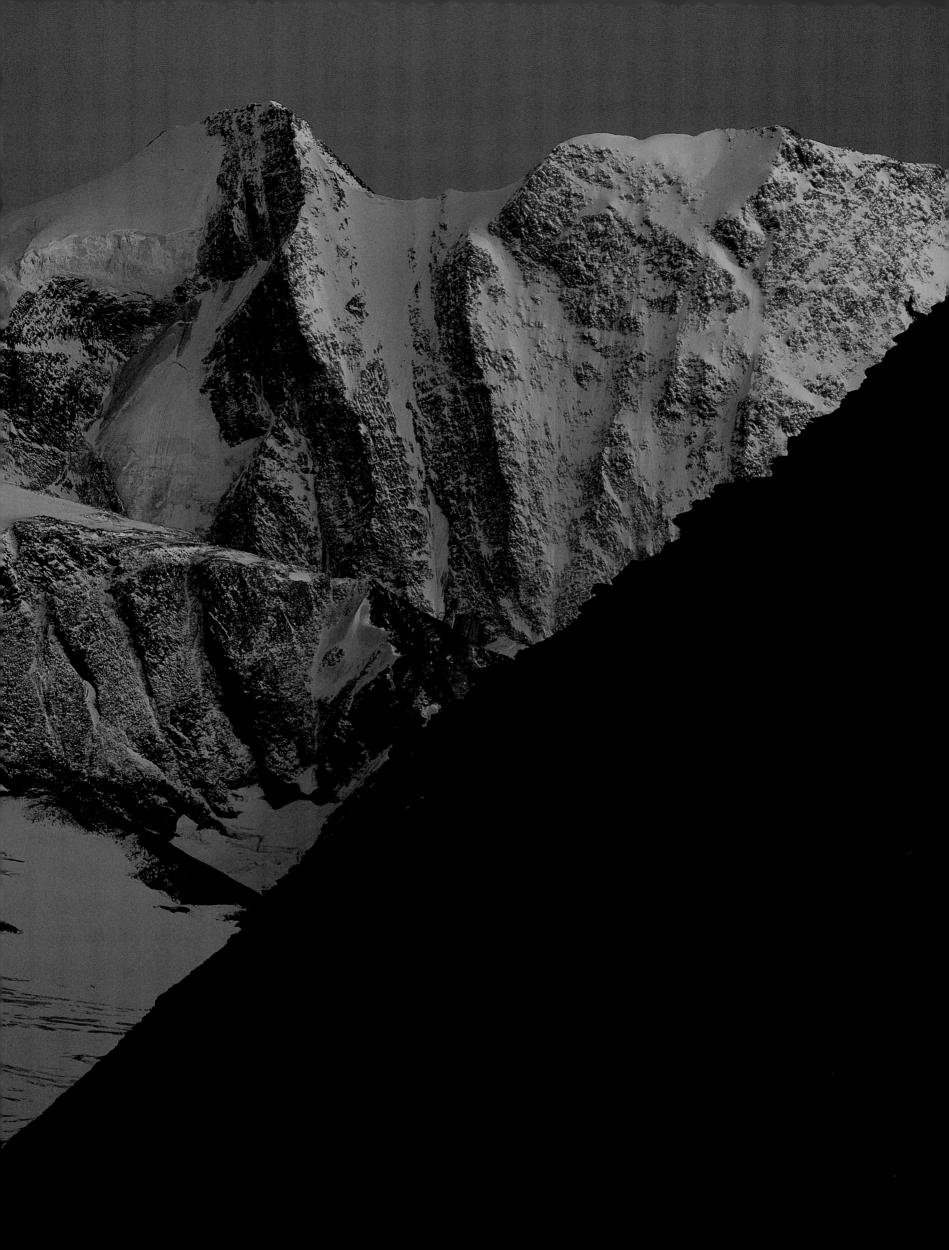

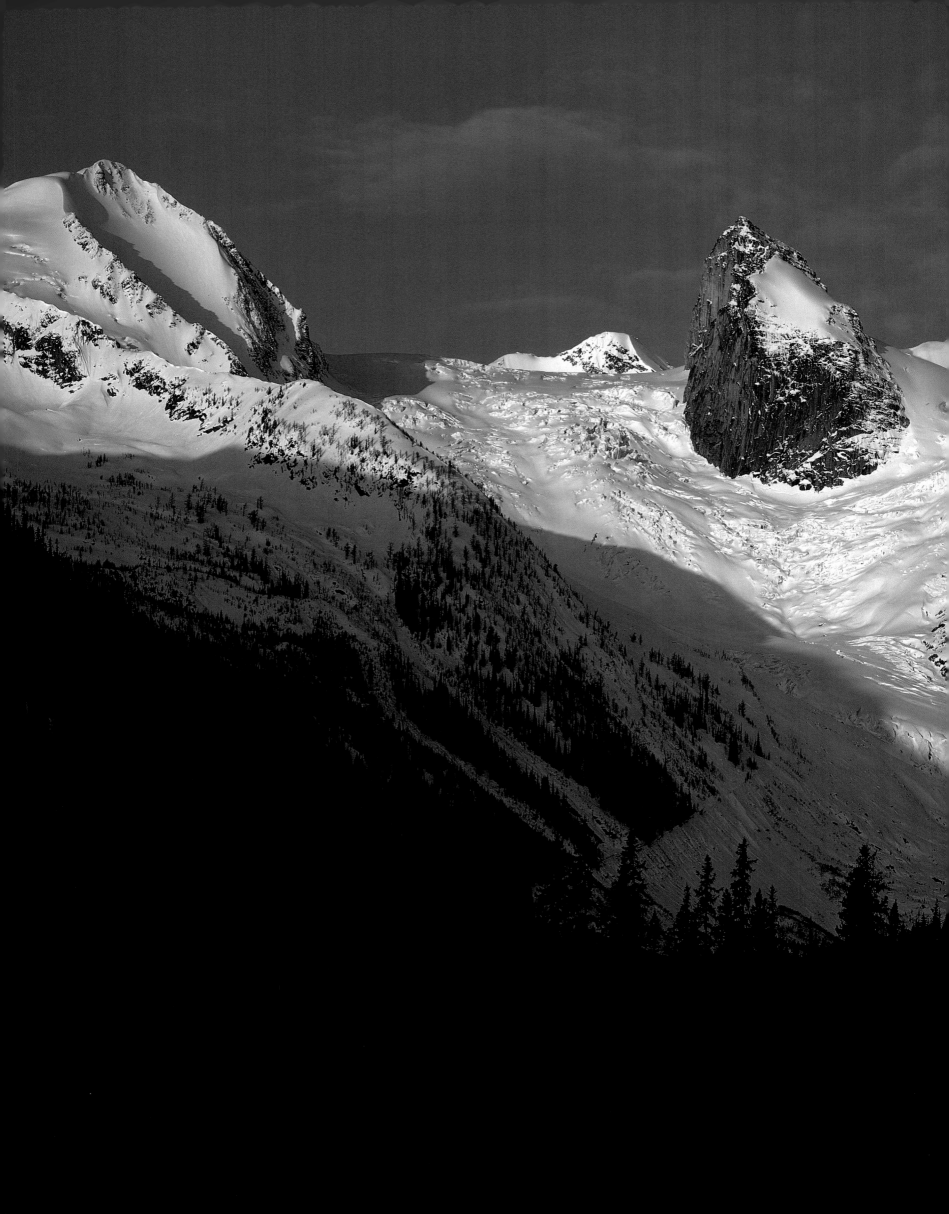

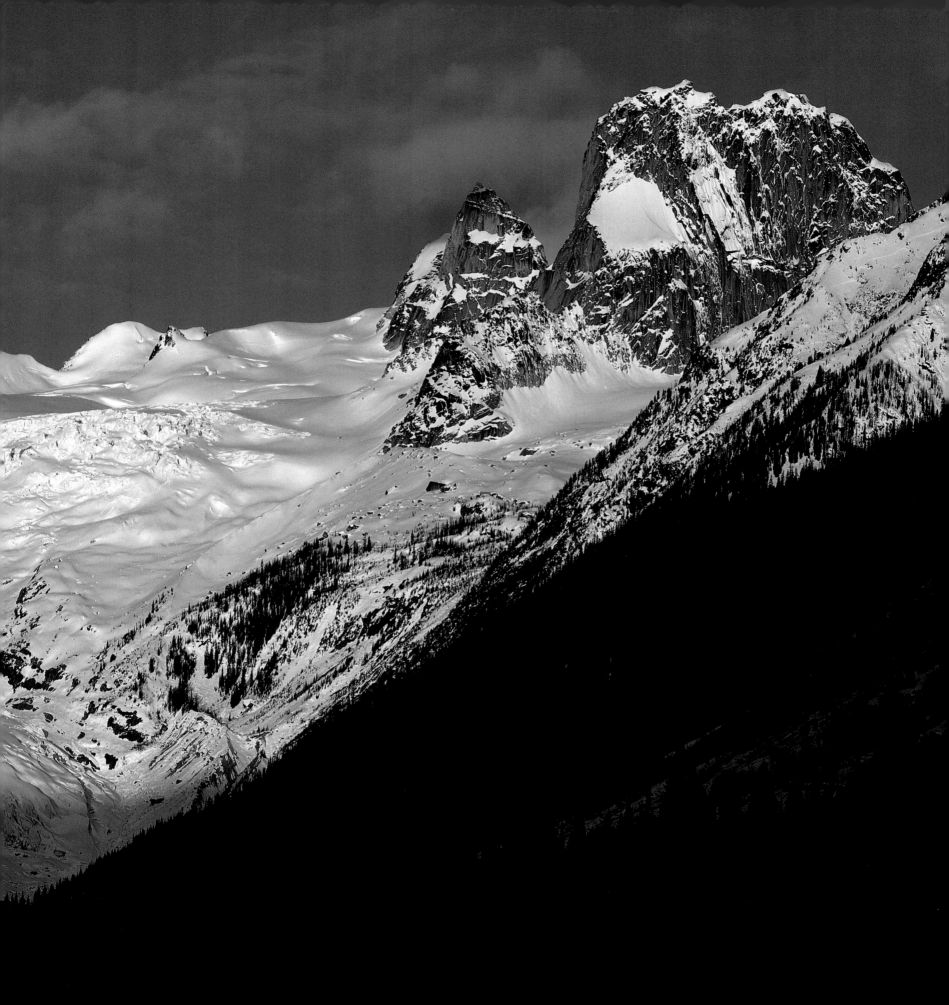

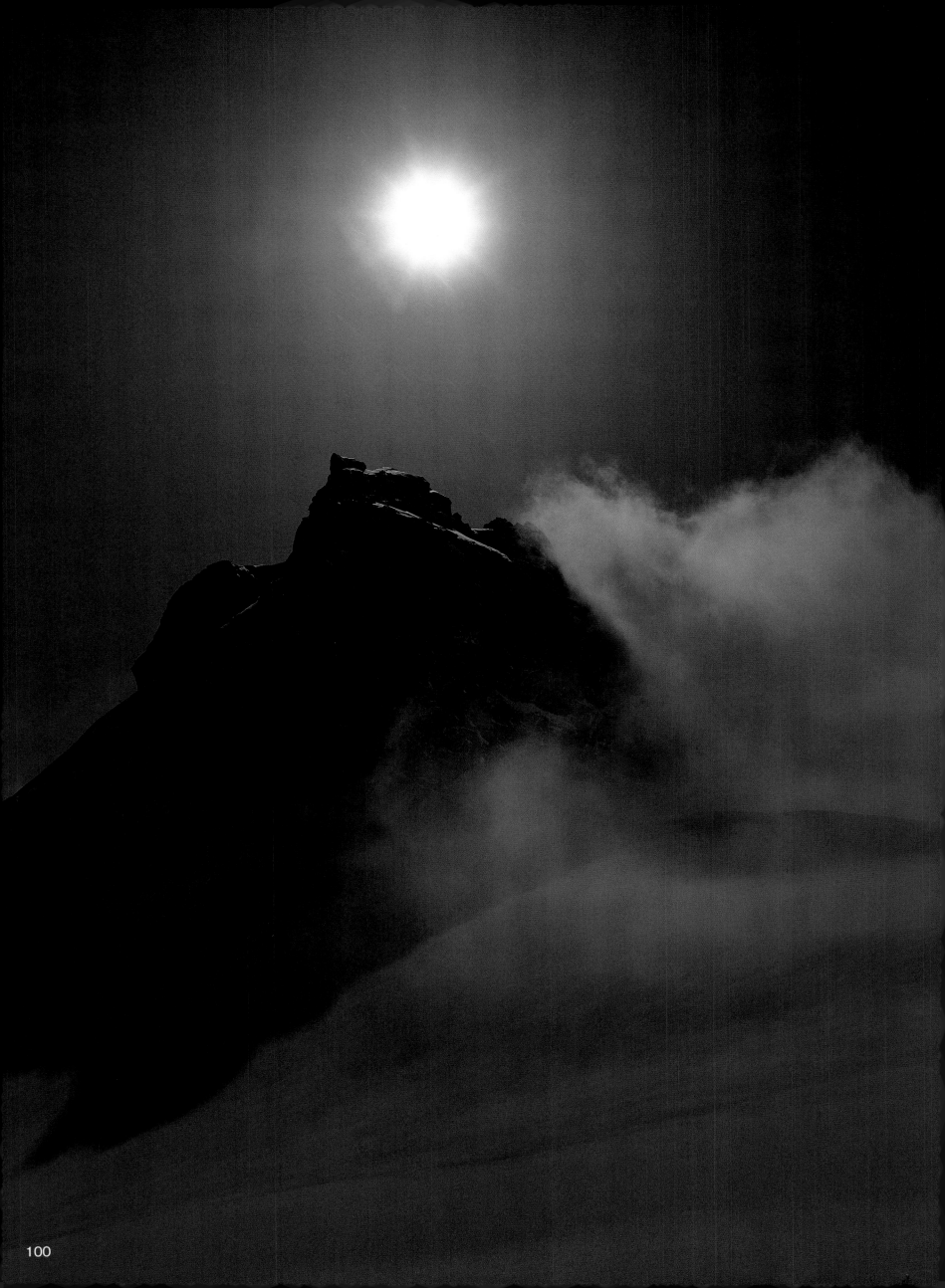

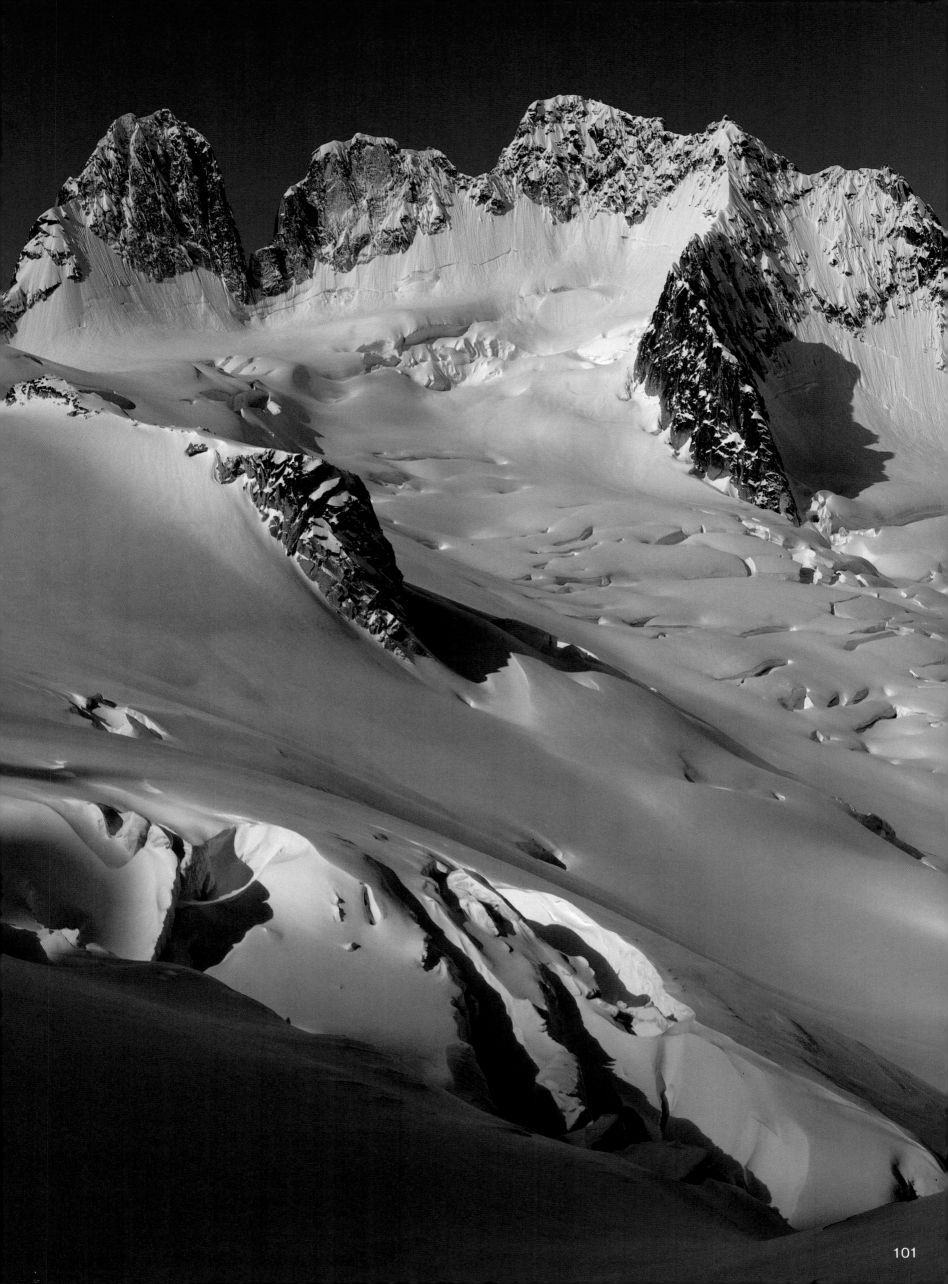

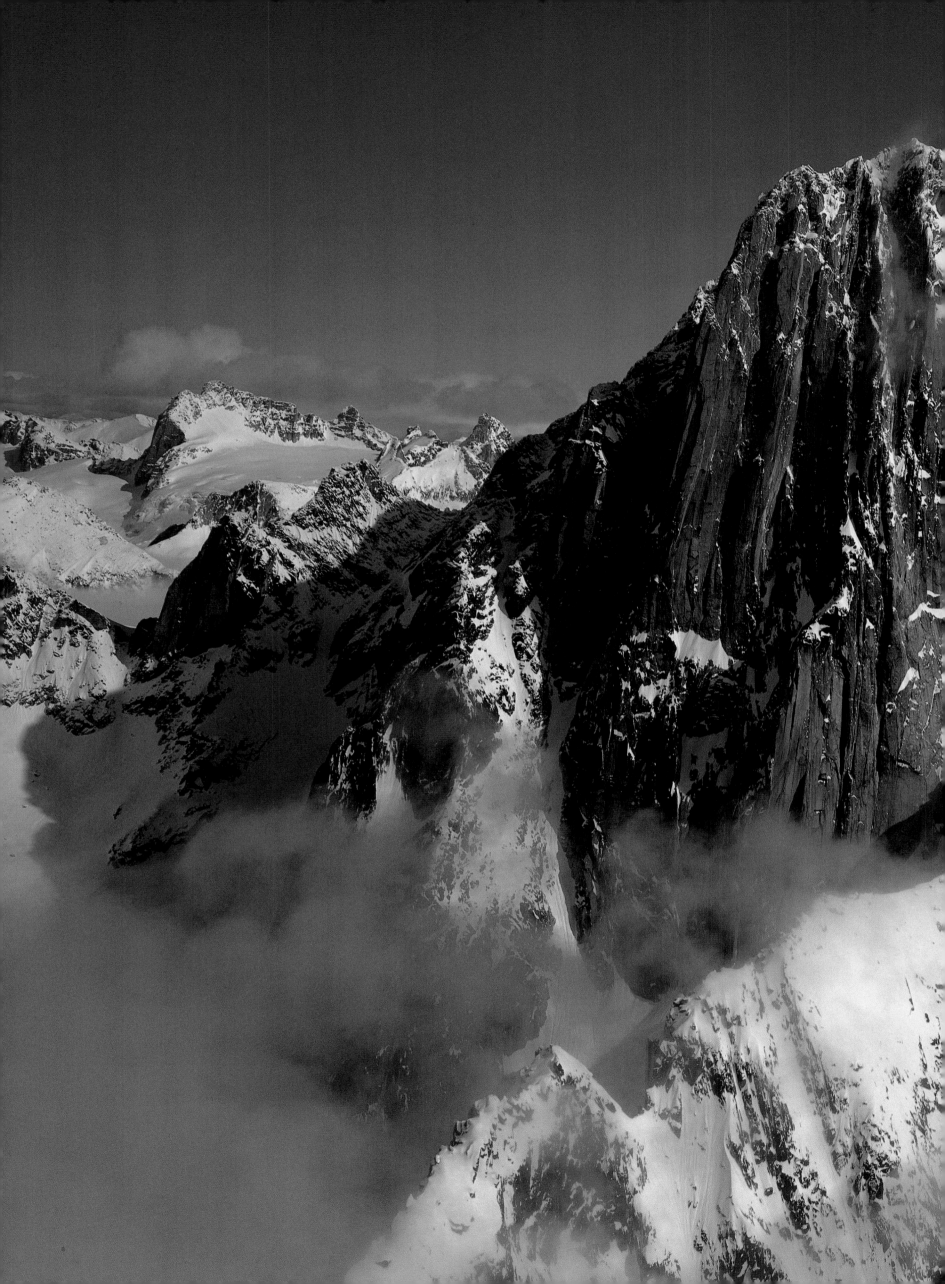

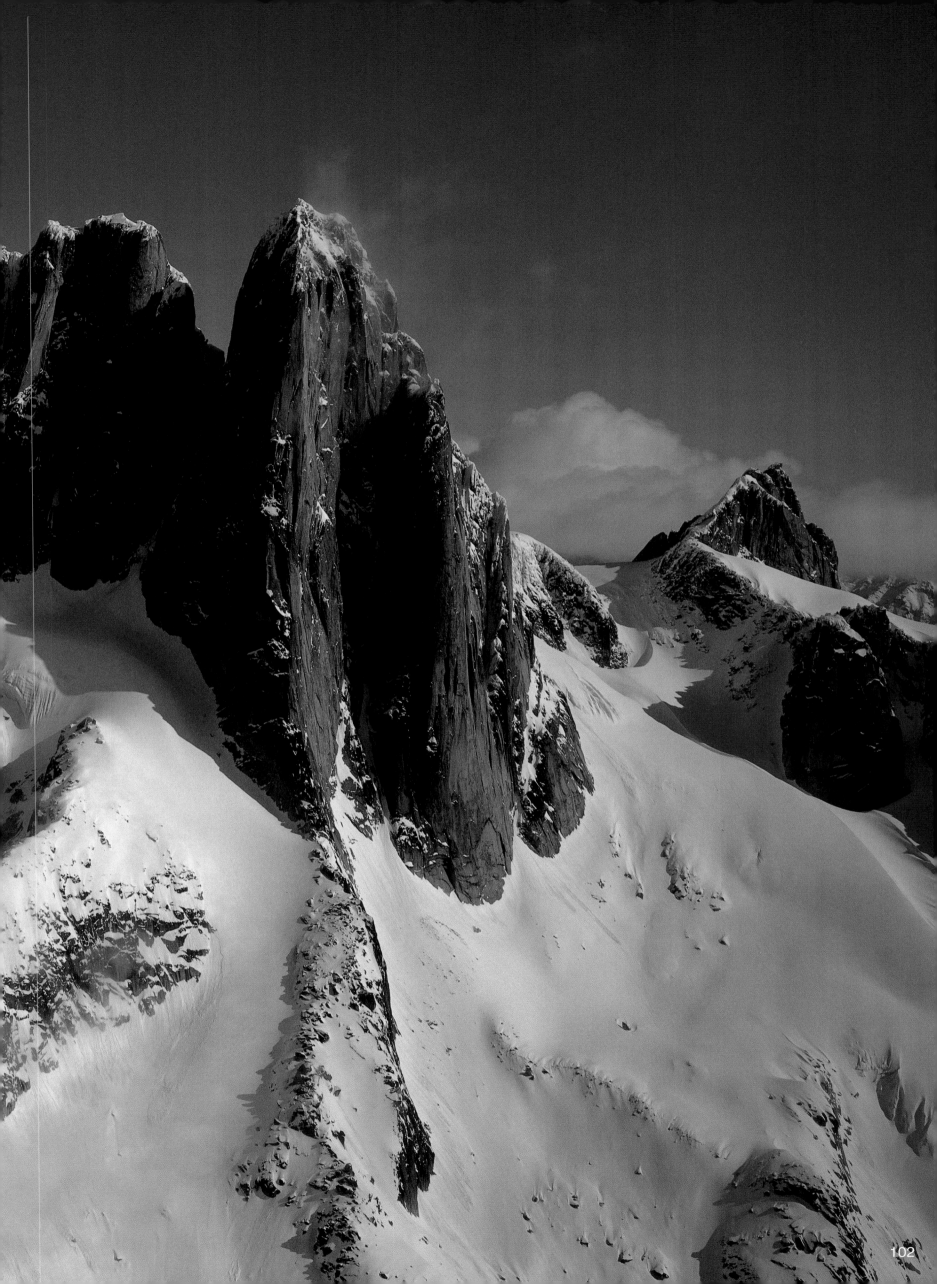

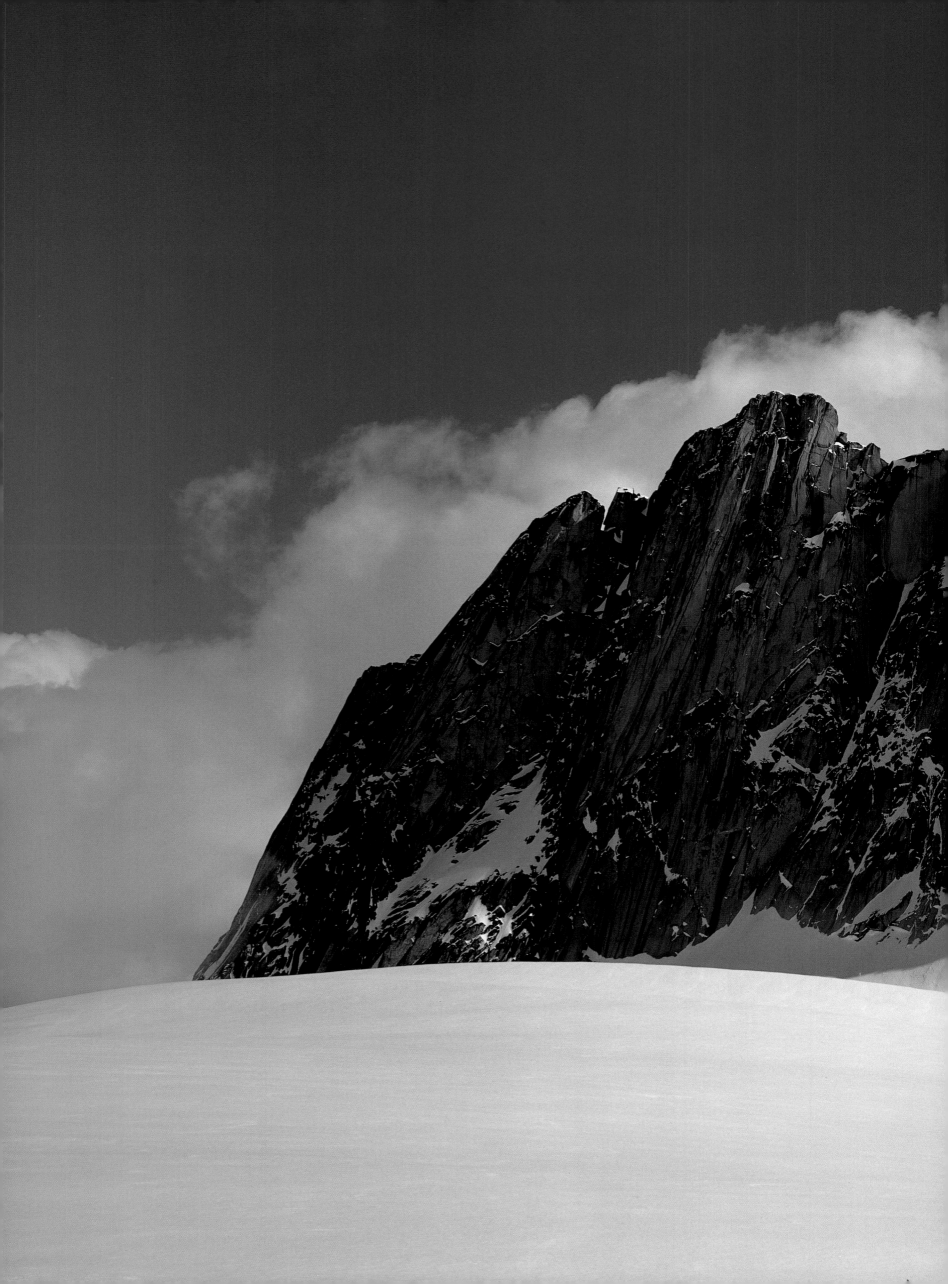

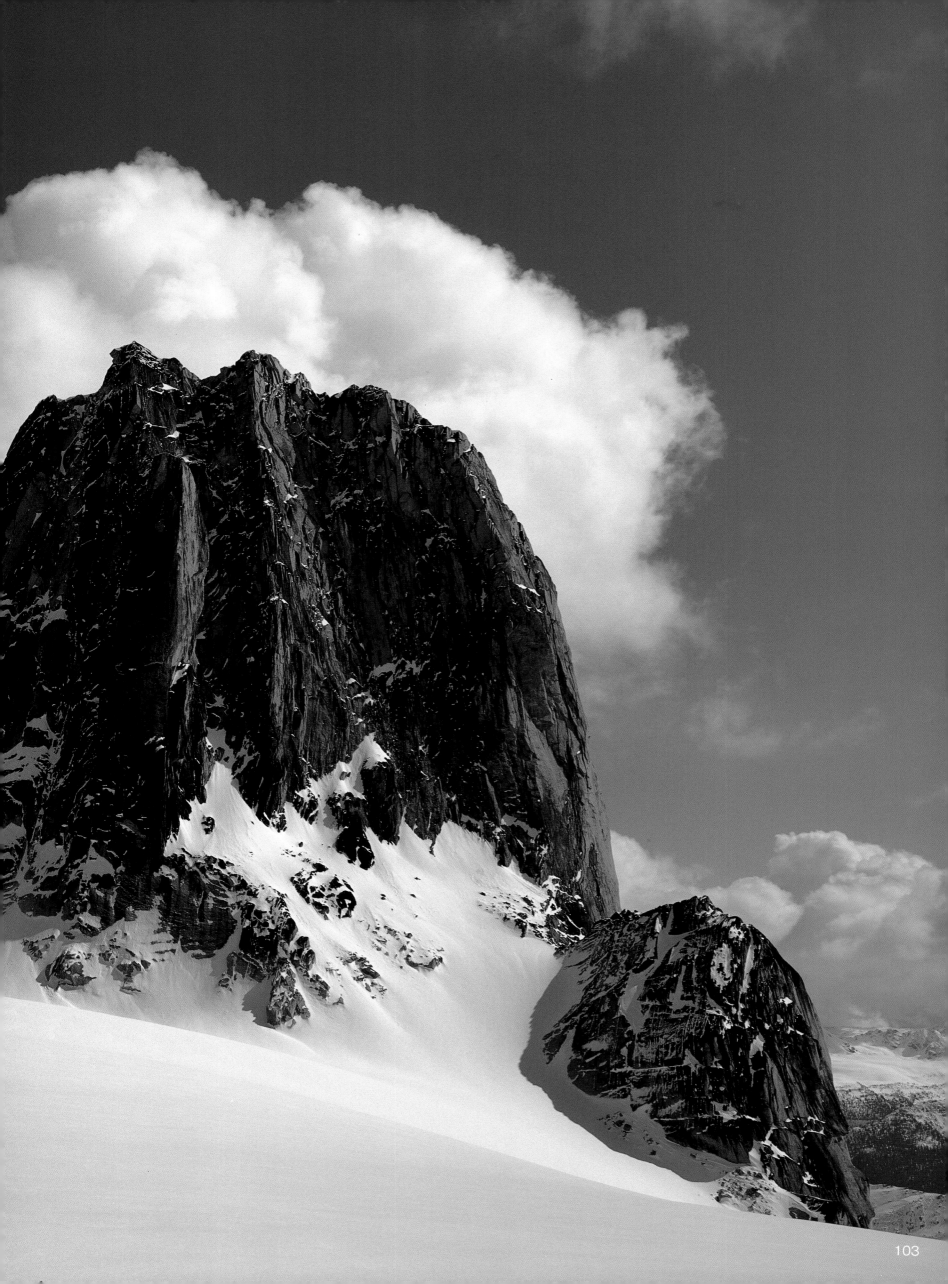

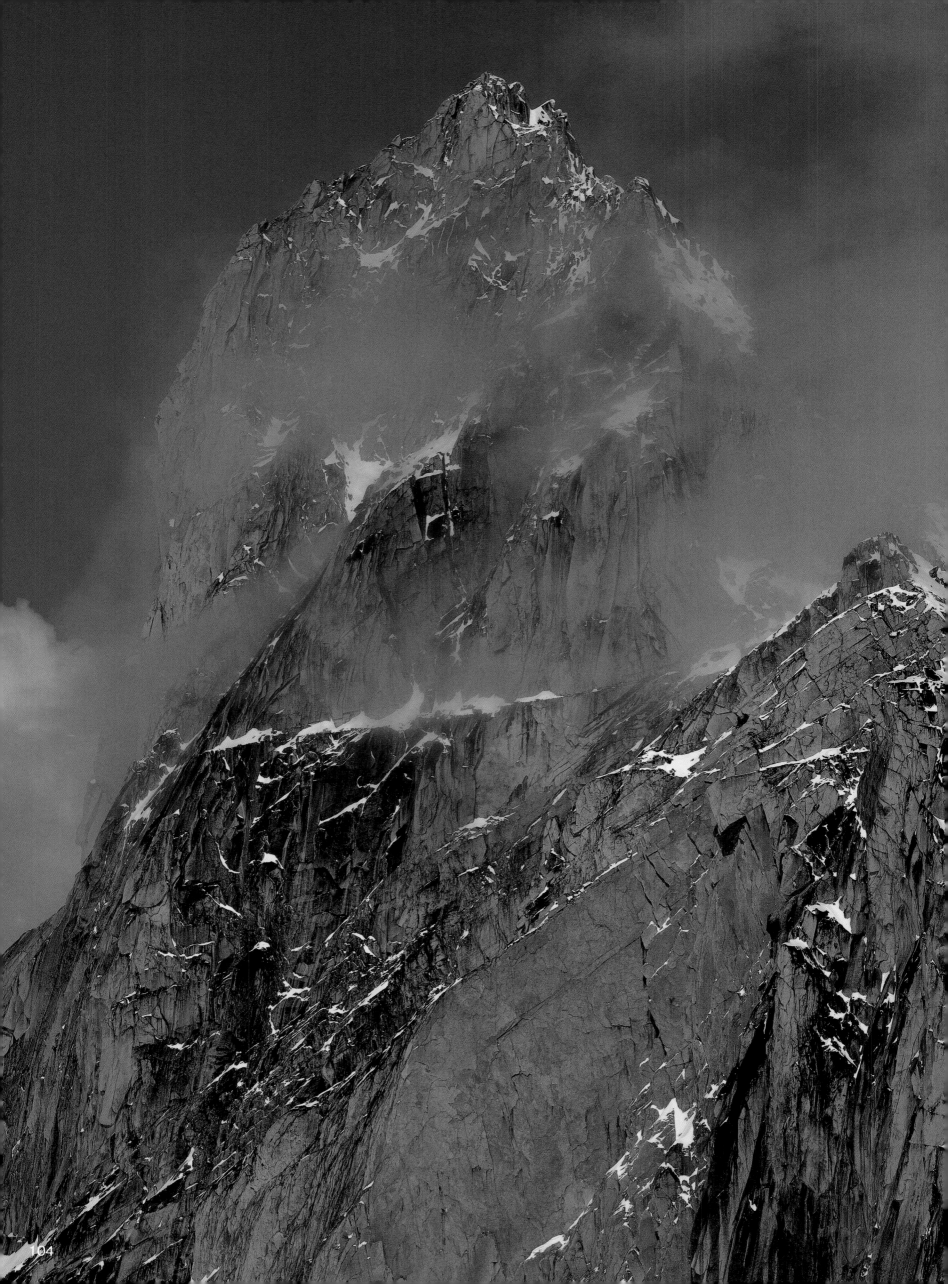

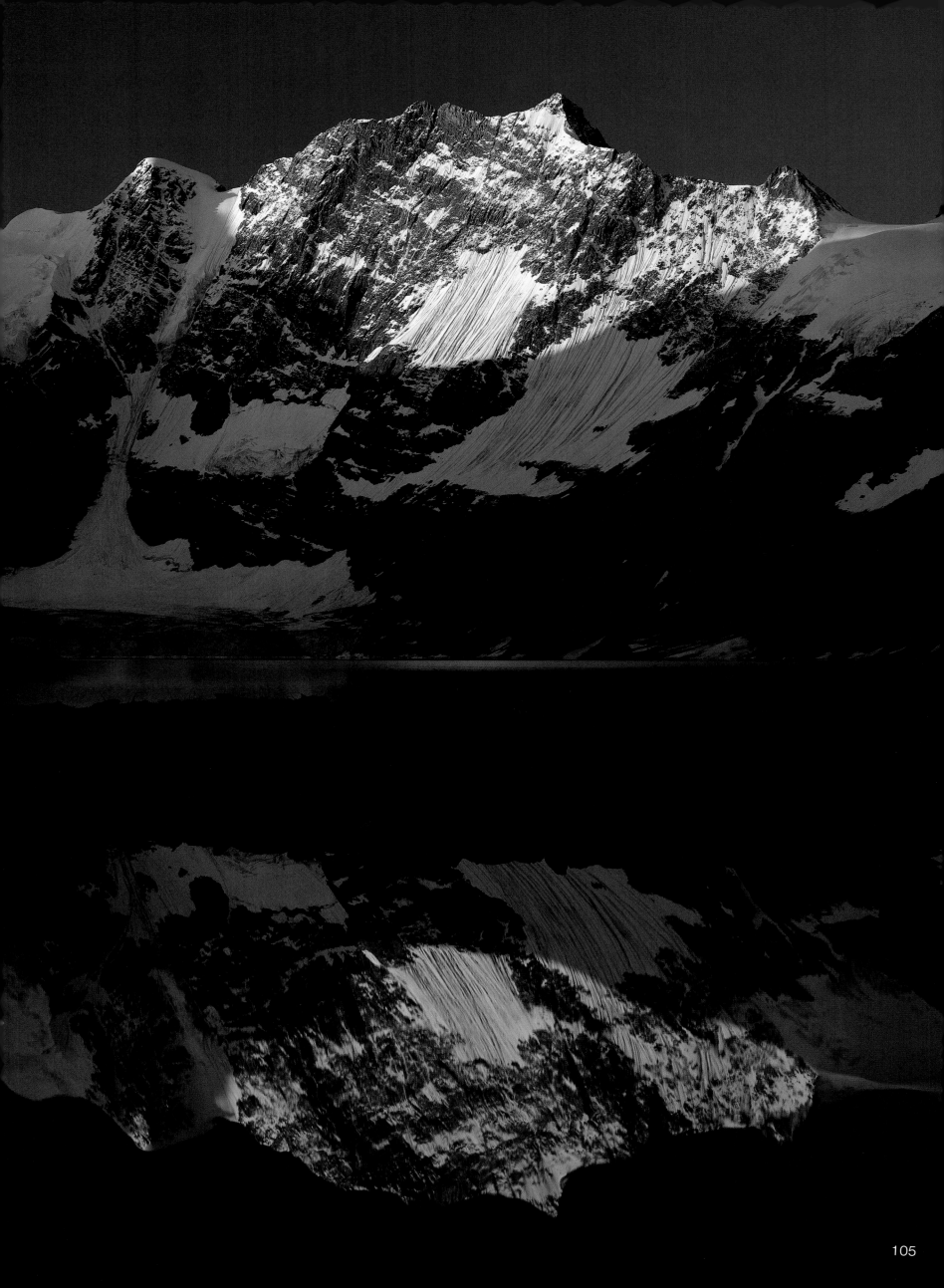

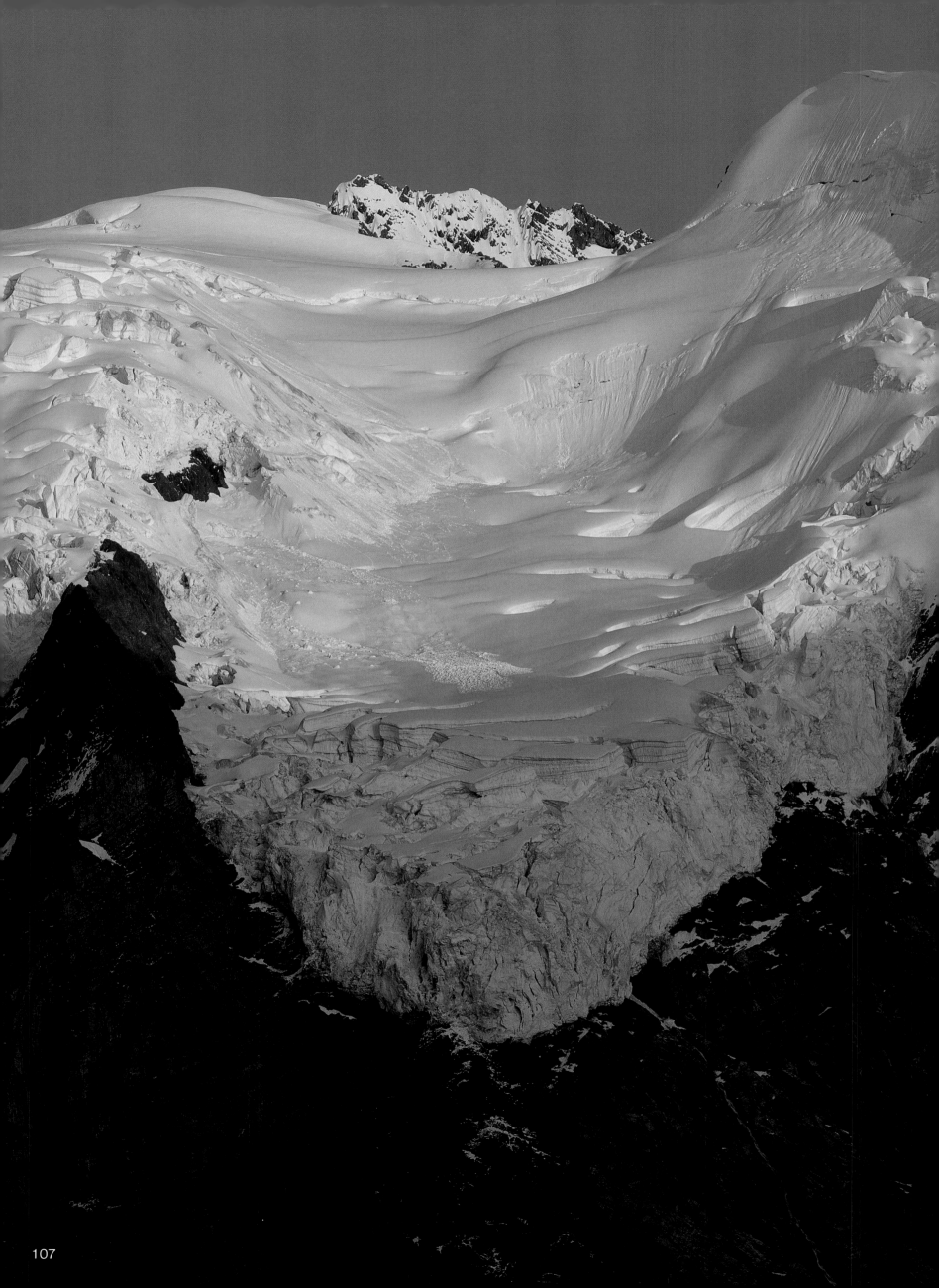

P A R T I

1. Mount Robson 3,954 meters

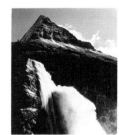

On the flank of the north shore of Berg Lake at an altitude of about 2,000 meters, I stamp the snow firm and pitch a tent. Mount Robson isn't visible in the thick fog. I have a hunch, however, that the weather will improve. In the past my hunches have brought me numerous opportunities to obtain good shots, but I have often been forced to get up early in the morning. The unpleasantness of rising early vanishes like mist when my expectations are met, as they are this morning. As if on cue, Mount Robson appears above the clouds as its colors change in the sunlight.

From the flank of the north shore of Berg Lake, late April
4×5 600 mm f32 1/2 sec SL + PL RVP

2. Robson Glacier and Resplendent Mountain 3,426 meters

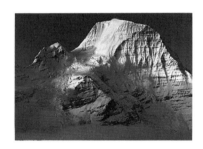

The water that flows out of Robson Glacier reaches the northwest side of Mount Robson to form Berg Lake. When it thaws, the meadow that I am walking through must be under water. While lost in such thoughts, I find myself standing at the end of Robson Glacier. The moraine is covered with mountain fireweed. Far beyond the moraine, I spot Resplendent Mountain. It soars over 3,400 meters. I am at an elevation of 1,650 meters, but Resplendent doesn't look as high as I thought it would. Perhaps it appears smaller due to its shape.

From the snout of Robson Glacier, mid-August
4×5 90 mm f32 1/8 sec SL RVP

3. Mount Robson and Emperor Falls

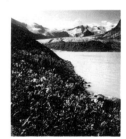

After spending two nights on Berg Lake, I leave my companions, who aren't good hikers, and take the path to Kinney Lake. As I turn left and hike down through the forest, the sound of a waterfall grows louder. Before long I arrive at Emperor Falls. The water descends in two steps. Its volume and strength are overwhelming. The spray caused by the waterfall drenches my camera like rain. Changing the lenses and moving from one place to another, I keep pressing the shutter. The unparalleled view never bores me.

From Emperor Falls, mid-September
4×5 180 mm f16 1/60 sec SL RVP

4. Mount Robson

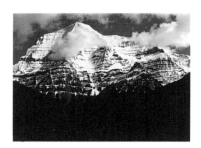

When I first visited Mount Robson 13 years ago, I was unable to see much because of the torrential rain. Nevertheless, the parking lot of the Mount Robson Visitor Centre was crowded with tourists. Mount Robson is the highest peak in the Canadian Rockies, but that isn't its only attraction. This mountain's many charms draw huge crowds. Today, however, there are few people, which we greatly appreciate. We can take as much time as we want to set up our tripods without worrying about disturbing other visitors.

From the Mount Robson Visitor Centre, early September
4×5 400 mm f22 1/30 sec SL RVP

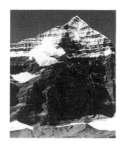

5. Whitehorn Mountain 3,395 meters

When you travel a little distance from Berg Lake toward Emperor Falls, you start to see Whitehorn Mountain. Rising up from the glacier in one stretch, the mountain's pyramid form looks simple, yet very attractive. Behind it, on the right, stands Mount Phillips with a bigger glacier that can't be seen because it is blocked by Whitehorn. Phillips is less than 150 meters lower than Whitehorn, but this difference is enough to make the latter mountain stand out. I never get tired of gazing at the sharp, soaring peak of Whitehorn Mountain set against the deep blue sky.

From the southwest side of Berg Lake, mid-September

4×5 400 mm ƒ22 1/15 sec SL + PL RVP

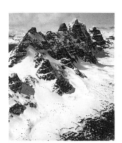

6. Mount Geikie 3,270 meters

At the north end of the The Ramparts there is a ridge that stretches west from Bastion, 2,970 meters. Mount Geikie is located in the center of this ridge, or the second from the right in this photograph. Accompanied by Turret, 3,120 meters, on the east, and Barbican, 3,120 meters, on the west, Mount Geikie has the dignified air of a king. The approach to The Ramparts is possible only from the east side or from Amethyst Lake. If you approach from the west side, you will have to travel alongside the Fraser River for many days. This view is taken from the northeast side of The Ramparts.

From the sky over Tonquin Pass, late April

6×9 ƒ16 1/250 sec RDP

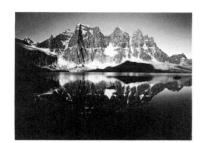

7. The Ramparts

The Ramparts are west of Amethyst Lake, which is approached from the Tonquin Valley. Among many other peaks, Mount McDonnell, 3,338 meters, is the highest. Because it is on the south end, you can't see it from Amethyst Lake. Instead, you get a glimpse of Bennington, 3,265 meters, which is north of Mount McDonnell. The southernmost peak is Oubliette, 3,090 meters. On its left, Paragon, 3,030 meters, shows its tri- angular shape, and on the right are Dungeon, 3,130 meters, and Redoubt. Altogether they present a beautiful complexity.

From Amethyst Lake, early September

4×5 120 mm ƒ32 1/8 sec SL RVP

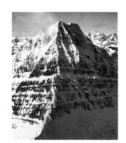

8. Mount Edith Cavell 3,363 meters

Mount Edith Cavell is a solitary mountain, which is often the case in the Rockies. Together with several other peaks from the south to the west, Mount Edith Cavell is part of the Cavell Group. To reach the summit of Edith Cavell, climbers commonly take the direct route, with a constant view of the north face, or the east ridge route, which follows the ridge line in the center. Situated on the east ridge is the east summit, which is slightly lower than the west summit. Returning from the Hooker Icefield, I come across an unexpected camera angle. I am able to capture Edith Cavell with the east ridge in the center – a view I had seen from only one angle before.

From the sky on the east, late April

6×9 ƒ16 1/250 sec RDP

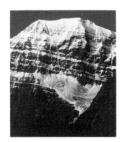

9. Mount Edith Cavell

Mount Edith Cavell is one of the most popular peaks in Jasper National Park. Although I have visited this mountain almost a dozen times, I can never seem to find a good camera angle. This time, however, I find the perfect spot, looking straight out at the mountain's magnificent north face. In fact, this angle provides a view that even encompasses the base of the face. Leaving the Wabasso Campground before dawn to get this shot, I soon glimpse the glow of morning as the day's impressive drama begins.

From the heights of the shore of the Astoria River, mid-July

4×5 600 mm ƒ32 1/4 sec SL RVP

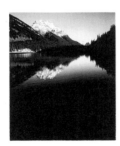

10. Horseshoe Lake and Mount Kerkeslin 2,950 meters

If you drive south from Jasper on the Icefields Parkway, you will find Horseshoe Lake just before reaching Athabasca Falls. Although Horseshoe Lake is next to the highway, it is hardly visited by tourists. This beautiful lake quietly reflects Mount Kerkeslin in the background. As a result of my many road trips along the parkway, I have become quite familiar with Kerkeslin. It isn't a high mountain, but it often displays unexpected aspects that entice me to pick up my camera.

From the shore of Horseshoe Lake, mid-May

4×5 90 mm ƒ32 1/15 sec SL RVP

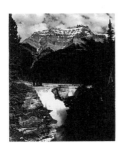

11. Athabasca Falls and Mount Kerkeslin

The Sunwapta River begins at Sunwapta Pass, which is located in the eastern part of the Columbia Icefield. West of this river, the Athabasca River has its source in the ridge that connects the peaks of The Twins, Snow Dome, Columbia, King Edward, and Chaba. The Sunwapta and Athabasca meet past Sunwapta Falls and continue to collect more water until, west of Mount Kerkeslin, the torrent becomes Athabasca Falls as it plunges over a rock step in two magnificent streams. On a good day the fortunate can see Mount Kerkeslin looming over the falls.

From Athabasca Falls, early July

6×9 90 mm ƒ22 1/125 sec SL RD

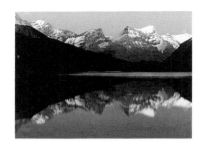

12. Maligne Lake and the Mount Brazeau Group

As is typical of a glacial lake, Maligne Lake stretches sinuously through the mountains. It is the largest natural lake in the Canadian Rockies. From Maligne you can see Mount Brazeau, 3,470 meters, and various other peaks. However, the only access to the area where this shot was taken is by canoe. Even though I have visited Maligne Lake many times, my heavy equipment load always prohibited me from making a canoe trip to this area. Finally, however, I am able to capture the majestic Mount Brazeau Group in all its glory at sunset, reflected in the limpid waters of Maligne.

From the northwest end of Maligne Lake, early October
4×5 600 mm ƒ32 1 sec SL RVP

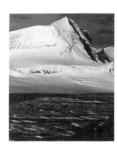

13. Mount Hooker 3,286 meters

When the helicopter lands on the Hooker Icefield, the fog finally starts to dissipate, revealing the surrounding mountains. The landing place is a little below the summit of Ermatinger, 3,060 meters. I pitch a tent and decide to wait for better weather, which arrives the following day. In April it is still winter in the Rockies. In addition, the location is about 3,000 meters above sea level at a latitude of 52 degrees. The temperature is unbelievably cold this particular morning, but I am extremely happy to be on the ridge looking at the mountain.

From the 3,000-meter elevation of Ermatinger
4×5 400 mm ƒ32 1/60 sec SL RVP

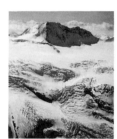

14. Mount Hooker

The morning of my third day on the mountain is very fine again. There is only good weather, however, at the elevation where I am situated. I can see thick clouds below. To reach Mount Hooker you must start at the Athabasca River, travel 45 kilometers through Whirlpool Valley, and then travel to the snout of Scott Glacier. From there you still have to climb icefalls before you can stand on the Hooker Icefield. I look at Mount Hooker from the snout of the glacier. With its north side in shadow, the mountain stands in the afternoon sunlight. The view deeply impresses me. It feels as if Mount Hooker is there only for me.

From the sky over the snout of Scott Glacier, late April
6×9 ƒ11 1/500 sec RDP

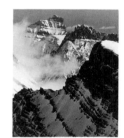

15. Mount Fryatt 3,361 meters

Mount Fryatt is a strange mountain. It can be seen from the Icefields Parkway, but it looks different depending on the angle from which you view it. Sometimes it is almost as if you are seeing different mountains. The most common view of it is from downstream of the Mount Christie viewpoint on the Athabasca River. The uniquely shaped peak of Mount Fryatt soars above. This shot, however, is from another angle. With Lick Peak in the foreground and with Mount Belanger, 3,120 meters, in the middle, Mount Fryatt leans to the right in the background.

From the Hooker Icefield, mid-April
4×5 600 mm ƒ32 1/4 sec SL + PL RVP

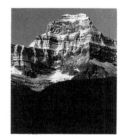

16. Mount Christie 3,103 meters

Mount Christie isn't that high. In fact, there are many other mountains just as high in the Rockies. What has made Christie noteworthy is the frontal face (called Northeast Face), the northeast ridge on the right, and the southeast ridge on the left. The steep face and the ridges fill viewers with admiration and stir the blood of climbers. At the viewpoint on the Athabasca River there are several spots from which you can enjoy the beautiful sights of this mountain.

From Athabasca Viewpoint, early October
4×5 600 mm ƒ32 1/2 sec SL + PL RVP

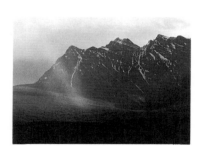

17. Dragon Peak 2,819 meters

Due to bad weather, I stay in the town of Jasper for an unexpectedly long time. I wait until the last moment, but early one morning I finally decide to leave for Calgary, even though the weather is still unstable. Just before reaching Sunwapta Falls, I notice the soft morning sunlight hitting a mountain on the west side of the Athabasca River. A rainbow forms over the mountain. I stop the car and quickly set up my camera. This is a lucky turn of events. Later I learn that the mountain is called Dragon Peak.

From near Honeymoon Lake, early July
4×5 300 mm ƒ32 1/8 sec SL RD

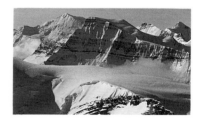

18. Mount Clemenceau 3,658 meters

I fully enjoy my three days on the Hooker Icefield. I am surrounded by mountains and, wherever I turn my camera, I get shots that are above average. I notice a big cluster of mountains in the southwest, but I am involved in photographing other mountains. It is only in the evening of my second day on the icefield that I turn to that cluster, which includes Mount Clemenceau.

From the Hooker Icefield, mid-April
4×5 600 mm ƒ32 1/15 sec SL RVP

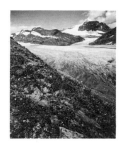

19. Clemenceau Glacier and Mount Clemenceau

The Clemenceau Icefield is the second largest icefield in the Canadian Rockies. There is no path to reach it. The intrepid explorer who wishes not to fly can only reach the icefield three ways: via the Cummins River, a tributary of the Columbia River in British Columbia; via the Columbia Icefield on skis and crampons; or, more popularly, from Sunwapta Falls in Jasper National Park via the Athabasca and Chaba Rivers, Fortress Lake, and Clemenceau Creek — a three- or four-day trip. After one week to 10 days of travel, you will see Mount Clemenceau sitting serenely beyond flower fields and glaciers.

From Lawrence Grassi Hut on the Clemenceau Icefield, early July
4×5 120 mm f22 1/30 sec SL RVP

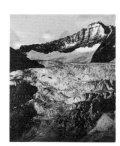

20. Mount Shackleton 3,330 meters

In order to get an overview of the Rockies, I charter a Yellowhead helicopter in Valemount and end up making use of the flight to land on the Clemenceau Icefield, which has no access road. Lawrence Grassi Hut stands on the right bank of the Clemenceau Glacier moraine. It is clean and quiet and there are no tourists, so it serves as a comfortable base for me. Enjoying flowers and observing the many squirrels and mountain goats, I take pictures of Mount Shackleton to my heart's content. I wonder if I will ever have a time as pleasant as this again.

From Lawrence Grassi Hut on the Clemenceau Icefield, early July
4×5 400 mm f22 1/8 sec SL RVP

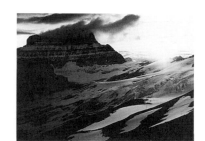

21. Mount Alberta 3,619 meters

I hike up the mountain from Woolley Creek. As I climb the unstable scree, just before reaching Woolley Shoulder, I begin to feel quite tired. The fatigue vanishes, however, when I finally see Mount Alberta, which I couldn't see from anywhere else. Although it takes me two days to climb up here, I never imagined that I would see the mountain so soon after finishing the climb. I am very touched. I wait for the clouds to clear from Alberta's summit. However, even strong winds are unable to blow them away. Still, the clouds produce an effect that pleases me.

From Woolley Shoulder, mid-July
4×5 180 mm f16 1/15 sec SL RVP

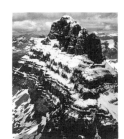

22. Mount Alberta

Mount Alberta is known for its rockfalls. In 1925 the Keio University party of Japan, led by Aritsune Maki, made the first ascent. They went up the Athabasca River hauling supplies on packhorses and approached the mountain from the west side. I can imagine the struggles they had to endure. I want the whole view and, upon returning from the Clemenceau Icefield by helicopter, I fly east to Mount Alberta. To the left of The Twins I see Mount Alberta soaring up from the Athabasca River. I fly around the mountain two or three times. For about 15 minutes I am totally absorbed by what I see in my camera's viewfinder.

From the southwest sky over Mount Alberta, early July
6×9 f11 1/500 sec RDP

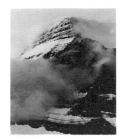

23. Mount Columbia 3,747 meters

I leave Golden, British Columbia, travel north, reach the Bush River, and then head toward its riverhead. I want to take pictures of Mount Columbia, the second highest peak in the Canadian Rockies, but it can't be seen from the base of the mountain. No results on the second or third day, either. On the fourth day, when my food supply is about to run out, mountains in the area start to become visible in the soft light. Mount Columbia, the shot I came for, appears through the fog now and then. Unfortunately I only get a few photos of it.

From the riverhead of the Bush River, late June
4×5 600 mm f32 1/15 sec SL RVP

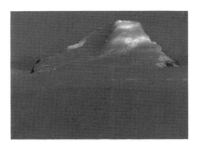

24. Mount Columbia

On my fifth day on the Saskatchewan Glacier I manage to pitch a tent at the northern end of Castleguard Mountain, 3,090 meters. I waste as many as three days because of bad weather. Time is precious, but I have no choice. In the Rockies there are many mountains that are difficult to locate. That is why I climb to the middle of the Columbia Icefield. On the following morning the long-awaited Mount Columbia, covered in snow, appears.

From the Columbia Icefield, mid-July
4×5 600 mm f32 1/4 sec SL RVP

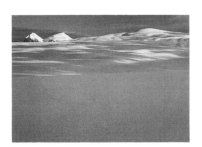

25. Snow Dome (right), 3,413 meters, and The Twins, North 3,730 meters, and South 3,580 meters

There are three of us, plus my camera equipment, packed into a tent. The uncomfortable night is over and the morning is very cloudy, but the weather slowly improves. The icefield had been shadowed by clouds, but the snow on it now starts to reflect some light. From behind The Twins and Snow Dome light begins to show intermittently, and then more and more. It will not be long before the snowfield is flooded with light.

From the Columbia Icefield, mid-July
4×5 300 mm f32 1/15 sec SL RVP

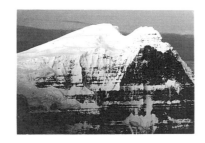

26. Sunrise on The Twins, North *(left)*, 3,730 meters, and The Twins Tower *(right)*, 3,640 meters

I spend the night on Woolley Shoulder. The following day the mountains turn rosy, although only for a short time. They are bathed briefly in the morning sun. Should I photograph Mount Alberta? Or The Twins? I want to shoot both. It isn't an easy choice. Fortunately the red hue of Mount Alberta doesn't increase that morning, while the reddish tinge of North Twin and The Twins Tower does, so I turn my camera toward them without hesitation.

From Woolley Shoulder, mid-July

4×5　400 mm　ƒ22　1 sec　SL + PL RVP

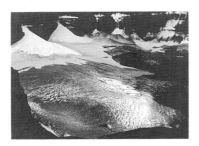

27. Glacier at the riverhead of Habel Creek

Time goes by quickly on Woolley Shoulder and evening draws near. The clouds above clear only occasionally to show blue sky for a short time, but the summit of The Twins remains in the clouds. There is little hope of witnessing the sunset. Unable to give up, I stand motionless on the ridge, praying for good luck. I look down at the glacier below The Twins. Impressed by its interesting shape, I wonder if I can do something with it. As if my prayers are heard, a small spot of light falls on the glacier and rapidly enlarges.

From Woolley Shoulder, mid-July

4×5　600 mm　ƒ32　1 sec　SL + PL RVP

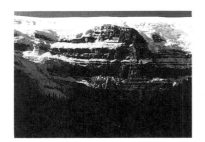

28. Stutfield Glacier

Stutfield Peak, 3,352 meters, is found east of The Twins on the contiguous ridge that runs northwest from Snow Dome. An extension of the Columbia Icefield, the Stutfield Glacier plunges steeply on the east side of Stutfield Peak. The glacier pours over a 500- to 600-meter cliff that must have been entirely covered by ice during the last Ice Age. At present, two-thirds of the cliff are exposed, offering a magnificent view.

From the viewpoint near Tangle Falls, early August

4×5　600 mm　ƒ32　1/8 sec　SL + PL RVP

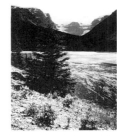

29. Stutfield Glacier

On the Icefields Parkway between the Columbia Icefield and Jasper, there are many viewpoints from which you can enjoy mountains, valleys, waterfalls, and glaciers. Each viewpoint is conveniently equipped with a parking lot. This viewpoint near Tangle Falls is a new one that is quickly becoming popular.

From Stutfield Glacier Viewpoint, mid-July

4×5　90 mm　ƒ32　1/15 sec　SL RVP

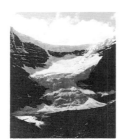

30. Dome Glacier

Castleguard, Saskatchewan, Columbia, Kitchener, Athabasca, Bryce, Dome, and Stutfield are the eight named glaciers that run out of the Columbia Icefield, one of the largest sheets of glacial ice in the interior of North America. There are also dozens of smaller unnamed glaciers in the vicinity of the Columbia Icefield. The Athabasca Glacier, however, is the best known. This could be because it is situated directly in front of the Columbia Icefield Information Centre. Dome Glacier is on the right, forming icefalls in two steps. This glacier, unfortunately, is now much smaller than it used to be.

From the Columbia Icefield Information Centre, mid-May

4×5　300 mm　ƒ22　1/30 sec　SL RVP

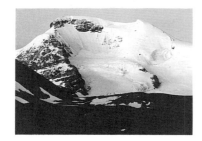

31. Mount Athabasca 3,491 meters, in the sunrise

After spending the night at the Columbia Icefield campground, I leave for Wilcox Ridge before dawn. The trail through the woods is longer than I expected, and the sun rises before I reach my destination. Hurriedly I set up my camera and press the shutter. This is the only chance I will get to take some pictures. Soon after, the weather suddenly deteriorates. I get only two shots, and this is one of them. This kind of situation happens often, making me realize how crucial my departure time can be.

From halfway up Wilcox Ridge, early July

4×5　240 mm　ƒ22　1/15 sec　SL RVP

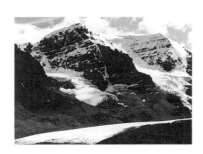

32. Mount Andromeda 3,450 meters

As soon as I get out of the car, the rough, cold wind chills my bones. Every time I go through the Columbia Icefield, I suffer from the harsh wind. Here the valley runs north to south, which makes a favorable passage for the wind. The elevation is high and the icefield cools the air. The wind is hard, and so is this mountain.

From the Columbia Icefield Information Centre, mid-May

4×5　400 mm　ƒ22　1/15 sec　SL RVP

33. Mount Lyell Group

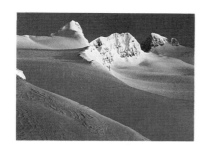

Lyell is a name used to represent a group of mountains in this small area. There are five peaks: Rudolph, 3,507 meters; Edward, 3,515 meters; Ernest, 3,511 meters; Walter, 3,400 meters; and Christian, 3,390 meters. The peaks were named to honor the pioneer Swiss guides of the Rockies – Rudolph Aemmer, Edward Feuz, Ernest Feuz, Walter Feuz, and Christian Häsler. This photo, taken at daybreak, shows only Christian *(left)*, Walter *(center)*, and Ernest *(right)*, and doesn't include Rudolph or Edward, which is the highest peak. According to another source, however, Ernest is the highest, with an elevation of 3,520 meters.

———

From north of Division Mountain on the Continental Divide, mid-April

4×5 600 mm *f*32 1/2 sec SL + PL RVP

34. Mount Forbes 3,612 meters

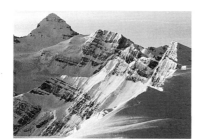

Neither the Lyell Group nor Mount Forbes can be seen from the base of the mountains or from the highway because they are hidden behind other mountains located in the foreground. Consequently they aren't well known, although their elevations are among the highest in the Rockies. The location of my tent, which I pitch on the Continental Divide at an elevation of 3,100 meters, is about equal distance to both Mounts Lyell and Forbes. Unfortunately the morning sun is too weak to photograph Forbes in the right colors.

———

From 3,100 meters on the main ridge of the Rockies, mid-April

4×5 600 mm *f*32 1/2 sec SL + PL RVP

35. Mount Bryce 3,507 meters

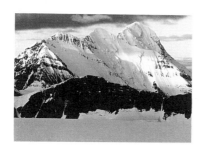

Mount Bryce, although it boasts a magnificent aspect and prominent elevation, isn't easily seen. This is also true of the Lyell Group and Mounts Columbia, King Edward, and Forbes, as well as Freshfield Peak, all of which have elevations of 3,300 to 3,700 meters. Their obscurity is due to their locations deep in rugged mountain ranges. On the other hand, these locations are blessings for Bryce and the other mountains because it means they are left in relative isolation.

From the Columbia Icefield, mid-July

4×5 600 mm *f*32 1/4 sec SL + PL RVP

36. Mount King Edward 3,490 meters

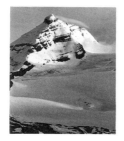

Mount King Edward is located near the west end of the Columbia Icefield and adjoins Mount Columbia. King Edward's summit is slightly slanted to the left in an almost stylish way. Many mountains in the Canadian Rockies, like this one, have been named after members of British royalty.

———

From the Bush River riverhead, late June

4×5 600 mm *f*32 1/15 sec SL RVP

PART II

37. Mount Murchison 3,333 meters

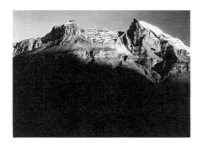

I wonder, as I look through the viewfinder of my camera, how many times I have photographed Mounts Chephren and Murchison aglow in the setting sun. Or how often I have tried to capture the elongated shape of Murchison from the proper angle. I know I have driven by this spot on the Icefields Parkway on my way from Lake Louise to Saskatchewan River Crossing many times. Nevertheless, I have never seen Mount Murchison this radiant in the sunset. At last I have hit the bull's-eye.

Near Saskatchewan River Crossing, late April

4×5 300 mm *f*32 1 sec SL + PL RVP

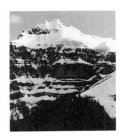

38. Epaulette Mountain 3,095 meters

South of Saskatchewan River Crossing three peaks — Sarbach (3,155 meters), Kaufmann (3,110 meters), and Epaulette (3,095 meters) — are found in a row on the west side of the Mistaya River. Even though Epaulette is the lowest of the three, it is still the most photogenic.

From the Icefields Parkway, six kilometers south of Saskatchewan River Crossing, late April

4×5 600 mm ƒ32 1/8 sec SL RVP

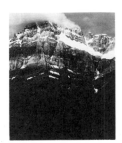

39. Howse Peak 3,290 meters

West of the Waterfowl Lakes and Mistaya Lake, eight peaks stand in a row, including, from the north, Mount Chephren, White Pyramid, and Howse Peak. Set a short distance from the Icefields Parkway, together they give the impression of a citadel rather than individual peaks. Among them, Howse Peak stands out because of its distinctive aspect. I spend five days at the Waterfowl campground, hoping for a good shot of this mountain. Finally I get one in the glorious morning light.

Near the Waterfowl Lakes, late July

4×5 600 mm ƒ32 1/8 sec SL RVP

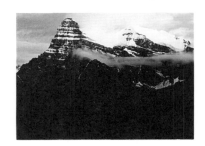

40. Mount Chephren 3,266 meters, and White Pyramid 3,275 meters

As I approach Saskatchewan River Crossing, a remarkably steep peak comes into sight on the west side of the Icefields Parkway. Its size is overwhelming. It soars into the sky so sharply that looking up at it almost causes an actual physical pain in the neck. This is Mount Chephren. Connected with it is a peak that reminds the viewer of a beautiful pyramid of snow. This is, appropriately, White Pyramid.

Near the Waterfowl Lakes, early July

4×5 400 mm ƒ22 1/2 sec SL + PL RVP

41. Mount Chephren

There are many mountains that stand near the Icefields Parkway, but few make really good subjects for photographs. Some, for example, lack dynamism. Others, although they have enough dynamism and a good configuration, are difficult to photograph. Mount Chephren falls into the latter category. I barely succeed in getting this shot after spending several days in the Waterfowl campground. With this photo-graph I try to express the image I have of Chephren in my mind.

Near the Waterfowl Lakes, late July

4×5 400 mm ƒ22 1/15 sec SL RVP

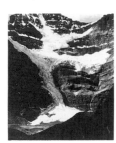

42. Mount Patterson 3,197 meters

Mount Wilson, north of Saskatchewan River Crossing, is an example of a mountain that is located near the Icefields Parkway but is hard to photograph because its configuration is too massive. Mount Patterson, which is found south of Mistaya Lake, is difficult to photograph for another reason — because it looks totally different depending on the angle from which you shoot it. Patterson has a strong, diverse personality. In other words, it is a mountain well worth photographing. It is only after many photography trips to the Rockies, however, that I face Mount Patterson squarely and bring myself, finally, to confront it.

From a place off the Icefields Parkway, late July

4×5 400 mm ƒ22 1/60 sec SL RDP II

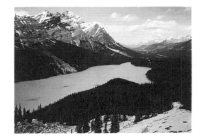

43. Peyto Lake and Mount Patterson

Among many lakes with unique personalities in the Rockies, Peyto and Louise are two of the most distinctive. Like many glacial lakes, Peyto has a remarkable turquoise color. The Peyto Glacier, seen at the end of this lake, is the source of many kinds of fine-grain minerals, which cause the lake's wonderful color. Over the lake, Mount Patterson looms large.

From the viewpoint on Peyto Lake, early July

4×5 90 mm ƒ32 1/30 sec SL RD

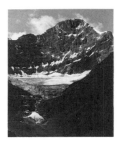

44. Snowbird Glacier on Mount Patterson

The glaciers on the east and south sides of Mount Patterson are very distinctive. The one on the east side, Snowbird Glacier, is particularly photogenic.

From a viewpoint by the Icefields Parkway, east of Mount Patterson, late July

4×5 400 mm ƒ22 1/30 sec SL RDP

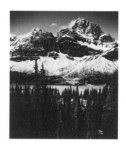

45. Crowfoot Mountain 3,050 meters

The Crowfoot Range is a small section of the Waputik Range, which stretches from Lake Louise to Saskatchewan River Crossing. Just off the main ridge of the Rockies, the Crowfoot Range is located between Hector and Bow Lakes. The glacier near the south end of this range has the shape of a crow's foot, after which the range and the mountain were named. It is a pity that one of the claws of the glacier has recently melted, thus only the name remains entirely intact.

From Crowfoot Viewpoint, late August

4×5 210 mm f22 1/30 sec SL RD

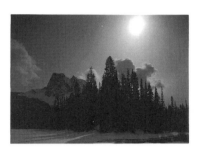

46. Emerald Lake and Mount Burgess 2,599 meters

I was here at this spot in Yoho National Park 13 years ago but left in a hurry because of a crowd of tourists. Since then I have tried to return many times. However, the weather has always been bad and I never get an opportunity to take any pictures. Still, such fruitless experiences haven't kept me from returning. It is now late March. The emerald water of the lake is still completely covered with snow and ice. Miraculously the clouds move. There is light. Deeply touched, I press the shutter for the first time on Emerald Lake.

From Emerald Lake, late March

4×5 65 mm f32 1/15 sec SL RVP

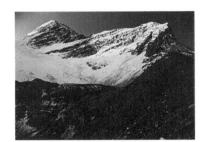

47. The President 3,138 meters

As soon as I enter the Little Yoho Valley, I come across a big black bear eating berries. I step back very quietly, hold my breath, and stay still for about an hour. It isn't a pleasant experience. I camp at Mount Pollinger in the evening and have another unpleasant experience trying to find my way in the dense fog. However, once the night is over and I reach a ridge with a clear view, there is nothing to be afraid of. The President seems to rule, and bless, the whole area.

From a high point on Mount Pollinger in the Little Yoho Valley, late September

4×5 240 mm f32 1/15 sec SL + PL RDP

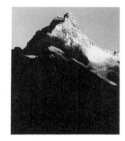

48. Cathedral Crags 3,073 meters

This mountain got its name because its appearance suggests a Gothic cathedral. Cathedral Mountain, 3,189 meters, adjoins Cathedral Crags and is higher, but I prefer the configuration of the Crags. I feel a sense of closeness to this mountain, particularly at sunset, and take a number of pictures every time I drive by it on the Trans-Canada Highway in Yoho National Park.

From the viewpoint near the entrance to the Yoho River Valley, late September

4×5 600 mm f32 1/2 sec SL + PL RDP

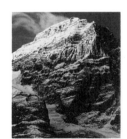

49. Mount Stephen 3,199 meters

Mount Stephen is closer to the Trans-Canada Highway than Cathedral Crags and Cathedral Mountain. Soaring into the sky, its dignified configuration is impressive and certainly one of the most outstanding in the Canadian Rockies. Some mountains are overlooked only because they are located near a road. As if it were indifferent to such considerations, Mount Stephen stands almost arrogantly alongside the highway.

From the viewpoint near the entrance to the Yoho River Valley, late September

4×5 400 mm f22 1/15 sec SL + PL RDP

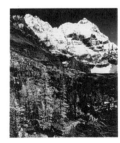

50. Hungabee Mountain 3,492 meters

In mid-September, with the arrival of autumn, I come to this area in Yoho National Park by shuttle bus. This new travel experience makes me feel restless. I pitch my tent in the campground, anyway, and begin taking pictures. On the second day, in the morning, I do some more photography on Lake O'Hara, and then, after visiting Mary Lake, I climb Opabin Plateau. The larch trees are already starting to change color here and there. Beyond the cluster of larches there are snow-clad peaks. One of these is the remarkably sharp peak of Hungabee.

From Opabin Plateau, mid-September

4×5 180 mm f32 1/30 sec SL RDP

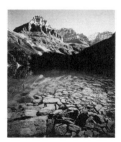

51. Mount Huber 3,368 meters, and Lake O'Hara

Lake O'Hara is in the center of Yoho National Park. All the mountains on the east side of this lake stand back-to-back to the mountains west of Lake Louise in Banff National Park. North of Lake O'Hara, Mount Huber is so prominent that the higher Mount Victoria, on Yoho's border with Banff, can't be seen. Mount Huber was shaped by glaciers and presents a distinctive appearance. It has a unique presence and is unlike any of the mountains surrounding it. The exceptionally clear water of Lake O'Hara displays fragile reflections of the nearby mountains.

From the northwest shore of Lake O'Hara

4×5 65 mm f32 1/8 sec SL + PL RDP

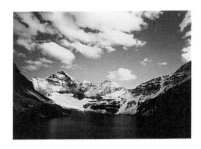

52. Mount Biddle 3,319 meters, and Lake McArthur

After spending three days in Yoho, I decide to visit Lake McArthur via McArthur Pass. After Lake O'Hara I pass the Alpine Club Chalet, travel over a steep slope in the woods, and come to Schaffer Lake. There are alpine meadows above McArthur Pass, but entry into the McArthur Creek area is prohibited because of grizzly bears. I am so involved in enjoying Mount Biddle, Lake McArthur, and the clouds drifting across the deep blue sky that I forget all about the time.

From the north side of Lake McArthur, mid-September

4×5 180 mm ƒ32 1/30 sec SL RVP

53. Ringrose Peak 3,281 meters, and a cascade

Before dawn I climb up onto the plateau on the southeast side of Lake O'Hara to get some morning shots. Sunrise was at 7:30 a.m., and I was up an hour earlier. After I finish photographing, I change the film and am surprised by how many pictures I have taken. I proceed along the trail to Lake Oesa and walk up a gentle slope. There are three small ponds that are connected by creeks in the sparse woods. I find a cascade there and capture the shining Ringrose Peak in the background.

From the trail to Lake Oesa, mid-September

4×5 150 mm ƒ16 1/60 sec SL RDP

54. Chancellor Peak 3,280 meters

I travel south to the Chancellor campground on the Kicking Horse River. Clouds move into the area in the late afternoon. I wait for two hours. Suddenly a streak of sunlight comes from a break in the clouds and hits the summit and flank of Chancellor Peak. I am completely enchanted by this unexpected good luck.

From the Kicking Horse River, late July

4×5 300 mm ƒ32 1/30 sec SL RVP

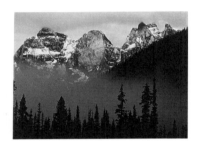

55. Mount Goodsir, North Tower (right), 3,525 meters, and South Tower (left), 3,562 meters

It is already August when I enter the Ottertail Valley in the southern part of Yoho National Park. Camping is controlled here, just as it is at Lake O'Hara. I hike on the wide firebreak in the valley as far as Goodsir Creek. The following day is cloudy with frequent rain but, for a brief moment in the morning, Mount Goodsir appears. This is my only chance to photograph the highest mountain in Yoho.

From Goodsir Creek in the Ottertail Valley, early August

4×5 300 mm ƒ32 1 sec SL + PL RVP

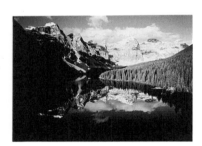

56. Moraine Lake and the Valley of the Ten Peaks

Moraine Lake is located south of Lake Louise. It used to be a quiet lake, but it became commercialized as soon as a hotel was built beside it and large tour buses started arriving. The serenity of days past is now virtually gone. The scenery, however, is as beautiful as ever. As it always has, the Valley of the Ten Peaks enthralls me with upside-down reflections on the water. All of the "ten peaks" are over 3,000 meters high. Their names, from west to east, are Wenkchemna, Neptuak, Deltaform, Tuzo, Allen, Perren, Peak 4, Bowlen, Little, and Fay.

From the Moraine Lake Viewpoint

4×5 150 mm ƒ22 1/60 sec SL RD

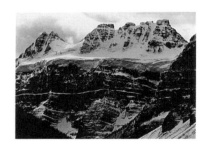

57. Bident Mountain (left), 3,084 meters, and Quadra Mountain 3,173 meters

Quadra Mountain's summit ridge stretches sideways. Its face below the glacier is much more threatening than the one it presents above. Blocks of ice constantly fall from the glacier, making it difficult to climb. In order to approach this mountain, I travel up Babel Creek, which is close to Moraine Lake. When I reach the Consolation Lakes, I see Quadra and Bident Mountains beautifully reflected in the water. My dream is to come here one day when there is no snow.

Near the Consolation Lakes, late April

4×5 600 mm ƒ32 1/15 sec SL RDP

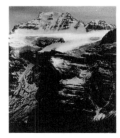

58. Mount Fay 3,234 meters

The official name for the Ten Peaks is the Wenkchemna Peaks. "Wenkchemna" means "ten" in the Stoney Native language. The original intention was to name each peak using the numbers one to ten in the Native language. Mount Fay is the fifth highest of the Ten Peaks and is popular because of its striking configuration.

From the Larch Valley Trail, late September

4×5 400 mm ƒ22 1/60 sec SL RDP

59. Grand Sentinel (Sentinel Tower) 2,610 meters

If you follow the Larch Valley Trail, hike to the upper plateau, and look back, you will see the Ten Peaks all lined up. In the other direction you will eventually come across two mountains — Eiffel Peak on the left and Pinnacle Mountain on the right. Behind Pinnacle Mountain, to the right, is Sentinel Pass. From there you can see the Grand Sentinel soaring up from the base of Pinnacle's face. It doesn't look big because everything around it is huge, but it is actually a tower of considerable height.

From Sentinel Pass, late September
4×5 600 mm ƒ32 1/8 sec SL + PL RDP

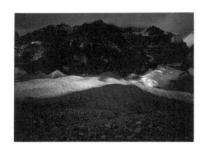

60. Hungabee Mountain 3,492 meters, and **Horseshoe Glacier**

It is early autumn. The trail in the Paradise Valley is quiet. I feel as if I am walking somewhere in the Okuchichibu Mountains in Japan. The environment suddenly changes at about 1,800 meters. I am surrounded by desolate rocks. The feeling of gloominess is heightened by the weather that has worsened as a result of the rain. On the following day I climb up the moraine that descends from Mount Lefroy, 3,432 meters. Clouds in the sky reflect the unstable weather, and the sun shines infrequently. The presence of the clouds, however, is exactly what I want in order to express my feelings in this picture.

From about 2,150 meters in the Paradise Valley, late September
4×5 120 mm ƒ32 1/15 sec SL RDP

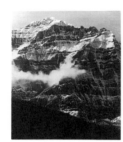

61. Mount Temple 3,543 meters

Early in the morning I drive from Banff to Lake Louise on the Bow Valley Parkway, the old highway that connects the two towns. My intention is to photograph Lake Louise. This plan, however, is completely abandoned because of good photography conditions on Castle Mountain. Once I pull out the camera, I can't stop pressing the shutter. I just keep taking pictures all the way until I arrive at the entrance to Lake Louise and obtain this shot of Mount Temple.

From near the entrance of Lake Louise, late September
4×5 600 mm ƒ32 1/8 sec SL RVP

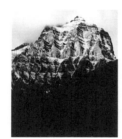

62. Mount Temple

Occupying 15 square kilometers, Mount Temple is one of the most massive mountains in Banff National Park. The third-highest peak in Banff, Temple presents the photographer with many wonderful possibilities, ranging from the Castle Mountain Viewpoint to all along the old Banff-Lake Louise highway. I have taken numerous pictures of this mountain in spring and summer, but none of them have ever really satisfied me. Naturally I am overjoyed when I find the angle of this shot, although I have to admit the lighting conditions are ideal.

From near the Bow Valley Parkway, late September
4×5 240 mm ƒ32 1/30 sec SL RDP

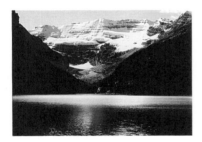

63. Mount Victoria 3,464 meters

As crowded as it is during summer, Lake Louise suddenly becomes deserted in autumn. Now the noises are gone. The rowboats that once swarmed the lake can't be seen. Lake Louise and Mount Victoria of days gone by are back again. Today I can accept even the common or mediocre angles I usually don't like. The lighting conditions are also good. A beautiful streak of light falls on the water.

From Lake Louise, late September
4×5 400 mm ƒ22 1/60 sec SL RDP

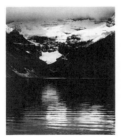

64. Lake Louise and **Mount Victoria**

Being a well-known tourist spot, Lake Louise is often crowded, which sometimes makes it difficult to set up tripods. Even if I manage to take pictures of the lake, they tend to turn out too ordinary. This time I decide to use the deteriorating weather. Although the summit of Mount Victoria is hidden, the light is rather entrancing and the reflections on the water are more effective.

From Lake Louise, early July
4×5 400 mm ƒ22 1/60 sec SL RDP

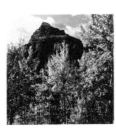

65. Pilot Mountain 2,935 meters

In many places along the Bow Valley Parkway I have secret viewpoints where I can take pictures without being interrupted by anyone. Here Pilot Mountain on a quiet autumn day seems particularly tranquil.

From the Bow Valley Parkway, late September
4×5 210 mm ƒ22 1/60 sec SL RDP

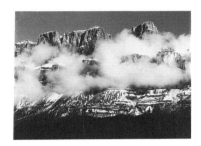

66. Castle Mountain 2,766 meters

If you take the Trans-Canada Highway north, you come across a viewpoint on your right just before you reach Redearth Creek. From this viewpoint a series of peaks can be seen ahead. These are the peaks of Castle Mountain. Although not very high, Castle Mountain is very popular with hikers and climbers. If you proceed north up the Bow Valley Parkway and turn left onto the Banff-Windermere Highway at Castle Junction, there is another excellent viewpoint of Castle Mountain.

———

From Castle Junction, late September

4×5 240 mm ƒ32 1/15 sec SL + PL RDP

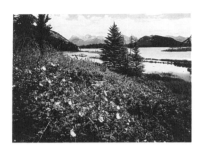

67. Vermilion Lakes and the Fairholme Range

The Vermilion Lakes are located just west of the town of Banff. There are pleasant trails off the lakes where hikers often encounter beavers and coyotes. In summer many people visit this place to take pictures of the rainbow of wildflowers and the mountains reflected on the lakes.

———

From the Vermilion Lakes, early July

4×5 90 mm ƒ32 1/15 sec SL RD

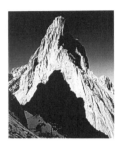

68. Mount Louis 2,682 meters

Mount Louis, located on the north side of the Bow River between the town of Banff and Johnston Canyon, bears a striking resemblance to Yarigatake in Japan, although Louis's spearlike peak is much bigger and steeper. It has snowed here the day before, and I discover that I am not dressed appropriately. The snow is much deeper than I imagined it would be. Both my pants and shoes get soaked and I end up having an uncomfortable time. The view at Edith Pass isn't as good as I expect, so I move north to Cory Pass where the view is perfect.

———

From Cory Pass, early October

4×5 150 mm ƒ16 1/125 sec SL RDP

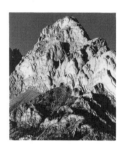

69. Mount Edith 2,554 meters

I am unable to find a good place near Edith Pass to take pictures of Mounts Edith and Louis in the morning light. I try to get a shot through a small gap between the trees, but the vantage point is unsatisfactory. From there to Cory Pass I trudge through deep snow via the east and north sides of Mount Edith, but I can't see Mount Edith again from anywhere. I almost give up taking pictures of it until I find an ideal angle on my way down. The lighting conditions are perfect, too, and I take a chance on shooting a close-up of just the summit of the mountain.

———

From the south ridge of Mount Edith, early October

4×5 600 mm ƒ32 1/8 sec SL + PL RDP

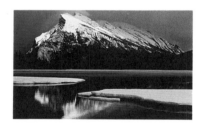

70. Mount Rundle 2,949 meters, and the Vermilion Lakes

I spend an afternoon taking pictures of the Three Sisters. After wondering for a while about what to do with my evening, I drive to the Vermilion Lakes. I have made the right decision. Soon after arriving, the clouds that have been cloaking the summit of Mount Rundle break up and soft sunlight shines through. I can't miss this chance. Filled with excitement and using all of my skills, I keep pressing the shutter for a good hour. I take 54 color pictures and 18 monochrome shots before I quit.

———

From the Vermilion Lakes, early April

4×5 300 mm ƒ32 1/8 sec SL RDP

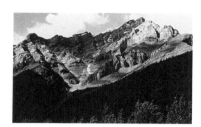

71. Cascade Mountain 2,998 meters

Mount Rundle is south of the town of Banff while Cascade Mountain sits to the north. Both function as gateways to the town and have trails on their west sides. I have seen Cascade so often that I almost end up not taking even one picture of it, just because I know that I can at any time. Cascade appears to be less steep than Mount Rundle only because of its configuration. Calculating the effects of light and shadow, I succeed in capturing its steepness.

———

From the outskirts of the town of Banff, early July

4×5 240 mm ƒ22 1/60 sec SL RD

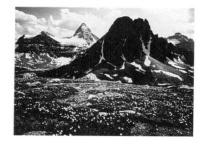

72. Sunburst Peak 2,830 meters, and Mount Assiniboine 3,618 meters

I hike from Lake Magog, travel between Sunburst and Cerulean Lakes, and climb Nub Peak. Seen from Nub Ridge, Sunburst Peak, at an elevation of more than 2,800 meters, doesn't look very high. Usually there are a lot of people on the slopes of Nub Peak, but this time only our party is present. White globe flowers and moss campion are in bloom on the ridge. They set off Sunburst Peak, Mount Assiniboine (in the background), and surrounding mountains beautifully.

———

From Nub Ridge, late June

4×5 65 mm ƒ32 1/15 sec SL RVP

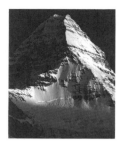

73. Mount Assiniboine

As I check the weather for my morning picture-taking, I open the door of my cabin and am surprised to see several huge elk running by. When I reach the spot where I usually set up my camera, I faintly see Mount Assiniboine in the weak light of dawn. I am treated to a visual feast before the morning completely arrives.

From the heights on the northern shore of Lake Magog, late June
4×5 600 mm ƒ32 1/8 sec SL RVP

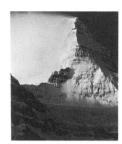

74. Mount Assiniboine

My luck with the weather this spring has been bad for weeks. Finally the sun appears and Mount Assiniboine, the "Matterhorn of the Rockies," displays its splendors as a stiff wind blows snow off a ridge. Assiniboine is the sixth-highest peak in the Canadian Rockies, and here it demonstrates how it got its nickname.

From the heights on the northern shore of Lake Magog, early April
4×5 600 mm ƒ32 1/8 sec SL + PL RVP

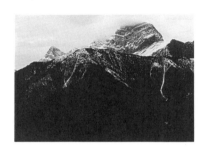

75. Mount Lougheed 3,105 meters

Chinaman's Peak, the Three Sisters, and Mount Lougheed are located in the north end of the Kananaskis Country provincial recreation area. Like Mount Assiniboine, they are frequently covered by clouds. After many fruitless attempts to photograph Mount Lougheed, I settle down on the heights of the north shore of the Bow River and manage to get this shot of the mountain in the evening glow.

From near Gap Lake off the north shore of the Bow River, early April
4×5 600 mm ƒ32 1/2 sec SL + PL RDP

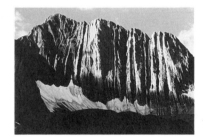

76. Mount Lyautey 3,082 meters

Mount Lyautey is one of the peaks of the Joffre Range in Peter Lougheed Provincial Park in the Kananaskis Country provincial recreation area. Ten mountains in this range are more than 3,000 meters high. Southwest of Upper Kananaskis Lake, Lyautey's vertical grooves and pillars are a delight for rock climbers.

From the western heights of the Foch Valley, mid-October
4×5 400 mm ƒ22 1/30 sec SL RDP

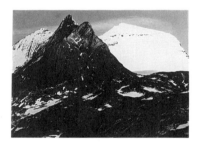

77. Mount Joffre 3,449 meters

The trail leading southwest from Upper Kananaskis Lake meanders through the woods on the lakeshore. Walking across dried-up Hidden Lake, I arrive at a plateau and climb a steep slope full of unstable rock. When I arrive at a smaller lake, I am exhausted. Before I can finish pitching my tent, the evening light descends. It has come as if to bless me for hiking this far. I spend a spectacular evening on Mount Joffre as if in a dream.

From near Hidden Lake, mid-October
4×5 600 mm ƒ32 1 sec SL + PL RVP

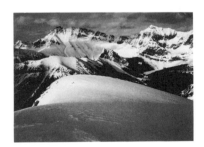

78. The Royal Group

Just as the name suggests, the 10 peaks of this mountain range are named after kings, queens, princes, and princesses of the British royal family. Six of the "royals" are 3,000 meters or more. In this photo Prince Henry, 3,227 meters, is on the right. On the left there are Prince John, 3,236 meters, with a small summit, and Queen Mary, 3,245 meters.

From a nameless peak, 2,650 meters, near Queen Mary Creek, mid-April
4×5 90 mm ƒ32 1/30 sec SL RVP

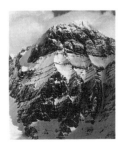

79. Mount King George 3,422 meters

Mount King George is the highest peak in the Royal Group and has a dignified configuration. Other "royals" are Princess Mary, 3,084 meters, Prince Albert, 3,209 meters, Prince George, 2,880 meters, King Albert, 2,981 meters, and Queen Elizabeth, 2,849 meters. These lesser-known mountains hold a special place in my heart.

From a nameless peak near Queen Mary Creek, early April
4×5 600 mm ƒ32 1/30 sec SL RVP

PART III

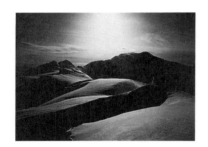

80. Mount Sir Wilfrid Laurier 3,520 meters, and Mount Mackenzie King 3,264 meters

I spend three nights in the tent that I pitch just below the summit of Penny Mountain in the Cariboo Mountains of British Columbia. The weather is fine only on the first day. Every evening thin clouds spread and cover the entire sky. Laurier, the highest peak in the Cariboos, and Mackenzie King stand in the backlight with their flanks half in shadow.

From a 2,950-meter campsite on Penny Mountain, early May
4×5 90 mm f22 1/125 sec SL RDP

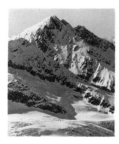

81. Mount Sir Mackenzie Bowell 3,275 meters

The vast plateau of ice and snow high in the Cariboo Mountains near Valemount, British Columbia, seems to extend forever. On that immense icefield peaks stick out here and there. As a warm-up to further shooting, I try to capture Mackenzie Bowell, the second-highest summit in the Cariboos, with a telephoto lens.

From a campsite on Penny Mountain, early May
4×5 600 mm f32 1/15 sec SL RDP

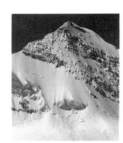

82. Mount Sir John Thompson 3,245 meters

I don't spend much time photographing Mount Sir John Thompson, largely because I mistake a nearby peak for Thompson and keep my camera set on the wrong mountain. Wanting to make up for my mistake, I take another series of pictures of Thompson, but the results aren't good. I suspect I am too close to the mountain. In the end I miss the opportunity for a good shot. To take pictures of a mountain, I need to be entirely focused and well prepared. In this case I don't have everything under control.

From the upper plateau of Little Matterhorn, early May
4×5 400 mm f22 1/60 sec SL RDP

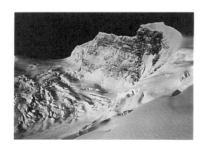

83. David Peak 3,090 meters

The Cariboo Mountains are about 200 kilometers long and 65 kilometers wide and have more than 10 peaks of 3,000 meters or higher. The main peaks, which exceed 3,200 meters, are Sir Wilfrid Laurier, Sir John Thompson, Mackenzie King, Sir Mackenzie Bowell, and Sir John Abbott, all named after Canadian prime ministers. David Peak is only a little over 3,000 meters, but it outshines the other mountains because of its location at the head of the South Canoe Glacier and its dramatic configuration.

From the campsite on the upper part of Little Matterhorn, early May
4×5 180 mm f32 1/30 sec SL + PL RDP

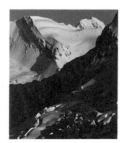

84. Chilkist Peak 2,820 meters, and Chamberlain Peak 3,110 meters

Because Mount Sir Wilfrid Laurier is the highest mountain in the Cariboos and I am greatly enticed by its constantly changing light conditions, I take too many shots of it. For a change I turn around to see a different motif. My timing is excellent because the sun has come around to the west, giving more depth to the mountains. Beyond the crevasse-filled head of the North Canoe Glacier, Chilkist reveals its snow-clad peak and Chamberlain can be seen in the background.

From the campsite at the head of the North Canoe Glacier, early May
4×5 600 mm f32 1/30 sec SL RDP

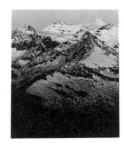

85. Torii Peak 3,200 meters

The Monashee Mountains are found on the west side of the Columbia River. The biggest range in the Columbia Mountains, the Monashees extend from Valemount to the Washington State border. Torii Peak seems to have been named after the Japanese term *torii*, meaning gateway to a Shinto shrine. There are *torii*-shaped rocks on the summit of this peak. According to my information, the elevation of Torii Peak is 3,200 meters but, in reality, it is higher than the neighboring Lempriere, 3,208 meters. In any case, it is a difficult mountain to access.

———
From Mount Sir Allen, mid-May

4×5　600 mm　*f*32　1/4 sec　SL RVP

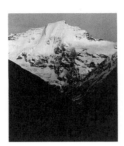

86. Mount Lempriere 3,208 meters

Elevation data for mountains in the Monashees is often sketchy. The highest peak in this range is said to be Monashee at 3,246 meters. The word *monashee* is Celtic for "mountain of peace." Like the Cariboos, the Monashees are difficult to explore. Other mountains in the area near Mount Lempriere are Albreda, 3,075 meters, Dominion, 3,125 meters, and Hallam, 3,128 meters.

———
From near the Thompson River, mid-May

4×5　600 mm　*f*32　1/15 sec　SL RVP

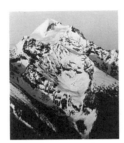

87. Mount Albreda 3,075 meters

Mount Albreda can be seen from various spots on the Yellowhead South Highway that connects Valemount and Blue River. However, you can enjoy it more from the higher vantage point of Mount Sir Allen where it appears to soar skyward like a pyramid. In the early evening Albreda has a delicate coloring.

———
From the summit of Mount Sir Allen, mid-May

4×5　400 mm　*f*22　1/8 sec　SL RVP

88. Mount Begbie 2,732 meters

Mount Begbie is located more or less in the middle of the Monashees. Bearing a distinctive configuration, it also boasts a small glacier. In the morning Begbie's three peaks look like a big dignified eagle with its wings spread.

———
From a site south of Revelstoke, British Columbia, early October

4×5　600 mm　*f*32　1/4 sec　SL + PL RDP

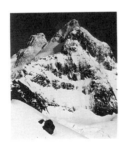

89. Big Blackfriar 3,255 meters

It is mid-April and snowy when I photograph the Adamant Range in the Selkirk Mountains. I cart my tent up to the head of the Silverchip Glacier and, judging that the weather will remain stable, decide to climb to the ridge bordering the Adamant Glacier. I trudge through the steep snow, arrive at the ridge and, clinging to its thin edge, secure my camera and myself with a rope. Hours of scorching sun have come and gone. Big Blackfriar rises in front of me, while over its left shoulder Little Blackfriar can be seen.

———
From the southeast ridge of Big Blackfriar, mid-April

4×5　400 mm　*f*22　1/60 sec　SL RDP

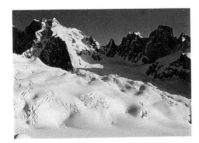

90. Adamant Range

If you look toward the Adamant Range from the Adamant Glacier area, you can see the southeast side of it. The peak on the extreme left is Adamant, 3,356 meters, and, proceeding from left to right, are The Stickle, 3,150 meters, Pioneer Peak, 3,290 meters, and The Gothic, 3,280 meters. Many of the elevations for peaks in the Selkirk Mountains, however, are uncertain.

———
From the southeast ridge of Big Blackfriar, mid-April

4×5　120 mm　*f*22　1/125 sec　SL RDP

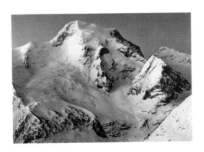

91. Mount Sir Sandford 3,533 meters

The Sir Sandford Range in the Selkirks is located just south of the Adamant Range. The main peak is Sir Sandford, which is the highest mountain in the Selkirks. Some of the other peaks are Bidette, 3,000 meters, Palmer, 3,015 meters, and Fort Stall, 3,170 meters. Bidette and Fort Stall can be regarded as peaks belonging to Sir Sandford. The morning sun shines on Sir Sandford and moves to Bidette on the right.

———
From the southeast ridge of Big Blackfriar, mid-April

4×5　240 mm　*f*32　1/4 sec　SL + PL RDP

92. Rocky Mountains in the morning glow

The summit of Alpina Dome, 2,730 meters, is an immense snowfield. The slope of snow is too gentle to obtain good photographic compositions of the Sir Sandford or Adamant Ranges, so I walk quite a distance from my tent, looking for decent angles. The next morning begins with a strong wind that blows up snow and disturbs my picture-taking. Nevertheless, I am able to capture tinted clouds over Mount Sir Sandford. What pleases me more, though, are the clouds over the distant Rocky Mountains that keep shifting colors in the glow of the morning light.

From Alpina Dome, mid-April

4×5　600 mm　ƒ32　1/2 sec　SL RVP

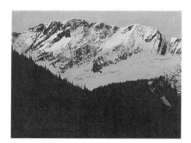

93. Mount Bonney 3,107 meters

At first the Rogers Pass area of British Columbia is cold and unfriendly but, after I pay several visits, the conditions in the area begin to improve. I see many mountains in the region and try to remember their names. In my efforts to identify these mountains I also attempt to gain a deeper understanding of them. Nevertheless, Mount Bonney eludes me. It always seems to hide behind the clouds. However, to my surprise, this morning Bonney is totally exposed. The glimpse lasts for only a moment, though. As soon as the morning light disappears, Bonney vanishes once again.

From the entrance to Rope Broke, late April

4×5　300 mm　ƒ32　1/4 sec　SL RVP

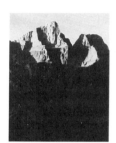

94. Mount Tupper 2,816 meters

At Rogers Pass in Glacier National Park I am amazed at how the builders of the Canadian Pacific Railway laid track in such a narrow valley of heavy snow. At the same time I am impressed by the wonderful mountains that are clustered together here. Mount Tupper stands on the north side of the entrance to Rogers Pass. The steepness of the face is quite extreme. In fact, it is vertical. I find myself transfixed by the sight of Mount Tupper bathed in the afternoon light.

From Abbot Ridge, early October

4×5　400 mm　ƒ22　1/2 sec　SL + PL RVP

95. Mount Macdonald 2,893 meters

Mount Macdonald rises at the south entrance to Rogers Pass. Upon approaching this area, this is the first mountain that comes into sight. In order to capture the stunning beauty of Mount Macdonald, I make several trips between East Portal and Rogers Pass. The result, unfortunately, is unsatisfactory, probably because the mountain is too big or too high. I climb one flank of Rogers Pass, face Macdonald directly, and finish the day's undertaking.

From five kilometers northeast of Rogers Pass, mid-April

4×5　120 mm　ƒ32　1/8 sec　SL + PL RDP

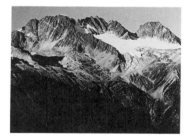

96. Hermit Range

The Hermit Range in the Selkirks is a group of mountains that stretches more than 20 kilometers north of Rogers Pass. It has 17 peaks ranging from 2,600 to 3,000 meters or more. The peaks of 3,000 meters plus are all located in the northern part of the range. The highest are Mount Rogers, 3,214 meters, and Swiss Peak, 3,208 meters. Hermit Mountain is a little lower at 3,110 meters. The photo shows, from left to right, Rogers Peak, Swiss Peak, and Hermit Mountain. The fourth peak is Mount Sifton, 2,940 meters, which is connected to the left side of Rogers Peak.

From Abbot Ridge, early October

4×5　300 mm　ƒ32　1/8 sec　SL RVP

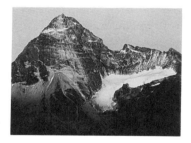

97. Mount Sir Donald 3,297 meters

Mount Sir Donald can be seen from the Trans-Canada Highway in Glacier National Park. I am often compelled to pick up my camera when I look upon its sharp pyramid form. After trying to photograph it numerous times from the highway, I decide to view it from a higher vantage point. I attempt to photograph it from Asulkan Pass in the southern part of the park, but the mountain looks totally different from that angle and doesn't satisfy me. I change locations and, at this new spot, I spend the whole day bonding with Sir Donald. It reveals a different aspect every moment. The finale is the evening light. I descend from the mountain completely contented.

From Abbot Ridge, early October

4×5　400 mm　ƒ32　1/2 sec　SL RVP

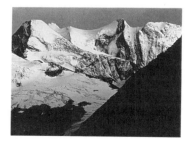

98. Dawson Group

The Dawson Group is located on the southeast side of Asulkan Pass. It contains five peaks that are 3,000 meters or more. Directly south of this group is the Purity Range, which has five 3,000-meter-plus summits. This photo shows, from left to right, Fox, 3,225 meters, Selwyn, 3,360 meters, Hasler, 3,386 meters, and Feuz, 3,350 meters — the last two comprise Mount Dawson.

From Abbot Ridge, early October

4×5　600 mm　ƒ32　1 sec　SL + PL RVP

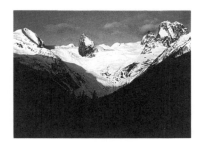

99. Bugaboo Group

The main characteristic of the Bugaboo Group south of Glacier National Park in the Bugaboo Alpine provincial recreation area is the rock spires that jut out of the glaciers like big teeth. They are remnants of the hills that were chiseled into these forms by glaciers. Year after year the glaciers continue to recede. In this photo, from right to left, are Snowpatch Spire, the much smaller Pigeon Spire, Hound Tooth, and Anniversary Peak.

From Bugaboo Lodge, mid-April
4×5 150 mm *f*16 1/60 sec SL RDP

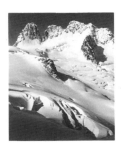

100. Pigeon Spire 3,124 meters

As soon as the sun ascends, the tranquillity of Pigeon Spire is disturbed. Vapor rises from its snowy surface as the wind begins to swirl. The vapor then becomes a dense fog and crawls over the snowfield in a thin layer. It appears to cover the mountains but is soon disrupted by the wind blowing up from below. A seesaw game between the fog and the wind ensues. I camp on the glacier at 3,100 meters. On the second day I am blessed with fine weather. From early morning on I struggle through the snow in heavy snowshoes and I am exhausted by the effort. In spite of everything, when I come across a sight such as the one in this photograph, the hard work is amply rewarded.

From the head of Vowell Glacier, mid-April
6×9 *f*22 1/125 sec SL RDP

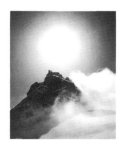

101. Howser Spire 3,399 meters

Howser Spire is the highest peak in the Bugaboo area and boasts an outstanding configuration. It is comprised of three peaks: North Tower, 3,399 meters, the highest; Central Tower; and South Tower. Both of these latter peaks are said to be 3,094 meters, which is questionable. In addition, my map shows Central Tower as the highest and North Tower as the lowest. What to believe?

From a col at the south end of Bugaboo Spire, mid-April
4×5 180 mm *f*32 1/15 sec SL RVP

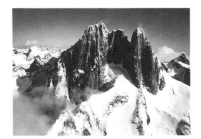

102. West face of Howser Spire

This photo clearly shows that the highest peak of Howser Spire is North Tower and that the second highest is South Tower. Central Tower, then, is the lowest. Furthermore, the spires aren't lined up from east to west, but from southeast to northwest. Often many facts about mountains in the Bugaboo region are unclear or inaccurate. Howser Spire is popular because of its rock-climbing potential. There are several routes leading to the peaks of South and North Towers.

From the southwest sky, mid-April
6×9 *f*16 1/250 sec RDP

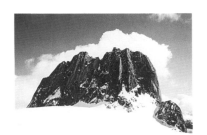

103. West face of Snowpatch Spire 3,063 meters

Snowpatch's name is derived from the fact that one spot on the east side of this spire always has unmelted snow, which looks like a white patch. Snowpatch looks much fresher from this angle than when it is photographed from the east side.

From the lower snowfield of Howser Spire, mid-April
6×9 *f*22 1/125 sec RDP

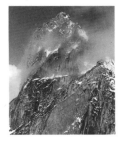

104. Bugaboo Spire 3,185 meters

When I first look at Snowpatch and Bugaboo Spires from Conrad Kain Hut, I am deeply impressed. I have to say, however, that looking up at them from down below is very different than looking at them from an elevation of 3,000 meters. In this photo, with the wide lower part eliminated, the spire looks simpler and more refreshing. Timely fog arrives to help enhance the sense of height.

From the head of Vowell Glacier, mid-April
4×5 600 mm *f*32 1/30 sec SL RDP

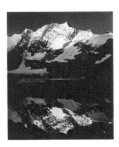

105. The Lieutenants 3,216 meters

I travel south from the Bugaboo Group and decide to hike to Lake of the Hanging Glaciers, which is in the north end of the Purcell Wilderness Provincial Conservancy. It is hot. In addition to the summer sun, the heavy load on my back contributes to the heat. The shore of Lake of the Hanging Glaciers is a perfect place in the midst of all of this untouched nature. I am very fortunate, though, to have good weather and to get a wonderful shot like this on the first day of my arrival. After enduring so much bad weather, this is like a dream.

From Lake of the Hanging Glaciers, early August
4×5 180 mm *f*32 1/2 sec SL + PL RDP

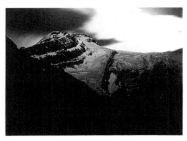

106. Commander Mountain 3,362 meters

Just when I am about to eat my dinner in the tent, it suddenly becomes bright all around. The moon has risen over the right shoulder of Commander. I leave the warm dinner I have just prepared, quickly take out my camera, set it up, and start taking pictures. The moon is bright but the mountain is very dark. Focusing is quite difficult. The result, however, greatly pleases me. The colors of the clouds are overwhelmingly beautiful.

From Lake of the Hanging Glaciers, early August
4×5 400 mm ƒ8 20 sec SL RDP

107. Karnak Mountain 3,399 meters

I heard about hanging glaciers many years ago and have always wanted to see one. Now, after several decades, my wish comes true. Karnak looks small against the glacier, probably because I am at a great distance from it. I look at the glacier all day and never grow bored with it. Every time I look away and then look back at the same spot, I notice that the glacier's pink tint has increased. Sunset must be near.

From Lake of the Hanging Glaciers, early August
4×5 600 mm ƒ32 1/2 sec SL RVP

THREE YEARS IN THE CANADIAN ROCKIES

In October 1989 I finished photographing the entire Karakoram. In the fall of 1990 *Great Karakoram* was published and my personal exhibition of these photographs was a huge success. After the Karakoram project, I intended to take two years off to recharge my batteries. But the "vacation" never happened and soon I was working on several new projects.

Otsuki, my hometown, asked me to work on a new book, *The Twelve Views of Mount Fuji*, and I also began trips to photograph other places in Japan and undertook yet another project to shoot the European Alps. However, in mid-August 1990, while waiting in line at a highway tollgate on my way back from a photography trip to the Southern Japan Alps, my van was struck from behind by an 11-ton truck whose driver had fallen asleep at the wheel. My van was completely smashed, sandwiched between the first truck and a four-ton truck in front of me. I was so severely injured that I couldn't walk. The accident forced me to give up my mountain trips. For a while recovery looked bleak, even though I received daily medical treatment in the hospital. At the time it was rumored among my colleagues that I would never take pictures of mountains again.

In 1991, though, I resumed work on *The Twelve Views of Mount Fuji*. After carrying nothing during an hour's walk on a gentle slope, I felt my entire body stiffen and I was unable to move. A bath in lukewarm water and a complete body massage were necessary before I regained mobility. Needless to say, my recovery was slow. Desperately, perhaps thinking work would help restore my health, I took every job offer I got. The Japan Broadcasting Corporation asked me to photograph the Southern Japan Alps three times, and I was also invited to speak at the 70th anniversary of the Enzanso Lodge in the Northern Japan Alps. On all of these occasions I was flown in by helicopter. Around the same time I even journeyed to Nepal, but only with a 35 mm camera. Finally, in January 1992, I climbed Mitsutoge in Japan and went to Pakistan in April. After I completed these two trips, I saw a ray of hope and decided to go ahead with my long-standing dream to do a major photographic study of the Canadian Rockies. June 23, 1992, was set as the departure date.

My very first photography trip to Canada was back in the summer of 1984 after I finished shooting the Nepal Himalayas. My wife, my friend Toru Nakano (who later died at Gasherbrum II), and I spent nearly three weeks in Canada. I fondly remember having a party in our camper

every day because the weather was bad the whole time. My second trip to the Rockies took place in August 1989. Unfortunately the weather wasn't good this time, either. Day after day it rained, and naturally I couldn't take pictures as I had hoped to. In fact, the morning of the day before my departure it snowed as much as 40 centimeters in spite of being summer. Miraculously, though, the sun did finally shine later in the day, and I felt as if I were being given a special gift.

So it shouldn't be too surprising that I was a little worried about the weather when I began preparations for my third trip to Canada in June 1992. Due to past experience I decided to stay a bit longer than I ever had before. The weather was fine on the day of my arrival. On the second day, however, it became cloudy, and immediately I feared worse was to come. To my great relief, though, the weather improved on the fourth and fifth days.

The sixth day also started out fine, becoming cloudy only later. I went back to Canmore, Alberta, then left again to resume my main project, which was to photograph the Continental Divide. From then on, until I returned to Canmore on July 13, I had only one good day of weather. For three days I saw sunshine only occasionally. The other days were all rainy or completely cloudy. Nevertheless, considering the bad weather, I believe the result was fairly satisfactory. Making a point of using even the least rift in the clouds and the weakest sunshine, I took good pictures of Mounts Columbia and King Edward from the head of the Bush River, and some more photographs at the Clemenceau Icefield.

Although I got a few good pictures in 1992, the project was off to a bad start. So the next year I left for Canada at the end of March and didn't return to Japan until mid-May. When I arrived in Vancouver it was raining once again, and a day later the weather was still rotten by the time I checked into the Assiniboine Lodge near Canmore. My pessimism increased, even though the sun shone briefly the next day; my mood only got bleaker when it snowed for two days after that. As the days passed, I adopted a who-gives-a-damn attitude and settled down to finish a number of articles I had been commissioned to write.

This kind of wait-and-see process is an occupational hazard for mountain photographers. I had experienced the same kind of weather delays in the Himalayas and Karakoram, but still put the time to good use. While I was shooting the Karakoram, I wrote several books during many lengthy waiting periods. Even bad weather has its

uses, since it allows me to write books and articles that generate income for my photography projects.

Still, the waiting period at Assiniboine Lodge dragged on for nearly three weeks. But finally, on April 10, the weather improved and I was able to get some good pictures of the Three Sisters near Canmore. At Vermilion Lakes I also photographed Mount Rundle in unexpectedly good conditions. Soon after that I headed for the Bugaboo Alpine provincial recreation area in British Columbia, where I photographed Snowpatch Spire and Hound Tooth from the Conrad Kain Hut, and took numerous shots of Howser, Pigeon, and Bugaboo Spires. The mountains displayed wonderful and varied aspects during this time, and the views were so exceptional that I felt somewhat compensated for all my previous frustration.

Encouraged by this good fortune, I moved on to Rogers Pass in Glacier National Park. Once again, though, the weather turned bad, so I decided to try my luck farther north near Adamant Mountain and Mount Sir Sandford, which, at 3,533 meters, is the highest peak in the Selkirk Mountains. I set up my base camp on a gentle south slope close to Adamant from where I could I also see Sir Sandford in the distance.

On April 19 I got up before dawn and left. The countless stars in the sky seemed to promise a good day. I climbed up to the ridge of Big Blackfriar in the Adamant Range. It had been snowing until the day before and, consequently, I had to trudge through soft snow on a steep slope with iced parts here and there, making the climb extremely hazardous. Because of this I missed the sunrise by a hairbreadth. What a pity! I had no other choice but to count on the next day.

Alhough I missed the sunrise, the snow-clad peaks of Sir Sandford and Adamant were still beautiful. With a rope I secured my camera and myself to a ridge of snow, ice, and rock. Excited and absorbed by the magnificent view, I almost forgot where I was and, as a result, had some frightening moments.

The next day the morning was fine again. This time I was able to climb up to the previous day's point with relative ease by following the trail I had already made. And, happily, I got the shots I was after. Later in the day I moved to Alpina Dome and spent another night in the area.

My next stop was Mount Robson Provincial Park, farther to the east. On three previous occasions I had tried to photograph Robson, twice unsuccessfully. This would be my final attempt, and I was determined not to fail. Fortune

smiled once more, and I managed to pitch my tent north of Berg Lake. I spent two days there and another couple of days near Snowbird Pass. During those four days it snowed steadily, but nevertheless I got good results and made the best use of the sun that occasionally shone when there was a rift in the clouds. Mount Robson and Resplendent Mountain appeared, but Whitehorn Mountain never did.

After waiting for three days in Valemount, British Columbia, I went to the Cariboo Range, again expecting fine weather. It was my first time there and I had no grasp of the terrain. To make the situation worse, the sunlight reflecting on the snow made it very difficult for me to discern the lay of the land, so I pitched my tent on a random spot. Fortunately I chose an ideal place with a commanding view of the main mountains, Sir Wilfrid Laurier and Sir John Thompson, as well as David and Chilkist Peaks. The fine weather lasted from the afternoon of the first day through the afternoon of the second day, and my time in the Cariboo Range proved very satisfactory. I then spent three days at the second spot, Penny Mountain. The days there were fine in the morning, but the good weather didn't last long – snow and fog came in.

After the Cariboo, I found it more difficult to locate a good photography point in the Monashee Range to the south, largely because that configuration is less steep compared with other ranges. In the summer of that same year I had the same problem when I photographed Hallam Peak, mistakenly thinking it was the highest peak in the region. In the end, I decided to climb Allen Peak located in the southern end of the Cariboo Range. Unfortunately the mountains there, except for Albreda, didn't meet my expectations.

After a brief return to Japan, I flew back to Canada on June 29 to resume my photography of the Rockies. It is often said that the third time is lucky. It was now the fourth time, and I still ended up with poor results. I tried the Bobbie Burns heli-hike, but that didn't work, either. All I got was more cloudy skies, occasional sunshine, and rain.

In the summer of 1992 I had gone up the Bush River, and from its riverhead I had seen Mount Columbia for the first time. This mountain stands in the middle of the Columbia Icefield and can only be seen properly at close range. Then, in the summer of 1993, I decided to enter the Columbia Icefield, and four of us went in with tents, bedding, food, fuel and, of course, my cameras.

In addition to the heavy load, other trials were waiting for us before we finished climbing up the icefield. On the

first day, we reached the route to the Saskatchewan Glacier via the big bend in the south end of Sunwapta Pass. It took us an unexpectedly long time because of a detour around the snout of the glacier, and we had to spend a night on the glacier. From the second day on, due to bad weather, we were forced to stay for three nights at the junction of the valleys that lead to Terrace Creek. Finally, on the fifth day, we were able to pitch a tent north of Castleguard Mountain, where our perseverance was fully rewarded. I was able to get fine shots of Mount Columbia, Mount Bryce, Snow Dome, and The Twins from difficult angles.

In order to photograph Mount Alberta, you have to go up the Athabasca River a fair piece, starting from Sunwapta Falls, or climb up to the Continental Divide. I chose the latter and waded across the Sunwapta River, then climbed up Woolley Shoulder via Woolley Creek. I had a hard time climbing the last portion of the glacier and the unstable scree. But that hardship meant nothing to me, since it allowed me to shoot The Twins, Mount Woolley, and Stutfield, Diadem, and Mushroom Peaks, as well as Mount Alberta, my main objective. However, except for the afternoon of the day I climbed up and the morning of the following day, the weather was bad. Consequently I had to spend five days on the Divide. It was as if I were being made to pay for the good photographs I had obtained.

After spending four days at a campsite on the Waterfowl Lakes near Mount Chephren in Banff, I returned to British Columbia via the Kicking Horse River and eventually headed for Lake of the Hanging Glaciers in the Purcell Range. In the afternoon of the day of my arrival the weather began to improve. The following day was quite fine and I was treated with marvelous views: the Lieutenants in the evening glow and their reflection in the lake; the snow on Karnak Mountain and its hanging glacier, turned red by the sunset; and Commander Mountain at moonrise. Those two days made me feel as if my good luck had returned.

I then proceeded to the Blaeberry Valley to photograph the Mummery Group, followed by a journey into the Ottertail Valley, where I finally glimpsed the long-sought Mount Goodsir. Even though I saw it only briefly, I was still glad.

I covered the Rockies again for the third time in 1993 for 41 days. Starting on September 6, I photographed the Tonquin Valley and The Ramparts first. I also flew to Mount Robson and Berg Lake by helicopter, descending via Emperor Falls and Kinney Lake. Then I covered the Yoho and Little Yoho River Valleys, Sentinel Pass, the Paradise Valley, Maligne Lake, Rogers and Asulkan Passes, and the Abbot Ridge. Everything went smoothly and, strangely enough, the rain that usually followed me didn't this time. The weather was fine, even when I was near the town of Banff to photograph Mounts Louis and Edith. There was no delay or interruption of any kind until I finished with the Kananaskis Country provincial recreation area and, in particular, Peter Lougheed Provincial Park, my last scheduled spot.

For my final coverage of the Rockies, I left for Canada on April 6, 1994, and returned to Japan on May 8. My plan was to cover the Royal Group, a range of mountains seldom photographed. Most of the time the weather was fine except for a few days. Thanks to the plentiful sunlight, my irritation was kept to a minimum. While in the Royal Group I pitched my tent on a ridge in deep snow. The snow-clad mountains looked so beautiful and pure that I felt as if I had been invited into a world of fantasy. During this last trip I could easily imagine how the Rockies must have looked in earlier times.

All told I took seven photography trips to Canada over a three-year period. I made numerous trips between Banff and Jasper on the Trans-Canada Highway, not to mention all the travel from Jasper to Mount Robson, from Robson to Valemount, from Valemount to Blue River, and other trips to Golden and Revelstoke. And then there were the countless logging roads near all these places that I found myself journeying down as I sought hidden glimpses of first one mountain, then another.

I used a number of different film sizes, including 4"×5," 6 cm × 17 cm, 6 cm × 9 cm, 6 cm × 6 cm, 6 cm × 4.5 cm, and 35 mm. In total I took 35,000 pictures. For the first time I used a helicopter, which didn't necessarily contribute to the large number of photographs.

The peculiarity of the Canadian Rockies and the Columbia Mountains lies in the physical effort and time spent in climbing them. Unlike the mountains of Japan, most of these peaks have no trails. Unlike the Nepal Himalayas, there are few trodden paths or cattle tracks you can take to a good photography point. Instead you have to wade across rivers, fight through bush, and struggle across swamps, as well as trudge over glaciers and climb rock walls. You need to carry food, fuel, bedding, and a tent. You also have to know that there is the additional weight of cameras, film, and related equipment. And you are required to

finish everything within a limited time frame. In my case, in addition to all of these conditions and limitations, I was slowed down by the continued effects of the traffic accident I suffered in 1990. For me, a helicopter proved to be one method of increasing my mobility.

I hope I have adequately described what a photographer undergoes physically and mentally during a photographic expedition. I have to confess that, while camping in the mountains, I had a genuine fear of being attacked by a bear. In the past I have had tense encounters with both grizzly and black bears. But all the problems and difficulties have long ended and only these photographs remain. This is a simple fact that still delights me.

AFTERWORD

Imagine, if you will, row upon row of mountain ranges studded with peaks and swathed in icefields as devoid of life as those of Antarctica's interior. Then imagine jagged skylines as impressive as the Himalayas, yet as accessible by road as the south rim of the Grand Canyon.

The mountains of western Canada harbor a vast treasure trove waiting to be discovered by the nature lover, and their valleys are a haven for countless species of plant and animal life. first perceived by 17th- and 18th-century European explorers and later by commercial exploiters as a barrier to opening up the country's resources, the healing powers of these same mountains now attract multitudes of urban refugees fleeing from the chaotic world we live in.

Of the rugged heights that form the Canadian Cordillera, the mountain system of British Columbia and Yukon Territory is by any measure the most extensive. British Columbia's ranges run roughly northwest to southeast, beginning in the west with the Coast Range, dramatic and inaccessible fjordland bordering the Pacific Ocean; continuing with the Columbia Mountains (Cariboos, Monashees, Selkirks, and Purcells), which fill up the interior of the province; and ending with the spine of the Rockies, which forms the Continental Divide.

Physiographically the Canadian Rockies run from the border of Montana north along the Alberta-B.C. boundary to the Liard River, near the Yukon border. They are separated from the Interior Ranges by the Rocky Mountain Trench with its seven major watersheds, and the Interior Plains shore up their eastern ranges.

In this book photographer Shiro Shirahata has chosen to share with us the portion of the Cordillera that features the most classic of the peaks and ranges. That is, his coverage stretches from the Kananaskis Country provincial recreation area in the south to Mount Robson Provincial Park in the north. He has also included the pick of the crop from the neighboring Interior Ranges of British Columbia.

Three town sites are located within this area: Jasper, Banff, and Canmore, with a current total population of no more than 20,000 people. In this respect the Rockies are similar to the Japan Alps. There are only a few towns actually in the Alps, whereas in the myriad valleys of the Himalayas, Andes, and European Alps whole cultures of indigenous peoples thrive.

Banff Park and town site are surrounded by three other national parks – Yoho, Kootenay, and Jasper – which have collectively earned the classification and status of a World Heritage Site. This distinction, bestowed by the United Nations, places them on a par with the Pyramids of Egypt, the Galápagos Islands, and the Incan site of Machu Picchu.

Contrary to the superficial impression of wilderness given by driving at top speed on a four-lane highway through the heart of these parks, the range has, in fact, been mercilessly whittled away on all sides by the logger's saw and the miner's bulldozer blade. Within the 100 years or less that Canada's first national park, Banff, came into existence, the core of the park has evolved into a cross between a mountain museum and a zoo.

People in Canada often take things like our riveting natural heritage for granted, and we sometimes need an outsider to point out how lucky we are to live in, or close to, such a pristine environment. One such person is Japan's celebrated mountain photographer, Shiro Shirahata. Through his love for mountains and his combative approach to overcoming extreme physical and mental challenges, Shirahata has persevered in producing, to date, the most significant large-format pictorial book in color of Canada's Rocky Mountains.

Apart from possessing the knowledge and skill of a photographic master, part of the secret of doing justice to such an awe-inspiring landscape is investing the huge blocks of time and patience necessary to be on-site when all the photographic elements finally fall into place. Certainly Shirahata realized this from having worked on other books – such as his studies of the Himalayas, the Andes, and the European Alps – and, as a result, devoted the better part of three summers to this project.

In my own experience of trying to capture the power and majesty of the Rockies on film, even though they are in my own backyard – the jutting limestone buttresses of Mount Rundle frequently catch fleeting rays of morning sun and taunt me through the bedroom window – it is really a matter of *being there* with your camera mounted on a tripod and pointed more or less in the direction you intend to shoot when that moment occurs.

The photographer who views this book should be aware of some of the technical difficulties that the Rockies present, apart from the logistics of moving oneself and one's heavy equipment through the vertical landscape. The first is the fickleness of mountain weather. Clouds in certain proportions make for interesting photos, but too many, or too few, can have an adverse effect.

In other great ranges, atmospheric pollution in the form of dust particles and water vapor provide a natural filter for the light, which warms up the colors considerably. On a sunny day in the Canadian Rockies, however, harsh, undistilled light pours through the dry, clean air and is often rendered in austere white and black tones by color photographic film.

There is also the great spread of intensity between the light falling on the highly reflective peaks of 3,000 meters or more, and the light-absorbing valley bottoms 2,000 meters below that are so hard to record on a film emulsion. Even for the naked eye, the range of lighting contrast makes it difficult to render detail in both highlight and shadow within the same scene.

Other notable photographers have come up against the same difficulties, so Shirahata is not alone in this respect. In 1928 the virtuoso of the black-and-white medium, Ansel Adams, spent part of a summer season as official photographer with the Sierra Club, attempting to document the area around Mount Robson. As is evidenced by a single uninspiring photo of Resplendent Mountain that has been published in numerous places, the Rockies yielded far fewer acceptable images than his native California Sierra would have in a similar time span. Despite these difficulties, Adams lauded the mountains in his autobiography: "The Canadian Rockies are another world: spectacular and difficult. The rock . . . is not as firm and bright as the granites of the Sierra. It is gorgeous country, with unpredictable weather: a glorious sunset can resolve into a sudden rainstorm, changing into sleet by the early morning hours."

Another mountain adventurer, Walter Wilcox, corroborates the challenge of photography in his illustrated book, *The Canadian Rockies*: "in an entire year there are only a few minutes, or at the most, a few hours in which the conditions are perfect for exposing a plate. . . ." An examination of Shirahata's portrayal of the Rockies, which has been presented along similar lines to his many other mountain books, reveals the way he relates to the mountain world. He opts to use telephoto lenses and show us spectacular "head-and-shoulder" portraits of peaks, in most cases cut off from their supporting valleys, riverbeds, and forests. It is as though he wants to personify the mountains, relying on available light to bring out their true nature. He seems to be attempting to expose the power and individuality of these mountains by isolating their uppermost reaches. Or, perhaps, this self-confessed lover of nature strives to eliminate from his photos the modified environment that lies at the foot of many of these peaks.

This book provides the impetus to go and see for yourself the magnificence of Canada's Rocky Mountains. If you are unable to make the journey, then this book, with its large, full-color layout, will allow you to hold the mountains close and almost feel the cool sensation of standing on a crevasse-ridden glacier on the brink of a world-class alpine view. And all this without having to wait for hours or days for the weather to clear. Enjoy!

Pat Morrow
Canmore, Alberta